TRANSFORMATIONS
IN LATE EIGHTEENTH CENTURY ART

Transformations
in Late
Eighteenth Century
Art

Robert Rosenblum

PRINCETON UNIVERSITY PRESS
PRINCETON, NEW JERSEY

Publication of this book has been aided
by the Publication Committee of the Department of
Art and Archaeology of Princeton University

Second Printing, with corrections and
a special preface for this printing, 1969

Third Printing, 1974

Printed in the United States of America
by Princeton University Press

To Professor Frances Godwin of Queens College,
who first taught me to love art history
and to understand its methods and goals

PREFACE AND ACKNOWLEDGMENTS

I N ART, as in history, the late eighteenth century created such profound breaches with the past that today, in the late twentieth century, we are still grappling with the problems that then announced the dawn of a new era. In histories of art, this period of unprecedented complexity has generally been divided into the two presumably antagonistic categories of Neoclassicism and Romanticism, a black-and-white polarity that, in more refined histories, also permits a single shade of gray called Romantic Classicism. With closer scrutiny, these semantic straitjackets, like the term Mannerism, have become impossible either to live with or to live without. What are we to call those strange new emotions we feel welling in so much late eighteenth century art, if not Romanticism? What are we to call that abundance of works newly inspired by Greco-Roman art, history, and mythology, if not Neoclassicism?

Yet, indispensable as they seem to remain for simple communication, these two unequal categories—one referring more to feeling, the other more to form and/or to subject matter— are pitifully inadequate in analyzing the bewildering new variety of emotions, styles, and iconography that emerged in the late eighteenth century. Even the hybrid term, Romantic Classicism, offers only the broad implication that some (or is it all?) art inspired by Greco-Roman antiquity is also saturated with Romantic sensations. And even if we decided to be rigorous and substitute objective chronology for subjective isms, we would soon find ourselves involved with the uncomfortable fact that when we say late eighteenth century art, we really must include much of early nineteenth century art as well; and that the awkward alternate phrase, "art around 1800," seems not to extend sufficiently into the eighteenth or nineteenth centuries to cover what we mean.

It should be quickly said that I have not found a new solution to these persistent problems, and that these semantic difficulties may well continue to vex the reader, as they do me. In fact, I

have gone on using these terms in as commonsensical a way as possible. But what I have tried to do as well is to undermine the ostensible clarity of the usual historical presentation of this period by offering, so to speak, a Cubist view. By this, I mean that I have consciously tried to avoid any absolutes of method and category, and have approached these decades in a kaleidoscopic manner that constantly shifts its vantage point and even moves freely from one nation and one medium to another. For, beginning around 1760, Western art becomes so hydra-headed that the historian who attacks it from a single approach is sure to be defeated. Thus, instead of a complete survey, I have offered four essays that touch upon some, but hardly all, of the major new issues of the period; and instead of choosing between the artificial Scylla and Charybdis of style versus iconography, I have tried to alter my methodological proportions to suit the particular case at hand.

Indeed, any attempt to present a definitive synthesis of these years would be unusually premature. By comparison with what we know, say, of the monuments of Quattrocento art, we are positively ignorant about the late eighteenth century. There are few modern studies of any of the major artists, not to mention the minor ones, and most of these are inadequate. Even photographs have yet to be made, as well as published, of thousands of works moldering in the storage rooms of the many European museums that have assumed the quality of Western art to taper off at just the point where this study begins. With this in mind, I have tried my best to introduce as many unfamiliar works as possible as well as to offer, in rather copious footnotes, any number of signposts for the scholar who would continue exploration of the *terra incognita* of late eighteenth century art. If the reader emerges with the feeling that most of these directions are yet to be pursued, that the period is far more complicated than he had imagined, and that I have raised many more questions than I have answered, then I shall feel largely satisfied with my efforts.

A few technical problems might also be mentioned here. One concerns the translation of the often lengthy titles given to French Salon paintings. In this, I have tried to use the following

rule of thumb. In the captions, all titles are given in English, and generally in abbreviated form. In the text and notes, however, the reader will find that titles of extremely well-known paintings (David's *Oath of the Horatii*) or of paintings that illustrate familiar subjects (Sylvestre's *Death of Seneca*) are usually given in English, whereas the original French Salon titles have most often been kept for more obscure subjects, especially when the narrative events are helpfully described (Greuze's *L'Empereur Sévère reproche à Caracalla, son fils, d'avoir voulu l'assassiner dans les défilés d'Écosse et lui dit: Si tu désires ma mort, ordonne à Papinien de me la donner avec cette épée*).

A second problem concerns bibliography. The manuscript was substantially completed in 1964; but given its wide range of topics and examples, an unusually large number of relevant books and articles have appeared since then. I have tried, when possible, to include some of these in the notes, even when it has been too late to incorporate their findings in my text; but the reader will obviously find many omissions in the post-1964 bibliography. Of these, the most centrally important promise to be James A. Leith, *The Idea of Art as Propaganda in France, 1750-1799; A Study in the History of Ideas*, Toronto, 1965; and a book by David Irwin on British Neoclassicism scheduled for publication in 1966. I understand, too, that the long-delayed catalogue of the major exhibition, *Les architectes visionnaires de la fin du XVIIIe siècle*, Paris, Bibliothèque Nationale, 1964, is finally to appear in 1966.

It is always a pleasure to reach the point where one can express both personal and professional gratitude to the many people and institutions who have helped in the preparation of a book; but there is also the anxiety, especially when the book's origins go back a decade to the 1950's, that many names will be inadvertently forgotten. At least there is no chance of forgetting that my heaviest debt was earned by Professor Walter Friedlaender. It was under his wise and witty guidance that, between 1951 and 1955, at the Institute of Fine Arts, New York University, I first learned to manipulate the scholarly tools necessary

to study art around 1800 and that I first began to realize that this period was susceptible to many different historical approaches. My unpublished doctoral thesis, written under his supervision, stressed an analysis of morphological change in late eighteenth century art (*The International Style of 1800: A Study in Linear Abstraction*, 1956); whereas another student effort, a report I gave in one of his seminars on stoical subject matter, concentrated on iconographical questions of the same period. The admirable flexibility of his teaching is, I hope, reflected in the varied methodology of these essays. Chapter II resumes many of the iconographical matters raised in his seminar; Chapter IV considers some of the formal questions elaborated more single-mindedly in my thesis.

The possibility of enlarging still further the scope of my interests in art around 1800 to include architecture was provided first by Professor Henry-Russell Hitchcock, who asked me to assist him in the preparation of bibliography and notes for his classic Pelican volume, *Architecture: Nineteenth and Twentieth Centuries* (1958); and second, by Professor Carroll L. V. Meeks, who, in 1961, invited me to speak on associative aspects of Neoclassic architecture to a graduate seminar at Yale. Without these opportunities, Chapter III would have been much the poorer. Indeed, it might not have been written at all.

My thanks go as well to certain people who have provided annual and most personal hospitality in institutions in England and France—Peter Murray and his staff at the Witt Library, London; Jean Adhémar at the Cabinet des Estampes, Bibliothèque Nationale; Sylvie Béguin, Michel Laclotte, and Pierre Rosenberg at the Louvre. To these should be added Marc Sandoz, who was unusually generous in sharing with me his remarkable knowledge of late eighteenth century French painting and his private photographic resources; and Boris Lossky, who was particularly kind in providing me with rare photographs. Many other friends, professional acquaintances, and students participated in the composition of this book in ways that ranged from bibliographical clues and photograph-hunting to museum trips and long discus-

sions. I have tried to thank some of them in appropriate places in the footnotes; but I should perhaps single out here—at the risk of forgetting others who were equally helpful—Charles Buckley, Richard Carrott, Anthony Clark, Donald Drew Egbert, Stuart Feld, Myron Laskin, Pierre Martory, Thomas McCormick, Ellis Waterhouse. L. D. Ettlinger and Sheldon Nodelman were good enough to read parts of the manuscript and to offer discerning criticism of fact and idea that permitted me to improve the text in many large and small ways. I must also express my gratitude to Princeton University, for so frequently providing me with the necessary time and research funds to complete this book; and to the American Council of Learned Societies, which contributed in the same indispensable way.

Finally, I wish to thank three ladies, without whom this book would never have come to light: Miss Kazuko Higuchi, who so often worked after hours to assist me in my own photograph hunts; Miss Jan Pikey, who retyped my manuscript with extraordinary speed and precision; and lastly, Miss Harriet Anderson, Fine Arts Editor of Princeton University Press, whose combination of tact, efficiency, and wisely flexible adherence to editorial rules made the transformation of a manuscript into a book a wholly agreeable and profitable dialogue between author and editor.

<div style="text-align: right">R. R.</div>

December 1965

PREFACE FOR THE SECOND PRINTING, 1969

This reprinting has provided me with the welcome opportunity to make many corrections, if not to alter in any way the basic arguments. For the reader who, like the author, wishes to continue weighing these arguments in the light of recent research, the following bibliographical indications should be of help.

The three books mentioned in my first preface have now all appeared. The first—James A. Leith, *The Idea of Art as Propa-*

ganda in France, 1750-1799: A Study in the History of Ideas (Toronto, 1965)—adds considerable material to the theme of my second chapter; the second—David Irwin, *English Neoclassical Art: Studies in Inspiration and Taste* (London, 1966)—offers a rich compendium of facts and illustrations related to those British artists who turn up in these pages. As for the third—the long overdue catalogue of the important Bibliothèque Nationale exhibition of 1964, *Les Architectes visionnaires de la fin du XVIII^e siècle*—it has finally appeared on the occasion of the reorganization of the exhibition in 1967 under the auspices of the University of St. Thomas, Houston. The resulting catalogue, *Visionary Architects; Boullée, Ledoux, Lequeu* (University of St. Thomas, 1968), has quickly become a standard reference.

Of recent studies of late eighteenth century art, the only general survey is Hugh Honour's *Neo-classicism* (Harmondsworth, 1968), an admirably fresh and literate cross-section of all the visual arts, viewed in the light of both stylistic and historical analysis. To this should be added the relevant chapters (iv, v) in Michael Levey's stimulating survey of the entire century, *From Rococo to Revolution* (London, 1966). A wide range of Neoclassic art (from Mengs, Copley, and Vien to Schick, Thorvaldsen, and Camuccini) was presented in the huge exhibition, *Angelika Kauffmann und ihre Zeitgenossen*, Bregenz, Voralberger Landesmuseum and Vienna, Oesterreichisches Museum für Angewandte Kunst, 1968; but unfortunately, the well-illustrated catalogue provides full entries only for works by Angelica, and not for those by her contemporaries. The most amply documented exhibition catalogue to coincide, at least in part, with the period discussed here, is *Romantic Art in Britain; Paintings and Drawings, 1760-1860*, Detroit Institute of Arts and Philadelphia Museum of Art, 1968, in which abundant bibliographical and biographical data are given about an unusually full selection of British artists.

In monographic terms, knowledge of many artists considered in these pages has been greatly enlarged. On Mengs, see now Dieter Honisch, *Anton Raphael Mengs und die Bildform des Frühklassizismus*, Recklinghausen, 1965; on Mortimer (whose date of birth

has recently been proved to be 1740, not 1741), see the exhibition catalogue, *John Hamilton Mortimer, A.R.A., 1740-1799,* Towner Art Gallery, Eastbourne and Iveagh Bequest, Kenwood, 1968; on Wright of Derby, see the definitive monograph by Benedict Nicolson, to appear shortly; on Girodet, see the bicentenary exhibition catalogue, *Girodet, 1767-1824,* Musée de Montargis, 1967; on Ingres, see, among the many publications to celebrate his death centenary in 1967, the exhibition catalogue, *Ingres,* Paris, Petit Palais, 1967, and the monograph, Robert Rosenblum, *Ingres,* New York, 1967.

As for architecture, the bibliography in the University of St. Thomas catalogue, *Visionary Architects,* is particularly full; but a few studies should be singled out for their special relevance to my third chapter: Johannes Langner, "Architecture pastorale sous Louis XVI," *Art de France,* III, 1963, pp. 171-186; *idem,* "Ledoux und die Fabriques," *Zeitschrift für Kunstgeschichte,* XXVI, 1963, pp. 1-36; Marie-Louise Biver, *Pierre Fontaine, premier architecte de l'Empereur,* Paris, 1964.

Lastly, a few specialized articles that pursue themes touched upon in my text should be noted: L. D. Ettlinger, "Jacques Louis David and Roman Virtue," *Journal of the Royal Society of Arts,* January 1967, pp. 105-123; Peter Walch, "Charles Rollin and Early Neoclassicism," *Art Bulletin,* XLIX, June 1967, pp. 123-126; Boris Lossky, "Léonard de Vinci mourant entre les bras de François I— peinture de François-Guillaume Ménageot au Musée de l'Hôtel de Ville d'Amboise," *Bulletin de l'Association Léonard de Vinci* (*Amboise*), no. 6, June 1967, pp. 43-46. To these may be added two compilations of studies concerning art of this period: "Kunst um 1800," a group of scholarly lectures reprinted in *Stil und Ueberlieferung in der Kunst des Abendlandes; Akten des 21. Internationalen Kongresses für Kunstgeschichte in Bonn, 1964,* I (Epochen Europäischer Kunst), Berlin, 1967, pp. 175-235; and a special issue of *Apollo* (LXXX, September 1964) devoted to Napoleon and the arts.

R. R.

New York, November 1968

PREFACE FOR THE THIRD PRINTING, 1970

This new printing has made it possible to correct some small errors, mainly typographical, as well as to sharpen the accuracy of several references to Blake. For the latter improvements, I must thank David Bindman in particular; for the former, some attentive students.

As before, I should also like to indicate a few recent publications that may provide up-to-date clues for the reader's further pursuit of issues raised in the text. Two books of Italian origin have surveyed the period in different ways: one, Francesco Abbate, ed., *Il Neoclassicismo* (Milan, 1966), offers a short, well-illustrated international survey of all the arts; the other, Mario Praz, *On Neoclassicism* (London, 1969), provides a new English edition of a remarkable series of essays originally published in 1940 as *Il Gusto neoclassico*. Partly because 1969 was the bicentenary of his birth, Napoleon naturally received the lion's share of recent art-historical research. In 1967 there had appeared a fresh account and a well-illustrated survey of the painting he inspired: Alvar González-Palacios, *David e la pittura napoleonica*, Milan, 1967. But it was 1969 that inevitably saw the peak of Napoleonic activities, of which the most important were two exhibitions in Paris: *Napoléon* (Grand Palais) and *Napoléon, tel qu'en lui-même* (Archives Nationales, Hôtel de Rohan). The catalogues for these exhibitions should prove indispensable for future scholarship.

Two articles that touch closely on works of art discussed in the text should also be cited here: Joseph Sloane, "David, Robespierre, and 'The Death of Bara,'" *Gazette des Beaux-Arts*, 6ᵉ période, LXXIV (September 1969), 143-160, which explores the relationship between David's painting and historical truth; and Xavier de Salas, "Sur Cinq dessins de Goya acquis par le Musée du Prado," *Gazette des Beaux-Arts*, 6ᵉ période, LXXV (January 1970), 29-42, which, by disclosing an inscription with the date "January 1795" on a drawing by Goya after Flaxman, makes it possible now to date the drawing reproduced in these pages (Fig. 206).

New York, May 1970 R.R.

xiv

CONTENTS

PHOTOGRAPHIC SOURCES

LIST OF ILLUSTRATIONS

TRANSFORMATIONS
IN LATE EIGHTEENTH CENTURY ART

I

NEOCLASSICISM:
SOME PROBLEMS OF DEFINITION

IN HISTORIES of painting, the most familiar demonstration of that new mid eighteenth century viewpoint generally known as Neoclassicism juxtaposes Joseph-Marie Vien's *Marchande à la toilette* (Fig. 1), exhibited at the Salon of 1763,[1] with an engraving of a freshly unearthed Roman painting first published in 1762 in the great folio edition of *Le Antichità di Ercolano* (Fig. 2).[2] Like the sculptural comparison of Thorvaldsen's *Jason* with the Doryphoros or the architectural one of Klenze's Walhalla, near Regensburg, with the Parthenon, such a pairing is often meant to imply that Neoclassic artists were content to produce slavish and hence stillborn imitations of Greco-Roman antiquity. With retrospective nostalgia, they presumably copied a past they believed greater than the present, and were willing even to submerge their own artistic personalities in this veneration of the antique.

Such an interpretation, if appealing in its simplicity, is hardly possible in the light of that unwieldy corpus of art which was created from about 1760 on and which has been loosely cate-

[1] No. 23. *La Marchande à la toilette* was its original title, but later it was referred to most often as *La Marchande d'amours*. This is already the case in C. P. Landon, *Annales du Musée et de l'école moderne des Beaux-arts*, xvii, Paris, 1809, pp. 121-122, where it is mentioned as deriving from an antique bas-relief, a mistake perhaps attributable to the existence of bas-relief versions of the theme by Clodion (Salon of 1773, no. 249) and by Bosio (Salon of 1793, no. 548).

[2] The presentation of paintings and bronzes comprised seven volumes published in Naples from 1757 to 1779, and was preceded in 1755 by a preliminary catalogue compiled by Ottavio Bayardi. Later volumes followed in 1792 and 1831.

The engraving (by C. Nolli) used by Vien was published in *Le Pitture antiche d'Ercolano*, iii, Naples, 1762, pl. vii, p. 41. Another engraving of the Roman painting (by the Comte de Parois) was exhibited at the Salon of 1787 (no. 293).

gorized as Neoclassic. Far from tending toward an anonymous and repressive uniformity of style and expression, that art of the late eighteenth and early nineteenth centuries which offers allusions to Greco-Roman antiquity in terms of subject matter and of borrowed classical forms is fully as various and contradictory, if not even more so, than the art subsumed under such other broad categories as Gothic, Mannerist, or Baroque. In fact, after confronting the scope of a Neoclassicism that must, at different times, comprise forms and emotions as unlike as those found in Fuseli and David, Carstens and Girodet, Sergel and Greenough, Schinkel and Nash, one soon wonders whether Neoclassicism may properly be termed a style at all, or whether it should not be termed, to use Giedion's phrase, a "coloration."[3]

Something of this vast range and flexibility may already be suggested by considering a few of the late eighteenth century progeny of the Roman painting that had inspired Vien's Salon entry of 1763. Discovered on June 13, 1759, in the Neapolitan suburbs of Gragnano,[4] such a work must have excited its new audience not only by virtue of the dramatic circumstances of its burial and resurrection in the shadow of Vesuvius, but also because of the relatively primitive austerity of its style by contrast with the prevailing Rococo mode.[5] Rendered still more severe in engraved reproduction, its clean geometric divisions of wall

[3] His exact phrase, in reference to late eighteenth century architecture, is "Klassizismus ist kein Stil. Klassizismus ist eine Färbung." (Sigfried Giedion, *Spätbarocker und romantischer Klassizismus*, Munich, 1922, p. 9.)

[4] *Le Pitture* . . . , III, p. 37 n. 2. For a modern study of the paintings found in this region, see Olga Elia, *Pitture di Stabia*, Naples, 1957.

[5] For a useful survey of the ancient and modern history of Pompeii and Herculaneum, see E. Corti, *Untergang und Auferstehung von Pompej und Herculaneum*, 5th ed., Munich, 1941. Two informative articles concerning the impact of the new excavations on arts and letters are those by Mario Praz, "Herculaneum and European Taste," *Magazine of Art*, XXXII, Dec. 1939, pp. 684-693; and Jean Seznec, "Herculaneum and Pompeii in French Literature of the Eighteenth Century," *Archaeology*, II, Sept. 1949, pp. 150-158. For a discussion of these excavations in the broader context of the origins of Neoclassicism, see Louis Hautecoeur, *Rome et la Renaissance de l'antiquité à la fin du XVIIIe siècle* (*Bibliothèque des écoles françaises d'Athènes et de Rome*, no. 105), Paris, 1912, pp. 79-93.

plane and furniture and its simplified, unbroken contours evoked a past that seemed to mark a virile beginning rather than a decadent conclusion to a cycle of art and civilizations.

Conservative taste in the mid eighteenth century could find little to commend in such rude pictorial illusions. In discussing the paintings found at Herculaneum, Charles-Nicolas Cochin *fils* had earlier contended that "ils ne présentent nulle part l'art de composer les lumières et les ombres," that "la composition des figures . . . est froide, et paraît plutôt traitée dans le goût de la sculpture, qu'avec cette chaleur dont la peinture est susceptible."[6] Yet more progressive taste, like Vien's, could be stimulated by these very qualities of anti-Rococo sobriety and simplicity, much as it could be fascinated by the seemingly crude *terribilità* of the Greek Doric order[7] or the elementary pictorial means visible in the flattened spaces and precise outlines of Greek vases and Italian primitive paintings.[8]

Writing about the Salon of 1763, an anonymous critic tidily summed up what he considered the new qualities that Vien had derived from "une rigoureuse imitation de l'Antique." They included "une grande simplicité dans les positions de figures presque droites et sans mouvement," "très peu de draperies, communément assez minces, sans jeu et pour ainsi dire collées sur le nud," "une sévère sobriété dans les ornemens accessoires." To his eyes, such austerity was therapeutic, "un moyen nécessaire à la perfection de notre École."[9]

The assimilation of what appeared to be so Spartan a style was,

[6] Charles Cochin *fils* and J. Bellicard, *Observations sur les antiquités de la ville d'Herculanum . . .* , Paris, 1754, pp. 59-61. The entire passage provides a remarkable example of conservative condescension toward these ancient paintings. An English translation of this appeared (*Observations upon the Antiquities of the Town of Herculaneum*, London, 1753, pp. 102-104), but the date of publication, 1753, is probably incorrect, as the British Museum Catalogue suggests.

On Cochin, see S. Rocheblave, *Les Cochin*, Paris, n.d.

[7] For the basic discussion of the revival of the Greek Doric order, see N. Pevsner and S. Lang, "Apollo or Baboon," *Architectural Review*, CIV, Dec. 1948, pp. 271-279.

[8] See below, Chapter IV.

[9] *Description des Tableaux exposés au Sallon du Louvre*, Paris, 1763, pp. 58-59.

however, a relative matter. In comparing Vien's painting to its Roman source—as Vien himself invited the Salon spectator to do[10]—the points of divergence soon become more conspicuous than those of replication.[11] For Vien's painting, despite its fashionably learned reference to a newly discovered antique painting, still fits most comfortably into a Rococo milieu. To be sure, the composition now stresses the shallow space and clean rectilinear divisions suggested by the Roman prototype, and the figures are modeled with a calm fluency of flesh and drapery that recalls the static, statuary poses of the Roman women. Yet for all this chastening of style, the painting still belongs to the world of Louis XV. The very source chosen for classicizing inspiration— the vending of loves to patrician ladies—is overtly erotic; and, as Diderot complained, the gesture of the suspended Cupid is covertly so.[12] No less compatible with the hedonistic milieu of Boucher are the small and doll-like heads; the sleek and tapered figure proportions; and, above all, the sophisticated textural varieties offered by the inlaid marble floor or by such still-life details as glistening pearls, a smoking censer, a glass vase filled with flowers.

Quite as essentially Rococo as Vien's reading of this antique painting is a later, sculptural version of it by an eighteenth century master of Meissen ware, Christian Gottfried Jüchtzer.[13] En-

[10] "On est en état de remarquer les différences qui se trouvent entre ces deux compositions." (*Salon de 1763, Explication des peintures* . . . , Paris, 1763, p. 9.) Frederick Antal has suggested—to my eye, not too convincingly—that Vien's painting is also patterned after Hogarth's *Moses Brought to Pharaoh's Daughter*. (*Hogarth and His Place in European Art*, London, 1962, pp. 200-201.)

[11] For a close analysis of the differences between Vien's painting and its Roman source, see Rudolf Zeitler, *Klassizismus und Utopia*, Stockholm, 1954, pp. 62-63.

[12] "C'est dommage que cette composition soit un peu déparée par un geste indécent de ce petit Amour papillon que l'esclave tient par les ailes; il a la main droite appuyée au pli de son bras gauche qui, en se relevant, indique d'une manière très-signicative la mesure du plaisir qu'il promet." (Jean Seznec and Jean Adhémar, eds., *Diderot Salons (1759, 1761, 1763)*, I, Oxford, 1957, p. 210.)

[13] Jüchtzer and this work are discussed in Ernst Zimmerman, *Meissner*

6

larged by a dimension but considerably diminished in size, his biscuit group of 1785, *Wer kauft Liebesgötter?* (Fig. 3), follows the Roman engraving far more literally than does Vien's painting, retaining the geometric severity of the cube upon which the matron at the left is seated and even the *viminea cavea* of the Roman original, which Vien had discarded in favor of an eighteenth century basket.[14] Yet despite this greater archeological fidelity, Jüchtzer's vendor of loves is, if anything, even more fully Rococo in flavor. Its miniature scale and exquisitely modeled detail transform the antique reference into a charming sculptural group that, right down to the diminutive landscape detail that covers the base, belongs unmistakably to the eighteenth century realm of amorous porcelain shepherds and shepherdesses. And a comparably Rococo sweetness and delicacy still cling to Goethe's gentle lyric *Wer kauft Liebesgötter?*, written in Weimar in 1795 under the inspiration of the same Roman painting.[15]

Such belated Rococo translations of the selling of loves could hardly be less like another late eighteenth century version of the theme. During his Italian sojourn (1770-1778), the Anglo-Swiss artist, Henry Fuseli, made a small drawing after the same classical source (Fig. 4).[16] Yet if this drawing is equally "Neoclassic" in its general dependence on antiquity, its reading of antiquity unveils expressive possibilities remote from the innocent and

Porzellan, Leipzig, 1926, pp. 296-300, fig. 60; and in Adolf Feulner, *Skulptur und Malerei des 18. Jahrhunderts in Deutschland* (*Handbuch der Kunstwissenschaft*), Wildpark-Potsdam, 1929, p. 121, fig. 120.

[14] Classical inspiration for Jüchtzer probably came via the German edition of *Le Antichità di Ercolano*: Christoph Gottlieb von Murr and Georg Christoph Kilian, *Abbildungen der Gemälde und Alterthümer, welche seit 1738 in Herculanum . . .* , Augsburg, 1777-1798. The *Vendor of Loves* is in vol. III, pl. VII.

[15] *Goethes Werke* (*Gedichte*, I), Weimar, 1887, p. 41.

[16] The date 1775 has been suggested for this drawing by Nicolas Powell (*The Drawings of Henry Fuseli*, London, 1951, p. 38), for it was at this time that Fuseli visited Naples. He could, of course, have known it from engravings before or after this visit. The drawing is also discussed briefly in F. Saxl and R. Wittkower, *British Art and the Mediterranean*, London, 1941, p. 83.

amoral eroticism of Vien and Jüchtzer.[17] Like his almost exact contemporary, the Marquis de Sade, Fuseli introduces a self-conscious exploration of erotic experience that approaches the bizarre, pornographic domain of which he himself was a master.[18] There is, indeed, something sexually grotesque and disquieting about the transformation of a Roman vendor of loves into a hooded, witchlike hag who thrusts a cringing Cupid at a coolly imperious lady who, in turn, half averts her body, but not her gaze, from this erotic confrontation. And if the odd psychology of this drawing recalls the sexual ambiguities of much sixteenth century Mannerist art, so, too, does the style.[19] Ignoring the static sculptural clarity whose potential Vien had partially recognized in this Roman source, Fuseli prefers to transcribe the antique painting with nervous, angular hatchings and circuitous linear attenuations that revive the perverse formal extremes of Parmigianino and Bandinelli.[20]

[17] Fuseli's studies after the antique generally exaggerate masculine and feminine elements in the interest of an erotic exploitation of titanic muscularity or perverse voluptuousness. For characteristic examples, see Marcel Fischer, *Das Römische Skizzenbuch von Johann Heinrich Füssli*, Zurich, 1942.

[18] On Fuseli's pornography, see Ruthven Todd, *Tracks in the Snow*, London, 1946, pp. 81ff. Unfortunately for connoisseurship, many of these pornographic drawings raise problems of attribution that are not likely to be aired through the usual art historical journals. Nevertheless, the attribution of some of the drawings partially reproduced in Todd's essay has already been questioned by Gert Schiff in "Theodore Matthias Von Holst," *Burlington Magazine*, cv, Jan. 1963, p. 24 n. 2.

[19] For a discussion of Fuseli's Neo-Mannerist qualities, see Frederick Antal, *Fuseli Studies*, London, 1956, *passim*.

[20] The enormous influence of Parmigianino's attenuated grace and eroticism on the formation of many late eighteenth century Neo-Mannerist currents (i.e., in Reynolds, Romney, Fuseli, Barry, not to mention the school of David) remains to be investigated. England was a particularly rich territory for this revival of Parmigianino, and it may be noted that in 1790 an edition of seventy-four drawings of the Italian master from the King's collection appeared: Conrad Martin Metz, *Imitations of drawings by Parmegiano in the collection of His Majesty*, London, 1790. This included seven more drawings of Parmigianino than were contained in Metz's *Imitations of ancient and modern drawings*, London, 1789. Many Parmigianino drawings (primarily from the collections of West and

On the other hand, when a pupil of Vien's, Jacques-Louis David, sojourned in Italy as an eager student from 1775 to 1780, he drew very different conclusions from the same Roman premise. His spare outline drawing after the painting that had inspired his master in 1763 is at once the most literal and the most abstract of these eighteenth century interpretations (Fig. 5).[21] Student-like in its fidelity to the exact disposition of forms in the antique painting, it nevertheless transcribes these forms through the reduced visual means of line alone. Interior modeling and textural description are radically minimized in favor of a flat and Spartan outline style that reduces the erotic potential of the classical source and extracts exactly that rude and invigorating simplicity which a revolutionary generation would seek out in Greco-Roman art and which an earlier eighteenth century generation had found visually inadequate and primitive by Rococo standards.

The dissimilarities among Vien's, Jüchtzer's, Fuseli's, and David's interpretations of the identical Roman source may begin to suggest that in the late eighteenth century, as before, antique stimuli could produce a wide range of stylistic and expressive

Reynolds) were included in another, later facsimile edition by Metz: *Imitations of ancient and modern drawings from the restoration of the Arts in Italy to the present time*, London, 1798. Note, too, such Continental publications as Antonio Faldoni, *Varii disegni inventati dal celebre Francesco Mazzuola, detto Il Parmigianino*, Venice, 1786.

Fuseli himself writes of Parmigianino in his Royal Academy Lectures with mitigated praise: "Parmegiano poised his line between the grace of Correggio and the energy of M. Agnolo, and from contrast produced Elegance; but instead of making propriety her measure, degraded her to affectation. That disengaged play of delicate forms, that 'sveltezza' of the Italians, is the prerogative of Parmegiano, though nearly always attained at the expense of proportion." (John Knowles, *Life and Writings of Henry Fuseli*, M.A., R.A., iii, London, 1831, p. 33.) Ironically, these criticisms seem equally applicable to Fuseli's own work.

[21] On David's drawing, see Jean Adhémar, ed., *David; naissance du génie d'un peintre*, Monte Carlo, 1953, p. 72 and pl. 199. The drawing is inscribed "bibliothècte du Vatican," from which Adhémar surmises that David copied the engraving in *Le Antichità di Ercolano* at the Vatican Library. Adhémar dates this and the related Roman sketchbook drawings ca. 1776 (p. 25).

results.[22] The popular image of Neoclassic art too often tends to see it as inert in theme and dryly imitative in style, as if the familiar qualities of "edle Einfalt" and "stille Grösse" praised by Winckelmann in his adulation of Greek art provided a bland norm for most late eighteenth century art inspired by classical themes and forms.[23] But in actual fact, Winckelmann's romantic image of a remote Greek art instilled with Mediterranean harmony and serenity was only one of many possible visions of antiquity. This "noble simplicity and quiet grandeur" were as abundantly contradicted in Neoclassic art as in classical art itself— indeed, even more so. Around 1800, at the time of the most profound historical transformations of public and private experience, the classical world could be molded to meet demands as varied as French Revolutionary propaganda, Romantic melancholy, and archeological erudition, and could be couched in visual vocabularies as unlike as the chaste outlines of Flaxman's classical illustrations, the icily voluptuous surfaces of Canova's marble nudes, or the dense sculptural incrustations of Napoleon's imperial architecture.

[22] Interpretations of this Roman painting extended into the nineteenth century, ranging from versions by the Riepenhausen brothers at the Salon of 1812 (no. 766), to later academic versions by Isambert (1855) and Denécheau (1899). Still to be seen today, at the Musée des Beaux-Arts, Béziers, is *Amours à l'encan*, by Auguste-Barthélemy Glaize (Salon of 1857, no. 1203). There is also a late eighteenth century version of the theme, incorrectly attributed to Angelica Kauffmann, at the Musée Bargoin, Clermont-Ferrand; and an elaborate narrative sequence by Canova that traces the nurturing, sale, and final escape of love (illustrated in Elena Bassi, *La Gipsoteca di Possagno; sculture e dipinti di Antonio Canova*, Venice, 1957, no. 109).

[23] Winckelmann's exact statement is: "Das allgemeine vorzügliche Kennzeichen der griechischen Meisterstücke ist endlich eine edle Einfalt, und eine stille Grösse, so wohl in der Stellung als im Ausdrucke." (*Gedanken über die Nachahmung der griechischen Werke in der Malerei und Bildhauerkunst*, Dresden, 1755, reprinted in *Winckelmann's Werke*, ed. C. L. Fernow, I, Dresden, 1808, p. 31.) Winckelmann goes on to find these qualities in the *Laocoön*.

The first English translation of this famous phrase is by Fuseli (*Reflections on the Painting and Sculpture of the Greeks*, London, 1765, p. 30), who gives it as "noble simplicity and sedate grandeur."

One such reading of antiquity might be called the "Neoclassic Horrific."[24] As a vehicle for expressing the most overtly Romantic impulses, this late eighteenth century current offers the most vigorous denial of Winckelmann's characterization of the antique. When the short-lived British painter, John Mortimer[25]—an exact contemporary of Fuseli—chose a classical theme, he preferred the very opposite of ideal beauty and perfect emotional equilibrium. His *Sextus the Son of Pompey Applying to Erictho to Know the Fate of the Battle of Pharsalia* (Fig. 6), exhibited at the Society of Artists in 1771,[26] suggests the growing classical erudition of the period in its choice of an obscure theme from Lucan's *Pharsalia*. Yet at the same time, it participates fully in those early tremors of "Gothick" horror that stirred in British art in the 1770's, for Mortimer selected for illustration one of the most nightmarish passages in all of Roman literature.[27] The scene takes place in Thessaly, known for its sorcery, and shows the hideous witch, Erictho, reviving a mangled corpse by lashing it with serpents in order that it may prophesy to Sextus Pompeius the outcome of the Battle of Pharsalia. In the grisly words of the verse translation that accompanied the engraving of 1776:

> Wroth was the Hag at ling'ring Death's delay,
> And wonder'd Hell could dare to disobey;
> With curling Snakes the senseless Trunk she beats,
> And curses dire, at ev'ry lash repeats;

[24] To my knowledge, the first use of this apt phrase was in the mimeographed catalogue of the British Museum exhibition, *William Blake and His Circle*, 1957, p. 20.

[25] The most worthwhile of the few discussions of this fascinating artist is in Geoffrey Grigson, "Painters of the Abyss," *Architectural Review*, cviii, Oct. 1950, pp. 215-220.

[26] No. 84. The title given in the Society of Artists catalogue omits the words, "the Battle of," which are included, however, in the title of the 1776 engraving.

[27] A comparable choice of classical witchcraft was later made by Romney in his drawings of *Canidia and the Youth* (ca. 1789-1791), a horrific episode in Horace's Epode v. See the exhibition catalogue, *The Drawings of George Romney*, Smith College Museum of Art, Northampton, Mass., 1962, no. 71.

With magic Numbers cleaves the groaning ground,
And, thus, barks downwards to the Abyss profound.[28]

The classical counterpart of such newly explored themes of horror and sorcery as could be found in the *Nibelungenlied* or the Bible, Ossian or Homer, Dante or Spenser, Shakespeare or Milton,[29] Mortimer's painting replaces reason by conjury, beauty by ugliness, an architectural background by a mysterious cave, and measured gestures by terrified reflexes. Moreover, the horrific qualities of this Roman subject are underscored by the febrile figure style and the murky, erratic light, visual elements borrowed from that most unclassical of artists, Salvator Rosa.[30]

Another member of Fuseli and Mortimer's generation of the 1740's, the Dane Nicolai Abildgaard, also sought out literary themes of *Sturm und Drang* passion and fantasy and also discovered that classical sources could be fully as fruitful as non-

[28] Book VI, lines 1103-1108, in the Nicholas Rowe translation, 3rd ed., London, 1753, p. 57. The two earlier editions date from 1718 and 1722.

[29] For examples of this new fascination with witchcraft and supernatural terror in British painting of the late eighteenth century, see the representations of *Saul and the Witch of Endor* (West, 1777, Wadsworth Atheneum, Hartford); *The Cave of Despair* (West, 1772, engraving by Henry Moses in *The Gallery of Pictures Painted by Benjamin West*, London, 1811, pl. x); *Macbeth and the Three Witches* (Reynolds, 1789, Petworth); *The Alchemist* (Wright of Derby, 1771/1795, Derby Museum and Art Gallery); not to mention Fuseli's countless excursions into the iconography of the supernatural culled from literary sources ranging from the *Nibelungenlied* to Wieland's *Oberon*. For a particularly well-documented assortment of newly discovered Fuseli drawings inspired by just such diverse readings, see Gert Schiff, *Zeichnungen von Johann Heinrich Füseli, 1741-1825 (Schweizerisches Institut für Kunstwissenschaft, Zürich; Kleine Schriften, 2)*, Zurich, 1959.

[30] Rosa's influence on eighteenth century landscape art and poetry in Great Britain is well known (see Elizabeth Manwaring, *Italian Landscape in Eighteenth Century England; A Study Chiefly of the Influence of Claude Lorrain and Salvator Rosa on English Taste, 1700-1800*, New York, 1925). However, his relevance for early Romantic currents in history painting of the late eighteenth century needs further exploration. Such themes of Rosa's as *Democritus, Saul and the Witch of Endor, Belisarius* are directly echoed in works by Wright of Derby, West, Mortimer.

classical ones.[31] In 1775, during his Roman sojourn (1772-1777), he painted the hero of Sophocles' *Philoctetes*, choosing the anguished moment that follows the wounding of the warrior's foot (Fig. 7).[32] Neoclassic in its ideal nudity, its Greek subject, and Greek inscription, Abildgaard's painting nevertheless flouts Winckelmann's idea of Greek nobility in suffering. By comparison with the *Laocoön* group, whose presumed restraint was so admired by Winckelmann, this Philoctetes gives full vent to the physiological and psychological reflexes of pain. Indeed, Philoctetes had been referred to by Lessing, and before him by Cicero, as an example of unrestrained anguish to be spurned by contrast with the noble suffering of Laocoön.[33] Abildgaard, in fact, violently emphasizes this ignoble extreme. Recalling Goltzius' Northern Mannerist interpretations of Michelangelo's heroic nudes,[34] Abildgaard's hypermusculated figure is grotesquely cramped in a space constricted both in height and depth. Even the windswept hair contributes to this compressive spiral rhythm, which twists Philoctetes into a gyrating knot of pain.[35]

[31] On Abildgaard, see Leo Swane, "Bemaerkninger om Abildgaard som maler," *Kunstmuseets Aarsskrift*, xxiv, Copenhagen, 1937, pp. 1-30; and a new monograph that was kindly called to my attention by Mr. Anthony Clark but which I have not yet seen: Bente Skovgaard, *Maleren Abildgaard*, Copenhagen, 1961.

[32] For further remarks on the painting, see Swane, *op.cit.*, pp. 5-6; Copenhagen, Statens Museum for Kunst, *Fortegnelse over den danske Samlings Malerier og Skulpturer*, Copenhagen, 1946, p. 1, no. 1; and the exhibition catalogue, *Il Settecento a Roma*, Rome, Palazzo delle Esposizione, 1959, no. 1.

[33] See L. D. Ettlinger, "Exemplum Doloris. Reflections on the Laocoön Group," in Millard Meiss, ed., *De Artibus Opuscula XL; Essays in Honor of Erwin Panofsky*, New York, 1961, p. 125.

[34] The painting has also been related to the *Polyphemus* of Carracci (Swane, *ibid.*), but this is unconvincing. There are, however, close analogies to Goltzius' circular prints after Cornelisz van Haarlem's *Tantalus, Icarus, Phaëton,* and *Ixion* (see F. W. H. Hollstein, *Dutch and Flemish Drawings and Woodcuts, ca. 1450-1700*, viii, Amsterdam, n.d., p. 103).

[35] The theme of Philoctetes was often treated by Romantic artists, who were attracted to this image of heroic isolation and suffering. In the decade of the 1770's, so important to the creation of Nordic Romantic sensibility, Abildgaard's *Philoctetes* had been preceded by that of an Irish artist of the

No less vehement in their full-blooded outburst of physical and psychological passion are the classical Greek protagonists of two related marble groups by the most prominent Neoclassical sculptors of the generation of the 1750's: Antonio Canova and John Flaxman. In the Englishman's *Fury of Athamas* (Fig. 8), executed in Rome during the years 1790-1793 for Frederick Hervey, Earl of Bristol and Bishop of Derry, the hero is seized by a fit of madness that leads him to kill his own son Learchus, despite the hysterical entreaties of his wife, Ino, whose Niobe-like figure is desperately clutched by her other son, Melicertes.[36] This high-pitched fury, with screaming mouths and violent propulsions, is crystallized into a greater compositional clarity and an even more uncontrollable passion in Canova's *Hercules and Lichas*, first projected in 1795 but not completed in marble until 1815 (Fig. 9).[37] Reduced to two figures and tautly frozen in a

same generation, James Barry, who painted it in 1770 for the Bologna Academy (see *Il Settecento a Roma*, Rome, 1959, nos. 25, 26). Later versions of Philoctetes include those by Taillasson (1784; École des Beaux-Arts, Paris); Baltard (Salon of 1810, no. 1201); Gois (sculpture; illustrated and discussed in C. P. Landon, *Salon de 1812 (Annales . . .*), Paris, 1812, p. 40, pl. 24); David Scott (1840, National Gallery of Scotland, Edinburgh); and the Chilean painter Alejandro Cicarelli (illustrated in Juan de Contreras, Marqués de Lozoya, *Historia del arte hispánico*, v, Barcelona, 1949, p. 573).

[36] Hugh Honour ("Antonio Canova and the Anglo-Romans; Part II, The First Years in Rome," *Connoisseur*, CXLIV, Jan. 1960, p. 230) gives further details of the commission and mentions that Canova may well have suggested to Flaxman the pose of Athamas, which he was soon to use in his own *Hercules and Lichas*. Flaxman's marble is briskly dismissed in W. G. Constable, *John Flaxman, 1755-1826*, London, 1927, p. 41. The subject of the *Fury of Athamas*, incidentally, is a rare one. I know of no examples prior to Flaxman. Later, however, a painting of the subject by Antoine Fleury was exhibited at the Salon of 1799 (no. 103).

[37] The first sketch dates from 1795 (illustrated in Elena Bassi, *Canova*, Bergamo, 1943, pl. 58b). The gesso was completed in 1796, but the marble remained unfinished until 1815. For a speculative interpretation of the work, in relation to contemporary political strife, see Rudolf Zeitler, *Klassizismus und Utopia*, Stockholm, 1954, pp. 104-108. The rare subject of Hercules and Lichas was illustrated earlier (1707) by Michel-Ange Houasse. See Boris Lossky, ed., *Tours, Musée des Beaux-Arts; Peintures*

single plane, Canova's group momentarily distills the corseted anguish of Hercules' poisoned garment in a tense gravitational network that links limbs into an unbreakable continuity and then implies an explosive rupture of this chain in the imminent fling-ing of Lichas into the sea.[38] By adding new dimensions of irra-tional suffering, Canova's group, like Abildgaard's *Philoctetes*, contradicts the classical containment that Winckelmann had dis-cerned in the *Laocoön* and that, more relevantly in this context, may still be sensed in the classical group of an unidentified war-rior about to hurl a youth (Fig. 10). This marble, then in Rome, most likely inspired both Flaxman and Canova,[39] as it had earlier attracted the attention of David.[40]

As inspiration for those crises of Romantic fear and trembling sought out by artists and empathic spectators around 1800, the domain of Greco-Roman art and literature seemed inexhaustible. Benjamin West, for instance, exhibited at the Royal Academy in

du XVIII^e siècle (*Inventaire des collections publiques françaises*, 7), Paris, 1962, no. 44.

[38] For a recent comparison of these two works, unfavorable to Flaxman, see Margaret Whinney, *Sculpture in Britain, 1530 to 1830* (*Pelican History of Art*), Harmondsworth, 1964, p. 188.

[39] The *Laocoön* is generally cited as the classical source of Flaxman's and Canova's works (as in Whinney, *loc.cit.*), but this statue offers a much closer classical prototype. On its history and many identifications (Atreus, Athamas and Learchus, Neoptolemos and Astyanax), see A. Ruesch, ed., *Guida illus-trata del Museo Nazionale di Napoli*, Naples, 1908, no. 243 (5999). For an early nineteenth century illustration and discussion (by Giovambatista Finati) of the group, see *Real Museo Borbonico*, xii, Naples, 1839, pl. xxxix, pp. 1-6. The reference given to Winckelmann's discussion (p. 4 n. 1) is, incidentally, incorrect. (It is in vol. ii, not iii, of the *Storia delle arti del disegno*, p. 400.)

[40] David sketched the marble group at the Palazzo Farnese during his Roman sojourn (1775-1780). For an illustration, see Jean Guiffrey and Pierre Marcel, eds., *Inventaire général des Dessins du Musée du Louvre et du Musée de Versailles; École française*, iv, Paris, 1909, p. 87, no. 3239; and Rudolf Zeitler, *Klassizismus und Utopia*, Stockholm, 1954, fig. 10a. The group had been sketched as early as 1591 by Goltzius. (See E. K. J. Reznicek, *Die Zeichnungen von Hendrick Goltzius*, ii, Utrecht, 1961, figs. 174-175, where it is identified as "Commodus als Gladiator.")

1805[41] a rarely illustrated incident from Apuleius' recounting of the Cupid and Psyche legend that could match the most infernal horrors of Dante (Fig. 11). Delicately modeled like a Wedgwood relief, the fragile Psyche is forced by the jealous Venus to fetch water from the Styx, whose monstrous perils include rushing cataracts, and slimy dragon heads. But at the most fearful moment, she is saved from this horrific fate by the *deus ex machina* of Jupiter's eagle, who provides her with a lekythos filled with black Stygian waters.

In France, too, such bloodcurdling pages of Greco-Roman legend and history were investigated. Thus, around 1798,[42] the Carcassonne painter Jacques Gamelin illustrated the cruel fate of a Vestal Virgin who had broken her vows (Fig. 12).[43] As described grimly in the Abbé Nadal's *Histoire des Vestales* of 1725,[44] such a transgressor was to be buried alive by Roman soldiers in the Campus Sceleratus, a fearful punishment that provides the spine-chilling subject of this little painting. In keeping with

[41] No. 153. I have discussed this picture in some detail in "Benjamin West's 'Eagle Bringing the Cup of Water to Psyche': A Document of Romantic Classicism," *Record of the Art Museum, Princeton University*, XIX, 1960, pp. 66-75.

[42] The date 1798 is suggested by the fact that the painting appears to be a pendant to another work by Gamelin, also in the Musée des Beaux-Arts, Orléans (*Andromaque pleurant sur l'urne qui renferme les cendres d'Hector*), which is signed and dated (1798) and is exactly the same size as the *Vestal Virgin* (32 x 48 cm.).

[43] For further information about Gamelin, see the exhibition catalogue, *J. Gamelin, 1738-1803*, Musée Municipal, Carcassonne, 1938. The *Vestal Virgin* is no. 47, p. 93. Mme. Cahn-Salvador (née Mlle. Simone Mouton), who compiled this catalogue, kindly permitted me to consult her unpublished doctoral thesis on Gamelin, which amplifies and corrects the standard monograph: Henri David, *J. Gamelin, sa vie et son œuvre*, Auch, 1928.

[44] Paris, 1725. This particular torture is described in detail (pp. 169-171) in the lurid section, "La Supplice des Vestales" (pp. 140ff.). Gamelin's choice of this subject was hardly unique. Other tortured Vestals appeared at the Salons of 1779 (Bounieu, no. 136); 1791 (Lesueur, no. 476); 1801 (Peytavin, no. 266); and 1804 (Lucas, no. 646). For an engraving after Peytavin's painting and a discussion of its grisly subject, see C. P. Landon, *Annales* . . . , I, Paris, 1801, pp. 95-96, pl. 46. The theme also persisted in later academic art, as in Baudry's painting (Lille; Salon of 1857).

his lugubrious theme, Gamelin enshrouds his archeological detail —the Roman military uniforms and poignantly meager Roman still life—in an atmosphere of murky gloom that recalls the contemporaneous madhouses and prisons of Goya[45] and looks forward to the full-scale, public horror of the climactic third act of Spontini's spectacularly successful opera, *La Vestale* (1805),[46] whose libretto by Étienne de Jouy looked back, in turn, to no less a source of eighteenth century learning than Winckelmann's *Monumenti antichi inediti*.[47]

A more lucid setting, if no less obscure a fate, dominates a work, by Jean-François-Pierre Peyron, that turns to the imminent slaughter of equally pitiable youths (Fig. 13). This time the scene is laid in archaic Athens, whose archeological evocation is broadly attempted by the somewhat Egyptoid capitals, and presents the youths of that city drawing lots to determine which unlucky seven boys and seven girls shall be sent to the minotaur in order to satisfy the cruel vengeance of King Minos.[48]

[45] On the Goyesque connections of Gamelin, see Paul Mesplé, *De Rembrandt à Goya; graveurs pré-goyesques toulousains*, Toulouse, 1936.

[46] The score was completed in 1805, although the first performance was not given until Dec. 16, 1807. The third act actually takes place in the pit where the Vestal is to be buried alive.

[47] As mentioned in Paolo Fragapane, *Spontini*, Bologna, 1954, p. 19. Jouy himself refers to Winckelmann in his "Préambule historique" to *La Vestale*: "Le trait historique sur lequel cette pièce est fondée remonte à l'an de Rome 269, et se trouve consigné dans l'ouvrage de Winckelman, intitulé *Monumenti antichi inediti*. Sous le consulat de Q. Fabius et de Servilius Cornelius la vestale *Gorgia* (Julia), éprise de la passion la plus violente pour *Licinius*, Sabin d'origine, l'introduisit dans le temple de Vesta, une nuit où elle veillait la garde du feu sacré. Les deux amants furent découverts; Julia fut enterrée vive, et Licinius se tua, pour se soustraire au supplice dont la loi punissait son crime." (*Œuvres complètes d'Étienne de Jouy*, XIX, Paris, 1823, p. 6.)

[48] The precise dating and identification of Peyron's several versions of this subject raise some unsolved problems. A drawing of this subject by Peyron was exhibited at the Salon of 1798 (no. 335) and, according to E. Bellier de la Chavignerie and L. Auvray, *Dictionnaire général des artistes de l'école française*, Paris, 1882, is in the Louvre. It is not. Perhaps it is to be identified with the Peyron drawing at the Sotheby sale, Nov. 19, 1963. Is the undated engraving published here based on this drawing? There is also a painted version of the subject in Apsley House, London (see

Archaic Greek horror also prevails, though in more concentrated form, in the *Clytemnestra* of Pierre-Narcisse Guérin, a painting exhibited at the Salon of 1817 (Fig. 14).[49] Like Cherubini's opera, *Medea* (1797), Guérin's picture molds classical means to horrific ends. In this case, a Davidian style of statuary stillness and clarity is used to translate the stark terror of Aeschylean tragedy.[50] Goaded on by her lover Aegisthus, Clytemnestra stands poised, dagger in hand, before her sleeping husband. The horror of this suspenseful moment is underscored not only by the dramatic rhetoric of the theatrical postures and expressions but by the flaming red of the curtain and by the lurid nocturnal light

Evelyn Wellington, *A Descriptive and Historical Catalogue of the Collection of Pictures and Sculptures at Apsley House, London*, II, London, 1901, p. 380, no. 108), which, on the basis of the architecture alone, would seem to pre-date this engraving, for it uses Roman and Renaissance rather than Egyptoid forms. The London painting, according to the catalogue, is signed and dated 1778, but no trace of this inscription is visible today. I wish to thank Mr. Jonathan Mayne, of the Victoria and Albert Museum, for information about the Apsley House painting.

Another version of this subject by Peytavin was exhibited at the Salon of 1802 (no. 233), but this shows the even more gruesome moment at which the Athenian girls are actually given to the minotaur.

[49] No. 398. A small version of the painting is in the Musée des Beaux-Arts, Orléans. The painting is described fully in C. P. Landon, *Annales . . . (Salon of 1817)*, Paris, 1817, pp. 63-66. Guérin's deviation from Aeschylus' text in locating the murder in the nuptial bed is justified here (p. 64).

[50] A taste for Aeschylus was in itself symptomatic of the primitivist currents of the late eighteenth century and has been compared to the new enthusiasm for the Greek Doric order by N. Pevsner and S. Lang ("Apollo or Baboon," *Architectural Review*, CIV, Dec. 1948, p. 279).

The first translations of Aeschylus into French and English had already appeared in the 1770's: *Tragédies d'Eschyle*, trans. Le Franc de Pompignan, Paris, 1770; and *The Tragedies of Aeschylus*, trans. R. Potter, Norwich, 1777. Another French translation appeared in 1794: *Théâtre d'Eschyle*, trans. F. J. G. de la Porte du Theil, Paris, An III, the year in which Flaxman's own Aeschylus illustrations appeared. In England a vigorous defense of Aeschylus' greatness was made by Richard Cumberland, who wrote of *Agamemnon* that "it would be a matter of astonishment . . . that any critic should be found of such proof against its beauties, as to lower its author to a comparison with Sophocles or Euripides." (*The Observer*, II, London, 1786, p. 218.)

that bathes the scene. Typically for the period, archeological accuracy is attempted in the suggestions of the Palace of Argos in the background and, at the left, the urn with the ashes of Iphigenia. An anonymous critic of the Salon of 1817 applauded as well the historical exactitude of the costume.[51]

If the new enthusiasm for Greco-Roman antiquity could yield the above examples of Romantic violence and terror, it could also be used more conservatively to enlarge or to continue more traditional veins of eighteenth century experience. Vien's *Marchande à la toilette* has already been referred to in terms of its conformity with the amorous themes of mid eighteenth century taste, and countless other paintings that followed it offer what can best be considered enduring Rococo eroticism in new antique clothing.[52]

Another painting of Vien's, *L'Amour fuit l'esclavage* is a case in point (Fig. 15). Exhibited just after the Fall of the Bastille, at the Salon of 1789,[53] it ignores David's moralizing Neoclassicism by perpetuating a thoroughly Rococo theme. Again, the ubiquitous mid eighteenth century Cupid dominates the scene; but here, in terms of an archeological fantasy that provides a sentimental postlude to the Roman source that had inspired Vien in 1763. Now, love escapes from the cage that imprisoned him, much to the frustration of the Roman lady and her attendants, who are at a loss to restrain this capricious and volatile emotion. There is nothing in this painting that would not be understood by those

[51] M. M * * *, *Essai sur le Salon de 1817, ou Examen critique des principaux ouvrages*, Paris, 1817, pp. 45-50: "Les costumes sont d'une exactitude historique. . . . C'est le style grec dans toute sa pureté, dans toute sa grandeur." (p. 50)

[52] This combination of Rococo sensibility and new classicizing tendencies has been dubbed "Pseudoklassizismus" by P. F. Schmidt ("Der Pseudoklassizismus des 18. Jahrhunderts," *Monatshefte für Kunstwissenschaft*, VIII, 1915, pp. 372-383, 409-422). Schmidt discusses this phenomenon only in relation to German art, but his assumptions are certainly applicable to other national currents of the period, particularly in France and England.

[53] No. 1. The Salon opened on August 25. Vien's painting is described in *Inventaire général des richesses d'art de la France; Province; Monuments civils*, VIII, Paris, 1908, p. 148, where it is misattributed to a certain Antoine-Charles-Horace Vien, a typographical confusion with Carle Vernet.

women of the *Ancien Régime* who, in the paintings of Fragonard, so urgently invoke the Goddess of Love. The change is, rather, a change of costume and decor which here conform to the classicizing fashion that Mme. du Barry herself had preferred when, in 1773 at her pavilion at Louveciennes, she returned Fragonard's *Progress of Love* series and commissioned Vien to restate the same Rococo theme in a more modish archeological manner.[54] Characteristic, too, for the later eighteenth century, Vien lends to his Roman scene a strong accent of heartrending grief in the heroine, who, like a sorrowing genre figure from Greuze, swoons with rhetorical abandon.

The same kind of self-conscious erotic despair is equally apparent in a painting by Angelica Kauffmann, one of the many woman artists of a period that encouraged feminine sentimentality.[55] Her *Ariadne* (Fig. 17) gazes with no less rhetorical desperation at the departing Theseus, while the melancholy of her isolation on Naxos is emphasized by the weeping Cupid at her feet.[56]

This mode, which might be called the "Neoclassic Erotic," was responsible for the exploration of many antique love stories far less well known than Ariadne's. One example is the delightful Greek legend of the origin of painting, according to which a

[54] On this symptomatic substitution of Vien's classicizing Rococo for Fragonard's more conservative Rococo, see Franklin M. Biebel, "Fragonard and Madame du Barry," *Gazette des Beaux-Arts*, 6e période, LVI, Oct. 1960, pp. 207-226. Biebel points out that Vien's *Marchande à la toilette* was owned by Mme. du Barry (p. 214).

[55] This sentimentalizing trend is discussed most amply in Louis Hautecœur, "Le Sentimentalisme dans la peinture française de Greuze à David," *Gazette des Beaux-Arts*, 4e période, LI, 1909, pp. 159-176, 269-286.

[56] For further bibliographical indications, see the exhibition catalogue, *Il Settecento a Roma*, Rome, Palazzo delle Esposizione, 1959, p. 134, no. 315. This version of *Ariadne* is not to be identified with that exhibited at the Royal Academy in 1774 (no. 145), which, Mr. Peter Walch kindly informs me, is illustrated in the catalogue, *Exhibition of Paintings by Angelica Kauffmann*, Kenwood (Iveagh Bequest), May-September 1955, no. 7. An earlier version of the theme, dated 1764, is also included in this catalogue (no. 1).

Corinthian maiden, Dibutade, knowing her lover is to depart, traces his silhouette upon a wall as an amorous memento.[57] This touching origin of the mimetic arts was illustrated, for one, in a painting of 1782-1784 (Fig. 16) by Joseph Wright of Derby,[58] who not only exploited the mysterious possibilities of nocturnal illumination, but used the opportunity as well to make an erudite allusion to a Roman relief of the sleeping Endymion, then popular among British Neoclassic circles.[59]

Such tenebrous settings and erotic emotions could lead, in later decades, to far more histrionic combinations of classical reference, luminary mystery, and amorous drama. In a *Sappho* exhibited at the Salon of 1801,[60] Baron Antoine-Jean Gros turns the Greuzian

[57] I have traced this popular late eighteenth century subject in "The Origin of Painting: A Problem in the Iconography of Romantic Classicism," *Art Bulletin*, xxxix, Dec. 1957, pp. 279-290. This article was subsequently amplified in addenda by George Levitine (*Art Bulletin*, xl, Dec. 1958, pp. 329-331); and in Hans Wille, "Die Erfindung der Zeichenkunst," in *Beiträge zur Kunstgeschichte, eine Festgabe für H. R. Rosemann zum 9. Oktober 1960*, Munich, 1960, pp. 279-300. Inevitably, I have come across other examples of the subject since the publication of these three articles, but they add little to the general points I had originally made. Of these examples, the most interesting historically is a print by John Mortimer (*The Origin of Drawing*, published May 1, 1771, by John Boydell), a classicizing version of the theme that dates from the same year as Alexander Runciman's *Origin of Painting*, the work I claimed as the first to lend this subject a Romantic and classicizing flavor that would separate it from earlier versions. Mortimer's treatment, if less mysterious than Runciman's, clearly belongs to this new mode of Romantic Classicism and, historically speaking, helps to strengthen the case I should make for British priority in the major innovations of late eighteenth century art. For two other British examples not included in the above articles, see those by Adam Buck (R.A. 1802, no. 521) and S. Williams (R.A. 1804, no. 82).

[58] For further bibliographical indications about Wright's painting, see the exhibition catalogue, *Painting in England 1700-1850; Collection of Mr. and Mrs. Paul Mellon*, Richmond, Virginia Museum of Fine Arts, 1963, p. 194, no. 372.

[59] A plaster cast of the relief was in the collection of Sir John Soane, and is still to be seen today in the Soane Museum, London. Moreover, it was copied in a Wedgwood relief, illustrated and discussed in Carol Macht, *Classical Wedgwood Designs*, New York, 1957, frontispiece and pp. 52-53.

[60] No. 164. See also C. P. Landon, *Annales . . .*, iii, Paris, 1802, pp. 63-64, pl. 28; and the exhibition catalogue, *Gros, ses amis, ses élèves*, Paris,

pathos of Vien's unhappy Roman heroine into high Romantic tragedy by illustrating the legendary suicide of the Greek poetess, whose love for the handsome young boatman, Phaon, went un-requited (Fig. 18). After a final libation, Gros's heroine stands on the brink of the Leucadian rock, silhouetted like a marble bac-chante against a milky-blue, moonlit sky. Only death can assuage her unbearable passion, a death that was later to be enacted on the stage in the suicidal finale of Gounod's first opera, *Sappho* (1850).

Not all examples of the Neoclassic Erotic attained such Wertheresque extremes. Most, in fact, simply continued to in-vestigate the more pleasurable aspects of Venus' realm that had already been explored by Rococo artists, thereby creating, in the conjunction of sexual themes and a coolly statuary style, the par-ticular Neoclassic ambiance that Mario Praz has characterized as the "Erotic Frigidaire."[61] In his *Zeuxis choisissant pour modèle les plus belles filles de la ville de Crotone*, exhibited at the Salon of 1789,[62] François-André Vincent seizes an opportunity to dis-

Petit Palais, 1936, p. 53. Other representations of Sappho's suicide include those by Taillasson (Salon of 1791, no. 14; Salon of 1795, no. 474); Taurel (Salon of 1795, no. 480); and a German example by Nahl, dis-cussed by Goethe in *Propyläen*, II, no. 1, Tübingen, 1799, p. 135. Gros's painting, incidentally, was coldly received and became the target of many amusing critical quips and puns. (See Henry Lemonnier, *Gros*, Paris, n.d., p. 24.)

[61] Mario Praz, "Canova, or the Erotic Frigidaire," *Art News*, LVI, Nov. 1957, pp. 24-27+.

[62] No. 19. The painting, which is dated 1789, is preceded by a preparatory drawing dated 1788 at the Musée Atger, Montpellier, in which, typically for French Neoclassic practice, the figures are as yet unclothed. Vincent's painting was re-exhibited at the Salon of 1791 (no. 334), and another version of the subject by Monsiau was to be seen at the Salon of 1798 (no. 311). The subject was treated as well by Angelica Kauffmann, and is to be found today at the Annmary Brown Memorial Library, Brown University, Providence, R.I. An engraving after Kauffmann's painting by Bartolozzi is illustrated in Saxl and Wittkower, *op.cit.*, pl. 82, no. 1. The *dramatis personae* of this scene, incidentally, recall not only the *Judgment of Paris* but, more symptomatically for the historical mobility of the period, the medieval legend of King Alfred of Mercia presenting his three unclad daughters to William de Albanac. For illustrations of this subject by West and Fuseli and a discussion of its literary sources, see

play feminine graces that would not have been lost on a Boucher or a Fragonard (Fig. 19). To this, however, he adds a Neoclassic erudition that presumes to ennoble this straightforward eroticism. Thus, the subject itself depends on the classical legend of the famous Greek painter Zeuxis, who wished to paint the portrait of Helen of Troy for the Temple of Juno at Crotona but, unable to find such beauty in one model, was obliged to select individual perfections from among the city's five most beautiful girls.[63] Moreover, the painting offers, in the most seductive guise, a pictorial demonstration of Neoclassic idealist art theory, which, reviving Seicento idealism, would maintain that the ideal perfections of art must be achieved by selecting the most beautiful component parts from the imperfect realities of nature.[64] Furthermore, this lofty theoretical message is combined with an archeological erudition that would attempt, with growing correctness, to reconstruct the historical truth of the scene depicted. Thus, Zeuxis, following the pictorial evolution initiated by Dibutade, begins his image of Helen with outline alone, in the manner of a Greek vase painting; the sculpture, whether the section of the Parthenon frieze visible in the background or the statue of Athena at the left, is of exclusively fifth century origin; and the architecture completes this historical synchronization of event and environment by its adherence to that severe Greek Doric order which earlier and more conservative eighteenth century generations had found barbaric and, in the word of Sir William Chambers, "gouty."[65]

Gert Schiff, *Zeichnungen von Johann Heinrich Füssli 1741-1825* (*Schweizerisches Institut für Kunstwissenschaft, Zürich*; *Kleine Schriften Nr. 2*), Zurich, 1959, p. 28, no. 25.

[63] The Salon catalogue recounts the story, which seems to depend on Cicero, *De Inventione*, II, 1, 1. A much briefer account is given in Pliny the Elder, *Natural History*, xxxv, 36.

[64] For a particularly clear account of Idealist art theory of the Seicento, see Kenneth Donahue, " 'The Ingenious Bellori'—A Biographical Study," *Marsyas*, III, 1943-1945, pp. 107-138.

[65] In a lecture prepared for the Royal Academy between 1768 and 1770: "Many of the Deformities which we observe in Grecian Buildings must be ascribed to their Ignorance in this Particular, such as their Gouty

The increasing punctiliousness of classical detail so evident in Vincent's painting was symptomatic of the encyclopedic curiosity of the late eighteenth century and the parallel growth of new disciplines of archeology.[66] Inevitably, Neoclassic art reflected this classical erudition and often, in fact, had as its primary *raison d'être* the illustration and accurate reconstruction of the swelling repertory of classical art and literature. Ironically, it was exactly those Nordic countries most remote from a Mediterranean tradition—Great Britain, Denmark, Sweden, Germany—which sought most fervently to retrieve the glories of a lost classical past with the tools of modern archeology. Schinkel's plans for rebuilding the Acropolis[67] and Thorvaldsen's actual restorations of the Aegina marbles[68] are characteristic tributes by Nordic artists to the reincarnation of Greek beauty, an elusive goal that has haunted German letters from Winckelmann, Goethe, and Hölderlin down to Mann's *Death in Venice*.[69]

This learned propagation of the classic faith, a pervasive current that affected almost all Neoclassic art and that might be called, somewhat cacophonously, the "Neoclassic Archeologic," reached a typical apogee in Goethe's Weimar Preisaufgaben of 1799-1805,[70] an annual competition that proposed themes from

Columns." (Quoted in N. Pevsner and S. Lang, "Apollo or Baboon," *Architectural Review*, CIV, Dec. 1948, p. 277.)

[66] The classic presentations of the rise of classical studies in the modern world are found in John Edwin Sandys, *A History of Classical Scholarship*, III, Cambridge, 1908; and Adolf Michaelis, *Ein Jahrhundert Kunstarchäologischer Entdeckungen*, 2nd revised ed., Leipzig, 1908.

[67] In a design for a royal residence for King Otto of Wittelsbach. See August Grisebach, *Carl Friedrich Schinkel*, Leipzig, 1924; and Paul Ortwin Rave, *Karl Friedrich Schinkel* [Munich, 1953], p. 39.

[68] Thorvaldsen worked on the restoration of the Aegina marbles in Rome in 1816. See Eugène Plon, *Thorvaldsen, sa vie et son œuvre*, Paris, 1867, pp. 54-55; and Paul Ortwin Rave, *Thorvaldsen*, Berlin, 1942, p. 82.

[69] For a stimulating study of German Philhellenism, see Eliza Marian Butler, *The Tyranny of Greece over Germany*, New York, 1935.

[70] The most ample study of the Weimar Preisaufgaben is now Walter Scheidig, *Goethes Preisaufgaben für Bildende Künstler* (*Schriften der Goethe-Gesellschaft*, 57. Band), Weimar, 1958, which includes the relevant documents. For an earlier, less complete compilation, see Richard Benz,

Greek literature to be illustrated by German artists. One of the two Homeric subjects[71] given for the competition of 1800—*Hector's Farewell*[72]—produced such entries as that by Ferdinand Hartmann (Fig. 20), which earnestly combines late eighteenth century sentiment and would-be archeology. Following the recommendations of Goethe's *aide-de-plume*, Johann Heinrich Meyer, Hartmann represents this farewell with a Romantic tenderness and heartfelt emotion. Focusing exclusively on the protagonists of this intimate scene, he offers a wife stooped in grief, a nobly consoling and virtuous husband, and a helpless babe protected by a nurse. Yet these domestic *dramatis personae* are simultaneously transported to a Homeric realm through such attempts at archeological truth as the military uniform derived from Greek vases, the literary detail of the infant Astyanax frightened by his father's helmet, the crude cobblestone pavement, and the battered Cyclopean walls of the Trojan gate, whose primitive geometric severity recalls the architectural inventions of Hartmann's great contemporary, Friedrich Gilly.[73] And Hartmann's pictorial style as well, in its simple, dry modeling and austere, airless ambiance, attempts to evoke the archaic purity of a long-lost Homeric world.[74]

Goethe und die Romantische Kunst, Munich [1940], pp. 71ff. An excellent general account of Weimar intellectual life at this period is W. H. Bruford, *Culture and Society in Classical Weimar, 1775-1806*, Cambridge, 1962.

The chief vehicle of Goethe's classicism during these years is his periodical, named appropriately enough *Propyläen* (Tübingen, 1798-1800). It is discussed well in Otto Harnack, *Die klassische Aesthetik der Deutschen*, Leipzig, 1892, pp. 195ff.

[71] The other subject was Ulysses and Diomedes Killing Rhesus and Capturing His Horses (*Iliad*, x, 377ff.). The program was announced in *Propyläen*, III, 1800, pp. 166-168 (reprinted in Scheidig, *op.cit.*, pp. 65-67).

[72] Dora Wiebenson ("Subjects from Homer's *Iliad* in Neoclassical Art," *Art Bulletin*, XLVI, March 1964, pp. 23-38) has discussed the theme of Hector's Farewell (pp. 27-28), although she does not consider the pictures executed for Goethe's Preisaufgabe of 1800.

[73] For further remarks on Gilly's architecture, see below, pp. 128, 147f.

[74] Other entries, illustrating Hector's Farewell, appear in Scheidig, *op.cit.*, pls. 4, 6, 7 (by Kolbe, Schnorr von Carolsfeld, and Nahl, respectively). Surprisingly, the prize-winning entry by Nahl is the least correct archeologically (e.g., it envisions the Trojan gates as a Cinquecento barrel

Even more explicitly archeological was another effort at reconstructing an image of legendary Greek beauty, in this case the lost Polygnotan paintings at Delphi as described by Pausanias.[75] On September 5, 1803, two very young German brothers, Franz and Johannes Riepenhausen,[76] then living in that great center of classical studies, Göttingen,[77] sent to Goethe at Weimar a series of twelve "Polygnotan" drawings with a letter explaining their choice of a Flaxmanesque outline style as appropriate to such an archeological endeavor (Fig. 21).[78] In the following year, 1804, Goethe devoted a long article to this reconstruction;[79] and in 1805, engravings after the Riepenhausens' drawings appeared.[80]

The Riepenhausens were hardly the first to attempt such a reconstruction. Already in the 1750's, the little-known French

vault with giant Tuscan Doric pilasters) although its style is the most severely spare and linear, in the manner of a Greek vase or a Flaxman outline engraving.

[75] x, 25-31, where there is a close description of Polygnotos' paintings in the Lesche of the Cnidians. The subjects treated were the *Sack of Troy* and *Odysseus' Descent into the Underworld*.

[76] The fullest discussion of the Riepenhausens is Otto Deneke, *Die Brüder Riepenhausen* (*Göttingische Nebenstunden*, 15), Göttingen, 1936. See also Benz, *op.cit.*, pp. 110ff.; Scheidig, *op.cit.*, pp. 370ff.; and Otto Fiebiger, "Zwei römische Briefe des Malers Franz Riepenhausens aus dem Jahre 1805," *Deutsche Rundschau*, CLXXVI, July-Sept. 1918, pp. 211-227.

The birth date of Johannes is occasionally given as 1786, but it is corrected to 1787 in Deneke, *op.cit.*, p. 2.

[77] The classical milieu at Göttingen included the famous classical philologist, Gottlob Heyne and, in 1800, Wilhelm Tischbein. The Riepenhausens' father, Franz Ludwig (1765-1840), was himself an engraver and worked on the Göttingen editions of Flaxman (Deneke, *op.cit.*, p. 14).

[78] The letter is reprinted in Scheidig, *op.cit.*, p. 372.

[79] "Polygnots Gemählde in der Lesche zu Delphi," *Jenaische Allgemeine Literatur-Zeitung*, 1. Jan.-March 1804, pp. 9-24.

[80] F. and I. Riepenhausen, *Gemählde des Polygnotos in der Lesche zu Delphi nach der Beschreibung des Pausanias gezeichnet*, Göttingen [1805]. This contained only fifteen plates, reconstructing the Sack of Troy. The second part, illustrating Odysseus' Descent into the Underworld, appeared only in 1826 (*Peintures de Polygnote à Delphes, dessinées et gravées d'après la description de Pausanias*, Rome, 1826) and was followed by a revised reprinting of the first part (Rome, 1829).

painter, Louis Joseph Le Lorrain, had tried to recreate these lost masterpieces of Greek art.[81] Yet his drawings, published in 1761 by the famous antiquarian, the Comte de Caylus,[82] turned out to be delightful Rococo fantasies, in which diminutive figures swarm through spaces enlivened by knowing architectural and atmospheric perspective devices (Fig. 22). In contrast, the Riepenhausens' version of the *Sack of Troy* recalls Carl, not Hubert, Robert.[83] If hardly Polygnotan, their style at least rejects the illusionistic sophistication still so conspicuous in Le Lorrain and replaces it with a Flaxmanesque purity of unmodeled outline drawing, whose archaic clarity was, in fact, to become the standard descriptive means in later archeological publications.[84]

Love, terror, pathetic sentiment, encyclopedic learning—these are only a few of the realms explored by late eighteenth century artists who treated classical themes. As suggested in Hartmann's version of Hector's farewell, the Greco-Roman world could ap-

[81] On Le Lorrain, see Jean Locquin, *La Peinture d'histoire en France de 1747 à 1785*, Paris, 1912, pp. 198-199. Like Bachelier and Diderot in the 1750's, Le Lorrain even attempted encaustic painting in the manner of the ancients.

[82] "Description de deux tableaux de Polygnote, donnée par Pausanias," *Histoire de l'Académie Royale des Inscriptions et Belles-Lettres; Mémoires*, XXVII, 1761, pp. 34-55. The essay was actually presented in 1757.

For a particularly delightful and informative discussion of these reconstructions and the controversy raging in French letters of the 1750's over the quality of Polygnotos, see Jean Seznec, *Essais sur Diderot et l'antiquité*, Oxford, 1957, pp. 47ff. For Falconet's opinion, see his "Sur deux peintures de Polygnote," in *Œuvres diverses concernant les arts*, nouvelle édition, II, Paris, 1787, pp. 105-134.

The primitive character of Polygnotos' paintings (at least as imagined by artists and antiquarians around 1800) presumably helped to inspire as well David's so-called Greek reform of the late 1790's (see M. E. J. Delécluze, *Louis David, son école et son temps*, Paris, 1855, p. 219).

[83] Carl Robert's archeological reconstructions of the late nineteenth century are, in fact, reproduced in Seznec, *op.cit.*, figs. 33-34. Robert's study, incidentally, gives a brief critical history of earlier Polygnotan reconstructions: *Die Iliupersis des Polygnot (Hallisches Winckelmannsprogramm, 17)*, Halle, 1893, pp. 28ff.

[84] Among the most familiar examples are the outline engravings in Salomon Reinach's numerous *Répertoires*.

peal to the noblest human experiences and, in particular, to that domain of heroism, virtue, and self-sacrifice which would become increasingly relevant to an age of Revolutionary activity. Another major vein of Neoclassicism might be referred to as the "Neoclassic Stoic," a viewpoint which looked toward antiquity for examples of high-minded human behavior that could serve as moral paragons for contemporary audiences. So rich were these possibilities that they are best considered later in a separate chapter. Their initial introduction at this point, however, may serve to raise further questions about the nature of Neoclassicism. To what extent are those works of art which deal with classical themes essentially different from contemporary works that would fall outside the Neoclassic category? To what extent are they more accurately considered only one facet of a broader, more embracing transformation that pervades late eighteenth century experience? In this context, two recurrent themes of the period— the deathbed and the virtuous widow—may help to pose new problems.

The first of these motifs—a deathbed surrounded by mourners —is so prevalent from the mid century on that examples may well run into the thousands.[85] As an antidote to the hedonistic pursuits of Rococo art, this somber theme served to evoke a new aura of gravity and seriousness. Such funereal solemnity became, in fact, a kind of anti-Rococo catharsis, whether through the passing of a great and noble hero or simply a bourgeois father.

The complete dramatic and compositional components of this edifying subject were fully presented in the 1760's by the Scottish painter and archeologist, Gavin Hamilton,[86] a member of that group of transalpine expatriates who had come to Rome to

[85] Recently, Geraldine Pelles (*Art, Artists and Society*; *Origins of a Modern Dilemma*; *Painting in England and France, 1750-1850*, Englewood Cliffs, N.J., 1963, pp. 127-128) has also commented on the revival of deathbed scenes in this period.

[86] The most ample compilation of material about Gavin Hamilton is now: David Irwin, "Gavin Hamilton: Archaeologist, Painter, and Dealer," *Art Bulletin*, LCIV, June 1962, pp. 87-102.

soak up the newly exposed and venerated wonders of antiquity.[87] His *Andromache Bewailing the Death of Hector*, probably painted in 1761 and engraved by Domenico Cunego in 1764,[88] states the essentials of this reformatory theme and pictorial organization (Fig. 23). A distant Homeric world of noble deeds and simple, powerful passions is created by a staid, gravity-bound composition in which the strong horizontal accent of the deathbed, in parallel alignment to the picture plane, is offset by the chorus of standing and seated mourners who demonstrate their grief with academic rhetoric.

If such an image of high pathos and seriousness appears as an alien intrusion in the Rococo milieu of the mid eighteenth century, it is, of course, hardly new to Western art. Its Christian associations with the Lamentation and with the expiration of saints are inevitable. So, too, are its allusions to such classical deathbeds as represented in the Roman Meleager relief or in such a Roman *conclamatio* as that copied by David (Fig. 24) during his Roman sojourn of 1775-1780[89] and used by him later as the emotional and structural basis for the mourning of heroes as varied as Hector, Jean-Paul Marat, and Louis-Michel Le Peletier de Saint-Fargeau.[90] But even closer in time, the immediate sources for Hamilton's image are such prototypal paintings of heroic

[87] The two fundamental studies of this international milieu in Rome remain: Carl Justi, *Winckelmann und seine Zeitgenossen*, 2nd ed., Leipzig, 1898; and Louis Hautecœur, *Rome et la Renaissance de l'antiquité au XVIIIᵉ siècle* (*Bibliothèque des écoles françaises d'Athènes et de Rome*, no. 105), Paris, 1912.

[88] The most recent discussion of the often reproduced Cunego engraving after Hamilton's painting is by Dora Wiebenson ("Subjects from Homer's Iliad in Neoclassical Art," *Art Bulletin*, XLVI, March 1964, p. 30), who points to Poussinesque sources for the composition. See also Ellis K. Waterhouse's important article, "The British Contribution to the Neo-Classical Style," *Proceedings of the British Academy*, XL, 1954, pp. 57-74, where the putative date of Hamilton's painting, 1761, is discussed (p. 69 n. 2).

[89] Jean Guiffrey and Pierre Marcel, eds., *Inventaire général des dessins du Musée de Louvre . . .* ; *École française*, IV, Paris, 1909, p. 96, no. 3311.

[90] Hautecœur (*Louis David*, Paris, 1954, p. 66) has also commented upon the relevance of this drawing for David's *Hector and Andromache*.

sorrow as provided by the French classicizing tradition of the seventeenth century and, in particular, by Poussin (*Death of Germanicus* [Fig. 25], *Testament of Eudamidas, Extreme Unction*).[91] Symptomatically, the French Academy chose the *Death of Germanicus* as its competition subject in sculpture in 1761,[92] and still earlier, in 1758, Mengs indicated his new Neoclassic orientation with a *Testament of Eudamidas* respectfully based on Poussin.[93]

The extreme relevance of Poussin for these reformatory directions may be explicitly demonstrated in a *Death of Germanicus* by the Viennese master Heinrich Füger,[94] a painting which, in keeping with its academic ambitions as the artist's reception piece for the Vienna Academy in 1789, pays learned, almost plagiaristic, homage to the French master's canonical image of the Roman general's deathbed (Fig. 26).[95] In the same way, the British sculptor Thomas Banks depends quite as heavily on Poussin in a marble relief of 1774, the *Death of Germanicus*,

[91] For a recent acknowledgment of Poussin's importance to these currents, see Wiebenson, *loc.cit.* For later prints after Poussin, see A. Andresen, *Nicolaus Poussin; Verzeichniss der nach seinen Gemälden gefertigten gleichzeitigen und späteren Kupferstiche, etc.*, Leipzig, 1863, revised and translated by Georges Wildenstein, *Gazette des Beaux-Arts*, 6ᵉ période, LX, July-August 1962, pp. 139-202.

[92] See J. Guiffrey and J. Barthélemy, *Liste des pensionnaires de l'Académie de France à Rome de 1663 à 1907*, Paris, 1908, p. 38. The winner of the first prize was Boizot.

[93] A drawing in Leipzig, discussed and illustrated in Kurt Gerstenberg, *Johann Joachim Winckelmann und Anton Raphael Mengs* (*Hallisches Winckelmannsprogramm*, 27), Halle, 1929, pp. 21-22.

[94] The basic monograph is Alfred Stix, *H. F. Füger*, Vienna, 1925, which also reproduces a Poussinesque preparatory drawing for the *Death of Germanicus* (pl. 58). For further remarks on the *Germanicus*, see Karl Wilczek, "Fügers Künstlerischer Entwicklungsgang," *Jahrbuch der kunsthistorischen Sammlungen in Wien*, n.f. II, 1928, p. 357; and the catalogue, *Österreichische Galerie; Galerie des neunzehnten Jahrhunderts im Oberen Belvedere*, Vienna, 1924, p. xxxiv, no. 124. Füger's painting was presented to the Vienna Academy on Feb. 15, 1789, and exhibited in 1790.

[95] For a literate discussion of Poussin's painting, see Sam Hunter, "Poussin's 'Death of Germanicus,'" *Bulletin of the Minneapolis Institute of Arts*, LCVIII, Jan. 1959, pp. 1-13.

although his Roman hero is stripped to full classical nudity and his abstraction of surface and contour occasionally reaches a degree of linear fluency that prophesies Blake (Fig. 27).[96]

The same Poussinesque source can be deduced for countless other Greco-Roman deathbed scenes of the period. Thus, when in 1818 a Spanish student of David's, José de Madrazo,[97] chose, with nationalistic pride, to paint the *Death of Viriathus* (Fig. 28), he simply substituted for Germanicus the Lusitanian hero who defended liberty against Roman troops in the Iberian peninsula and whose tragic murder at the hands of his own bribed servants would soon be avenged by the warriors at the right.[98]

In the years around 1800, these Greco-Roman deathbeds bore the expiring or expired bodies of dozens of great men, be they warriors like Hector, Germanicus, and Viriathus or philosophers like Socrates and Seneca. But if we interpret these sorrowful images as belonging to an exclusively Neoclassic mode, we are immediately confronted by any number of other paintings that complicate such an easy definition. If the period was attracted

[96] For further remarks on this relief, executed during Banks's Roman sojourn (1772-1779), see C. F. Bell, ed., *Annals of Thomas Banks*, Cambridge, 1938, pp. 35, 39-40; and Margaret Whinney, *Sculpture in Britain, 1530-1830 (Pelican History of Art)*, Harmondsworth, 1964, p. 176. On Banks, see also Rupert Gunnis, *Dictionary of British Sculptors, 1660-1851*, London [1953], pp. 37-40.

[97] On Madrazo, see Angel Vegue y Goldoni and F. J. Sánchez Cantón, *Tres Salas del Museo Romántico*, Madrid, 1921, pp. 68-74; and Bernardino de Pantorba (José López Jiménez), *Los Madrazos*, Barcelona, 1947, pp. 8ff. Both these studies suggest 1818 as the date for the *Viriathus*, which was executed during Madrazo's Roman sojourn. The work was considered to have been inspired by Flaxman and was also the subject of some humorous verses (Pantorba, *op.cit.*, p. 10). Madrazo and the *Viriathus* are also discussed in Aureliano de Beruete y Moret, *Historia de la pintura española en el siglo XIX*, Madrid, 1962, pp. 61-63 and fig. 11; and Juan de Contreras, Marqués de Lozoya, *Historia del arte hispánico*, v, Barcelona, 1949, p. 249.

[98] The fullest account of Viriathus is given in Appian, *Romanarum historiarum*; *De rebus hispaniensibus*, 60-74, although he is also referred to in Valerius Maximus (vi, 4) and Lucius Annaeus Florus (ii, 17). Appian's work appeared in a French translation by J. J. Combes-Dounous (*Histoire des guerres civiles de la République romaine*, Paris, 1808), perhaps the literary source used by Madrazo.

31

to this lugubrious but edifying theme, its attraction was hardly to Greco-Roman deaths alone.

In 1777 and 1778, Nicolas Guy Brenet[99] painted several versions[100] of the death of another great military hero, the French constable, Bertrand Du Guesclin, who died of illness in 1380 during the siege of Châteauneuf-de-Randon. In accord with the period's new didactic tenor, the subject, one of two episodes from the history of France chosen for royal commission by the Comte d'Angiviller,[101] was designed to elicit respect for a virtuous hero (Fig. 29). As such, it was based on the same edifying premises as the Neoclassic deathbeds and, moreover, on the same compositional principles. Yet by conventional categories, in which Greco-Roman subject matter belongs to Neoclassicism and medieval subject matter to Romanticism, Brenet's painting should be located in a realm of proto-Romantic medievalism that looks forward to Delacroix and Hugo. It is clear, though, that the painting offers no essential differences from Hamilton's *Hector*, Füger's *Germanicus*, and Madrazo's *Viriathus* other than a change of

[99] The fullest, most accurate account of Brenet's work is now found in Marc Sandoz, "Nicolas-Guy Brenet, peintre d'histoire (1728-1792)," *Bulletin de la Société de l'histoire de l'art français, 1960*, Paris, 1961, pp. 33-50.

[100] The version reproduced here (Musée des Beaux-Arts, Dunkirk) is the later replica of 1778. The earlier version, exhibited at the Salon of 1777 (no. 18), is now at Versailles, and is vertical rather than horizontal in format (Sandoz, *op.cit.*, pp. 42-43). Representations of the life of Du Guesclin continued into the nineteenth century. See Vafflard's *Honneurs rendus à Du Guesclin* (Salon of 1806, no. 509), discussed and illustrated in C. P. Landon, *Annales* . . . , XIV, Paris, 1807, pp. 77-78, pl. 35; Delacroix's *Du Guesclin au Château de Pontorson*, a drawing of 1829 (Louvre), illustrated in René Huyghe, *Delacroix*, New York and London, 1963, pl. 221; and Tonny Johannot's *Mort de Du Guesclin* (Salon of 1834, no. 1034), illustrated in C. P. Landon, *Salon de 1834 (Annales du Musée . . .)*, Paris, 1834, pl. 8. Ingres also contemplated illustrating the subject (H. Delaborde, *Ingres, sa vie, ses doctrines, ses travaux*, Paris, 1870, pp. 325-326).

[101] Jean Locquin, *La Peinture d'histoire en France de 1747 à 1785*, Paris, 1912, p. 51. The other commission from French history was Durameau's *Le Chevalier Bayard remet sa prisonnière à sa mère et la dote*. These two paintings were coupled with a group of moralizing paintings from ancient history.

costume and decor. Moreover, Brenet himself painted many Greco-Roman[102] subjects as well as a *Death of St. Joseph*,[103] so that were the *Hommages rendus à Du Guesclin* classified as a Romantic painting, Brenet would have to be considered a schizophrenic artistic personality. What has happened concerns rather a new attitude toward historical fact which, with the aid of new tools of learning, could reconstruct with hopeful accuracy any moment, whether B.C. or A.D., and any place, whether near or far. Thus, the Salon description of Brenet's painting enlists the authority of Villaret's *Histoire de France* to verify the events and the locale of the scene.[104] We are told not only that Châteauneuf-de-Randon is situated between the sources of the rivers Lot and L'Allier, but that the mourners include Olivier Clisson and the Maréchal de Sancerre, who was to replace Du Guesclin as constable. Quite as important, the Salon *livret* tells us that Du Guesclin's courage was so great that when he died of illness during the siege, the British were sufficiently moved to hold to their promise of surrender and to return, in the hands of the commander kneeling at the foot of the bed, the keys to the city.

These factual details are all used by Brenet to reconstitute, as it were, the truth of an edifying historical moment, a goal of historical veracity which is also served by the inclusion, in the background, of the crenellated fortress at Châteauneuf-de-Randon

[102] As abundantly enumerated in Sandoz, *op.cit.* The classic case of this historical mobility is that of West, who, in the early 1770's, illustrated the deaths of Wolfe, Bayard, and Epaminondas. (See Grose Evans, *Benjamin West and the Taste of His Times*, Carbondale, Ill., 1959, p. 44.)

[103] The *St. Joseph* (Musée de Peinture et de Sculpture, Grenoble) is, in fact, simply a Christian variation on the deathbed theme.

[104] The passage cited in the Salon *livret* (and reprinted in Sandoz, *op.cit.*, p. 43 n. 1) comes from the description in Villaret, *L'Histoire de France depuis l'établissement de la monarchie jusqu'au règne de Louis XIV*, XI, Paris, 1763, pp. 54-63. Villaret's history partook of a monumental enterprise characteristic of late eighteenth century Historicism. This multivolumed *Histoire de France* was begun in 1755 by the Abbé Velly, continued by Villaret and J. J. Garnier, interrupted by the Revolution, and then resumed until the final volume appeared in 1821.

The other major source for the life of Du Guesclin is Guyard de Berville, *Histoire de Bertrand Du Guesclin*, Paris, 1767 (2nd ed., 1772).

(whose ruins are still visible today), and of the medieval armor and costume so conspicuous in the foreground.[105]

This new approach to history, most conveniently called Historicism,[106] permitted a growing chronological and geographical mobility in the painting of the late eighteenth century that was the exact counterpart of the period's simultaneous exploration of diverse historical and exotic architectural styles. Thus, it was hardly the Middle Ages alone that could vie with Greco-Roman antiquity as a possible realm for this new attempt at documentary recreation of historical fact. In addition to the commemoration of such medieval heroes as Du Guesclin or the Chevalier Bayard,[107] the Renaissance itself could newly be seen through the

[105] The accuracy of costume and weapons, however, is criticized in René Lanson, *Le Goût du moyen âge en France au XVIIIe siècle*, Paris, 1926, p. 44.

[106] This broad concept, suggesting the new retrospective and archeological attitudes toward the historical past that appeared in the mid eighteenth century and that continue to be elaborated and refined in our own time, is found most often in modern German historical studies. It is a term, however, that might be usefully expanded in art historical writing in English, for it encompasses all historical revivals, Neoclassicism included, and thereby avoids the perplexing Neoclassic-Romantic polarity. A related term, used more often for architecture than for painting and sculpture and used more narrowly for stylistic phenomena, is Eclecticism.

For a fundamental study of Historicism as a phenomenon of cultural history, see Friedrich Meinecke, *Die Entstehung des Historismus*, Munich and Berlin, 1936, which concentrates on the eighteenth century. Most recently, the term has been used as the key to an art historical symposium (characteristically, in German) on nineteenth century problems: Ludwig Grote, ed., *Historismus und bildende Kunst* (*Studien zur Kunst des neunzehnten Jahrhunderts*, 1), Munich, 1965. The contribution by Nikolaus Pevsner, though it deals mainly with British architecture, is particularly stimulating for the broader aspects of the problem ("Möglichkeiten und Aspekte des Historismus," pp. 13-24).

[107] Bayard's death was represented by Beaufort (Salon of 1781, no. 108) and is now at the Musée des Beaux-Arts, Marseilles. Paradoxically, this subject, like many others from French medieval history, was illustrated earlier in England than in France (by West, R.A. 1773, no. 305), yet another indication of the priority of England in the introduction of the new iconography of late eighteenth century art. This has been admirably and unchauvinistically proven in the domain of Greco-Roman subjects by Jean Locquin ("Le Retour à l'antique dans l'école anglaise et dans l'école

objective lens of historical retrospection, so that soon we find deathbed scenes of Italian geniuses. Exhibited at the Salon of 1781,[108] the *Death of Leonardo da Vinci* by François Ménageot

française avant David," *La Renaissance de l'art français et des industries de luxe*, v, 1922, pp. 473-481). In addition to the example offered above, two other French medieval subjects were treated earlier in England: Penny, *The Generous Behaviour of the Chevalier Bayard*, exhibited at the Society of Artists of Great Britain, 1768, no. 121 (see also E. K. Waterhouse, *Painting in Britain, 1530 to 1790*, 2nd ed., Baltimore, 1962, p. 196), which precedes Durameau's version of 1777 (Musée de Peinture et de Sculpture, Grenoble); and Kauffmann, *The Death of Leonardo da Vinci in the Arms of Francis I*, exhibited at the Royal Academy, 1778, no. 174, which precedes Ménageot's version of 1781 (Musée de l'Hôtel de Ville, Amboise). There is an undated drawing of Leonardo's death by Richard Cosway (Truro, County Museum and Art Gallery), which may also precede Ménageot's work.

For a partial list of paintings of British medieval subjects exhibited at the Royal Academy in the 1770's, see Anthony Blunt, *The Art of William Blake*, New York, 1959, p. 7 n. 16.

[108] No. 151, *Léonard de Vincy, mourant dans les bras de François Premier*. An engraving of Ménageot's painting by Le Vasseur was exhibited at the Salon of 1789 (no. 315). Earlier English versions of this subject are mentioned in the preceding note. Of the later versions, popular after the Bourbon Restoration, the most famous are those by Ingres (G. Wildenstein, *Ingres*, London, 1954, nos. 118, 119, 267). There is also an undated etching of the subject (*Leonardo da Vinci moribondo tra le braccia di Francesco I*) by the Italian master Giuseppe Cades (1750-1799), which includes the portraits of other Italian artists who later flourished in Francis I's court (Andrea del Sarto, Rosso, Primaticcio, Salviati, Cellini). However, a preparatory drawing for it (Oxford, Ashmolean Museum) is dated 1783 (see Anthony M. Clark, "An Introduction to the Drawings of Giuseppe Cades," *Master Drawings*, II, no. 1, 1964, p. 21, pl. 10), which indicates that in any case Cades' etching postdates and may be influenced by the work of Ménageot and the British.

For a study of the nineteenth century revival of subjects from French history, see the unpublished thesis submitted to the École du Louvre, Paris, 1934: Roland Balny d'Avricourt, *Le Siècle de François I^er^ vu par les peintres de l'époque romantique*. It is summarized in the *Bulletin des Musées de France*, VI, Oct. 1934, pp. 168-170. I wish to thank Mr. W. McAllister Johnson for calling this thesis to my attention.

Ménageot's painting, based on Vasari's account of Leonardo's death (*Vite*, ed. Milanesi, IV, Florence, 1879, p. 49), is discussed in C. P. Landon, *Annales . . .* , v, Paris, 1803, pp. 137-138, where it is highly praised as a forerunner of later achievements: "C'est un de [ces tableaux] qui marquent

repeats the now familiar deathbed pattern by offering simple substitutions of historical data (Fig. 30). Du Guesclin becomes the gray and bearded Leonardo; the chief mourner becomes what looks like a full-standing variation of the Titian portrait of François I; and the setting, with such details as the Borghese Gladiator affirming the arrival of classical antiquity in Renaissance France, becomes Amboise on May 2, 1519, rather than Château-neuf-de-Randon on July 13, 1380.

Similarly, when a student of David's, Pierre-Nolasque Bergeret,[109] exhibited his *Honneurs rendus à Raphael après sa mort* (Fig. 31) at the Salon of 1806,[110] he intended to transport us to Rome, April 6, 1520, via details of setting, costume, and portraiture which, by now, have become so precise that the painting begins to resemble a photograph of a waxworks tableau, recreating before our eyes the illustrious assembly that paid homage to this young genius. In the center, Pope Leo X—realistically transposed from Raphael's portrait much as François I had been from Titian's—strews flowers on Raphael's corpse while Cardinal Bembo is about to depose a laurel wreath; and on the sides and in the background, all manner of great men and Raphael pupils have come to grieve and to venerate this untimely passing. Bergeret himself explains that he has included Marcantonio, Giulio Romano, Luca Penni, Polidoro da Caravaggio, Michelangelo, Sebastiano del Piombo, Ariosto, Vasari, and the aged master Perugino.[111] To the would-be historical veracity of this

le retour de son goût dans notre école moderne. On y admire une composition noble et sage, un dessin correct, beaucoup d'expression, l'observation rigoureuse du costume, un coloris brillant et un pinceau large et facile." Landon also claims (incorrectly) that Ménageot was the first to treat the theme.

[109] His name is occasionally spelled Bergerat.

[110] No. 24. The subject had been treated earlier by Monsiau (Salon of 1804, no. 325), illustrated and discussed in C. P. Landon, *Annales . . .* , x, Paris, 1805, p. 101; and by Harriet (Salon of 1800, no. 182), in a *dessin allégorique*, which formed a pendant to *Virgile mourant* (no. 181).

[111] A long and adulatory discussion of Bergeret's painting, including the artist's own description of the work, is found in P. Chaussard, *Le Pausanias français . . . Salon de 1806*, Paris, 1806, pp. 84-96.

funereal portrait gallery are added such other truthful details as Raphael's own paintings—the *Transfiguration* on the right, which Vasari tells us was placed above his head,[112] and, half visible on the far wall, the *Madonna della Sedia*. Once again, the picture is essentially a deathbed scene based on Greco-Roman and Christian tradition, now historicized through sufficient documentary detail to convince the spectator that he is seeing a literal recreation of a real historical moment. It should come as no surprise to learn that Bergeret had made a print after Poussin's *Extreme Unction*[113] and that, in later Salons, he transported this composition to paintings that illustrated the deathbeds of Poussin himself (1819), Henry IV (1822), Titian (1833), and Columbus (1851). Greek, Roman, medieval, Renaissance—these varied historical milieux could now all be recreated through the growingly specialized tools of Historicism.

Nor was the contemporary world neglected. The expanding bourgeois audience of the mid eighteenth century also enjoyed the reflection of its own image, although often somewhat distorted in the direction of sententious eloquence. Already in 1765, Jean-Baptiste Greuze exhibited at the Salon *Le Fils puni*,[114] his famous drawing of the punishment of a modern Prodigal Son— a story in which the artist, like Hogarth before him, had found the dramatic material for the moral edification of the middle-class spectator.[115] In the later, painted interpretation (1778) of this pathetic scene (Fig. 32), Greuze is even more explicit in his

[112] *Vite*, ed. Milanesi, IV, Florence, 1879, p. 383. For all such presumed historical accuracy, Bergeret's painting is obviously inaccurate, including portraits of Michelangelo, who was absent from the deathbed scene, and Vasari, who was only nine years old at the time.

[113] See Henri Béraldi, *Les Graveurs du XIXe siècle*, I, Paris, 1885, p. 51.

[114] No. 125 (esquisse). This pen-and-wash drawing is now in the Musée de Lille, and is illustrated in Anita Brookner, "Jean-Baptiste Greuze—I," *Burlington Magazine*, xcviii, May 1956, fig. 39. For Diderot's well-known eulogy, see Seznec-Adhémar, *Diderot Salons (1765)*, ii, Oxford, 1960, pp. 157-160.

[115] The standard study of Hogarth and his legacy in eighteenth century moralizing painting is now Frederick Antal, *Hogarth and His Place in European Art*, London, 1962. For remarks on Greuze's debt to Hogarth, see pp. 198ff.

37

close allegiance to the Hamilton-Poussin deathbed composition, merely transforming the Greco-Roman world into the workaday costumes and furnishings of the Third Estate, though preserving such hints of academic pomp as the sweeping curtains above the body of the wizened and long-suffering father.[116] And in *Les Derniers moments d'une épouse chérie*[117] by Pierre-Alexandre Wille *fils*,[118] we have the feminine counterpart of this solemn scene in which, once again, a familiar domestic situation becomes ennobled and generalized through a heroic composition and a reverential silence that is imposed even upon the unfed spaniel and the family infant, whose elder brother (or sister?) suggests that he stop beating his snare drum (Fig. 33).[119]

At the same time, the secularization of this lamentation motif could be seen in the commemorative icons of the deaths of such modern heroes as General James Wolfe and Jean-Paul Marat, a tradition that finally became capable of reconstructing the last and often intimate moments of any notable contemporary figure.[120] Thus, at the Salon of 1817, which included paintings of

[116] Brookner (*op.cit.*, Part II, June 1956, p. 195) points out the classicizing flavor of this later version and its companion (*La Malédiction paternelle*) and suggests the relevance of *Le Fils puni* to David's *Hector and Andromache*. That Greuze based this painted version of *Le Fils puni* on Hamilton's *Andromache Mourning Hector* seems probable, especially in view of his efforts in the late 1760's to be elected a *peintre d'histoire* by ennobling his style through references to classical statuary and Neoclassic art. Greuze's complex relation to Neoclassicism is, in fact, worth exploring. A stimulating effort in this direction has just been made by Willibald Sauerländer ("Pathosfiguren im Œuvre des Jean Baptiste Greuze," in *Walter Friedlaender zum 90. Geburtstag; eine Festgabe . . .*, eds. G. Kauffmann and W. Sauerländer, Berlin, 1965, pp. 146-150).

[117] Exhibited at the Salon of 1785, no. 143. The painting is dated 1784.

[118] The best study is Louis Hautecœur, "Pierre Alexandre Wille le Fils," in *Mélanges offerts à M. Henry Lemonnier* (*Archives de l'art français*, VII), Paris, 1913, pp. 440-466.

[119] The Salon description, at least, refers to him as a brother, whereas Hautecœur (*op.cit.*, p. 450) calls him "une des filles." Hautecœur, incidentally, points out the dependence of the snare drum motif on Greuze's *Le Repos* of 1759.

[120] The classic study of the intrusion of heroic scenes of modern history into late eighteenth century history painting is Edgar Wind, "The Revolu-

the final moments of Louis VI (Menjaud), Louis XII (Blondel), St. Louis (Rouget and Scheffer), Abbé Edgeworth (Menjaud), and Masaccio (Couder),[121] Louis Hersent exhibited a painting that commemorated the death of one of his famous contemporaries: *La Mort de Xavier Bichat, médecin de l'Hôtel-Dieu de Paris* (Fig. 34).[122] The generalized situation and lachrymose rhetoric of Greuze's and Wille's anonymous father and mother have now become a most intimate and most particularized person, time, and place; for Hersent has here reconstructed, as had Brenet for Du Guesclin or Bergeret for Raphael, a specific historical moment, July 22, 1802, at 14 rue Chanoinesse, Paris, where the famous anatomist, Xavier Bichat, died in his thirty-second year, watched over by two students, Dr. Esparron and Dr. Roux.[123] Although the almost Dutch realism of detail, especially in the medical still life at the left, lends the painting a photographic verisimilitude that is now fully of the nineteenth century, echoes of classical idealism still pervade this grouping by now so familiar. As a contemporary critic remarked, "Tout est simple, vrai, pathétique dans ce tableau; tout y est sévère comme le sujet même. Il y a du Poussin dans cette composition de M. Hersent."[124]

Such grave and simple pathos was often attempted in a second motif of great popularity in the later eighteenth century and one that was closely allied to the ambiance of the deathbed. A perfect

tion of History Painting," *Journal of the Warburg Institute*, II, 1938-1939, pp. 116-127.

[121] Lorenz Eitner ("The Open Window and the Storm-Tossed Boat," *Art Bulletin*, XXXVII, Dec. 1955, p. 283 n. 5) has already indicated the prevalence of deathbeds, especially French historical ones, at this first Salon after the Bourbon Restoration.

[122] Salon of 1817, no. 416.

[123] The Salon description, incidentally, is incorrect, for it mentions that Bichat expired in his 33rd year, whereas he was born on Nov. 11, 1771, and died on July 22, 1802. A commemorative statue of him by David d'Angers, which records these dates, may be seen at Bourg-en-Bresse as well as in the courtyard at the École de Médecine, Paris.

[124] M. M***, *Essai sur le Salon de 1817, ou Examen critique des principaux ouvrages*, Paris, 1817, p. 117.

combination of a moralizing lesson and an essay in doleful senti-
ment, the theme of the virtuous widow provided, as it were, the
feminine aftermath of these funereal scenes. Just as the deathbed
motif could enlist emotions associated with the *Pietà*, the theme
of a grieving widow could likewise secularize Christian senti-
ments familiarly related to images of the sorrowing Virgin or
the melancholic Magdalene. And with the new mobility of His-
toricism, this theme could be transported to a remarkable variety
of reconstructed milieux—historical, geographical, or even ethno-
logical.

Not unexpectedly, the prototypal image of the grieving widow
can be found in the work of Greuze. His *Veuve inconsolable* of
ca. 1763,[125] a painting which, characteristically, has on occasion
been misidentified as the Magdalene,[126] offers the most extreme
dramatic statement of a marital fidelity that continues, with
heartrending desperation, even after death (Fig. 35). Her gar-
ment disheveled, her hair unkempt, and her breast bared, this
nameless heroine gesticulates futilely among the relics of her late
husband—a box of letters and a tender portrait bust in bronze,
strewn with fresh flowers, that commemorates his former exist-
ence. The widow's sole companion in grief is the ubiquitous
Fido, who bears out this tearful paragon of unswerving fidelity.

[125] The painting is undated, but I am proposing here the date ca. 1763
on the basis of the work's close resemblance to *Une jeune fille qui a cassé
son miroir*, exhibited at the Salon of 1763 and now also in the Wallace
Collection, London (no. 442). In fact, it would seem probable that *La
Veuve inconsolable* might be identified with an untraced painting, also
exhibited at the Salon of 1763, *Le tendre ressouvenir* (no. 138). The
dimensions given in the Salon catalogue (15 pouces sur 1 pied) also con-
form to the work (15¾" x 12⅝"). Mr. Edgar Munhall, who is preparing
a catalogue of Greuze's work, has kindly confirmed this proposal. For
further information about *La Veuve inconsolable*, see the Wallace Collec-
tion catalogue, *Pictures and Drawings*, 15th ed., London, 1928, p. 122, no.
454, and the Greuze catalogue of M. J. Martin and Charles Masson, in-
cluded in Camille Mauclair, *J.-B. Greuze*, Paris [1906], no. 221. Neither
entry, however, suggests a date.

[126] Mauclair (*loc.cit.*) mentions that it was so identified at the Wallace
Collection. For other Greuze widows and their transformations, see Mau-
clair, *op.cit.*, Cat. nos. 697ff.; and Edmond Pilon, *J.-B. Greuze, peintre de
la femme et la jeune fille du 18e siècle*, Paris, 1912, p. 75.

The same kind of all-consuming widowhood may be found transposed to a specific biographical situation in a tomb by Jean-Baptiste Pigalle for the Comte Henri-Claude d'Harcourt, whose death in 1769 reduced his wife to a prolonged state of Greuzian despair. In the solitary years that followed, the Comtesse helped to assuage her grief by supervising the construction (1771-1776), in a chapel at Notre-Dame de Paris, of a mausoleum to her late husband (Fig. 36). Pigalle's funerary symbolism was carefully dictated by the unhappy widow, who chose an unfamiliar theme for a tomb—that of a marital reunion after death. With arms eagerly outstretched toward her husband's coffin, she realizes that Death's hourglass has marked her time and that she is at last to be freed from her earthly sorrows.[127]

In 1776, a critic referred to the Comtesse d'Harcourt as a "nouvelle Artémise,"[128] the kind of classical allusion that was borne out in many other late eighteenth century representations of notable Greek and Roman widows. The most famous Greek widow to be celebrated was, of course, Andromache, who appeared not only at Hector's deathbed, as in Gavin Hamilton's and David's version of the theme (Figs. 23, 37), but also in a later, unspecified moment, at Hector's tomb. Appropriately enough, a lady painter, Angelica Kauffmann, chose this scene of a more intimate and more exclusively feminine grief for exhibition at the Royal Academy in 1772 (Fig. 38).[129] Accompanied by

[127] The fullest discussion of the tomb, whose symbolism has been frequently misinterpreted, is in Louis Réau, *J.-B. Pigalle*, Paris, 1950, pp. 99ff. A further discussion of its symbolism may be found in Jean Seznec, *Essais sur Diderot et l'antiquité*, Oxford, 1957, pp. 37-39.

[128] *L'Espion anglais*, IV, Oct. 15, 1776, p. 200: "C'est une comtesse d'Harcourt qui l'a fait élever. Nouvelle Artémise, ne pouvant se consoler de la perte de son mari, elle n'a plus d'autre douceur sur la terre que de s'en occuper. . . ." The theme of Artemisia ordering a mausoleum for her late husband may be found already in seventeenth century French painting (William Crelly, *The Painting of Simon Vouet*, New Haven, 1962, no. 142, fig. 181). The theme of Artemisia Mourning may also be found in a late eighteenth century painting at the Musée des Beaux-Arts, Orléans, which is attributed, not too convincingly, to Lagrenée *l'aîné*.

[129] R.A., no. 128. *Andromache and Hecuba Weeping over the Ashes of*

Hecuba and Astyanax, Andromache is virtually Greuze's incon-
solable widow, recreated by costume, Greek inscription, and
candelabra in a Homeric milieu.

In the same way, Roman widowhood could evoke the tearful
piety of an Andromache or a Comtesse d'Harcourt and needed
only the assistance of mid eighteenth century archeology for its
recreation. Thus, in 1768, the stylistically and iconographically
precocious Benjamin West, whose provincial and literal-minded
training in the American Colonies permitted him to seize all the
more readily the new realistic basis of Historicism, could be
inspired by a reading of Tacitus' *Annals*[130] to reconstruct the virtu-
ous widowhood of Agrippina with the detail of a *tableau-vivant*.[131]

Hector. Mr. Peter Walch kindly informed me that Kauffmann's painting
is in the collection of Lady Cicely Goff, and is reproduced in Elizabeth
Harvey, "Painter of the Soul, Angelica Kauffmann, 1741-1807," *Country
Life*, Dec. 5, 1941, p. 1082. For less chaste feminine tears at a sepulcher,
see Kauffmann's *Cleopatra, Adorning the Tomb of Marc Anthony*
(Burghley House; also engraved by Thos. Burke in 1772 and exhibited at
the R.A., 1770, no. 118).

[130] III, 1-2.

[131] West's various versions of the theme have not yet been untangled.
Two paintings entitled *Agrippina*, it seems, were exhibited at the Society of
Artists in 1768 (nos. 175 and, as a late and special entry, 120), but these
are not likely to correspond to the two identical paintings of the theme at
Burghley House and the Yale University Art Gallery (one presumably a
later copy). Recently, too, a small version (13" x 18½") of the painting,
signed and dated 1766, turned up on the London art market (Christie
Sale, Lot 121, July 19, 1963, bought by Jones) and, as Mr. Thomas Mc-
Cormick kindly pointed out to me, was recently acquired by the Philadel-
phia Museum of Art and illustrated in its *Bulletin*, LXI, no. 286, Summer
1965, p. 105. Furthermore, West exhibited a later, more intimate inter-
pretation of the theme showing *Agrippina, surrounded by her children,
weeping over the ashes of Germanicus* (R.A., 1773, no. 303; The John
and Mable Ringling Museum of Art, Sarasota, Fla.; illustrated in Evans,
Benjamin West . . . , pl. 25). As Locquin has pointed out (*La Peinture
d'histoire . . .* , p. 157 n. 9), West's *Agrippina* precedes the only French
version of the theme exhibited at an eighteenth century Salon (that by
Renou, Salon of 1779, no. 76). Other British versions of the theme include
that of Gavin Hamilton at Althorp (R.A., 1772, no. 109; illustrated in Ellis
Waterhouse, "The British Contribution to the Neo-Classical Style," *Pro-
ceedings of the British Academy*, XL, 1954, pl. XI); and those by Alexander
Runciman, who, like West, illustrated both the funereal disembarkation at

This zealous study of Roman art could yield the solemn, heroic moment in A.D. 19 when Agrippina, after having courageously accompanied her husband Germanicus throughout his perilous Eastern campaigns, disembarked at Brundisium with his ashes (Fig. 39). The closely copied Roman temple and, above all, the almost exact replica of the Ara Pacis reliefs for the stately procession of mourning women and children,[132] give the painting the quality of what becomes almost a photographic image of an event in Roman history. Unlike the classicism of Raphael or Poussin, that of West is not innate, but is better considered a sharply focused realism that happens here to scrutinize a scene from classical history.

As with the late eighteenth century deathbed, the theme of the inconsolable widow could extend far beyond the more familiar territories of Greek and Roman antiquity. At the Salon of 1802,[133] Fleury François Richard,[134] a David pupil known for his attachment to medieval themes, exhibited an early fifteenth century translation, as it were, of Greuze's *Veuve inconsolable*. It shows us the unfortunate Valentine de Milan, whose husband, the Duc d'Orléans, was assassinated during the course of the bloody rivalries between the Orléans and Bourgogne families (Fig. 40). Unable to avenge his death, she remained alone, finally dying of grief. The artist has underscored this desolate widowhood by the inclusion of Valentine's device, *Rien ne m'est plus;*

Brundisium (R.A., 1781, no. 374; at Sotheby sale 9/6/32, no. 64, bought by Croal Thomson; preparatory drawing in National Gallery of Scotland, D2305f) and the more focused grief of Agrippina alone with Germanicus' ashes (undated etching; illustrated in the *Auckland, N.Z., City Art Gallery Quarterly*, no. 6, Summer 1958, p. 7).

[132] West's dependence on the Ara Pacis reliefs has been pointed out in Evans, *op.cit.*, p. 5 and pls. 1, 2.

[133] No. 243. *Valentine de Milan, pleurant son époux, assassiné en 1407 par Jean, Duc de Bourgogne.*

[134] On Richard, see Marius Audin and Eugène Vial, *Dictionnaire des artistes et ouvriers d'art du Lyonnais*, II, Paris, 1919, pp. 168-169. I have not been able to discover the present whereabouts of Richard's painting, which may well be in Russia today (*ibid.*). Another outline engraving of the painting is found in François Benoit, *L'Art français sous la révolution et l'Empire*, Paris, 1897, p. 391.

43

plus ne m'est rien, as well as of the faithful dog, who seems, like Greuze's spaniel, to share his mistress' sorrow.[135] Again, archeological detail—the costume, the family arms on the window, the Gothic architecture—permits the spectator here, as in Méhul's later operatic version of the story (1822),[136] to carry his empathy to a remote historical realm. Indeed, a critic praised Richard's punctilious efforts to assure such historical veracity.[137]

Other artists could effect even more distant and exotic journeys of the spectator's empathy. Like the Moorish, Hindu, or Chinese pavilions that began to spice Romantic gardens, non-Western widows soon appeared in the late eighteenth century repertory. For the Salon of 1783,[138] Louis-Jean-François Lagrenée[139] painted a curious episode derived from Diodorus Siculus (Fig. 41).[140] Eumenes, one of the successors of Alexander the Great, found

[135] The historical circumstances that lay behind this image of widowhood are fully described in C. P. Landon, *Annales* . . . , IV, Paris, 1803, pp. 13-14.

[136] A posthumous work, completed in 1822 by Méhul's nephew, Daussoigne, after the composer's death in 1817. The opera coincides with two more versions of the theme at the Salon of 1822 by Coupin de la Couperie (no. 265) and Mme. Servières (no. 1191).

[137] Landon, *op.cit.*, p. 14.

[138] Salon of 1783, no. 2. *Les deux veuves d'un indien*. Mme. Geiger, of the Musée des Beaux-Arts, Dijon, was kind enough to have the painting newly photographed for me.

[139] On Lagrenée *l'aîné*, see now the detailed account by Marc Sandoz ("Louis-Jean-François Lagrenée, dit l'aîné (1725-1809), peintre d'histoire," *Bulletin de la Société de l'Histoire de l'art français, 1961*, Paris, 1962, pp. 115-136).

[140] XIX, 33. There were many eighteenth century French editions of this ancient life of Alexander the Great (1705, 1737, 1743, 1758). The text mentions the officer's name (Ceteus), which is omitted in the Salon description. It should be said that accounts of this noble tale are often ambiguous and contradictory in the matter of whether the younger or the elder wife was pregnant and which one, in fact, was finally permitted to sacrifice herself. The situation is reversed, for example, in the account given by Bachaumont (*Mémoires secrets* . . . , XXIV, London, 1784, pp. 13-15, letter of August 25, 1783), whereas the description in *L'Année littéraire*, Paris, 1783, pp. 241-242, makes it clear that the younger, pregnant wife was the sacrificial victim. This subject is generally allied to the successful tragedy by Lemierre, *La Veuve du Malabar* (1770; again performed in 1780).

the corpse of an Indian officer who had two wives. Although Indian law required that the widow expire on her husband's funeral pyre, no provision had been made for such a bigamous situation. Thus both wives presented themselves eagerly for sacrifice, the younger, who was pregnant, claiming that the elder should be spared; the elder claiming that the younger be spared, for she had not spent as many years with the deceased warrior. Much to the grief of the elder wife, the younger was chosen. In Lagrenée's painting, she ascends the funeral pyre with gravid step, her own brother helping her to her death.

Such uncommonly harrowing virtue in widowhood could be found not only in the exotic mores of Asia but also of North America. In 1785, two years after Lagrenée's Oriental widows, Joseph Wright of Derby exhibited a scene of comparably inspiring widowhood among the North American Indians (Fig. 42).[141] In the primeval forest, a custom almost as rigorous as that of ancient India was said to prevail. At the first full moon after the death of an Indian chief, the widow was obliged to sit under his military trophies, exposed to the elements for a full day. To emphasize the stoicism of this noble savage, Wright has stirred up the most violent meteorological conditions—a raging storm and a volcanic eruption that even surpass his Vesuvian spectacles for sublime fury. Pitted against this malevolent nature, the Indian widow appears all the more solemn and implacable in her devotion, her cleanly modeled silhouette recalling a melancholic mourner from a Neoclassic tomb.[142] Such scenes of fem-

[141] Wright's painting was first exhibited in 1785 at Robins' Rooms, Covent Garden. See Theodore Crombie, "Wright of Derby's 'Indian Widow,'" *Apollo*, LXX, Oct. 1959, p. 107; and Benedict Nicolson, "Two Companion Pieces by Wright of Derby," *Burlington Magazine*, CIV, March 1962, pp. 113-117. Another version of this painting, probably a replica by a hand other than Wright's, is in the National Gallery, Washington, D.C., and is reproduced in Robert Rosenblum, "Wright of Derby: Gothick Realist," *Art News*, LIX, March 1960, p. 25.

[142] The most obvious analogy would be with the grieving figures from Canova's exactly contemporaneous *Tomb of Clement XIV*, SS. Apostoli, Rome (1783-1787); or, in fact, with the figure of Sabina from David's *Horatii* (1784).

inine stoicism among exotic races must have struck chords of moral admiration in these contemporaries of Jean-Jacques Rousseau and Lord Monboddo who, lamenting the corruption of over-civilization, were fascinated by the unspoiled virtues of primitive man.

The presentation of elemental feminine grief could be transplanted to even more imaginative terrains than Wright's virgin woods. At the Salon of 1806,[143] Madame Elisabeth Harvey, one of the fifty-odd woman painters who exhibited that year, re-created a scene of primitive mourning that was stimulated by the Ossianic poems (1762-1765) of James Macpherson (Fig. 43). Fully translated into French as early as 1777,[144] this literary falsification appeared as a revelation to all of Europe and America. Its evocation of a primitive Nordic domain excited readers as different as Jefferson[145] and Napoleon;[146] and Mme. de Staël, in 1800, was to locate Ossian in a theoretic polarity with Homer, according to which the two bards offered, as it were, the primal statements of Nordic versus Mediterranean sensibility.[147] From these poems, with their descriptions of a remote, fog-covered realm and noble, heroic deeds, Mme. Harvey appropriately chose a scene of feminine appeal that might be considered the Nordic

[143] No. 247. *Malvina pleure la mort de son cher Oscar; ses compagnes cherchent à la consoler.*

[144] Several chants were, in fact, published earlier (e.g., *Carthon* [1762], translated by the Duchesse d'Aiguillon). On the impact of Ossian in France, see Adrienne Tedeschi, *Ossian, 'Homère du Nord,' en France*, Milan, 1911; and Paul van Tieghem, *Ossian en France*, Paris, 1917.

[145] Jefferson found "the rude bard of the North the greatest poet who ever existed." See Claude G. Bowers, *The Young Jefferson, 1743-1789*, Boston, 1945, p. 307; and E. D. Berman, *Thomas Jefferson among the Arts*, New York, 1947, pp. 230-232.

[146] For Napoleon, see Van Tieghem, *op.cit.*, II, ch. I. Méhul even composed a *Chant d'Ossian* to be sung at the Opéra in 1811 to celebrate the birth of the Roi de Rome.

[147] *De la littérature considerée dans ses rapports avec les institutions sociales*, Paris, 1800, 1ère partie, ch. XI ("De la littérature du Nord"). The same polarity had already been expressed by Goethe in *Die Leiden des jungen Werthers* (1774): "Ossian hat in meinem Herzen den Homer verdrängt." (Part II, letter of Oct. 12, 1772.)

46

equivalent to the feminine sorrow depicted in Angelica Kauff-mann's *Andromache and Hecuba* (Fig. 38).[148] Here the incon-solable Malvina mourns her treacherously slain young husband Oscar,[149] while a group of maidens tries to assuage her sorrow. One offers her a rustic harp to play; another plays this primitive instrument herself, as an accompaniment to a song; the third, with two hunting dogs behind her, suggests with a proffered bow that she take up the distractions of the hunt; but none suc-ceeds in shaking Malvina from her profound melancholy. It was the kind of episode whose evocation of archetypal sorrow in a primitive Nordic race could cast a spell well into the nineteenth century: as late as 1860, Johannes Brahms included in his *Vier Gesänge für Frauenchor* (Opus 17) a comparable scene of plain-tive mourning from Ossian, scored, with fitting musical primitiv-ism, for women's voices, two French horns, and harp.[150]

Like her contemporaries, Mme. Harvey attempted a scrupu-lous reconstruction of truthful detail, all the more remarkable in view of the legendary character of the historical domain with

[148] Mme. Harvey's imagination may well have been spurred on by two operas based on Ossianic themes: Lesueur, *Les Bardes* (première, July 10, 1804) and Méhul, *Uthal* (première, May 17, 1806). In French painting, Girodet's, Gérard's, and Gros's Ossian illustrations are well known. An earlier Ossianic work by Duqueylar has recently been identified and con-nected with "Les Primitifs" by George Levitine ("The *Primitifs* and Their Critics in the Year 1800," *Studies in Romanticism*, I, Summer 1962, pp. 209-219). For a very incomplete, but international, list of Ossian illustra-tions, see Klaus von Baudissin, *Georg August Wallis, Maler aus Schottland, 1768-1847*, Heidelberg, 1924, pp. 60-63.

[149] At least it was identified as her husband in the contemporary descrip-tion of the painting found in C. P. Landon, *Annales . . .* , XIII, Paris, 1807, pp. 113-114, as well as in an illustration by Girodet, discussed in Van Tieghem, *op.cit.*, II, p. 154. However, the poem itself identifies Oscar as Malvina's lover ("Croma," in *Ossian, fils de Fingal*, trans. Le Tourneur, Paris, 1777, pp. 270-271). Mme. Harvey's painting is also discussed in Van Tieghem, *op.cit.*, II, pp. 159-160.

[150] The *Vier Gesänge* were composed in Hamburg in February 1860 and first performed there on May 2, 1860, although the Ossianic song (*Gesang aus Fingal*) was, in fact, omitted at the première (see Friedrich Blume, ed., *Die Musik in Geschichte und Gegenwart*, II, Kassel, 1952, p. 195).

which she was dealing. Thus, the landscape is bleak and craggy; the harps—commonly associated with the recitation of early Celtic poetry—look as though they were culled from an early chapter in a history of musical instruments; and the dolmen-like forms of a castle at the left similarly conjure up a primitive state of Nordic civilization. And as an anonymous observer at the Salon of 1806 pointed out,[151] in admiration of Mme. Harvey's attention to Ossianic details, not only are the maidens blonde (with the exception of the huntress), but Fingal's Cave is dimly visible in the background.[152] His only complaint was that, for an Ossianic landscape, the fog is perhaps not sufficiently pervasive.

Ossianic and North American wildernesses, Greek and Roman funerary rituals, French Gothic and Italian Renaissance costume— from the late eighteenth century on, all times, all places, all peoples could be entered into an encyclopedic repository of knowledge and could be reconstructed with a growing precision of detail.[153] The gain was also a loss. In an age that witnessed the most profound upheaval of long-established institutions, the classical and Christian traditions began to lose their living actuality and became part of a dead past that could only be regarded retrospectively, from the dawn of another historical era. Like

[151] Comments by "Un amateur," in P. Chaussard, *Le Pausanias français*, Paris, 1806, pp. 135-139.

[152] The engraving by C. Normand, reproduced in Landon, *op.cit.*, pl. 53, apparently mistakes Fingal's Cave for a proto-Doric temple, hardly an incomprehensible error in the context of this primitivizing architecture. For Fingal's Cave and Romantic art, see Geoffrey Grigson's fascinating article, "Fingal's Cave," *Architectural Review*, CIV, August 1948, pp. 51-54.

[153] A typical reflection of this viewpoint is found in *The Historic Gallery of Portraits and Paintings; or Biographical Review . . .* , 7 vols., London, 1807-1819, which made accessible, in words and in outline engravings after famous works of art, great historic events and great lives, ranging from Xenophon and Cleopatra to Kouli Khan and Lady Montagu. The museological counterpart of this attitude may be observed in Alexandre Lenoir, *Description historique et chronologique des monumens de sculpture, réunis au Musée des monumens français*, Paris, 1800, which catalogues sculpture in chronological order from Egyptian tombs down to the tomb of the eighteenth century antiquarian, Bernard de Montfaucon.

most new viewpoints originating in the late eighteenth century, that of Historicism became more and more vulgarized until, in our own century, it reached its inevitable conclusion, the presentation of different historical milieux through animated, photographic verisimilitude. The roster of popular historical films today offers the most restricted narrative themes within the most unrestricted range of environments—the Ice Age, Ancient Troy, Imperial Rome, Renaissance France, Colonial America, the Third Reich—all carefully reconstructed in Technicolor by a learned staff of experts whose historical specialties may range from archeology and decorative arts to coiffures and ballistics.

Such movies, in which the audience may find comfort in a familiar dramatic situation and adventure in an unfamiliar but almost palpably real visual confrontation, are the ultimate descendants of the late eighteenth century's combination of an easily communicable emotion and a search for the appurtenances of historical truth. But if today, the specific evocative qualities of these diverse milieux have been so flattened in value that a popular audience barely recognizes a difference between Greece five centuries before, and Gaul, five centuries after, Christ, the situation around 1800 was not yet of so leveling an objectivity. In an age of political revolution, the Greco-Roman world, in particular, could still be looked at with a Romantic fervor that temporarily revitalized it for new reformatory and propagandistic purposes. It is this facet of Neoclassicism that will dominate the next chapter.

II

THE *EXEMPLUM VIRTUTIS*

THE UNCOMMON heroism of a Hector or a Germanicus, the noble tears of an Andromache or an Agrippina—such high moments from Greco-Roman history and literature began to provide a realm of emotional experience that we have already referred to as the "Neoclassic Stoic." From the mid eighteenth century on, a new moralizing fervor penetrated the arts, as if to castigate the sinful excesses of hedonistic style and subject that had dominated the Rococo. The origins of this didactic mode may be traced back, broadly, to the growth of bourgeois audiences and, more narrowly, to the emergence in eighteenth century England of such moralizing popular art as the prints of Hogarth[1] and the novels of Richardson.[2] It was around 1760, however, that these currents gained new impetus, especially in France. There, the zealous re-examination of Greco-Roman antiquity was gradually combined with the new demand for stoical sobriety of form and emotion. And there, too, thanks to the equally new flexibility provided by Historicism, not only classical but other historical milieux could be culled for lessons in virtue that were ultimately to permit an extraordinarily close identifica-

[1] Problems of the social background for these moralizing currents in eighteenth century art have been pursued most intensively by the late Frederick Antal, especially in his posthumously printed *Hogarth and His Place in European Art*, London, 1962; and in his earlier series of articles, "Reflections on Classicism and Romanticism," *Burlington Magazine*, LXVI, April 1935, pp. 159-168; LXVIII, March 1936, pp. 130-139; LXXVII, Sept. and Dec. 1940, pp. 72-80, 188-192; LXXVIII, Jan. 1941, pp. 14-22.

For other socially oriented approaches to the period, which is particularly conducive to Marxist interpretation, see Milton Brown, *The Painting of the French Revolution*, New York, 1938; and Leo Balet, *Die Verbürgerlichung der deutschen Kunst, Literatur und Musik im 18. Jahrhundert* (*Sammlung Musikwissenschaftlicher Abhandlungen*, Band 18), Strasbourg, 1936.

[2] It is worth noting that the subtitle of Richardson's extraordinarily popular epistolary novel, *Pamela* (1740), was *Virtue Rewarded*.

tion of the historical past with the changing political goals of the French historical present. From the overthrow of the Bourbon dynasty in 1789 to its restoration in 1814, this moralizing Historicism could serve, chameleonlike, the diverse demands of monarchy, republic, and empire.

The tracing of this moralizing current in French art might conveniently begin in 1761, which also saw the publication of Marmontel's *Contes moraux*.[3] At the Salon of that year, both François Boucher and Jean-Baptiste Greuze exhibited scenes of rustic love. In the former's *Pastorale*,[4] we are taken to an unreal, erotic Arcadia in which the amorous shepherd and shepherdess are freed from all responsibilities but the fulfillment of their own desire (Fig. 44). In Greuze's *L'Accordée de Village*,[5] such amorous activities are, on the contrary, no longer ends in themselves, but are directed toward the preservation of middle-class virtues (Fig. 45). The institutions of marriage and family surround the rural bride and groom most literally in the presence of parents, brothers, sisters, and notary and, more symbolically, in the presence of a mother hen and her brood. Lest the rewards of such virtuous adherence to solid social institutions be left obscure, the painting's original title offers an irresistible clarification: *Un mariage, et l'instant où le père de l'Accordée délivre la dot à son gendre.* Indeed, this financial transaction takes place in the center of the pictorial stage, attesting most materially to Diderot's belief that

[3] The following year saw the publication of a characteristic link between French and British moralizing tendencies: Diderot's *Éloge de Richardson* in the *Journal étranger* (Jan. 1762, pp. 5-38). Most manuals of French literature give the publication date incorrectly as 1761.

Marmontel's *Contes moraux*, incidentally, established a literary genre that was imitated later in the century, as in the works of Mme. Leprince de Beaumont: *Contes moraux* (1773) and *Nouveaux contes moraux* (1776).

[4] Boucher's painting was one of a group of six works, exhibited at the Salon under the general title *Pastorales et paysages* (no. 9). See also Seznec-Adhémar, *Diderot Salons (1759, 1761, 1763)*, I, Oxford, 1957, p. 83.

[5] Salon of 1761, no. 100. For Diderot's famous comments on this painting, see *ibid.*, pp. 141ff. Its religious overtones have been considered most recently in Edgar Munhall, "Greuze and the Protestant Spirit," *Art Quarterly*, XXVII, no. 1, 1964, pp. 3-22.

the goal of the arts should be to "rendre la vertu aimable, le vice odieux."[6]

The moralizing plane of Greuze's painting rejects not only the amorality of Boucher's interpretation of erotic goals but also the amorality of his style. For Greuze has pruned Boucher's garden of what eighteenth century critics referred to as "chicory"[7] in order to reinstate a new and sobering monumentality. Powdered, pastel tints yield to lean and somber hues; impulsive, errant contours are clarified and disciplined; diminutive, pampered dolls capable only of pleasure take on full-scale, even heroic, human proportions; a sinuous, meandering composition gives way to geometric stability.

Like Gluck's operatic reforms of the 1760's,[8] Greuze's purging of the florid artifice of Rococo style permitted a new legibility

[6] The exact quotation is: "Rendre la vertu aimable, le vice odieux, le ridicule saillant, voilà le projet de tout honnête homme qui prend la plume, le pinceau ou le ciseau." (*Essai sur la peinture*, 1765, ch. v.) The essay, incidentally, remained unpublished until 1795.

[7] For example: "Le goût du *vrai beau* n'est qu'un; il tient à la nature toujours égale dans sa marche: nous ne mettrons pas au nombre des ornemens ces masses vagues, baroques, qu'on ne peut définir, et que nous nommons *chicorée*: écartons ces extravagances gothiques, quoiqu'il n'y ait pas encore une dizaine d'années qu'on s'en servait, et que malheureusement elles aient été en usage parmi nous pendant plus de trente-cinq ans." (Le Camus de Mézieres, *Le Génie d'architecture, ou l'analogie de cet art avec nos sensations*, Paris, 1780, p. 52). The chicory metaphor is broadened to general cultural dimensions in Rémy G. Saisselin, "Neo-classicism: Virtue, Reason and Nature," in Henry Hawley, *Neo-classicism: Style and Motif*, Cleveland, 1964, pp. 3-4.

[8] The innovations of *Orfeo ed Eurydice* (1762) and *Alceste* (1767) are directly parallel to the artistic transformations of the 1760's in their insistence on naturalness and clarity of style and emotion. Translated into visual terms, the reforms set forth in the famous preface to *Alceste* (1769) amount to a manifesto of Neoclassic art. (On these reforms, see the classic study by Alfred Einstein, *Gluck*, London, 1936, pp. 64ff.) A comparison between Gluck's music and the painting of his time was, in fact, made by an anonymous critic in discussing Vincent's entries at the Salon of 1785 (*Le Frondeur, ou Dialogues sur le Sallon, par l'auteur du Coup-de-Patte et du Triumvirat*, Paris, 1785, pp. 62-63). It was characteristic, too, of the period that Gluck could also compose an opera set in a moralizing genre milieu *à la* Greuze: *L'Ivrogne corrigé* (1760).

and seriousness of dramatic narrative. It should also be remembered, however, that such stylistic redirections toward naturalness and simplicity were not necessarily accompanied by the moralizing intention of Greuze's characteristic themes. Thus, Anton Raphael Mengs' celebrated ceiling painting, *Parnassus* (Fig. 46), painted in the same year as the *Accordée de Village*, 1761, offers almost identical pictorial components—a broad horizontal frieze of clearly sculptured figures arranged frontally and symmetrically within the geometric dictates of an oval[9]—but avoids completely Greuze's moralizing goal and vulgar milieu. Similarly, Vien's paintings, such as the *Marchande à la Toilette*, share Greuze's stylistic reforms, albeit in antique guise, while often preserving the overtly amoral eroticism of Boucher. In the later eighteenth century, a one-to-one correlation of style and subject was as frequently the exception as the rule. The friezelike compositions and statuary groupings associated with Neoclassic style may dominate scenes of genre, like Greuze's *Fils puni* of 1778 (Fig. 32), as well as scenes of explicitly Christian subject matter, like Vien's *La Piscine miraculeuse, et la Guérison du paralytique* (Salon of 1759) (Fig. 47),[10] Jean-Germain Drouais's *Enfant Prodigue* (1782) (Fig. 48),[11] or West's *Elisha Raising the*

[9] Kurt Gerstenberg (*Johann Joachim Winckelmann und Anton Raphael Mengs* (*Hallisches Winckelmannsprogramm*, 27), Halle, 1929, pp. 18-19) has discussed Mengs's preference for an oval pictorial structure in terms of its intermediary geometric status between Baroque and Neoclassic style, and has indicated as well Winckelmann's own recommendation: "Die Linie, die das Schöne beschreibet, ist elliptisch, und in derselben ist das Einfache und eine beständige Veränderung: denn sie kann mit keinem Zirkel beschrieben werden, und verändert in allen Punkten ihre Richtung." (See "Errinerung über die Betrachtung der Werke der Kunst," in *Winckelmann's Werke*, ed. C. L. Fernow, 1, Dresden, 1808, p. 247. Gerstenberg, incidentally, gives the page reference incorrectly as 241.)

[10] No. 18. For Diderot's favorable comments on Vien's painting, see Seznec-Adhémar, *op.cit.*, p. 65.

[11] On Drouais' painting, see the exhibition catalogue, *Trésors d'art des églises de Paris*, Chapelle de la Sorbonne, 1956, no. 10. It is also reproduced, with comments by Anita Brookner, in the *Burlington Magazine*, xcviii, Nov. 1956, pp. 414, 422; and in Munhall, *op.cit.* The unexplored œuvre of the short-lived Drouais (1763-1788) is a major example of Neo-Poussinism in the 1780's, especially in such paintings as the *Résurrection du fils*

Shunammite's Son (1766) (Fig. 49),[12] all of which apply Poussinesque classicizing principles to religious themes. Conversely, Greco-Roman subjects may often be painted in styles that revive, or continue, aspects of Baroque and Rococo.[13]

Nevertheless, throughout this complex historical web of styles that are both in the process of dying naturally and being revived artificially, the new moralizing tenor is pervasive on all levels of artistic activity. In fact, Greuze's own work may demonstrate the late eighteenth century's flexibility in moving from one historical milieu to another while retaining the same dramatic and, in this case, moralizing theme. In the *Fils puni* of 1778 (Fig. 32), we have seen how Greuze translated a Neoclassic deathbed formula into a genre scene; at another point in his career, he did quite the opposite. In 1769, in an ambitious, if unsuccessful, attempt to elevate his status from a "peintre de genre" to a "peintre d'histoire,"[14] Greuze submitted to the Salon

du veuve de Naim (1788, Musée Granet, Aix-en-Provence); or the winning painting for the Prix de Rome competition of 1784, *Christ et la Cananéenne* (Louvre). The other prize-winner, that by Louis Gauffier (École des Beaux-Arts, Paris), similarly depends on Poussin's prototype.

[12] On this painting, see Addison Franklin Page, "A Biblical Story: Benjamin West," *J. B. Speed Art Museum Bulletin* (Louisville, Ky.), xxiv, June 1964, pp. 5-6. The same combination of religious subject and Neoclassic style is found in West's *Jacob and Esau* (1766; Oberlin, Allen Memorial Art Museum).

[13] Such currents might be traced, for instance, in Gabriel-François Doyen's *Mort de Virginie* (1759, Parma); Louis Durameau's *Combat d'Entelle et de Darès* (1779, Riom); Antoine-François Callet's *Vénus blessée par Diomède* (1795, Bourges). In terms of quantity alone, in fact, there is enough Rubensian and Rococo survival, or revival, in classical history painting of the late eighteenth century to warrant considerable modification of prevailing ideas about the hegemony of Neoclassic style at the time.

[14] The story of these ambitions has often been told. See, for example, Locquin, *La Peinture d'histoire en France de 1747 à 1785*, Paris, 1912, pp. 250-251; Anita Brookner, "Jean-Baptiste Greuze—Part i," *Burlington Magazine*, xcviii, May 1956, p. 162. For further references, see Henry Hawley, *Neo-classicism: Style and Motif*, Cleveland, 1964, no. 33; and most recently, Edgar Munhall, "Les dessins de Greuze pour 'Septime Sévère,'" *L'Œil*, no. 124, April 1965, pp. 22-29ff.

a learned painting of a Roman subject: *L'Empereur Sévère reproche à Caracalla, son fils, d'avoir voulu l'assassiner dans les défilés d'Écosse et lui dit: Si tu désires ma mort, ordonne à Papinien de me la donner avec cette épée* (Fig. 50).[15] In its dramatic essentials, then, Greuze's ostensibly Neoclassic painting is close to his *Fils puni*. Both present the touching moral lesson of filial inconstancy, in which an unworthy, evil son is contrasted with a noble, suffering father, whether Septimius Severus himself or an anonymous member of the Third Estate. And in its composition, it is no less similar, being equally dependent on the Poussinesque deathbed tradition.[16] Once more, what has been changed is simply the milieu, which moves from a humble home in France on the eve of the Revolution to a Roman outpost in York in A.D. 210.

If the framing of a moral paradigm in a classical milieu was an exceptional event in Greuze's career, it was hardly an uncommon practice among his contemporaries. As early as 1747, La Font de Saint-Yenne had begun to criticize the decadence of the artistic situation then prevailing, and recommended the *Iliad* and the *Odyssey* as salutary iconographical sources;[17] and by 1754, he affirmed the necessity of history painting to become "une école de moeurs," and to present "les actions vertueuses et

[15] No. 151. Greuze's historical source is generally given as Louis Moréri, *Grand dictionnaire historique*, which was first published in Lyons, in 1674. However, the story of Caracalla's conspiracy is not told there or, unless it has escaped my notice, in the many later editions. Mr. Robert Hunter kindly called my attention to a source which does, in fact, describe this event, using the very quotation Greuze included in his Salon description: Dio Cassius, LXXVII, 14.

The subject of Caracalla's inconstancy was later treated by Chaise (Salon of 1793, no. 260) and Lafitte (Salon of 1795, no. 261).

[16] Locquin (*loc.cit.*) points out Greuze's efforts to ennoble the painting by studying Poussin. Gerstenberg (*op.cit.*, p. 23) suggests that Greuze was influenced by Mengs's *Augustus and Cleopatra*, though this hardly seems a convincing or necessary source for such a familiar compositional type.

[17] *Reflexions sur quelques causes de l'état présent de la peinture en France*, The Hague, 1747, pp. 8-9: "Le Peintre Historien . . . seul peut former des Héros à la postérité, par les grandes actions et les vertus des hommes célèbres qu'il présent à leurs ïeux. . . ."

héroïques des grands hommes, les exemples d'humanité, de générosité, de courage, de mépris des dangers et même de la vie, d'un zèle passioné pour l'honneur et le salut de sa Patrie, et surtout de défense de sa religion." For such exemplars, he proposed a wide historical range that moves from Socrates and Brutus to Charlemagne and the Chevalier Bayard.[18]

The remedies proposed by La Font de Saint-Yenne were prophetic. In growing number, from the 1760's on, the *exemplum virtutis*—the work of art that was intended to teach a lesson in virtue—began to dominate iconographical choice with particular preference given to events culled from Greek and Roman history. A characteristic enterprise was that of Charles Cochin, who, in 1764, just following the Seven Years' War, organized for the Château de Choisy a program of decorations that would venerate the pacific and munificent deeds of Roman emperors.[19] These paintings, with their new moral sobriety, happened to displease Louis XV, who had them removed, but their progeny was ultimately to destroy the Rococo world the King preferred as a substitute. The scenes illustrated virtuous acts of Augustus Caesar, Titus, Trajan, and Marcus Aurelius; two of them may exemplify here the common moral denominator as well as the stylistic diversity of these didactic images.[20] In the painting by Noël Hallé, Trajan is shown interrupting his journey to render justice to an unfortunate widow (Fig. 51);[21] in the painting by Vien, Marcus

[18] *Idem, Sentiments sur quelques ouvrages de peinture, sculpture, et gravure écrits à un particulier en province*, n.p., 1754, pp. 51ff. La Font de Saint-Yenne's comments are discussed in Locquin, *op.cit.*, pp. 163ff.

[19] On this commission, see Locquin, *op.cit.*, pp. 23ff.; and Seznec-Adhémar, *Diderot Salons (1765)*, II, Oxford, 1960, pp. 8-9.

[20] The other two are Van Loo, *Auguste fait fermer le Temple de Janus* (Salon of 1765, no. 1); and Lagrenée *l'aîné, Titus renvoyant les prisonniers après la chute de Jérusalem*, which did not appear at the Salon.

[21] Salon of 1765, no. 16. *L'Empereur Trajan, partant pour une expédition militaire très pressée, eut néanmoins l'humanité de descendre de cheval pour écouter des plaintes d'une pauvre femme et lui rendre justice*. For a discussion of the iconography of the Justice of Trajan, see Seznec, "Diderot and the Justice of Trajan," *Journal of the Warburg and Courtauld Institutes*, XX, 1957, pp. 106-111. As Seznec points out, Hallé ignores the fact that, according to the story, the widow's child had been murdered.

Aurelius is shown distributing food and medicine to the people at a time of famine and plague (Fig. 52).[22] Both works, then, extol a ruler's virtue, but with different pictorial styles. Vien's painting, with its complex Roman architectural background imposing columnar stability on the coolly modeled figures, smacks of a more learned archeological antiquity;[23] Hallé's painting, despite its allusion to the Dioscuri of Monte Cavallo and the fact that, as the Salon catalogue entry boasts, "la tête de Trajan est imitée de l'antique," is still pervaded by a thoroughly Rococo vision, especially in the small and mincing gestures, the intricacy of light and contour, the fussy landscape detail.[24]

Within these stylistic vacillations, however, the moral paradigm remains the same. Readings of classical history and literature are now to produce examples of virtuous conduct rather than erotic adventures, and such lessons as demonstrated by Trajan and Marcus Aurelius were increasingly common in the late eighteenth century. Thus we find that the familiar story of the continence of Scipio Africanus is retold, as in Brenet's version of the theme at the Salon of 1789 (Fig. 53).[25] Here the 24-year-old Roman virtuously returns one of his prisoners—a noble and beautiful Carthaginian maiden—to her parents and fiancé, a benevolent act which is further magnified by the addition of money to her dowry of golden treasures, brought to Scipio for her ransom. It

[22] Salon of 1765, no. 18. *Marc-Aurèle fait distribuer au peuple des alimens et des médicamens, dans un temps de famine et de peste.*

[23] Vien's painting may, in fact, be related to a relief on the Arch of Constantine that was later copied by David during his Roman sojourn: *Congiarium distribué au peuple après le triomphe de Marc-Aurèle en 176.* See Jean Adhémar, ed., *David; naissance du génie d'un peintre*, Monte Carlo, 1954, p. 70 and pl. 159.

[24] Diderot disliked both Hallé's and Vien's paintings. See Seznec-Adhémar, *op.cit.*, pp. 82-84, 87-89; and Seznec, *Essais sur Diderot et l'antiquité*, Oxford, 1957, pp. 98-99.

[25] No. 4. The story is told in Valerius Maximus, iv, iii, 1. Other Salon examples include: Restout (Salon of 1750, no. 11); Levasseur, engraving after Lemoine (Salon of 1769, no. 255); Renaud (Salon of 1800, no. 446). There are, of course, hundreds of earlier examples of this subject, as listed in the indispensable A. Pigler, *Barockthemen*, ii, Budapest, 1956, pp. 404-409.

was typical, though, of the period's historical mobility that this very story could be told in connection with a different historical period, simply by a change of clothing and decor, just as in the case of deathbeds, virtuous widows, or filial inconstancy.[26] Thus, in France, as well as in England, episodes from the life of the exemplary Pierre Terrail, Seigneur de Bayard (1473-1524)— "chevalier sans peur et sans reproche"—were often painted;[27] and in the *Continence de Bayard*, a painting by Louis Durameau exhibited at the Salon of 1777,[28] we have, as it were, Scipio's noble deed recreated in a sixteenth century French milieu by means of costume, Gothic paneling, and Bayard's coat of arms (Fig. 56). Here the good and noble knight, whose life was popularized in France by eulogistic biographies published in 1760[29] and 1769,[30] demonstrates rare virtue when presented, at Grenoble, with a young girl secured for his pleasure by his valet. On seeing her chaste tears, Bayard not only provides her with separate sleeping quarters but, as is seen in the painting, returns her to her grateful mother with the gift of a doubled dowry.

Such scenes of uncommon charity could be translated as well to more prosaic environments. In England, for instance, a similar

[26] Under the new direction of the Comte d'Angiviller, commissioned series of moralizing subjects culled from both ancient and French history were included at the Salons of 1777 and 1779. See Locquin, *op.cit.*, pp. 50ff.

[27] On British iconographical precedence over the French, even in the representation of the life of Bayard, see above, Chapter 1, n. 107. Another painting of *La Continence de Bayard* was exhibited at the Salon of 1808 (Dumet, no. 196). It is described and illustrated in C. P. Landon, *Salon de 1808 (Annales du Musée . . .)*, II, Paris, 1808, pp. 27-28, pl. 19.

[28] No. 22. Much confusion has surrounded the identity of Durameau's painting at Grenoble, which was generally called *La Courtoisie de Bayard*, a painting by Brenet at the Salon of 1783 (no. 12). This confusion, however, has now been dispelled by M. Marc Sandoz in "Le 'Bayard' de Louis Durameau (1777)," *Bulletin de la Société de l'Histoire de l'art français, 1963*, Paris, 1964, pp. 105-119. M. Sandoz was kind enough to let me see his manuscript before its publication.

[29] Guyard de Berville, *Histoire de Pierre Terrail, dit le Chevalier Bayard, sans peur et sans reproche*, Paris, 1760 (2nd ed., 1768). Exceptionally, Locquin (*op.cit.*, p. 160 n. 10) is here in error, giving the incorrect date of 1772 for this biography.

[30] Combes, *Éloge de Pierre Terrail, dit le Chevalier Bayard*, Dijon, 1769.

generosity of a financial, if not an erotic, nature is demonstrated in a painting by Edward Penny exhibited at the Royal Academy in 1782.[31] Here the scene moves to the kind of rural milieu venerated by Oliver Goldsmith, and we see a poor widow, Mrs. Costard, whose few paltry possessions—a cow and some earthenware kitchen utensils—have first been seized by the tax-collector, and then restored to her by the generosity of a rustic Trajan named Johnny Pearmain (Fig. 57). Not surprisingly, Penny had earlier in his career painted the *Generous Behavior of Chevalier Bayard*.[32]

The possession of abstract virtue rather than material wealth was extolled in many pictures that exemplified worldly sacrifice in all walks of life and all epochs of history. In particular, noble Romans from the earlier days of the Republic were venerated for their stoical devotion to an almost Rousseauan ideal of a primitive and uncorrupted way of life. Pliny the Elder, Livy, Plutarch, Valerius Maximus were searched for such examples of high-minded behavior and yielded any number of edifying Roman lives.[33] For one, there was the story of Caius Furius Cressinus,

[31] No. 30. *The Generosity of Johnny Pearmain, or the Widow Costard's cow and goods, restrained for taxes, are redeemed by the generosity of Johnny Pearmain.* For further references, see the exhibition catalogues, *The First Hundred Years of the Royal Academy*, London, Royal Academy, 1951, no. 117; and *Painting in England 1700-1850; Collection of Mr. and Mrs. Paul Mellon*, Richmond, Virginia Museum of Fine Arts, 1963, p. 130, no. 246. Unfortunately, neither these references nor my own research can offer the source of Penny's story.

[32] Exhibited at the Society of Artists of Great Britain, 1768, no. 121. See also E. K. Waterhouse, *Painting in Britain, 1530 to 1790*, 1st ed., Baltimore, 1953, p. 206.

[33] Eighteenth century French translations of these authors were abundant. Pliny the Elder's *Histoire naturelle*, trans. Poinsinet de Sivry, appeared in a twelve-volume edition (Paris, 1771-1782); and its chapters on art appeared in separate editions (Amsterdam, 1772; The Hague, 1773). The 1721 Dacier translation of Plutarch appeared later in two new editions (Paris, 1762; Paris, 1778). Livy was translated four times: by P. Du Ryer (Rouen, 1720-1722); François Guérin (Paris, 1739-1740); Abbé Joseph Brunet (Paris, 1741-1742); Guérin and Cosson (Paris, 1770-1772). Valerius Maximus appeared in three French translations: by Tarboicher (Paris,

illustrated by both Nicolas-René Jollain and Brenet in the 1770's.[34] In the latter's interpretation, exhibited at the Salon of 1777 (Fig. 54), we see the rudely clothed Caius at the right, defending himself against an accusation of sorcery aroused by the astonishing abundance of his crops. He points to his wife, daughter, agricultural tools, and oxen: "Voilà mes sortilèges; mais je ne puis apporter avec moi, dans la place publique, mes soins, mes fatigues, et mes veilles." His words echo, in classical guise, Rousseau's own veneration of agriculture as "le premier métier de l'homme . . . le plus honnête, le plus utile, et par conséquent, le plus noble qu'il puisse exercer."[35]

A comparable dedication to an unspoiled, rustic life, so ironically contemporaneous with the pseudo-rusticity evoked by the new royal *hameaux* at Chantilly (1775) and Versailles (1783-1787),[36] is again underscored in the story of Curius Dentatus. In a painting by Peyron, exhibited at the Salon of 1787 as his *morceau de réception*,[37] we see the Roman in retirement, after a highly applauded career as consul and military leader (Fig. 55). A group of Samnites attempts to persuade him to take up his former activities, but he refuses, claiming that he prefers his simple earthen-

1713); Ivan Alexiewitz (St. Petersburg, 1772); and René Binet (Paris, 1796).

Recently, a useful iconographical catalogue of antique subjects and sources related to eighteenth century Salon painting has appeared: Henry Bardon, "Les Peintures à sujets antiques au XVIIIe siècle d'après les livres de Salons," *Gazette des Beaux-Arts*, 6e période, LXI, April 1963, pp. 217-249.

[34] Jollain's version, the earliest, appeared at the Salon of 1773 (no. 153). Brenet painted two versions: a small one (3' x 5') for the Salon of 1775 (no. 28) and a large one (10' x 10') for the Salon of 1777 (no. 19; Fig. 29). For further remarks on Brenet's versions, see Sandoz, *op.cit.*, p. 42. The Salon catalogue gives the source as "Pline, Hist. Nat. Liv. 18, Chap. 6," but in modern Pliny editions the story is found in XVIII, viii, 3.

[35] *Émile* (1762), livre III.

[36] On these *hameaux*, see Louis Hautecoeur, *Histoire de l'Architecture classique en France*, V, Paris, 1953, pp. 40-41.

[37] No. 153. The Salon *livret* recounts the story. The subject had already been proposed by the Dijon Academy for its 1776 Prix de Rome competition (see the exhibition catalogue, *L'Académie de peinture et sculpture de Dijon*, Musée des Beaux-Arts de Dijon, 1961, p. 15). A later interpretation of this subject by Caraffe appeared at the Salon of 1795 (no. 67).

ware pots to the wealth of golden vases offered to him. The same preference is made by another noble Roman, Fabricius Luscinus, whom Valerius Maximus, in fact, couples with Curius Dentatus under the category, *De abstinentia et continentia*.[38] In the painting by Lagrenée *l'aîné* for the Salon of 1777,[39] a luxurious offer of money, golden vases, and statues is firmly rejected by Fabricius, who remains steadfast by his family and primitive post-and-lintel home (Fig. 58).

Women as well as men could resist such worldly pleasures. The Roman counterpart to the virtuous mothers of Greuze, Cornelia —the mother of the Gracchi—was as often venerated in the late eighteenth century as she had been by her own people who, according to Plutarch, erected a statue in her honor.[40] Of those paintings which newly praised her virtue, one at the Salon of 1779,[41] by Noël Hallé, is typical (Fig. 59). It shows Sempronius' exemplary widow surrounded by her children and visited by a Campanian matron who asks to see her jewels. "These are my

[38] IV, iii, 5-6. A comparable story is that of Quinctius Cincinnatus, another model of Roman frugality who returned to his plough after being called to the dictatorship (Livy, III, 26-29). It was illustrated by Brenet for the Salon of 1779 (no. 32). See Sandoz, "Nicolas-Guy Brenet, peintre d'histoire (1728-1792)," *Bulletin de la Société de l'Histoire de l'art français, 1960*, Paris, 1961, p. 44. Later versions include those by Demarne (Salon of 1795, no. 122); J. Gensoul (Salon of 1799, no. 133); Chaudet (statue designed for the Sénat, illustrated and discussed in C. P. Landon, *Annales . . .*, VII, Paris, 1803, pl. 32, p. 71); and a Spanish student of David's, Juan Antonio Ribera y Fernández (1779-1860), illustrated in F. Jiménez-Placer, *Historia del arte español*, II, Barcelona, 1955, p. 885.

Another comparable classical theme is that of the rejection of society and wealth by Timon of Athens, as retold by Shakespeare (Act IV, scene 3), and illustrated by Nathaniel Dance (Society of Artists of Great Britain, 1767, no. 43). For the most recent reference to Dance's painting, as well as a reproduction, see the exhibition catalogue, *Shakespeare in Art*, Arts Council of Great Britain, 1964, no. 18, pl. 3.

[39] No. 2. For further remarks on this painting, see Sandoz, "Louis-Jean-François Lagrenée, dit l'aîné (1725-1809)," *Bulletin de la Société de l'Histoire de l'art français, 1961*, Paris, 1962, p. 125. A related drawing by Moreau *le jeune* appeared at the Salon of 1783 (no. 310): *Fabricius recevant des Députés au moment qu'il fait cuire des légumes.*

[40] *Vitae*, "Tiberius and Caius Gracchus," XXXIII.

[41] No. 1.

jewels," Cornelia replies, indicating the children to whose up-bringing she was to devote her entire life.[42]

If Cornelia's virtue remained within the Greuzian confines of domestic bounty, other Roman women extolled by the late eighteenth century performed heroic deeds that trespassed upon a world of masculine stoicism. Such was the case in a painting by Nicolas-Bernard Lépicié at the Salon of 1777 which illustrated the courage of Brutus' wife, Portia (Fig. 60).[43] Having discovered her husband's plot to assassinate Caesar, Portia cuts her own thigh with a razor given to her for presumably cosmetic purposes. Bleeding upon her Roman bed like a female Seneca, she explains to Brutus that her self-inflicted wound bears witness to her devotion and to her willingness to take her own life should his plot fail.

The bloody character of Portia's lesson in morality was prophetic of the ever grimmer virtues that were soon to be exemplified in the actual experience of the Revolution. Indeed, in the decade preceding the Fall of the Bastille, the very character of the sacrifices illustrated begins to take on a more violent tenor, and one that frequently introduces new motifs of Romantic horror. As an ominous counterpart to those tranquil scenes of

[42] The story is told in Valerius Maximus, IV, iv, introduction. Other illustrations of Cornelia's maternal virtue include those by Peyron (1780?, Toulouse); Gauffier (1792, Fontainebleau); Bosio (Salon of 1793, no. 512); Suvée (Salon of 1795, no. 458, Besançon); Le Barbier (Salon of 1795, no. 304, drawing); Avril (Salon of 1795, no. 3010, engraving); Fleury (Salon of 1810, no. 247); Gaillot (Salon of 1817, no. 347); Van Ysendyck (a version in modern costume, Salon of 1831, illustrated in C. P. Landon, *Annales du Musée; Salon de 1831*, Paris, 1831, pl. 54). The important non-French examples are listed in A. Pigler, *Barockthemen*, II, Budapest, 1956, p. 367. The theme was so pervasive in the late eighteenth century that, when engraved in 1791, Reynolds' famous portrait of Lady Cockburn and her children was entitled *Cornelia and Her Children*. See Martin Davies, *The British School (National Gallery Catalogues)*, London, 1959, pp. 84-85.

[43] No. 11. The source is Valerius Maximus, III, ii, 15. There was a later version of the subject by Jacques Lebrun at the Salon of 1799 (no. 185). For further details about Lépicié's painting, see Philippe Gaston-Dreyfus, *Catalogue raisonné de l'œuvre peint et dessiné de Nicolas-Bernard Lépicié (1736-1784)*, Paris, 1923, no. 34.

aristocratic generosity culled from the lives of Trajan, Bayard, or Henri IV, new themes of uncommon death and martyrdom begin to play a prominent role that was to reach its climax in the paintings of Jacques Louis David. Thus, Peyron, in 1782, at the end of his seven-year Roman sojourn, painted the grisly story of Cimon and Miltiades, related in Valerius Maximus under two moralizing categories: *De ingrates* and *De pietate in parentes* (Fig. 61).[44] Here the scene moves to the lugubrious environment of an Athenian prison, where the corpse of the great general Miltiades is left to rot by an ungrateful populace that has turned against him. To permit his father's burial, Miltiades' son Cimon offers to replace him in the dungeon, which ultimate sacrifice is the subject of a painting that combines ancient Greek virtue, Romantic horror, and Caravaggesque luminary drama.

The much clearer light of an ancient Near Eastern day helps to vitiate the horror of another example of deathly extremes of devotion. Using a story found in a source rarely used by artists of the period—Quintus Curtius' biography of Alexander the Great[45]—*La Fidelité d'un Satrape de Darius*, a huge painting by Lagrenée *l'aîné*[46] exhibited at the Salon of 1787,[47] shows the remarkable heroism of Boetis, one of Darius' captains and governor of Gaza (Fig. 63). In refusing to humble himself when taken prisoner, Boetis aroused Alexander's rage. So infuriated was the great conqueror by the satrap's stubborn silence that he determined to make him speak by having him dragged, like Hector, around the city. Yet Boetis remained mute until death, never

[44] v, iii, 3; and v, iv, 2. A smaller replica of the painting is found in the Musée municipal, Guéret; and a preparatory drawing for it, in the Bibliothèque de la Ville de Besançon (see *Inventaire général* . . . ; *Monuments civils*, ii, p. 225). Another interpretation of this rare subject was exhibited at the Salon of 1806 (Devosge, no. 155).

[45] iv, 6. This biography appeared in many eighteenth century French editions: 1760, 1762, 1764 (trans. Abbé Dinouart); 1781, 1789 (trans. Beauzée).

[46] 3.30 x 5.30 meters.

[47] No. 5. For further references to the painting, see Sandoz, "Louis-Jean-François Lagrenée . . . ," p. 127.

swerving in his loyalty to Darius and ultimately humiliating Alexander's own vanity and pride.

The Oriental background succinctly suggested here by the palm tree formed the exotic environment for other scenes of extraordinary loyalty to national or religious beliefs.[48] The *Books of Maccabees* provided new tales about the ancient Jews, whose uncommon religious zeal might be considered the Orientalizing counterpart to the virtues of Republican Rome extolled by Livy or Valerius Maximus. For the Salon of 1783,[49] Lépicié illustrated the text's description of how Mattathias, fervent in his monotheism, destroys a pagan idol, kills a king's officer who had come to enforce a sacrifice, and then, kills a Jew whom he finds guilty of idolatry (Fig. 62).[50]

No less passionate in his Judaism is the aged scribe Eleazar, whose gruesome martyrdom is likewise described in *Maccabees*[51] and provided the subject for the Prix de Rome competition of 1792.[52] In the entry of the young Antoine-Jean Gros,[53] the exotic and luxurious trappings of the Orient create a dramatic foil for an action of Spartan sacrifice (Fig. 64). Here, the evil Syrian king, Antiochus, tries to force the ninety-year-old Jew to break kosher

[48] Predictably enough, the palm tree and many of the figures indicate a close study of Charles Le Brun's versions of the Life of Alexander, particularly the well-known *Tente de Darius* (discussed and illustrated in the exhibition catalogue, *Charles Le Brun, 1619-1690, peintre et dessinateur*, Château de Versailles, 1963, no. 27).

[49] No. 5. For further references to the painting, see Gaston Dreyfus, *op.cit.*, no. 42; and Boris Lossky, ed., *Tours, Musée des Beaux-Arts; Peintures du XVIIIᵉ siècle (Inventaire des collections publiques françaises, 7)*, Paris, 1962, no. 70. The theme was not new to eighteenth century painting; it had been the subject in 1754 for the Prix de Rome competition. (See J. Guiffrey and J. Barthelemy, *Liste des pensionnaires de l'Académie de France à Rome de 1663 à 1907*, Paris, 1908, p. 35.)

[50] The story comes from the *First Book of Maccabees*, II, 23-25.

[51] *Second Book of Maccabees*, VI, 18-31.

[52] The prize-winner was Landon (Guiffrey and Barthelemy, *op.cit.*, pp. 48-49). The subject had been illustrated earlier by Berthélemy (Salon of 1789, no. 67), and is now in the Musée des Beaux-Arts, Angers.

[53] On Gros's painting, see also the exhibition catalogue, *Gros, ses amis, ses élèves*, Paris, Petit Palais, 1936, p. 44, no. 5; and the long description in J. B. Delestre, *Gros, sa vie et ses ouvrages*, 2nd ed., Paris, 1867, p. 20.

dietary laws by making him eat the proscribed pork. With Michelangelesque fury, Eleazar refuses to compromise his religious beliefs, even though he knows that the alternative is the death to which the executioner drags him so brutally.

Unyielding dedication to abstract beliefs, even to the point of death—such stoical preference for an ideal realm of untarnished virtue to a commonplace world of fallible behavior could also cut family ties. Often the sternness of Spartan or Roman Republican justice, unmitigated by the tears of sons, wives, daughters, or sisters, casts a shadow across these moralizing paintings. Already in the 1760's, in a context still innocent of contemporary political allusion, these tragic histories began to offer a severe countercurrent to Rococo mythologies. In particular, British painting of the time, in the hands of such precocious Neoclassicists as Gavin Hamilton, Benjamin West, and Nathaniel Dance, veered toward these pathos-ridden extremes of classical tragedy.[54] Thus in London, in 1761, at the one-year-old Society of Artists, Dance exhibited the fearful story of the death of Virginia (Fig. 65).[55] Culled from Livy and retold by the Abbé Vertot in the eighteenth century,[56] the narrative reaches an even more grisly demonstration of death preferred to dishonor than that of the noble

[54] The basic demonstrations of British iconographical and stylistic priority in the formation of Neoclassicism are the superlative studies of Jean Locquin: *La Peinture d'histoire* . . . , pp. 153ff. and, in particular, p. 157 n. 9; and "Le Retour à l'antique dans l'école anglaise et dans l'école française avant David," *La Renaissance de l'art français et des industries de luxe*, v, 1922, pp. 473-481. In this connection, see also E. K. Waterhouse, "The British Contribution to the Neo-Classical Style," *Proceedings of the British Academy*, XL, 1954, pp. 57-74.

[55] No. 25. On Dance, see Basil Skinner, "Some Aspects of the Work of Nathaniel Dance in Rome," *Burlington Magazine*, CI, Sept.-Oct. 1959, pp. 346-349.

[56] The basic account of the story is in Livy, III, 44-58. The inscription on the engraving reproduced here (by John Gottfried Haid) refers to the Ozell translation (first edition, 1720; often reprinted) of Aubert de Vertot d'Aubeuf, *Histoire des révolutions arrivées dans le gouvernement de la république romaine*, Paris, 1719. Skinner (*op.cit.*, p. 346) states that the Haid engraving dates from the year previous to the painting's exhibition (i.e., 1760), but the date clearly reads August 2, 1767.

Lucretia. The decemvir Appius Claudius has tried to take Virginia as a slave, and her father, rather than see her so dishonored, seizes a butcher's knife and kills her. In Dance's interpretation, this chilling morality is presented in an appropriately severe style of marmoreal figures rigorously ordered upon a rectilinear grid, a style of stoical spareness that prophesies David,[57] while depending, in turn, on the precocious Neoclassicism of Gravelot's illustrations to Roman history.[58]

A comparable combination of a more severely Neoclassic style and, in this case, literally Spartan behavior is seen in a painting by West exhibited at the Royal Academy in 1770.[59] This harshly moral episode from Plutarch shows the Spartan king, Leonidas II, making the decision to banish his own son-in-law Cleombrotus for treason (Fig. 66).[60] Again prophesying the emotional cleavage of families so conspicuous in David's work, the moral virility of the father, at the left, is contrasted to the Greuzian sorrow, at the right, of his daughter, who, nevertheless, was virtuously to follow her husband into banishment.

Tragic, but inevitable, allegiance to state rather than to family was as abundantly demonstrated in French art, especially as the Revolution approached. At the Salon of 1785,[61] for which, as the

[57] By Davidian standards of Neoclassicism, its style is, in fact, well in advance of such eighteenth century French versions of the theme as those by Doyen (Salon of 1759, no. 119, now in the Pinacoteca, Parma); Brenet (Salon of 1783, no. 11, now in the Musée des Beaux-Arts, Nantes); or by Doyen's student Lethière (Salon of 1795, no. 354, dessin; and Salon of 1831, no. 1384, finished version, now in the Louvre). Another version of the Virginia story was exhibited at the Salon of 1795 by Le Barbier (no. 306).

[58] That Dance's painting is indubitably based on Gravelot's 1739 engraving of the *Death of Virginia* (frontispiece to Abbé Rollin, *Roman History*, 2nd ed., II, London, 1754) was kindly called to my attention by Mr. Peter Walch.

[59] No. 197. An earlier version by West was exhibited at the Society of Artists, 1768, no. 122.

[60] *Vitae*, "Agis and Cleomenes," XVI. Later French versions of the story include those by Lemonnier (Salon of 1787, no. 214); Fortin (Salon of 1798, no. 308, sculpture); and Bouillon (Salon of 1804, no. 55).

[61] No. 63.

Comte d'Angiviller had written, "la plupart des peintres d'histoire avaient adopté des sujets noirs,"[62] Jean-Simon Berthélemy exhibited the horrifying story of Manlius Torquatus, a Roman consul who sentenced his own son to death for violating his orders not to engage the enemy, the Latins, in combat (Fig. 67).[63] With academic rhetoric, the artist indicates Manlius' dreadful but successful struggle to maintain legal impartiality and the state's welfare over personal interests; for his right hand is publicly outstretched in the preservation of justice, whereas his left hand clutches privately at a father's agonized heart.[64] In its severity, Berthélemy's painting foretold the imminent sacrifices of the Revolution; it was in fact re-exhibited at the Salon of 1791, under the heading "Exemple de discipline militaire."[65] And in the same year, 1785, the eighteen-year-old Anne-Louis Girodet, a new student of David's, painted an equally horrific demonstration of preference for political over family loyalties. In the *Death of Camilla*, the Prix de Rome subject for that year, he illustrated the terrible sequel to the oath of the Horatii (Fig. 68). Here, before the Porta Capena, Horatius kills his own sister Camilla because

[62] In a letter of Feb. 6, 1786, to Lagrenée *l'aîné*, asking him to paint a less severe subject, for the public had complained about the grimness of the themes illustrated at the preceding Salon. (A. Montaiglon and J. Guiffrey, eds., *Correspondance des directeurs de l'Académie de France à Rome*, xv, Paris, 1906, p. 73.) The letter is also referred to in Louis Hautecoeur, *Louis David*, Paris, 1954, p. 83.

[63] The basic ancient sources are Valerius Maximus, v, viii, 3 and vi, ix, 1; and Livy, viii, 7. Like so many of the Roman stories illustrated by French artists in the later eighteenth century, that of Manlius Torquatus is recounted in Charles Rollin's immensely popular *Histoire romaine*, 16 vols., Paris, 1738-1748. So many later editions of this work appeared—identical, enlarged, abridged—that it is difficult to find precise references to the particular volume and chapter numbers often given in eighteenth century texts. Later citations from Rollin used here refer to the original edition.

[64] For further references to Berthélemy's painting, see Boris Lossky, ed., *Tours, Musée des Beaux-Arts . . .* , no. 3. Berthélemy's name, incidentally, is sometimes given as Berthélémy.

[65] No. 241. The subject was also chosen in 1799 for the Prix de Rome competition.

she mourns her fiancé, one of the enemy Curiatii killed by her own brother.[66]

The prolix gestures, the diffuse and turbulent action of Girodet's youthful effort of 1785 are foreign to the laconic drama and style of the greatest painting exhibited that year, Jacques Louis David's *Oath of the Horatii* (Fig. 69).[67] In this work, the multiple late eighteenth century currents of didactic theme, reformatory style, and classical allusion are distilled, as it were, in a single, stoical image that weds pictorial genius to ethical passion. By comparison with the electrifying energy and fervor of the *Horatii*, earlier images of classical virtue are flaccid in both style and moral conviction. Their vacillations and compromises are now fully obliterated by a painting that synthesizes the most rigorous potentialities of both Neoclassic form and Roman Republican virtue.

David's theme—a patriotic oath of allegiance to Rome taken by the triplet brothers, the Horatii, before departing for combat against Alba, represented by their triplet cousins, the Curiatii— is to be found in neither classical nor post-classical texts and may well be the artist's own invention.[68] Yet, more generally speaking,

[66] The story is told, complete with references to the Porta Capena, in Rollin, *op.cit.*, I, pp. 165-166. For further comments on the painting, see George Levitine, "The Influence of Lavater and Girodet's *Expression des sentiments de l'âme,*" *Art Bulletin*, XXXVI, March 1954, pp. 40-41. The Prix de Rome winner was Potain (Guiffrey-Barthelemy, *op.cit.*, p. 46).

[67] Salon of 1785, no. 103. The original title was: *Serment des Horaces, entre les mains de leur Père.* The literature on the *Horatii* is, of course, enormous, but two modern studies are vital to any consideration of the work: Edgar Wind, "The Sources of David's *Horaces,*" *Journal of the Warburg and Courtauld Institutes*, IV, 1940-1941, pp. 124-138; and Louis Hautecoeur, *Louis David*, Paris, 1954, ch. IV.

David's painting offered so definitive an interpretation of this unique subject that, to my knowledge, no later artist attempted to reinterpret it. There is, however, a plaster group of *Les Trois Horaces* by Gois (Salon of 1800, no. 434), which represents David's triplets at the moment following the oath, just as they are about to leave for battle. This sculpture is illustrated and discussed in Landon, *Annales du Musée . . . ,* I, Paris, 1801, pl. 63, p. 129.

[68] On the problem of the painting's iconographical source, see Wind,

David's choice of the oath motif as an expression of fervent political loyalty was hardly new. It marked, rather, a climax to a series of earlier images of oath-taking that strike, in a lower key, the same chords of dynamic idealism that ring with such urgent clarity in the *Horatii*. Such is the case in Gavin Hamilton's *Oath of Brutus* of 1763-1764 (Fig. 70), a painting that transforms the familiar scene of Lucretia's private tragedy of lost chastity to one of active political determination to avenge the Tarquins' corrupt deeds;[69] or in West's *Hannibal Taking the Oath* of 1770-1771, a scene that shows the young Carthaginian's father, Hamilcar, making him swear before an altar of Jupiter eternal hatred of Rome (Fig. 71).[70] And again in the 1770's, a similar patriotism pervades the subject as well as the commission of Fuseli's *Oath on the Rütli*, a picture ordered for the Zurich Town Hall in 1778-1779 to commemorate the origins of Swiss freedom (Fig. 72).[71] Here, with the mobility typical of the period, William Tell temporarily replaces Livy and Plutarch and the political ideals of Roman history become those of Switzerland in 1307, when the

op.cit.; and R. Rosenblum, "Gavin Hamilton's *Brutus* and Its Aftermath," *Burlington Magazine*, CIII, Jan. 1961, pp. 8-16. That the oath was not included in historical and literary accounts of the Horatii was already noticed by David's contemporaries. See *Lettres analitiques, critiques et philosophiques sur les tableaux du Sallon*, Paris, 1791, p. 54; and C. P. Landon, *Annales* . . . , VII, Paris, 1803, p. 129: "Le trait que M. David a représenté n'est pas rapporté par les Historiens. . . . L'artiste a supposé qu'au moment où les trois frères vont partir pour le combat, le vieil Horace, tenant dans ses mains leurs épées, leur fait jurer de vaincre ou de mourir."

[69] Hamilton's picture and the chain of oaths that follows it are discussed in Rosenblum, *op.cit.* To the various oaths listed, there may be added another version of Brutus' oath by Wicar (1789), a drawing (with variants) discussed and illustrated in Fernand Beaucamp, *Le Peintre lillois Jean-Baptiste Wicar (1762-1834), son oeuvre et son temps*, Lille, 1939, I, pp. 108-109 and II, p. 665, nos. 148-150; as well as a painting by a student of David's, Saintomer, *La Mort de Lucrèce* (Salon of 1804, no. 416), which, judging from the catalogue description, also represents the oath; and by Elie Delaunay, *Oath of Brutus* (1861; Tours).

[70] R.A., 1771, no. 209.

[71] On the Fuseli, see Rosenblum, *op.cit.*, p. 15; and Frederick Antal, *Fuseli Studies*, London, 1956, pp. 71-74, where analogies to the *Horatii* are also suggested.

representatives of the three cantons met on the shores of the Rütli to free themselves from Austrian tyranny. No less characteristic of the period is the *Sturm und Drang* passion that animates Fuseli's Neo-Mannerist figures, who, monumentalized by the low horizon and dramatized by the violent weather conditions, swear to uphold a nationalistic ideal.

The *Horatii* resumes and amplifies this series of fervent oaths. Its image is so forceful that the essential action of its patriotic theme is immediately communicated even to a spectator ignorant of the complex historical events that surrounded the oath. Indeed, so emblematically clear is David's image of sworn loyalty that in 1794, at a vast Republican demonstration organized by David and Robespierre, the youth and old men re-enacted these idealistic gestures.[72]

This clarity is a product of the painting's magnificent fusion of form and ethos. David's heroes are now animated by a vigorous assertion of will that, in the history of art, is perhaps rivaled only by the burning volition that places Donatello's and Masaccio's figures of the 1420's at the beginning of a comparably new historical epoch. In David's four heroes—father and sons—this new proclamation of moral energy pervades mind and body, from the determined gaze of their firm heads to the tautened muscles of their outstretched limbs. In dramatic contrast, the women and children at the right—the mother of the Horatii, her two daughters, Sabina and Camilla, and her grandchildren—are overcome by a helpless resignation to grief. Such a polarity between masculine strength and feminine weakness had already been suggested in many of Greuze's family dramas as well as in David's earlier *Death of Seneca* (1773),[73] in which the calmness of the stoic philosopher in the face of death is a foil to his wife Paulina's swooning hysteria (Fig. 73). In the *Horatii*, however, this schism becomes even more pronounced. Not only does the

[72] See David Dowd, *Pageant-Master of the Republic; Jacques-Louis David and the French Revolution*, Lincoln, Nebraska, 1948, p. 123.

[73] On David's *Seneca,* see Charles Saunier, "La 'Mort de Sénèque' par Louis David," *Gazette des Beaux-Arts*, 3ᵉ période, xxiii, March 1905, pp. 233-236.

composition, in its separate groupings of male and female, rupture decisively the unity of the family,[74] but even the drawing style distinguishes between virile self-determination and feminine abandonment to weaker passions. Thus, in the group of the *Horatii* at the left, the tense muscles of the superbly studied anatomy create contours and figure postures whose firm and angular rhythms seem permeated with the metallic rigidity of the javelin and swords that are soon to be used in combat. In the group of women at the right, this vibrant rectilinearity—the stylistic equivalent of the sternest moral decision—gives way to a style of malleable, fluent contours which, in the ascent from Sabina's left foot to the expiration in Camilla's left arm, create abstractly the image of limp and hopeless mourning.[75]

The perfect coincidence of David's style and moralizing inten-tion is borne out as well by the entire pictorial environment, which is characterized by the same rigor of will and intellect that dominates the oath itself. From the many suggestions of stylistic reform that were offered in France by Greuze, Vien, and Brenet, or in England by West, Hamilton, and Dance, David at last crystallizes a definitive statement whose pictorial power, like its moral power, marks an irreparable cleavage between an old and a new world. In the context of these earlier paintings, the

[74] The composition of the *Horatii* seemed disturbingly new to contemporaries in its sharp isolation of parts. For a characteristic example of this criticism of the *Horatii's* heretical style, see *Avis important d'une femme sur le Sallon de 1785*, Paris, 1785, pp. 29-31, where complaints are registered about the pictorial holes and abrupt cuts into space, features which contradicted earlier Baroque and Rococo compositional systems. The new distinctness of visual elements so conspicuous in the *Horatii* (as in Canova's contemporaneous *Tomb of Clement XIV*, Rome, SS. Apostoli, 1783-1787) is the pictorial analogy to the new formal systems closely analyzed in architecture by Emil Kaufmann (*Architecture in the Age of Reason; Baroque and Post-Baroque in England, Italy, and France*, Cambridge, Mass., 1955).

[75] The idea of a strong masculine-feminine polarity in David's work is provocatively elaborated by René Huyghe in his preface to the indispensable exhibition catalogue, *David*, Paris, Orangerie des Tuileries, 1948. Huyghe even suggests that this polarity is expressed in David's handwriting (p. 24).

severity of David's style, like the severity of the oath, creates, as it were, a *tabula rasa* of a new epoch. The box space, with its rigidly plotted ground plane and rectilinear alignments, invests the preliminary reforms of the 1760's and 1770's with an all-pervasive intellectual control that recalls the perspective studies of the Quattrocento; and within the precise boundaries of this stage-like atrium, the figures firmly take their earthbound poses with a consonant sense of geometric predetermination.[76]

The tonic clarity of the spatial order pertains as well to the lighting, which, once and for all, destroys any vestiges of Rococo haze and glitter. In this cool and limpid ambiance, a theatrical light of Caravaggesque sharpness, if not warmth, defines with maximum plasticity the figures, whose incisive contours are echoed in the sharply delineated shadows. The color, which a critic called "Romain,"[77] also partakes of this austerity. Fully rejecting the pastel softness and warmth of the eighteenth century, these primary hues, tinged with a metallic chill, have an astringent quality that supports an expression of moral alertness rather than sensual relaxation. Even the architecture, which we shall later reconsider, participates in this stern evocation of an heroic age. The rudimentary Doric columns, without base, not only bear out David's historicizing intention of creating an authentic archaic Roman setting, but correspond as well, in their severe cylindricality, to the noble simplicity of form and action that dominates the whole painting. To cite a critique of 1785, "La simplicité et l'énergie de l'ordonnance sont dignes des temps simples et héroïques dont on nous donne ici le vrai portrait."[78]

Under later and different political conditions, David was able to present the Horatii's stirring oath in the context of contem-

[76] Louis Hautecœur (*Louis David*, Paris, 1954, pp. 82-84 and plate facing p. 92) has even proposed that the painting is organized on the basis of a geometric system familiar to eighteenth century architecture and painting.

[77] "Le ton de couleur est aussi Romain, sans avoir rien de ce noir lourd, défaut dont M. David s'est corrigé aussi promptement que les Copistes l'ont adopté." (*Observations sur le Sallon de 1785*, pp. 4-5.)

[78] *Ibid.*, p. 4.

porary history. In the 1780's, however, his moral and political idealism remained couched in classical terms. At the Salon of 1787,[79] his *Death of Socrates* (Fig. 74) offered yet another *exemplum virtutis* that now entered the funereal confines of a prison, an environment increasingly familiar in late eighteenth century art and one that also evoked some of the most original and awesome expressions of Romantic Classic architecture.[80] The edifying theme of Socrates' suicide had been well known in Paris since 1762, when Cochin proposed it for an Academy competition which produced results like that by Jean-François Sané (Fig. 75);[81] and it had been essayed even earlier—in 1756 in Lancaster, Pennsylvania, by young Benjamin West before his departure from the Colonies (Fig. 76).[82] Moreover, the gloomy

[79] No. 119. *Socrate au moment de prendre la ciguë*. An as yet untraced sculptural version of this theme by René Milot appeared at the Salon of 1785 (no. 254) and may well have influenced David.

[80] Among others, Piranesi's *Carceri* (1744-1745); George Dance II's Newgate Prison, London (begun 1769); Ledoux's Prison, Aix-en-Provence (1784); Friedrich Gilly's designs for prisons (1790's); the Prison of Gisors *le jeune*, Pontivy, formerly called Napoléonville (1811, now half destroyed).

[81] On this competition and on the theme in general, see the delightful and learned discussion by Jean Seznec (*Essais sur Diderot et l'antiquité*, Oxford, 1957, ch. 1). In addition to the French examples cited by Seznec, it may be noted that the Dijon Academy also chose the *Mort de Socrate* for its Prix de Rome competition subject of 1780. (See the exhibition catalogue, *L'Académie de peinture et sculpture de. Dijon*, Musée des Beaux-Arts de Dijon, 1961, p. 51.)

On Sané, see Jean Locquin, "Notice sur le peintre Jean-François Sané (1732?-1779)," *Bulletin de la Société de l'Histoire de l'art français, 1910*, Paris, pp. 42-60. Sané's painting of *La Mort de Socrate*, as yet untraced, is preserved in an engraving by Jacques Danzel (1786) that appeared seven years after Sané's death (Fig. 75).

[82] On this precocious Neoclassicism, see James Thomas Flexner, "Benjamin West's American Neo-Classicism," *The New York Historical Society Quarterly*, XXXVI, Jan. 1952, pp. 5-33, where a source in Gravelot's illustrations is given; and, more briefly, Grose Evans, *Benjamin West and the Taste of His Times*, Carbondale, Ill., 1959, p. 13. West, of course, was not the first to reflect a new wave of interest in such austere classical themes. For earlier examples and a discussion of the Socrates theme in art, see A. Pigler, *Barockthemen*, II, Budapest, 1956, p. 412; and *idem*, "Sokrates in der Kunst der Neuzeit," *Die Antike*, XIV, 1938, pp. 281-294.

drama of a last farewell to a political martyr had penetrated late eighteenth century experience in the context of current events as well. In 1762, the French protestant, Jean Calas, was put to death on the wheel, after a false confession of the murder of his son, a convert to Catholicism, had been extracted from him.[83] Calas' case was to become one of the moral *causes célèbres* of the century, inflaming Voltaire to write an essay on tolerance (1763)[84] and Marie-Joseph Chénier to write a tragedy (1791).[85] The story also inspired the Berlin artist, Daniel Chodowiecki, whose painting of 1767, commemorating Calas' tragic adieux to his family, was made familiar through prints (Fig. 77).[86]

Like the *Horatii*, David's *Socrates* depends on dramatic motifs familiar to the late eighteenth century but elevates them to greatness through pictorial genius and moral rigor. By comparison with Chodowiecki's and Sané's interpretations of political martyrdom, David's lofty idealism of style and drama is conspicuous. The spongy swaying figures of Sané's *Socrates* are crystallized here, as in the *Horatii*, into figures of marmoreal firmness, disposed upon a ground plane marked out with perspectival exactitude; and in keeping with this vigorous lucidity of style, the stoicism of the subject is dramatically underscored. Instead of the Greuzian despair that seizes all of Chodowiecki's figures

[83] Two recent studies have considered *l'affaire Calas*: David D. Bien, *The Calas Affair; Persecution, Toleration, and Heresy in Eighteenth Century Toulouse*, Princeton, 1960; and Edna Nixon, *Voltaire and the Calas Case*, New York [1961].

[84] *Traité sur la tolérance à l'occasion de la mort de Jean Calas.*

[85] *Jean Calas, ou l'école des juges.* Chénier's play followed shortly after two lesser known tragedies on the subject: Auguste-Jacques Lemierre d'Argy, *Calas, ou le fanatisme* (1790); and Jean-Louis Laya, *Jean Calas* (1790). It was first performed on July 6, 1791, and published two years later, in 1793, with a letter on Calas by Palissot.

[86] For late eighteenth century prints after the painting, see D. Jacoby, ed., *Chodowiecki's Werke*, Berlin, 1808, nos. 48 (1767), 48a (1768), 353 (1780). Knowledge of Chodowiecki's painting must have been widespread in the late eighteenth century, for the work was even used by Lavater as a textbook demonstration of the four temperaments. See G. Levitine, "The Influence of Lavater and Girodet's *Expression des sentiments de l'âme*," *Art Bulletin*, xxxvi, March 1954, p. 43 and fig. 12.

(from the passive, victimized father and sobbing children to the fainting wife in the armchair at the right), David offers a firm moral paradigm of uncommon nobility. For dramatic foils to Socrates' steadfast resolution, he uses the philosophers' own disciples. These are animated by a spectrum of grief that ranges from the rhetorical despair of the youths, bracketing the group at the left and right, to the sorrowful resignation of the aged Plato, who sits in profile at the foot of the bed. In ironic contradistinction to Socrates' quiet heroism is the youth who proffers the hemlock. Cringing at his own act, he is unable to look at the lethal kylix.[87]

That David did, in fact, choose a kylix as the vessel of death was characteristic of his full espousal of late eighteenth century Historicism. Despite such anachronisms as the barrel-vaulted corridor and Plato's advanced age, the painting is filled with archeological detail—the lyre, the incised owl of Athens, the scroll, the use of a Socrates portrait bust[88]—that purports to create a maximum of verisimilitude. We know, in fact, that David had consulted an Oratorian for these historical precisions.[89] Indeed, it is this very prominence of archeological realism as well as the pronounced realism of flesh, wood, cloth, hair that distinguishes David's vision of antiquity (as it does West's) from Poussin's, and that made it possible for an Englishman visiting Paris in 1803 to refer to David's paintings as "waxwork bas reliefs."[90] Combined with David's idealism of form and morality, this literalism of detail, which extends here to the chips in the

[87] This dramatic irony was already pointed out in David's own time. See C. P. Landon, *Annales . . .* , III, Paris, 1802, p. 142.

[88] The review in the *Mercure de France* (Sept. 22, 1787, p. 177) had already pointed out that "David a conservé à Socrate la tête qu'un buste antique nous a donné pour celle du célèbre philosophe."

[89] See E. Bonnardet, "Comment un oratorien vint en aide à un grand peintre," *Gazette des Beaux-Arts*, 6e période, XIX, May-June 1938, pp. 311-315; and Seznec, *op.cit.*, p. 20.

[90] *An Englishman in Paris: 1803; The Journal of Bertie Greatheed*, eds. J. P. T. Bury and J. C. Barry, London, 1953, p. 27. Mr. Arthur Marks kindly called my attention to this journal, which offers some piquant comments on French art at the turn of the century.

blocks of the masonry wall (just as it extends to the irregular patches of exposed brick above the arcade in the *Horatii*), produces the new kind of classicism inaugurated in the late eighteenth century as one facet of Historicism—an image of a lost Greco-Roman past optimistically retrievable through exact archeological reconstruction.

Unlike their vulgarized academic descendants of the nineteenth century, which often were only "waxwork bas reliefs," David's painstakingly realistic images of antiquity were visually ennobled by a genius for pictorial abstraction and ethically invigorated by the growing allusions to the impassioned political actualities in which the artist lived. In his last classical drama conceived before and exhibited after the storming of the Bastille, the lesson of personal sacrifice to political belief is the grimmest of all (Fig. 78).[91] The story is of Lucius Junius Brutus, founder of the Roman Republic, who ordered the death of his own sons, Titus and Tiberius, for their guilt in attempting to restore the Tarquins.[92] The horror of this chilling morality was hardly new in a late eighteenth century repertory of history painting that already included Virginius killing his daughter, Horatius killing his sister and, most directly comparable, Manlius Torquatus ordering his son's death for treason. Yet David's interpretation of this theme was, like his interpretation of the *Horatii*, an invention unfamiliar in classical literary sources or earlier pictorial ones.[93] The crucial moment of Brutus' decision, chosen for earlier and later interpretations of the theme,[94] was rejected

[91] Salon of 1789, no. 88. The full title is: *J. Brutus, premier consul, de retour en sa maison, après avoir condamné ses deux fils qui s'étaient unis aux Tarquins et avaient conspiré contre la liberté Romaine; des Licteurs rapportent leurs corps pour qu'on leur donne la sépulture.*

[92] The basic sources for the story are: Livy, II, 5; Valerius Maximus, V, viii, 1; Plutarch, "Publicola," VII.

[93] As with the *Horatii*, David's contemporaries noted his deviation from classical texts in the *Brutus*, even commenting on his ignorance of Roman burial practices. See *Lettres analitiques, critiques, et philosophiques sur les tableaux du Sallon*, Paris, 1791, pp. 54, 57-58.

[94] Other versions of the Brutus story deal with the judgment, e.g., Cochin *fils* (Salon of 1741, a sketch for an illustration to Rollin, unnum-

by David for the more abstract and edifying moment that fol-
lowed the decision and the deed. In the wake of so dreadful but
so inevitable a judgment, Brutus is seen in a state of quiet con-
templation that elevates him to a loftier, more isolated moral
plane than would a scene of mere horror or dramatic conflict.
Here, the family cleavage already so prominent in the *Horatii*
reaches its extreme statement. The appalling spectacle of the
lictors bringing home the bodies of Tiberius and Titus for
burial transforms the women of the family into a group of
hysterical bacchantes. In radical contrast, Brutus himself turns
away from the convulsive presence of his wife and daughters and
the funereal one of his sons. Risking an astonishing composi-
tional heresy for an ethical purpose, David separates Brutus from
his women by a poignant void that emphasizes, as it were, the
unbridgeable gulf between masculine stoicism and feminine
abandonment to the passions. In the same way, the radical lumi-
nary contrast—Brutus in shadow, the women in glaringly
clear light—underlines this tragic rupture, which is even borne
out by the conflicting position of the two chair backs. Heroically
isolated by his inviolable political morality, Brutus masters his
passions—even his toes are tensely contracted—while seeking
consolation under the Capitoline cult statue of Mother Rome.[95]

David's painting was exhibited at the Salon of 1789, which
opened on August 25, six weeks after the storming of the

bered, listed between nos. 127 and 128); Wicar (1788, drawing, illustrated
and discussed in Fernand Beaucamp, *op.cit.*, I, p. 107 and II, p. 663, no.
133); Vignaly (or Viguiallis) (Salon of 1791, no. 705); and Lethière (Salon
of 1795, no. 353; Salon of 1801, no. 229, Louvre). There is also a painting
of the subject attributed to Girodet at the Musée des Beaux-Arts, Alger.
However, one post-Davidian version of the theme deviates from the familiar
scene of the judgment. At an exhibition held at Versailles in 1799, the
sculptor Robert-Guillaume Dardel (1749-1821) exhibited: *Brutus, après
l'exécution de ses fils convaincus d'avoir voulu livrer Rome aux Tarquins,
console son épouse qui cherche en vain à écarter l'image sanglante de ses
enfans, qui frappe incessamment ses yeux* (no. 4). (The catalogue is in
the Bibliothèque Nationale, Cabinet des Estampes, Coll. Deloynes 651.)

[95] This and the other archeological borrowings in the *Brutus* are listed
in Hautecœur, *Louis David*, Paris, 1954, p. 100.

Bastille.[96] Like the patriotic oath of the *Horatii* or the stoical suicide of Socrates, the severe political morality of Brutus—which a hundred years earlier, in England, had already been interpreted in the context of the political actualities of the Restoration[97]—was quickly to be directed to the needs of Revolutionary propaganda. So explicit, in fact, was Brutus' idealism that even a century later, on the eve of the Russian Revolution, the Menshevik philosopher, Georgy Plekhanov, praised David's painting for its patriotic presentation of a father suppressing normal sentiments in favor of the state's welfare.[98]

The same historical mobility that permitted the pre-Revolutionary decades to cull exemplary deeds from the lives of both a Scipio and a Bayard continued throughout the Revolution with new emphasis, of course, upon political heroism. If for David and his contemporaries, such virtue was found primarily in the

[96] For further comments on the exhibition of the Brutus, see Dowd, *Pageant-Master of the Republic; Jacques-Louis David and the French Revolution*, Lincoln, Nebraska, 1948, pp. 19ff.

[97] In the play by Nathaniel Lee, *Lucius Junius Brutus, Father of His Country*. After its presentation in December 1680, the play was withdrawn, for some of the references to Tarquin's character had been considered unflattering allusions to Charles II. For further references to the play's history, see *The Works of Nathaniel Lee*, eds. Thomas B. Stroup and Arthur L. Cooke, II, New Brunswick, N.J., 1955, pp. 317-319. Professor Robert Herbert of Yale University has noticed independently the rapports between Lee's and David's interpretations of Brutus and is planning to elaborate them in an article. On the relation of Voltaire's tragedy *Brutus* (1731) to David's painting, see Dowd, "Art and the Theater during the French Revolution: the Role of Louis David," *Art Quarterly,* XXIII, Spring 1960, p. 5.

[98] "Les qualités picturales de Brutus passent au second plan. Ce qui importe, c'est que Brutus médite devant la statue de Rome à laquelle il a sacrifié la vie de ses fils criminels contre la patrie et la liberté. On ne voit que le patriotisme de Brutus, sa vertu politique de père sachant étouffer les sentiments naturels et ne considérant que le bien de la République." Plekhanov's remarks may be found in his *Oeuvres,* XIV, Moscow, 1925, pp. 111ff. They are cited, appropriately enough, in Agnes Humbert, *Louis David, peintre et conventionnel; essai de critique marxiste*, Paris, 1936, p. 60, and there dated "aux environs de 1910." See also Dowd, *Pageant-Master . . .* , p. 157, for further bibliographic remarks on Plekhanov and David.

lessons of Greece and early Republican Rome,[99] it could nevertheless also be found in postclassical history. Thus on June 15, 1789, the playwright Marie-Joseph Chénier wrote: "J'avais conçu le projet d'introduire, sur la scène française les époques célèbres de l'histoire moderne, et particulièrement de l'histoire nationale; d'attacher à des passions, à des événements tragiques, un grand intérêt politique, un grand but moral."[100] And most frequently, paradigms from both ancient and modern, sacred and secular, history were cited together to illustrate a common heroism of immediate relevance to current events. Thus, Robespierre, in 1792, wrote that the great benefactors of mankind were also martyrs and, to bear this out, he cited examples that move from Agis, Cato, Brutus, and Jesus Christ to Algernon Sidney and, finally, to the Revolutionary mayor of Paris, Pétion de Villeneuve.[101] And similarly, the

[99] The fervent use of classical history in the iconographical service of the Revolution is a vast subject with a huge literature. For an excellent introduction, see Harold T. Parker, *The Cult of Antiquity and the French Revolutionaries*, Chicago, 1937. Among artists, the close identifications between classical past and Revolutionary past are legion. David, for instance, is reported to have said to Robespierre, "Si tu bois la ciguë, je la boirai avec toi" (Hautecoeur, *op.cit.*, p. 143; and Dowd, *op.cit.*, p. 16 n. 53); and one of David's early biographers, A. Thomé, writes how the artist "voyait Phocion dans Marat, et dans Robespierre un nouveau Marius" (*Vie de David*, Brussels, 1826, p. 93). Even Hubert Robert, in a drawing of himself imprisoned in Sainte Pélagie (1793; Musée Carnavalet, Paris), could inscribe on the lintel, "Carcer Socratis. Domus honoris," as I have already pointed out in my review of Seznec, *Essais sur Diderot et l'antiquité* (*Romanic Review*, LI, April 1960, pp. 138-140).

[100] *De la liberté du théâtre en France*, Paris, 1789, p. 15. A. J. Bingham (*Marie-Joseph Chénier, Early Political Life and Ideas, 1789-1794*, New York, 1939, p. 9 n. 46) suggests that this printed date of publication, 15 juin 1789, is too early, and that the pamphlet was actually completed in late June or early July.

[101] The exact quotation follows: "Lisez l'histoire, vous verrez que les bienfaiteurs de l'humanité en furent les martyrs. Agis est condamné par les éphores pour avoir voulu établir les lois de Licurgue; Caton déchire les entrailles; le second des Brutus est réduit à s'arracher la vie, après l'avoir enlevée au tyran; le fils de Marie expire sous les coups de tyrannie; Socrate boit la sigué; Sydnei [*sic*] meurt sur un échafaut; Pétion se trouva en un instant accablé de tous les honneurs qu'on prodiguoit naguère à Lafayette." (*Lettres de Maximilien Robespierre, membre de la Conventional Nationale de France, à ses commettans*, I, Paris, 1792, letter no. VII, p. 334.)

playwright Antoine-Marin Lemierre, who was afraid to have his tragedy of Virginia produced for fear of inciting Revolutionary passions,[102] created his famous couplet on Greco-Roman martyrdom in the context of a drama, first produced in 1790, about the early seventeenth century Dutch political martyr, Barnevelt:[103] "Libre au moins dans la mort—Mon fils, qu'avez-vous dit? Caton se la donna—Socrate l'attendit."

David himself demonstrated the same historical mobility in the elaborate allegory, *Le Triomphe du peuple français*, designed in 1793 for the curtain of the Opéra and revised in 1794.[104] Here the virtuous procession that follows the triumphant chariot of the French people includes examples from classical, medieval, and modern heroism (Figs. 79, 81). First we find Cornelia and her children; then Brutus, carrying his edict, "à la mort que l'on mène mes fils"; then the great Swiss political hero, William Tell, and his son, who carries the arrow and split apple;[105] and finally

[102] On Lemierre's *Virginie*, presumably written after *Barnevelt* but never published or produced, see René Perin, ed., *Œuvres de A.—M. Le Mierre*, I, Paris, 1810, pp. xcviii-xcvix.

[103] The lines come from Act IV, scene 7, a dialogue between Barnevelt and his son Stautembourg, who commits suicide in front of his father. In his preface to *Barnevelt*, Lemierre characteristically discusses issues of political freedom in reference not only to Roman Republican history but also to the history of William Tell.

[104] The earlier drawing (1793) does not include the modern martyrs. It is reproduced in Jean Guiffrey and Pierre Marcel, eds., *Inventaire général des dessins du Musée du Louvre et du Musée de Versailles; École française*, IV, Paris, 1909, no. 3199. The two drawings are discussed in J.-L. Jules David, *Le Peintre Louis David*, I, Paris, 1880, p. 657; and are briefly mentioned in Dowd, "Art and the Theater . . . ," pp. 6, 9 n. 33. For two other David drawings related to the *Triomphe du peuple français*, see A. P. de Mirimonde, *Catalogue du Musée Baron Martin à Gray*, Gray, 1959, nos. 177-178 (*Les Héros de la liberté* and *Cornélie et ses deux fils*).

[105] William Tell's role in Revolutionary iconography would be worth studying. A law of August 2, 1793, demanded that Lemierre's tragedy, *Guillaume Tell* (1766) be performed (together with Chénier's *Brutus* and *Caius Gracchus*) three times a week at the expense of the Republic. (See Marian Hannah Winter, *Le Théâtre du Merveilleux*, Paris, 1962, p. 73.) As a great Jacobin hero, Tell also inspired at least two paintings of the 1790's: F. Schall, *Heroïsme de Guillaume Tell* (1791), Musée des Beaux-Arts, Strasbourg; Vincent, *Guillaume Tell renversant la barque sur laquelle*

behind them, a group of martyrs of those very months, 1793-1794—Jean-Paul Marat, Louis-Michel Le Peletier de Saint-Fargeau, Thomas-Augustin de Gasparin, Marie-Joseph Chalier, Pierre Bayle, Charles-Nicolas de Beauvais de Préaux, and Denis Fabre de l'Hérault—who form a procession of new saints, each exhibiting, like a Christian martyr, the attribute of his demise, whether the wound of an assassin's dagger, a suicidal rope, a vial of poison, or the blade of a guillotine.[106]

In attempting to locate these new Revolutionary martyrs in a venerable historical dynasty that extended back not only to Tell and Brutus, but, implicitly, to early Christian saints, David typified the new iconographical problems of many artists of the late eighteenth century. In Revolutionary and Imperial France, as in the newly founded United States, a historical pedigree, so to speak, had to be created to aggrandize the new political ideals, the new rulers and heroes that replaced earlier monarchic systems.[107] Thus, in David's art executed under the Revolution, the relationship between historical past and present is reversed. In the work of the 1780's—the *Horatii*, the *Socrates*, the *Brutus*—a reconstructed classical environment couches allusions to modern virtue; in the *Tennis Court Oath* and the martyr images of the early 1790's, a reconstructed modern environment couches al-

le gouverneur Gessler traversait le lac de Lucerne (commissioned in 1791; Salon of 1795, no. 528), Musée des Augustins, Toulouse. Both paintings depend on Lemierre's play. For further remarks on Schall's painting and the relation of Tell to the Jacobins, see the *Catalogue des peintures anciennes*, Strasbourg, Musée des Beaux-Arts, 1938, no. 433; and the exhibition catalogue, *Paris et les ateliers provinciaux au 18ᵉ siècle*, Bordeaux, 1958, no. 66.

[106] These martyrs are listed, with their attributes of death, in J.-L. Jules David, *loc.cit.*, but the identifications given there are incorrect. They are correctly described, however, in a statement by David himself, cited elsewhere in the text (I, p. 211).

[107] The most explicit example of this is David's own *Bonaparte au Mont-Saint-Bernard* (1800), in which the mountain pass is inscribed with the names of Bonaparte, Karolus Magnus, and Hannibal. The other side of the historical coin around 1800 is Goya's "dethroning" of absolute monarchy by means of almost caricatural references to earlier Baroque traditions of royal portraiture.

lusions to paragons of classical and Christian virtue. Thus, the *Tennis Court Oath* (Fig. 80) may be seen as primarily a document of contemporary history that follows the journalistic tradition inaugurated in England by such reportage as West's *Death of Wolfe* and Copley's *Death of the Earl of Chatham*;[108] but at the same time, it offers an unmistakable reference to the virtuous Roman oath exemplified by the pre-Revolutionary *Horatii*, which was, in fact, re-exhibited with it at the Salon of 1791.[109]

This resurrection of moribund classical and Christian traditions in the service of modern history is nowhere seen more powerfully than in David's great painting of Jean-Paul Marat's sanctified corpse (1793; Fig. 82).[110] For one, it may be considered a translation, in the context of current events, of David's earlier *Andromache Mourning Hector* (1783; Fig. 37);[111] the classical

[108] This Anglo-American development and its later repercussions on the Continent are analyzed in the basic study by Edgar Wind, "The Revolution of History Painting," *Journal of the Warburg Institute*, II, 1938-1939, pp. 116-127.

[109] The *Tennis Court Oath* and the *Horatii* were, respectively, nos. 132 and 134. It should be noted that the *Socrates* and the *Brutus* were also re-exhibited (nos. 299 and 274) for obvious reasons of propaganda.

[110] David was hardly the only one to represent Marat's martyrdom. In addition to the many popular prints representing the event, there are paintings by Joseph Roques (1793, Musée des Augustins, Toulouse; illustrated in the exhibition catalogue, *Ingres et ses maîtres de Roques à David*, Toulouse, Musée des Augustins, 1955, pl. 14); and Jean-Jacques Hauer (1793, Musée Lambinet, Versailles; possibly to be identified with *La Mort de Marat*, Salon of 1793, no. 447). Incidentally, the theme of Marat's murder, with new emphasis upon Charlotte Corday, artistically survived the Revolution, as in the paintings by Henri Scheffer (Salon of 1831, illustrated in C. P. Landon, *Annales du Musée*; *Salon de 1831*, Paris, 1831, pl. 42); Paul Baudry (Salon of 1861; Nantes); Jean-Joseph Weerts (Salon of 1880; Evreux); Edvard Munch (1906; Oslo Municipal Collections).

The reader's attention should also be called to a remarkably suggestive and well-documented essay on David's painting which duplicates many of my own points but which I was able to consult only after completion of my text: Klaus Lankheit, *Der Tod Marats* (*Werkmonographien zur bildenden Kunst in Reclams Universal-Bibliothek*, no. 74), Stuttgart, 1962.

[111] Salon of 1783, no. 162. *La Douleur et les regrets d'Andromache sur le corps d'Hector son mari*. The political implications of this pre-Revolutionary scene of mourning have been provocatively interpreted by Rudolf Zeitler

hero, dead for his country, is replaced by the modern one.[112] Speaking to the Convention, David, in fact, had explicitly compared the exemplary nobility of Marat's life to such classical heroes as Cato, Aristides, Socrates, Timoleon, Fabricius, and Phocion.[113] And in the same way, the dead Marat may be seen as embodying Christian motifs, as had even been the case with *Andromache Mourning Hector*.[114] As a rabid Jacobin, David of course rejected Christianity,[115] yet disguised Christian traditions inevitably persisted in his work as clearly as in Greuze's secular dramas of death, chastity, and repentance. Before Marat's sacrifice to political beliefs, it is hard not to think of a *Pietà*.[116] The somber and resonant void above the martyred figure creates a supernatural aura that demands a religious silence; it is the post-medieval painter's equivalent of a gold background. Similarly, the Caravaggesque light, emanating from a high and invisible source, saturates the bloody scene with an immateriality that metamorphoses the victim of a sordid bathtub murder into an icon of a new religion. Even more explicitly Christ-like is the prominence of the wound in Marat's right side, though here David re-

(*Klassizismus und Utopia*, Stockholm, 1954, p. 55) as *La France* mourning a son who has died for the fatherland.

[112] In this classical context, the close resemblance between Marat and the enshrouded Miltiades in Peyron's painting of 1782 (Fig. 61) might be noted.

[113] ". . . que sa vie nous serve d'exemple. Caton, Aristide, Socrate, Timoléon, Fabricius et Phocion, dont j'admire la respectable vie, je n'ai pas vécu avec vous, mais j'ai connu Marat, je l'ai admiré comme vous; la postérité lui rendra justice." (Alfred Bougeart, *Marat, l'ami du peuple*, II, Paris, 1865, pp. 281-282.)

[114] "*L'Andromaque* de David . . . rappelle un peu trop quelques Magdeleines du Guide et son école." (*Année littéraire*, VI, 1783, p. 237, cited in Locquin, *La Peinture d'histoire* . . . , p. 243.)

[115] Even before the Revolution, David apparently found religious subjects repugnant, as is borne out by the difficulties entailed in Mme. de Noailles' commission for a *Crucifixion*. See A. Th[omé], *Vie de David*, Paris, 1826, pp. 22-23.

[116] Analogies to such Seicento Pietàs as Annibale Carracci's (Naples, Pinacoteca) are obvious; but for an example chronologically more relevant to David, see Jean-Baptiste Regnault's very Bolognese *Descente de croix* (Louvre; Salon of 1789, no. 90).

mained truthful to the gruesome facts of the autopsy.[117] It is hardly surprising that, in this crypto-Christian ambiance, the inanimate objects that surround the martyr—the knife, the quill, the inkwell—take on the quality of holy relics; in fact, some of the material traces—the writing block, the bathtub, the bloody shirt—of what was considered an irreparable spiritual loss were exhibited at Marat's funeral as objects of worship.[118] Moreover, Marat's unworldly nobility was coupled with that of Christ in many perorations. One orator intoned, "O coeur de Jésus! O coeur de Marat!"[119] and other *citoyens* claimed that Marat's great humanity could be compared to Christ's, a comparison that was attacked only by an indignant M. Brochet, who thought it unworthy of a modern martyr dedicated to the destruction of Christian superstition.[120] It was characteristic, too, of this Revolutionary idolatry that one of the most venerated images of Paris —a statue of the Virgin in the Rue aux Ours which, in 1418, was said to have bled when struck by a drunken Swiss soldier and which, until 1789, was the object of a yearly procession—was temporarily replaced, in 1793, by a statue of Marat.[121]

The same clandestine Christianity helps to transform from a secular to a sacred image the slaughtered corpse of the thirteen-year-old drummer boy, Joseph Bara, shot by Royalist troops in

[117] Bougeart (*op.cit.*, II, p. 265) records that "le couteau avait pénétré sous la clavicule du côté droit si profondément que le chirurgien, quelques minutes après, put faire pénétrer l'index de toute sa longueur à travers le poumon blessé; le tronc des carotides avait été ouvert." Popular prints of Marat's assassination were much more indifferent to documentary truth, frequently locating the wound at the left or in the center of Marat's chest. It is worth noting that earlier, David had similarly emphasized a Christ-like wound in his lost painting of the martyred Le Peletier de Saint-Fargeau.

[118] For a description of the funeral, see *ibid.*, pp. 28off.; and Dowd, *Pageant-Master of the Republic* . . . , pp. 104ff. Marat's funeral rites of July 16, 1793, are represented in a painting at the Musée Carnavalet, Paris (no. 356).

[119] The intonation is mentioned in Michaud's *Biographie universelle* and in Bougeart, *op.cit.*, p. 287.

[120] *Ibid.*

[121] Philippe Lefrançois, *Paris à travers les siècles* (*Rue Saint Martin* . . .), Paris, 1951, pp. 10-11.

1793 when he responded, "Vive la République!" to their demand that he proclaim the King (Fig. 84). Again, David's unfinished painting of this martyrdom (1794), designed for a funeral service organized by Robespierre, presents this poignant sacrifice of an innocent child to a political cause in terms of veiled Christian imagery.[122] Clutching the tricolored cockade to his breast as if it were the crucifix of an early Christian saint, the young Bara closely recreates, in both position and swooning sentiment, the Counter-Reformation image of an equally pathos-ridden martyrdom—Stefano Maderno's statue of Saint Cecilia (1600) (Fig. 83). Later in the nineteenth century, this touching icon of a noble idealism too virtuous and too innocent for an evil world was restored to its original context in such a work as Falguière's marble of a young Christian martyr, *Tharsicus* (1868), who died carrying the Eucharist (Fig. 85).[123]

Like David, other painters of the 1790's espoused the *exemplum virtutis*.[124] Echoing Diderot's beliefs of the 1760's, Gérard, in 1793, claimed that the arts should "faire haïr le vice, adorer la vertu en charmant les yeux";[125] and in the same year, the Salon catalogue, with a typically classical reference, explained that its motto was emphatically not "in arma silent artes." It recalled,

[122] It should be said that the identification of the martyr as Joseph Bara (or, as it is also spelled, Barra) has been contested by Hautecœur (*Louis David*, Paris, 1954, pp. 129-130), who, following Delécluze, suggests that the young martyr is rather to be identified as Joseph-Agricola Viala. On the *fêtes* planned, but not given, for Bara and Viala, see Dowd, *op.cit.*, pp. 108-109.

[123] Falguière's statue was exhibited at the Salon of 1868, no. 3578. The same pose was used by another academic master, James Bertrand for his painting *La Mort de Virginie* (Salon of 1869, Châteauroux). Bara himself was represented in the nineteenth century in a statue by David d'Angers (1838; Salon of 1839); a statue at Bara's birthplace, Palaiseau (Seine-et-Oise), by Louis Albert-Lefeuvre (1881); and a painting by Jean-Joseph Weerts (Salon of 1882, Roubaix).

[124] For a brief survey of the general character of the Revolutionary Salons, see Colette Caubisens-Lasfargues, "Les Salons de peinture de la Révolution française," *L'Information d'histoire de l'art*, v, May-June 1960, pp. 67-73; and *idem*, "Peinture et préromantisme pendant la Révolution française," *Gazette des Beaux-Arts*, 6e période, LVIII, Dec. 1961, pp. 367-376.

[125] J.-L. Jules David, *Le Peintre Louis David*, I, Paris, 1880, p. 153.

in fact, Pliny the Elder's account of the painter Protogenes creating a masterpiece during the siege of Rhodes.[126]

A revealing instance of the close identification between classical and Revolutionary virtue may be seen in a subject allied in mood to the story of Cornelia and her jewels. At the Salon of 1785, Brenet exhibited his *Piété et générosité des dames romaines*,[127] another extraordinary example of the feminine sacrifice of jewelry to nobler causes (Fig. 86). As recounted by Plutarch[128] and retold by the Abbé Rollin,[129] the women of Rome offered their gold and jewelry to the state, in order to fulfill Camillus' pledge to Apollo of a golden bowl commemorating a victory over Veii. Four years later, the virtue exemplified by such remote history became vividly real. On September 7, 1789, a group of eleven women—artists' wives and daughters—headed by Mme. Moitte, the wife of the sculptor, and including Mesdames David, Peyron, and Vien, all dressed themselves in white, ornamented their hair with the tricolor, and donated their jewelry to the state.[130] This kind of donation, a practice that was soon to become common, was immediately commemorated in prints[131] as well as in *Le Courier* [*sic*] *français* (Fig. 87); and in both cases, the patriotic Frenchwomen are equated with their prototypes in noble Roman womanhood. The newspaper refers to the event as a "Trait d'héroïsme et de générosité des Camilles françoises," and goes on to recount how a member of the Assemblée Nationale eulogized

[126] *Salon de 1793, Description des ouvrages de peinture . . .* , Paris, 1793, p. 2. The account of Protogenes is found in Pliny, xxxv, 36.

[127] No. 7. Brenet's painting, incidentally, was hung just to the left of the *Horatii*, as may be seen in P. A. Martini's engraving of the Salon of 1785.

[128] "Camillus," x.

[129] The Salon catalogue refers to "tome 2" in Rollin's history, although the story is told in vol. vi, ch. i in the original edition.

[130] *Journal inédite de Mme. Moitte*, ed. Paul Cottin, Paris, 1932, pp. 1-2.

[131] There were, in fact, several prints commemorating such donations. The one illustrated here gives Sept. 21, 1789, as the date of that particular donation. There is also a drawing of a donation by Jean-Louis Prieur (Louvre, no. 6191). For further remarks and illustrative material on these patriotic ladies, see Hippolyte Gautier, *L'An 1789; évenements, moeurs, idées, oeuvres, et caractères*, Paris [1888], pp. 700-702.

this sacrifice even beyond "ce qui s'est passé en Grèce ou à Rome";[132] the legend on the engraving makes the same classical reference; and Mme. Moitte herself published a brochure entitled *L'Âme des dames romaines dans les femmes françaises.*[133] Subsequent issues of *Le Courier français*, in fact, offered regular accounts of donations, whose usual rubric, "Actes de Patriotisme et de Générosité," recalls a moral category in Valerius Maximus. Thus, when Louis Gauffier exhibited his *Générosité des dames romaines* at the Salon of 1791,[134] it must have resembled a noble Latin translation, so to speak, of contemporary feminine virtue (Fig. 88).

A similar moral paradigm is offered in antique clothing in a painting executed by Girodet in Rome in 1791-1792.[135] The Greek

[132] *Le Courier français*, no. 65, Sept. 8, 1789, pp. 313-315.

[133] *Journal inédite* . . . , p. 2.

[134] No. 633. Gauffier's painting (executed in Rome in 1790) is briefly discussed in R. Crozet, "Un Tableau de Gauffier au Musée de Poitiers," *Musées de France*, Jan.-Feb. 1950, pp. 15-16. Unlike most Neoclassic paintings, which are generally relegated to the storeroom, Gauffier's painting is not only exhibited at Poitiers, but has also been lent to two recent exhibitions: *Paris et les ateliers provinciaux au 18e siècle*, Bordeaux, 1958, no. 131; and *Il Settecento a Roma*, Rome, Palazzo delle Esposizione, 1959, no. 229.

Another painting by Gauffier, now at Fontainebleau (no. 217), combines this theme with the story of Cornelia: *Cornélie, mère des Graecques, sollicitée par les dames romaines de donner des bijoux à la patrie* (1792). For a life and *catalogue raisonné* of Gauffier, see Crozet, "Louis Gauffier (1762-1801)," *Bulletin de la Société de l'Histoire de l'art français, 1941-1944*, Paris, 1947, pp. 100-113.

The subject of Roman women donating jewelry was also treated by Mme. Giacomelli (Salon of 1804, no. 206); by Camuccini; and in a drawing of 1818 by Delacroix (Louvre; illustrated in René Huyghe, *Delacroix*, New York and London, 1963, pl. 68). This virtuous behavior, incidentally, was to persist throughout modern history, even if the Plutarchian allusions were lost. As recently as November 1962, Nehru's daughter, Indira Gandhi, instigated the women of India to offer their gold ornaments to the state at the time of the Chinese Himalayan invasion.

[135] Dated 1792, the painting was begun in Rome in November 1791. (See Girodet's letter to M. Trioson of Nov. 25, 1791, in Girodet-Trioson, *Oeuvres posthumes*, ed. A. Coupin, ii, Paris, 1829, p. 400.) The painting was to decorate Dr. Trioson's house at Bourgoin. For an excellent discussion of the painting, with reference to questions of physiognomy, see George

counterpart to the lessons taught by the stories of Curius Dentatus and Fabricius Luscinus, it again shows the rejection of wealth in favor of moral—and, in this case, patriotic—principles. Here, in a story Girodet had read in Abbé Barthélemy's *Voyage du jeune Anacharsis en Grèce* (1788),[136] the ambassadors of the Persian king, Artaxerxes, visit Hippocrates in the hope of persuading him to heal their sick at a time of plague. The great Greek physician, however, steadfastly refuses the gifts poured at his feet, remaining loyal to his own people. For Girodet, an artist who was later to abandon this stoical realm in favor of erotic and fantastic themes,[137] this subject appeared as "un des plus beaux de l'antiquité, tant par la vénération attachée à Hippocrate, que par le bel exemple de patriotisme et de désintéressement dont il offre le tableau."[138] The patriotism of a young Davidian, even when working in Rome, is perhaps better expressed in the preparatory drawing (Fig. 89) than in the painting itself;[139] for here, the severe restriction to outline alone and the rigidly calculated perspective construction echo most directly the rational, anti-sensual nature of the austere moral lesson depicted.

Such exemplars of patriotism were also created on far less exalted levels than Girodet's. A case in point is the *Départ du Volontaire* by the charming master, François Watteau de Lille (Fig. 91). Probably painted in the trying days that preceded the Austrian siege of Lille in 1792,[140] Watteau's stirring scene replaces

Levitine, "The Influence of Lavater and Girodet's *Expression des sentiments de l'âme*," *Art Bulletin*, xxxvi, March 1954, pp. 41ff.

[136] I, Paris, 1788, p. 203 (Introduction, 2e partie, 3e section: Siècle de Périclès; guerre de Pélopenèse). Barthélemy is the source given when the painting was belatedly exhibited at the Salon of 1814 (no. 45). Levitine (*loc.cit.*) gives the source as Plutarch's life of Marcus Cato, which has a briefer account of the story and does not mention the plague in Persia.

[137] With exceptions for commissions to record Napoleonic history.

[138] Girodet's description is cited in *Oeuvres posthumes*, II, pp. 276-277, where the painting's full title is also given: *Hippocrate refusant la pourpre et l'or que font briller à ses yeux les envoyés du roi de Perse, pour l'engager à venir guérir la peste qui ravageait ses états.*

[139] The painting is in the École de Médecine, Paris.

[140] For a discussion of the painting and its probable date (1792), see

the familiar *fêtes galantes* with which he perpetuated the name and tradition of his great-uncle, Antoine. What is offered instead is essentially a modern prose translation of the classical theme of Hector taking leave of Andromache and Astyanax, a subject immensely popular in the late eighteenth century.[141] In fact, the central group merely presents this Homeric scene of family sentiment and military obligation in contemporary clothing. Against a background of anxious parents, this modern Andromache and Astyanax say their last tearful goodbyes to a modern Hector—a French Republican soldier in red, white, and blue uniform and cockade, who is momentarily torn between love of family and duty to the country whose troops and encampments await him through the open door.[142]

In the later 1790's, under the Directoire, the mood of active sacrifice and vigorous moral allegiance so prominent at the beginning of the decade was often replaced by themes that suggested the establishment of peace and order in the wake of war and chaos. Many works of these years were plainly anti-Revolutionary in intention, inverting the stoical messages of *Brutus* or *Marat* into posthumous lamentations for the lives wantonly lost under the Terror. Thus, at the Salon of 1796, a painting by Joseph-Benoît Suvée showed two victims, a father and son, reading Plato in order to prepare themselves for the death that awaited them at a Revolutionary tribune of "le 7 thermidor, An II";[143] and another painting, *L'Affreuse nouvelle*, by a woman, Fanni Ferrey, depicted, less stoically, the sudden grief of a wife who learns, by

André M. de Poncheville, *Louis et François Watteau, dits Watteau de Lille*, Paris, 1928, pp. 89-90.

[141] See above, Chapter I, n. 72.

[142] For a comparable theme of a soldier's *adieux* to his family, but this time in classical guise, see the work of another Lille artist: Wicar, *Le Départ du guerrier* (1792), illustrated and discussed in Fernand Beaucamp, *Le Peintre lillois Jean-Baptiste Wicar (1762-1834)*, Lille, 1939, I, p. 121 and II, p. 637, no. 51.

[143] No. 442. *Tableau de famille. Un père lisant Platon, dit à son fils,* "*Pénétré de ce principe, on ne craint pas la mort.*"—*C'est l'instant où ces deux prisonniers attendaient l'ordre de marcher au tribunal révolutionnaire, le 7 thermidor de l'an 2.*

letter from Nantes, that her husband had been executed there by Revolutionary forces.[144]

These retrospective sorrows, forming a lachrymose countercurrent to the fanatic virtues earlier extolled by David, reached their climax, in classical guise, at the Salon of 1799,[145] where Guérin exhibited his *Return of Marcus Sextus*, a painting he had already begun in 1797 (Fig. 90). The tragic theme, presumably the artist's own invention,[146] imagines a Roman, Marcus Sextus, who returns home after his banishment by the dictator Sulla, only to find his wife dead and his daughter in despair. Such drama apparently provided a classical catharsis for those émigrés who had fled during the Terror and returned to find their homes and families blighted. So fully, in fact, did the theme express the anti-Revolutionary sentiments of the time that the painting was a triumphant success, honored at the Salon by a laurel wreath and a steady stream of pious visitors.[147] And in the same year, 1799,[148] even David revealed, if more implicitly, such an anti-Revolutionary expression in his *Sabines*, a work he had already begun to contemplate during his imprisonment at the Luxembourg in 1794 (Fig. 92). What is notable about this subject is its relative rareness; in place of the familiar Rape of the Sabines, David has chosen the pacific aftermath, the heroic moment when

[144] No. 164. The catalogue goes on to explain: *C'est l'instant où une épouse, entourée de sa famille, apprend, par une lettre, la mort cruelle de son mari, victime d'un jugement révolutionnaire à Nantes.* The dates of Mlle. Ferrey's birth and death are unknown.

[145] No. 153.

[146] That the subject is the artist's own invention is pointed out in C. P. Landon, *École française moderne (Annales du Musée . . .)*, I, Paris, 1832, p. 133.

[147] The crowds of visitors are often mentioned: see *idem, Annales du Musée . . .*, I, Paris, 1801, p. 17; M. E. J. Delécluze, *Louis David, son école et son temps*, Paris, 1855, pp. 211-212; Charles Blanc, "Pierre-Narcisse Guérin," in *Histoire des peintres de toutes les écoles; école française*, III, Paris, 1865, p. 2.

[148] On completion in 1799, the *Sabines* was exhibited at the Palais National des Sciences et des Arts. Later, however, it was re-exhibited at the Salon of 1808 (no. 146) in the company of two of David's Napoleonic paintings (*Le Couronnement* and *Le Portrait en Pied de S. M. l'Empereur*, nos. 144, 145).

Hersilia intervenes between the battling Romans and Sabines and pleads for an end to this internecine bloodshed. The call to arms, the moral idealization of death and sacrifice so conspicuous in the bellicose virility of David's work of the 1780's and early 1790's are now replaced by a veneration of feminine heroism that would cry out with the voice of peace and reconciliation against the folly of war.[149]

The same message had already been related, in less monumental form, in a painting at the Salon of 1798 by Lagrenée *l'aîné*, which controverted the stern lesson of Horatius killing his own sister Camilla. Instead, it depicted the sorrowful story of a soldier who discovers that he has accidentally killed his own brother, who belonged to the enemy army.[150] And earlier, at the Salon of 1795—the first year of the Directoire—Jean-Jacques-François Le Barbier exhibited a painting that commemorated *Le Courage héroïque du jeune Désilles le 30 août 1790 à l'affaire de Nancy* (Fig. 93).[151] Unlike the Revolutionary martyrs worshiped in 1793-1794, Lieutenant Antoine-Joseph-Marc Désilles had sacrificed his life in the interests of peace. To prevent a fratricidal conflict between his mutinous fellow soldiers and the royalist forces that had come to Nancy to suppress them, he vainly attempted to block his own cannon's fire. "Ne tirez pas! ce sont vos amis, nos frères, l'Assemblée Nationale les envoie." Translated into clas-

[149] The iconographical precedents and political implications of this work are discussed more fully in R. Rosenblum, "A New Source for David's *Sabines*," *Burlington Magazine*, CIV, April 1962, pp. 158-162. Incidentally, another link between Rubens and David may be offered by Fragonard's copy after Rubens' *Reconciliation of the Romans and Sabines*, recently acquired by the University of California, Los Angeles, and illustrated in the *Art Quarterly*, XXV, Spring 1962, p. 77.

[150] No. 229. *Deux frères qui s'aimaient tendrement, servaient néanmoins dans deux armées opposées; ils se battirent sans se connaître. L'un d'eux, lorsqu'après la bataille on dépouillait les morts, reconnaît qu'il a tué son frère et s'abandonne à la douleur.*

I have not been able to locate this painting.

[151] No. 303. The Salon catalogue mentions that "ce fait historique de nos jours est si connu qu'on s'est cru dispensé d'en donner les détails." The painting is in the Musée des Beaux-Arts, Nancy; the preparatory drawing (reproduced here), in the Musée Carnavalet, Paris.

sical terms, these are words that were later to be spoken by David's heroic Hersilia.

Such pacifist lessons were taught in many other paintings of the Directoire. For the Salon of 1796,[152] Jean-Joseph Taillasson painted a scene from the exemplary political life of Timoleon, a hero extolled by Plutarch (Fig. 94).[153] A Greek Republican, Timoleon had left his native Corinth for Sicily, after having had his own brother, Timophanes, murdered for fear he was becoming a despot.[154] His hatred of tyranny then led him to expel the younger Dionysius from Syracuse, where he succeeded in establishing a benevolent democracy. In the painting, Timoleon is shown in his blind old age, lovingly cared for by the people of Syracuse, who bring strangers to pay homage to this great leader. With its historicizing efforts to reconstruct a classical Sicilian milieu (the vista of a smoking Mount Etna and the unfluted, baseless Doric order, derived from the Temple at Segesta), Taillasson's painting creates a serene image of a democratic society that, after great strife, has at last been attained.[155] That the stirring story of Timoleon's replacement of a reign of terror with a reign of peace could have immediate allusions to the political realities of the 1790's was more than borne out by the play that

[152] No. 450. *Timoléon à qui les Siracusains amènent les étrangers.*

[153] In addition to Plutarch's life of Timoleon, the Abbé Barthélemy's popular *Voyage du jeune Anacharsis en Grèce* (Paris, 1788) recounts the story of Timoleon (iii, ch. lxiii).

[154] This subject, *La Mort de Timophane*, was popular in the 1790's: Lafond *le jeune* (Salon of 1796, no. 226); A. E. Fragonard (Salon of 1793, supplement, no. 789); Gros (drawing, 1798, Louvre, illustrated and discussed in J.-B. Delestre, *Gros, sa vie et ses ouvrages*, 2nd ed., Paris, 1867, pp. 6off., and J. Guiffrey and P. Marcel, eds., *Inventaire général . . .* , vi, Paris, 1911, no. 4610).

[155] The painting is discussed in Boris Lossky, "Une peinture de Jean-Joseph Taillasson au Musée de Tours," *La Revue du Louvre et des Musées de France*, xi, no. 1, 1961, pp. 35-38, which includes a reproduction of a small oil study for the painting (Musée Ingres, Montauban), in which the Vignolesque architecture has not yet been "primitivized." For further comments on the painting, see Landon, *Annales . . .* , ix, Paris, 1805, p. 145 and pl. 71; and B. Lossky, ed., *Tours, Musée des Beaux-Arts*; *Peintures du XVIII⁰ siècle* (*Inventaire des Collections publiques françaises*, 7), Paris, 1962, no. 107. See also below, p. 126.

undoubtedly inspired Taillasson's painting. With words by Marie-Joseph Chénier and music by Étienne-Nicolas Méhul, the tragedy of *Timoléon*, in which the great Talma played the title role, was performed in 1794 and preceded by an "Ode sur la situation de la République durant l'Oligarchie de Robespierre et de ses complices."[156] The analogies between this contemporary tyrant and the classical ones destroyed by Timoleon were thus made so explicit that the play was quickly banned by the governing Robespierre faction.[157] Like the theater of his Italian contemporary, Vittorio Alfieri (which also included a *Timoleon*),[158] Chénier's tragedies invoked the moral lessons of classical history to comment upon contemporary politics.[159]

The promotion of peaceful, restitutive activities may also be seen on a more homely didactic level in *L'Agriculture*, a painting by Vincent exhibited at the Salon of 1798 (Fig. 95).[160] Here a Rousseauan lesson in agricultural virtue, directly reflecting the ideal education proposed in *Émile*, is given in the appealing guise of a Directoire genre scene set against a Pyrenean landscape near Toulouse. A wealthy merchant from Bordeaux, accompanied by his wife and daughter, takes his son to watch a farmer till the soil. Without this lesson, the Salon catalogue tells us, the

[156] I hope this answers the question posed by Boris Lossky ("Une peinture de Jean-Joseph Taillasson . . . ," p. 38) about the identity of the theatrical source alluded to by a contemporary critic.

[157] The Revolutionary implications of Chénier's play are mentioned in Jack Lindsay, *Death of the Hero; French Painting from David to Delacroix*, London, 1960, p. 99; and discussed in detail in A. J. Bingham, *Marie-Joseph Chénier, Early Political Life and Ideas (1789-1794)*, New York, 1939, pp. 158ff. There is also an earlier French drama based on the life of Timoleon by La Harpe (1764).

[158] It was first published in the Siena edition (1783-1785) of ten plays by Alfieri.

[159] The basic study of Chénier is A. Lieby, *Étude sur le théâtre de Chénier*, Paris, 1902.

[160] No. 425. A comparable scene was exhibited earlier in a drawing at the Salon of 1796 by René Gouzien (no. 199, *Un laboreur, se reposant sur sa charrue, montre à ses enfans l'astre qui fait mûrir les moissons*); and later, at the Salon of 1801, in one of Greuze's last paintings (no. 159, *Un cultivateur remettant la charrue à son fils en présence de sa famille*), now in the Pushkin Museum, Moscow.

son's education would be incomplete: "L'Agriculture est la base de la prospérité des États."[161] In Vincent's painting, the moral admiration of simple agricultural life seen in those late eighteenth century history paintings which had venerated Caius Furius Cressinus or Quinctius Cincinnatus is now transposed to a contemporary genre situation which, in turn, prefigures the virtuous peasant labors humbly recorded by Jean-François Millet.[162]

The détente of the more stoic *exemplum virtutis* in the later 1790's was not to last, for the belligerent and expansive intentions of Napoleon demanded its vigorous revival. As Napoleon's official court painter, David himself could reawaken the Spartan heroism of his Revolutionary paintings in the context of a new political situation. In the *Distribution of Eagles*, exhibited at the Salon of 1810,[163] he commemorates an event of December 5, 1804, that provides the Napoleonic counterpart to the oath taken by the Horatii in a Roman atrium and by the Third Estate in the Salle du Jeu de Paume at Versailles. Now, on the Champ-de-Mars, Napoleon, fresh from his Coronation, distributes imperial eagles to the Grande Armée, which swears by its very life to uphold the principles of the new government (Fig. 96).[164] Yet this new

[161] Vincent's painting is informatively discussed in a most out-of-the-way newspaper: Robert Mesuret, "Jean-Jacques au pieds des Pyrénées," *Le Petit Commingeois* (Toulouse), Nov. 29, 1953, pp. 1, 3. Mesuret not only identifies the family (Bernard Boyer-Fonfrède, a Bordeaux merchant who established a textile factory at Toulouse, and his son, Jean-Bernard) and the circumstances of the commission, but makes the relevant references to *Émile*. Appropriately, the painting was exhibited at the Bibliothèque Nationale for the 250th anniversary of Rousseau's birth, and discussed in the catalogue, *Jean-Jacques Rousseau, 1712-1778*, Paris, 1962, no. 263. For further remarks on Rousseauan influence on the arts in the 1790's, see Paul Vitry, "Les Projets de monuments à la mémoire de J.-J. Rousseau," *Bulletin de la Société de l'Histoire de l'art français, 1912*, Paris, 1912, pp. 250-251, with illustration of Moitte's *L'Éducation d'Émile* (1793).

[162] On representations of the classical agricultural themes, see above pp. 59-61.

[163] No. 188. *Serment de l'Armée fait à l'Empereur après la distribution des aigles au Champ-de-Mars.*

[164] Napoleon's oath was as follows: "Soldats, voilà vos drapeaux, ces aigles vous serviront toujours de point de ralliement, ils seront partout, où votre empereur les jugera nécessaires pour la défense de son trône et de son

moral fervor of patriotic sacrifice is now displayed in a visual
environment that rejects the Spartan simplicity of Revolutionary
ideals. Instead, an aura of extravagance pervades this incredibly
congested scene. A surfeit of spectators and actors, a decor of
gold and velvet pomp contribute to an ambiance that, in keep-
ing with the new imperial symbolism, substitutes the lavishness
of the Roman Empire for the sobriety of the Roman Republic
that dominated Revolutionary imagery.[165]

With such dense and expansive images, which single out a
man of destiny from the teeming crowds around him, Napoleonic
art was dedicated to the myth of an imperial rule embodying
virtues that ranged from the patriotic sacrifice of life to the estab-
lishment of welfare homes. Like the martyr icons of the French
Revolution, the pictorial recording of Napoleonic history was an
attempt to create the image of a new saviour. From the ruins
of the classical and Christian traditions, great themes of benevo-
lence and heroism, both natural and supernatural, were translated
into the secularized experience of the modern world. Thus, the
uncommon virtues associated with, on the one hand, magnani-
mous Roman emperors and, on the other, Christ and Christian
saints were newly attributed to Napoleonic deeds. The pictorial
pageant of Napoleonic history rephrased traditional iconographic
patterns to meet these requirements of modern sanctification.[166]

Baron Gros's two most famous records of Napoleonic mercy
and enlightenment—the scenes of the pesthouse at Jaffa (Fig. 97)
and the battlefields of Eylau—bear out this fresh affirmation of

peuple; vous jurez de sacrifier votre vie pour les défendre, et de les main-
tenir constamment par votre courage sur le chemin de la victoire: vous le
jurez: NOUS LE JURONS." ("Lettre de Louis David," *Archives de l'art
français*; *Documents*, IV, Paris, 1855-1856, pp. 36-37.)

[165] Even when David painted a literally Spartan subject in these years—
the *Leonidas at Thermopylae* (begun in 1800 and completed only in
1814)—his style reflects the profuseness and density of Napoleonic history
painting.

[166] The basic study of the commissions for Napoleonic history painting is
Pierre Lelièvre, *Vivant Denon, Directeur des Beaux-Arts de Napoléon*,
Paris, 1942.

the *exemplum virtutis*. In the *Pesthouse at Jaffa* (Salon of 1804),[167] an ostensibly documentary account of an event of March 11, 1799,[168] Gros draws upon a thematic heritage that may be illustrated most conveniently in two works of Vien considered earlier—*Marcus Aurelius Distributing Food and Medicine* (1765; Fig. 52) and *Christ Healing the Paralytic* (1759; Fig. 47). In both cases, a scene of dire misery is suddenly enlightened by the arrival of a saviour, whether Christian or pagan, who cures through heavenly or earthly means. Already in the later eighteenth century, this respect for humanitarian deeds had been presented in more prosaic documentary terms. One may cite a popular print like *L'Acte d'humanité* (after a painting by Jean Defraine; Fig. 98), which records how in the winter of 1783 a certain Mme. de C*** (of whom modesty forbade full identification) came to the rescue of a sick and starving family in a nearby village;[169] or, less anonymously, a painting of 1787 by Francis Wheatley exhibited at the Royal Academy in 1788, which illustrates the penological reforms of John Howard, who brings material and spiritual comfort to wretched British prisoners (Fig. 99).[170]

In Gros's painting (Fig. 97), this humanitarian tradition, sacred and secular, ancient and modern, is inflated to imperial dimensions. Calm and fearless, Napoleon enters the fetid ambiance of

[167] No. 224. *Bonaparte, général en chef de l'Armée de l'Orient, au moment où il touche une tumeur pestilentielle en visitant l'hôpital de Jaffa.*

[168] For the most recent historical discussion of this event, see J. Christopher Herold, *Bonaparte in Egypt*, London, 1963, pp. 278-279.

[169] I have not been able to locate the exact date or whereabouts of the painting. Little is known about Defraine, who was born in 1754 but whose death date is not given in the standard encyclopedias.

[170] No. 31. *Mr. Howard Offering Relief to Prisoners.* See also the exhibition catalogue, *The First 100 Years of the Royal Academy, 1769-1868*, London, 1951, no. 39. This humanitarian subject was also treated in sculpture by John Bacon and in drawings by George Romney, both of which offer abstract and idealized interpretations of what, in Wheatley's hands, is essentially a genre scene. On the Romney drawings, see the exhibition catalogue, *The Drawings of George Romney*, Smith College Museum of Art, Northampton, Mass., 1962, no. 80.

a pesthouse. Unlike the two generals who accompany him, Berthier and Bessières, he appears to be supernaturally immune to the stench and horror of the scene; indeed, he miraculously perpetuates the legend of the divine touch of kings by extending his healing finger to the bubo of the wretched plague victim.[171] In earthbound contrast to this crypto-Christian miracle, Arabs and French medical officers desperately attempt to provide food and medical care to the rotting patients in the foreground.

A less divine, if no less benevolent, deed is commemorated in Gros's painting for the Salon of 1808 of the equally lurid horrors of Eylau (Fig. 100).[172] Here again, the extremities of human suffering—the frozen bodies of the dead and the dying—are magically alleviated by the arrival of Napoleon, who comes, like a new Trajan or a new Christ, to bestow mercy, tolerance, and wisdom upon the enemy troops. The Christian flavor of this healing of the sick is made more explicit by the crucifixes (at eye level, in the left hand corner) that are administered to the expiring enemies; and the classical allusions of this benevolent conquest are made equally clear by the painting's actual sources in Roman Imperial sculpture[173] and the presumed words of the conquered Lithuanian officer at the left: "Let me live, Caesar, and

[171] The Christian implications of divine healing are discussed in Walter Friedlaender, "Napoleon as Roi Thaumaturge," *Journal of the Warburg and Courtauld Institutes*, IV, 1940-1941, pp. 139-141.

Mrs. Linda Nochlin, of Vassar College, kindly called my attention to a later example of such aristocratic intrusion into a scene of plague: A. Johannot, *Le Duc d'Orléans visitant les cholériques* (1832), Musée Carnavalet, Paris. In fact, such deeds continued to be recorded under the July Monarchy and the Second Empire. See, for example, N. L. F. Gosse, *S. M. La reine des français visitant les blessés de juillet à l'ambulance de la Bourse, le 25 août 1830* (Salon of 1833); and P. F. Guérie, *L'Impératrice Eugénie visitant les cholériques de l'Hôtel-Dieu* (Salon of 1868; Musée de Picardie, Amiens; sketch at Musée du Palais de Compiègne).

[172] No. 272. *Champ de Bataille d'Eylau.* The picture represents the day after the battle, which took place on Feb. 8, 1807.

[173] The Roman Imperial references are discussed in John McCoubrey, "Gros's *Battle of Eylau* and Roman Imperial Art," *Art Bulletin*, XLIII, June 1961, pp. 135-139.

I will serve you as faithfully as I have Alexander."[174] And an even more thoroughgoing classical transformation occurred in a commemorative medallion of 1811 that represented the "Praelium ad Eylau" by showing Napoleon, nude except for the lion's skin of Hercules, triumphant upon the trophies of war and under the inscription, "Constantia Augusti" (Fig. 101).[175]

The same virtuous mixture of Christian mercy and Roman Imperial enlightenment pervades the lesser known pictorial records of Napoleonic history. In the *Rentrée de l'Empereur dans l'île de Lobau, après la bataille d'Esling* (Salon of 1812),[176] the artist, Charles Meynier, records a comparable moment following a bloody French victory of May 22, 1809 (Fig. 102). Scrupulous documentary detail of uniform, topography, portraiture—the heritage of late eighteenth century Historicism—is used by Meynier, as by Gros, to reconstruct history with the ostensible truth of a photograph. But against the indubitable realism of this environment, a scene of lofty morality is played. As in the Neoclassic dramas of David, attention to verisimilitude on a level of commonplace fact is meant to convince the spectator that the dramatic level of uncommonplace moral idealism is equally true. Here, the wounded French soldiers, seen against the vernal panorama of the Danube near Vienna, surge toward the vision of a new saviour, who greets them with outstretched arm, like a Roman lawgiver or a blessing saint. Even the severely wounded are wrenched from their suffering by this benevolent apparition, whom they call "leur ange tutélaire, leur vengeur," while the French medical officers, who provide first-aid of a less spiritual kind, express realistic concern over the violent physical exertion that erupts among their battle-scarred patients.[177]

[174] Cited in the exhibition catalogue, *Gros, ses amis, ses élèves*, Paris, Petit Palais, 1936, no. 40. The Salon catalogue of 1808 describes the event as follows: "Touché de l'Humanité de ce grand monarque, un jeune chasseur lithuanien lui en témoigne sa reconnaissance avec l'accent de l'enthousiasme."

[175] Illustrated in Ernest Babelon, *Les médailles historiques du règne de Napoléon le Grand*, Paris, 1912, p. 285.

[176] No. 645.

[177] This description depends on C. P. Landon, *Salon de 1812 (Annales . . .)*, I, Paris, 1812, pp. 14ff.

Inexhaustible clemency of the kind the late eighteenth century had venerated in its paintings of such noble Romans as Scipio or Trajan, or such noble Frenchmen as Bayard or Henri IV, was attributed also to Napoleon, particularly in his attitude toward an enemy whose benighted ignorance was to be divinely enlightened by the deeds of French conquest.[178] In a painting for the Salon of 1808,[179] Guérin records a precocious demonstration of Napoleonic mercy—the pardoning of the native rebels at the Place d'Elbekir, Cairo, on October 23, 1798. Here a civilized scene of benevolent law-giving through a native interpreter brings peace and order after the bloody insurrection fomented by natives still ignorant, as it were, of the virtues of Napoleonic rule (Fig. 103).[180]

A more dramatic scene of Napoleonic clemency that took place in Madrid, in December 1808, is offered in a painting by Charles Lafond *le jeune* at the Salon of 1810 (Fig. 104).[181] Having

[178] For a useful anthology of Napoleonic virtue as recorded in history painting, see *idem, Recueil des ouvrages de peinture, sculpture . . . cités dans le rapport du Jury sur les prix décennaux, exposés le 25 août 1810, dans le grand salon du Musée Napoléon*, Paris, 1810, pp. 19ff., under the heading "Tableaux représentant un sujet honorable pour le caractère national." Characteristically, this group forms a pendant to a selection of "Tableaux d'histoire," which included primarily scenes from classical history.

At times, Napoleonic virtue could be represented even in the most trivial genre guise, as in a painting by Leroy de Liancourt, at the Salon of 1806 (no. 352): *S. M. l'Empereur visitant les environs du château de Brienne*. The painting (now at Versailles) represents Napoleon's visit to an old lady who had supplied him with eggs when he was a youth at the École Militaire, Brienne-le-Château. Now, despite his imperial glory, he pauses to take two eggs from her as an affectionate reminder of the past. (See Eudoxe Soulié, *Notice du Musée Impérial de Versailles*, 2nd ed., II, Paris, 1860, no. 1705.)

[179] No. 276. *S. M. l'Empereur pardonnant aux révoltés du Caire, sur la place d'Elbekir*.

[180] Among many comparable themes of Napoleonic mercy toward his enemies, see Dunant, *Trait de générosité française* (Salon of 1806, no. 179), in which money is distributed to Austrian prisoners; and Debret, *L'Empereur honorant le malheur des blessés ennemis* (Salon of 1806, no. 131), illustrated in C. P. Landon, *Annales . . .*, XII, 1806, pl. 69.

[181] No. 456. *Clémence de sa Majesté l'Empereur envers Mlle. de Saint-*

joined the Spanish rebels fighting against Joseph Bonaparte, the Duc de Saint-Simon, grandee of Spain, was guilty of a treason punishable by death. His daughter desperately sought an audience with the Emperor in order to plead for her father's life, and finally found him in the middle of military maneuvers. Suddenly pausing before this pathetic spectacle of feminine despair, Napoleon hears her case and assuages her with the presentation of a verdict of clemency which, in fact, had already been given. The startling confrontation of an equestrian ruler by an unhappy woman who asks for, and receives, mercy recalls, of course, the grouping of the Justice of Trajan, as seen, for instance, in the painting by Hallé of 1765 (Fig. 51). Moreover, the dramatic situation itself offers an even closer parallel to another exemplar of Roman virtue illustrated in the late eighteenth century, the story of Metellus saved by his son. In Brenet's painting of this scene, exhibited at the Salon of 1779,[182] we see the merciful Caesar sparing the life of an implacable enemy, the aged Metellus, when this traitor's son, one of Caesar's own judges, pleads for his father (Fig. 105).[183]

Simon, qui demande la grâce de son père. The same subject was painted by Pajou *fils* (Salon of 1812, no. 692), and is illustrated and described in Landon, *Salon de 1812 (Annales . . .)*, I, Paris, 1812, pls. 55, 56, p. 75. A comparable event from Napoleonic history was his granting of mercy to the traitor, the Prince de Hatzfeld, whose wife pleaded for him. It was represented at least three times: Lafitte (Salon of 1808, no. 332); Vafflard (Salon of 1808, no. 587); Boisfremont (Salon of 1810, no. 195). See also Colson, *Entrée du général Bonaparte à Alexandrie, le 3 juillet 1798; sa clémence vers une famille arabe* (Salon of 1812, no. 219), illustrated and discussed *ibid.*, pls. 43, 44, p. 61.

[182] No. 31. *Metellus sauvé par son fils.* The painting is discussed in Marc Sandoz, "Nicolas-Guy Brenet, peintre d'histoire (1728-1792)," *Bulletin de la Société de l'Histoire de l'art français, 1960*, Paris, 1961, pp. 44-45. Another smaller version of the painting, possibly a replica by Brenet, is now in the Musée, Montargis. The story of Metellus is found in Appian, IV, 42.

[183] Such scenes of Roman virtue were exhibited under the Empire as well, when they carried Napoleonic allusions if only by proximity to comparable paintings of contemporary events. See, e.g., Denis-Joseph Abel, *Clémence de César* (Salon of 1808, no. 1), which showed Caesar pardoning his enemy Ligarius.

The contagion of Napoleonic virtue extended even to the public image of Josephine. In a painting at the Salon of 1806 (Fig. 106),[184] again by Lafond, the Empress is shown in an act of Christian mercy that brings up to imperial date the aristocratic lady's act of humanity in the winter of 1783 (Fig. 98). Here the artist documents a newly established *Hospice de la Maternité* at Paris, "une des institutions qui attestent le plus évidemment les bienfaisances du gouvernement." In this home for abandoned children and unwed mothers, the Empress herself appears, offering consolation to these unfortunates, who move toward her in waves of admiration and gratitude. "Un exemple de la plus sublime des vertus," this modern *Caritas* provides the feminine domestic parallel to the Christian mercy bestowed upon the wounded in the Napoleonic battlefields.[185]

Ironically, such images of virtue were soon to be turned to anti-Napoleonic ends. Just as the Bourbon Restoration had substituted the bust of Louis XIV for that of Napoleon in the Neoclassic allegory of Napoleonic magnificence still to be seen in the pedimental sculpture of the East façade of the Louvre,[186] so, too, did it oblige artists to claim a very different dynastic pedigree for humanitarian acts. At the Salon of 1817, the first after Louis XVIII's definitive return from Ghent, Louis Hersent exhibited a

[184] No. 296. *Sa Majesté l'Impératrice, entourée des enfans dont elle a secouru les mères.*

[185] The painting is described in Landon, *Annales du Musée . . .*, XIV, Paris, 1807, p. 13. Such Napoleonic virtue rubbed off on Marie-Louise as well. See Lafond's *Trait de Bonté de S. M. l'Impératrice (Sujet extrait du Moniteur Westphalien)*, at Salon of 1812, no. 522. It is discussed in Landon, *Salon de 1812 (Annales . . .)*, I, Paris, 1812, p. 29.

[186] The group, by François-Frédéric Lemot, was originally entitled *Les Muses, sur l'invitation de Minerve, venant rendre homage au souverain qui a fait achever le Louvre; Cléo tenant le burin de l'Histoire, grave sur le cippe qui porte le buste de l'Empereur: Napoléon le Grand a terminé le Louvre.* The relief is dated 1808, and a drawing of it was exhibited at the Salon of 1810 (no. 9911). It is illustrated and discussed in Landon, *op.cit.*, pls. 58-60, pp. 79ff. Under the Restoration, it was replaced with the inscription, *Ludovico Magno.* (See Stanislas Lami, *Dictionnaire des sculpteurs de l'École française au 19ᵉ siècle*, III, Paris, 1919, p. 308.)

painting that now praises Bourbon charity (Fig. 107).[187] With a political retrospection comparable to that of the Revolution for Republican Rome, the world of Louis XVI is nostalgically reconstructed. The poignant setting is a suburb of Versailles, with snowcovered peasant cottages in the foreground and a chilly vista of the palace in the distance; the time is the particularly severe winter of 1788—Louis's last winter as a king; the action is the merciful distribution of royal alms to Louis's humble neighbors. As a description of 1817 proclaimed, "Quelle famille fut plus féconde en vertus que l'auguste famille des Bourbons! et parmi les vertus qui les feront toujours admirer et chérir, quelle autre a plus de droit à nos hommages que leur bienfaisance envers les malheureux!"[188] Indeed, the spectator of 1817 is assured that this virtuous dynasty will be continued under Louis XVIII; for in the puffy jowls, protruding belly, and gouty stance, the portrait of Louis XVI has been so altered that it might easily be mistaken for that of his more fortunate younger brother.

However, such a revival of monarchical virtue under new political conditions was as feeble as the Bourbon Restoration itself. Napoleonic art marked the epic swansong of the *exemplum virtutis*; and even David, first under Napoleon and then, after 1816, as a voluntary political exile in Brussels, began to controvert completely the stoical reading of antiquity that permitted his art to participate so vigorously in the dynamics of the French Revolution. The classical subjects of his last years—*Cupid and Psyche* (1817), *Telemachus and Eucharis* (1822), *Mars Disarmed by*

[187] No. 414. *Louis XVI distribuant des bienfaits aux pauvres pendant le rigoureux hiver de 1788*. Another scene of Bourbon virtue could be seen at the same Salon (no. 55): Berthon, *Trait de justice de S. M. Louis XVI*. Two interesting later examples of the transformation from Napoleonic to Bourbon justice were exhibited at the Salon of 1822, in this case restating the theme of Napoleon at Jaffa: Guillon-Lethière, *S. Louis visitant et touchant un Pestiféré dans les plaines de Carthage* (no. 657; now at Bordeaux); and Gassies, *S. Louis visitant ses soldats mourant des maladies contagieuses qui ravageaient son armée* (no. 546). Both these paintings are illustrated and discussed in Landon, *Salon de 1822 (Annales . . .)*, Paris, 1822, pls. 17, 36, pp. 31, 61.

[188] Landon, *Salon de 1817 (Annales . . .)*, Paris, 1817, p. 53.

Venus and the Three Graces (1822)[189]—paradoxically revive the eighteenth century mode of the Neoclassic Erotic that his *Horaces, Socrates,* and *Brutus* had seemingly obliterated as decisively as the Revolution had obliterated the *Ancien Régime.* In these late works, the goddess of love dominates the god of war, and a feminine environment of lacquered sensuality and voluptuous abandon replaces the stark ambiance of Spartan virility that pervaded his art of the eighties and early nineties. Ironically, David follows here the effete and precious vision of antiquity explored around 1800 by his most refractory, unpolitically-minded pupils.[190]

For the most vital currents of the nineteenth century, the possibility of a work of art conveying a lesson in morality rapidly weakened. When, in 1840, Eugène Delacroix exhibited the *Justice of Trajan* (Fig. 108),[191] his interpretation could hardly have been more different from Noël Hallé's of 1765 (Fig. 51). The theme, rather than belonging to a didactic, governmental program of Roman emperors performing benevolent deeds, is culled from Antoni Deschamps's new translation of Dante (1829),[192] so beloved by the French Romantics; and the painting, instead of emphasizing the calm and exemplary justice of Trajan, exploits rather the thrilling spectacle of a Roman equestrian pageant suddenly halted by earthly misery in the form of a widow and dead child.[193] If, for Delacroix, a lesson in imperial virtue was subordinate to a dramatic confrontation of Romantic extravagance,

[189] The usual date given for this painting, 1824, has been corrected by Hautecœur (*Louis David,* Paris, 1954, p. 270).

[190] In particular, the debt of David's late work to the early work of his greatest pupil, Ingres, needs further exploration. For some brief, but stimulating remarks on this master-pupil reversal, see the essay by Daniel Ternois, "Ingres et David," in the exhibition catalogue, *Ingres et ses maîtres de Roques à David,* Toulouse, Musée des Augustins, 1955, pp. 13-17.

[191] Salon of 1840, no. 406.

[192] *Purgatorio,* x, lines 76ff. Delacroix's peculiar choice of Dante as a source for Trajanic history is discussed in Irène de Vasconcellos, *L'Inspiration dantesque dans l'art romantique français,* Paris, 1925, pp. 52ff.

[193] For further remarks on this theme, see Jean Seznec, "Diderot and the Justice of Trajan," *Journal of the Warburg and Courtauld Institutes,* xx, 1957, pp. 106-111.

for his critics, the overriding question posed by the painting concerned the pinkish tones of the horse. In Baudelaire's defense of Delacroix's right to paint a horse any color he wished, new problems of an aesthetic order obscured the moral aspects only dimly implicit now in Delacroix's subject.[194]

To be sure, the virtuous deeds of a historical past and present continued to be recorded throughout the nineteenth century. On other occasions, Delacroix himself painted such subjects as Hippocrates Refusing the Gifts of Artaxerxes, the Death of Seneca, or a group of illustrious Romans that included the frugal Cincinnatus and the heroic Cato and Portia,[195] yet these heroes, in general, become either vehicles for a scene of murky Romantic drama or mere enumerations in an encyclopedic compendium of history.[196] And in the domain of academic art, the *exemplum virtutis* was most often reduced to either an inert textbook illustration or an excuse for the kind of sensationalism found in Joseph Sylvestre's Rubensian *Death of Seneca* of 1875,[197] which has as little moral content as a photograph of a display in Mme. Tussaud's Chamber of Horrors (Fig. 109).

Perhaps only once again in the nineteenth century was youthful and rebellious art to consider seriously the *exemplum virtutis*

[194] For Baudelaire's rebuttal of Alphonse Karr's complaints about the horse's unnatural color, see "Exposition Universelle, 1855, Beaux-Arts," *Curiosités esthétiques*, ed. Henri Lemaitre, Paris, 1962, p. 233. Another reference to Karr's comments is made in Baudelaire's "Salon of 1859," *op.cit.*, p. 336.

[195] These subjects are included in Delacroix's decorations for the Bibliothèques at the Palais Bourbon (1838-1847) and Palais du Luxembourg (1845-1847). For further comments on these schemes, see Maurice Sérullaz, *Les Peintures murales de Delacroix*, Paris, 1963, pp. 49-78, 85-110. Delacroix's easel paintings similarly included such classical moralities as the *Death of Cato* (1824; Musée Fabre, Montpellier) and the *Death of Marcus Aurelius* (1845; Musée des Beaux-Arts, Lyon).

[196] As exemplified even more characteristically in Chenavard's program for the decorations of the Panthéon. On this, see the chronological list in Joseph C. Sloane, *Paul Marc Joseph Chenavard, Artist of 1848*, Chapel Hill, N.C., 1962, pp. 196ff., a list which includes many of the major Neoclassic moralities (e.g., *Socrates* and *Brutus*).

[197] Exhibited at the Salon of that year (no. 1863).

as a major aspect of its program. Like the Neoclassic reformers who opposed Rococo decadence through morally edifying narrative and artistically truthful style, the Pre-Raphaelite Brotherhood of 1848 sought out painted remedies to the moral diseases of a godless Victorian England. In what is probably the most fervent proclamation of the group, Holman Hunt's *Awakening Conscience* of 1853, a drama of sexual morality is conveyed through an equally "moral" style (Fig. 110).[198] Here in a sitting room in St. John's Wood, London, whose dense contents combine, with Eyckian intensity, both microscopic truth of detail and moral symbolism in secular guise, a Victorian woman is suddenly seized by the overwhelming revelation that her adulterous life is evil. Yet this *exemplum virtutis*, designed to burn an indelible lesson into the spirit of the spectator, is of a very different order from the heroic virtue of a Socrates, a Brutus, or a Leonidas. It recalls, rather, a philosophy professor's unforgettable quip that whereas in antiquity and the Renaissance, *virtus* meant virility in a man, in the Victorian period, it only meant chastity in a woman.[199]

Indeed, by the 1860's, the definitive assault was made upon the idea that a work of art could exist primarily as a conveyor of absolute moral values. In 1867, Edouard Manet painted the death of the ill-fated Austrian archduke Maximilian, whose execution at the hands of a Mexican firing squad on a sunny June morning of 1867 was considered a barbarous outrage to civilized standards of political morality (Fig. 111).[200] Yet Manet conceived this horrific event in terms that evoke no moral standards at all. Instead of the heroism of Seneca, Cato, or Marat, there is only a kind of moral anaesthesia, an emotional nullity that, at least for

[198] Exhibited at the Royal Academy, 1854. Ruskin's famous analysis of the disguised symbolism in this painting (letter to *The Times*, May 25, 1854) is most conveniently reprinted in *The Art Criticism of John Ruskin*, ed. Robert L. Herbert, New York, 1964, pp. 398-400.

[199] The quip is cited in William Barrett, *Irrational Man*; *A Study in Existential Philosophy*, New York, 1958, p. 177.

[200] The best study of the *Execution of Maximilian* is found in Nils Sandblad, *Manet*; *Three Studies in Artistic Conception*, Lund, 1954, pp. 109-158.

mid twentieth century spectators, is perhaps more moving, because it is now more true, than the paragons of courage and mercy who were heroized in the art of the late eighteenth and early nineteenth centuries. Just as he had destroyed so many other fixed values of the Western tradition, Manet here annihilates once and for all any accepted system of Christian or classical morality. As such, Manet's painting introduces the moral conditions—or absence of them—that still prevail in Western art and history.

III

ASPECTS OF NEOCLASSIC ARCHITECTURE

FROM the mid eighteenth century on, Historicism pervaded architecture as thoroughly as it had the other arts. In fact, this new viewpoint has usually been pointed out more clearly in histories of architecture[1] than in histories of painting and sculpture, where concentration upon individual masters of genius has often meant that questions of basic historical change around 1800 have been neglected. The frequently composite architectural images of the period may well have contributed to the greater awareness of Historicism in architecture than in painting and sculpture, for these offer some of the most vivid demonstrations of the new approach. In two works that roughly bracket, chronologically speaking, the core of this essay—Sir William Chambers' designs of 1763 for the pavilions at Kew Gardens,[2] as later recorded by Sir John Soane (Fig. 112),[3] and the *Architect's Dream* of 1840, a painted fantasy by the American, Thomas Cole (Fig. 113)[4]—the essentials of Historicism are indelibly presented.

[1] For English-speaking readers the term has become familiar through the many editions of Nikolaus Pevsner, *An Outline of European Architecture* (1st ed., London, 1943), in which Chapter VIII is entitled, "The Romantic Movement, Historicism, and the Beginning of the Modern Movement."

[2] For Chambers' own publication of Kew, see his *Plans, Elevations, Sections, and Perspective Views of the Gardens and Buildings at Kew in Surrey*, London, 1763. This does not, however, include a composite illustration of the various pavilions.

[3] This drawing, by Soane and his pupils, is found in Sir John Soane, *Lectures on Architecture*, ed. Arthur T. Bolton, London, 1929, pl. 84. The discussion of Kew (p. 183) comes from Lecture X, read on March 9, 1815.

[4] On this painting, executed for the architect Ithiel Town and exhibited at the National Academy of Design in 1840 (no. 93), see Louis L. Noble, *The Life and Works of Thomas Cole*, ed. Elliott S. Vessell, Cambridge, Mass., 1964, pp. 212-213; and the exhibition catalogue, *Thomas Cole, 1801-1848; One Hundred Years Later*, Hartford, Wadsworth Atheneum, 1948, p. 30, no. 36. Cole's friend, the poet William Cullen Bryant, described the painting as "an assemblage of structures, Egyptian, Grecian, Gothic, Moorish, such as might present itself to the imagination of one who had fallen asleep after reading a work on the different styles of architecture." (Noble, *op.cit.*, p. 213.)

Whether in terms of diminutive caprices for a royal garden in the suburbs of London or a grandiose Romantic reverie upon long-lost civilizations, both the drawing and the painting display an encyclopedic variety of architectural styles culled from other times and other places. Greek and Gothic, Egyptian and Turkish, Roman and Hindu—these diverse worlds could be newly evoked and reconstructed through increasingly learned means, just as the paintings of the period could not only begin to mimic styles as unlike as those of Rubens and Poussin, Terborch and Caravaggio, Perugino and Van Eyck,[5] but could also begin to conjure up, through accuracy of costume, decor, landscape, and architecture itself, civilizations as different as Renaissance Italy and Ancient Britain.[6]

Yet among these multiple possibilities, it was the formal and associative power of the Greco-Roman tradition that still dominated architectural practice around 1800, much as it had since Brunelleschi. The experience of that tradition, however, was tremendously enlarged in the late eighteenth century. For one thing, the archeological zeal of the period produced in its new publications a vast panorama of Greco-Roman architecture whose unsuspected diversity of style offered a maximum of fresh interpretative possibilities.[7] Just as the antique painting examined by

[5] Thus, the paintings of David alone imitate, in varying degree, the styles of all of these masters (not to mention the various styles of Greek and Roman art); and this same eclecticism (to borrow the term usually employed for the revival styles in architecture) can be found in other masters of the late eighteenth century and the early nineteenth (e.g., West and Ingres, whose ability to change from one pictorial style to another already prophesies Picasso's attitude toward the history of art).

[6] As discussed above, pp. 34ff. Needless to say, the construction of, say, Ancient Britain, was more speculative than that of Renaissance Italy, but it was nevertheless attempted by the inclusion of Stonehenge-like buildings in James Barry's *Death of Cordelia* (Tate Gallery, London, formerly Grittleton House, Gloucs.).

[7] Among the most famous of these mid eighteenth century publications are: Julien David Leroy, *Les Ruines des plus beaux monuments de la Grèce*, Paris, 1758; James Stuart and Nicholas Revett, *The Antiquities of Athens*, London, 1762-1816; John Berkenhout, *The Ruins of Paestum or Posidonia*, London, 1767; Thomas Major, *The Ruins of Paestum, otherwise*

the eighteenth century could range from the rudimentary linear and chromatic means of Greek black- and red-figured vases to the virtuoso illusionism of Roman frescoes, so too did the newly exposed architectural styles extend from the primitive Doric order of Paestum to the Baroque complexities of Split. Moreover, these new stimuli were absorbed by architects and patrons who explored the complex experiences, public and private, that attended the origins of modern history. Indeed, the late eighteenth century readings of Greco-Roman architecture were susceptible to as great a flexibility of formal vocabulary and emotional evocation as found in the painting and sculpture of the period. Piquant modishness, Romantic nostalgia, Utopian purism, political propaganda, encyclopedic learning, the delights and terrors of the primitive—these were some of the potential ends sought out, singly and in combination, by that enormous and diverse body of architecture loosely known as Neoclassic.

One of these potentials involved the inspiration of antiquity as essentially an up-to-date fashion that knowledgeably reflected the late eighteenth century's archeological revelations. Robert Adam's many transformations of pre-existing buildings offer this kind of grafting of classical allusions to outmoded forms. Such is the case in Osterley Park, where Adam's remodeling, begun in 1761 for Francis Child, provided, as it were, a stylish new costume for an Elizabethan house (Fig. 114).[8] Here the double portico, which interrupts an old red-brick wall with an elegant white temple front, pays explicit homage to John Wood's publication of the Temple of the Sun at Palmyra.[9] Like Vien's contemporaneous

Posidonia, in Magna Graecia, London, 1768; *Suite des plans, coupes, profils, élévations géometrales . . . des trois temples . . . de Paestum . . . mesurés et dessinés par J.-G. Soufflot . . . en 1750 et mis au jour par les soins de G. M. Dumont en 1764*, Paris, 1764; John Wood, *The Ruins of Palmyra*, London, 1753; Giovanni Battista Piranesi, *Della magnificenza ed architettura de' romani*, Rome, 1761; Robert Adam, *The Ruins of the Palace of the Emperor Diocletian at Spalatro in Dalmatia*, London, 1764.

[8] For a detailed description of Osterley Park, see Arthur T. Bolton, *The Architecture of Robert and James Adam*, i, London, 1922, pp. 279-302.

[9] The quotations from Palmyra, however, are by no means so literal as the Adam literature would suggest. James Lees-Milne (*The Age of Adam*,

Marchande à la toilette (Fig. 1), Adam's new façade could win admiration not only for its learned allusion to the Greco-Roman past, but for the simple clarity of its sober forms. After visiting it in 1773, Horace Walpole remarked, with up-to-date archeological reference, that the double portico was "as noble as the Propyleum of Athens."[10] Adam's portico, however, had as little to do with the severity of fifth century Greek Doric as Vien's painting had to do with the austere pictorial means of fifth century Greek vases. Like so much Neoclassic painting of the 1760's and 1770's, its delicacy of proportion and refinement of detail are still reminiscent of the earlier eighteenth century. It is revealing that one of the painters who often collaborated with Adam was Angelica Kauffmann, who, like Vien, perpetuated aristocratic Rococo sensibilities in antique guise.[11] And in the interiors at Osterley, this modish redecorating *all'antica* reached an even more explicit statement of this hybrid Rococo Neoclassicism. In the Etruscan Room (Fig. 115),[12] begun in 1775,[13] complex classical arabesques,

London, 1947, p. 106) says that the portico depends upon the entrance to the court of the Temple of the Sun (i.e., pl. IV, in John Wood, *op.cit.*) and this is repeated by John Summerson (*Architecture in Britain, 1530 to 1830*, London, 1953, p. 267). Pevsner, though, emphasizes the unclassical character of the portico in *Middlesex* (*The Buildings of England*) (Harmondsworth, 1953, p. 128); and, in the fourth revised edition (1963) of his Pelican volume, Summerson refers to the Portico of Octavia, Rome, rather than to Palmyra as the source for the Osterley portico (p. 264). Both these Roman porticoes, however, use the Corinthian order rather than Adam's curiously spindly, elegant, and unclassical Ionic order; though the general idea of a double portico and the particular proportions of the pediment may well be stimulated by John Wood's publication of Palmyra. More explicitly dependent upon a Palmyran source are the octagonal decorations in the Osterley soffit, which, as Lees-Milne points out (*loc.cit.*), derive from Wood's engraving of the "soffit of the side door" (i.e., pl. VIII).

[10] In a letter to the Countess of Ossory, June 21, 1773. See Peter Cunningham, ed., *The Letters of Horace Walpole*, v, London, 1891, pp. 474-475.

[11] She was involved, for instance, in the decoration of Harewood House, the Adelphi, Osterley Park, Chandos House. For comments on her decorative work, see Lady Victoria Manners and Dr. G. C. Williamson, *Angelica Kauffmann, R.A., Her Life and Works*, London, 1924, pp. 129-137.

[12] Adam's description of his "Etruscan style" is found in *The Works in*

chastened to a greater flatness and linearity, still enliven entire wall surfaces with a thin and restless pattern that suggests a series of Rococo panels, ironed out in depth and in contour and brought up to archeological date by presumably Etruscan references.

An archeological revision of a different sort occurred in several Parisian churches, of which the most notable is St. Médard (Fig. 116).[14] In 1784, the architect Louis-François Petit-Radel[15] (who so strongly opposed the Gothic style that he later submitted a scheme for destroying a Gothic church by fire in less than ten minutes)[16] modernized the choir of this late Gothic building by the remarkably simple device of adding fluting and primitive capitals to the stumpy shafts of pre-existing Gothic columns. By this means, the Gothic, a style outdated and frequently scorned

Architecture of Robert and James Adam, II, London, 1779, preface. For illustrations of the Etruscan bedroom at Home House, 20 Portman Square, see Bolton, *op.cit.*, II, p. 92. For some succinct comments on the style, see F. Saxl and R. Wittkower, *British Art and the Mediterranean*, London, 1948, no. 73, 3.

[13] See Bolton, *op.cit.*, p. 286. It was apparently completed before July 16, 1778, when Walpole described it in a letter to the Reverend W. Mason (*ibid.*).

[14] For the history of this church, see Amédée Boinet, *Les Églises parisiennes*, I, Paris, 1958, pp. 348ff.; and C. Manneville, *Saint-Médard*, Paris, 1906. An earlier example of such "Doricizing" modernization is found in St.-Nicolas-des-Champs, Paris, where the columns of the Gothic choir were given the detailing of a fluted Doric order under Louis XV (see *Inventaire général des richesses de la France: Paris, Monuments réligieux*, III, Paris, 1901, p. 399; and Boinet, *op.cit.*, I, p. 325).

[15] For further information on Petit-Radel, see Adolphe Lange, *Dictionnaire des architectes français*, II, Paris, 1872, p. 202.

[16] Lange (*ibid.*) and, following him, Manneville (*op.cit.*, p. 19 n. 1) state incorrectly that this was proposed at the Salon of 1806. It was, rather, at the Salon of 1800, no. 516: *Destruction d'une église, style gothique, par le moyen du feu*. The full pyrotechnical details are given as follows: "Pour éviter les dangers d'une pareille opération, on pioche les pilliers à leur bases sur deux assises de hauteur; et à mesure que l'on ôte la pierre l'on y substitue la moitié en cube de morceaux de bois sec, ainsi de suite; dans les intervalles, l'on y met du petit bois, et ensuite le feu. Le bois, suffisamment brûlé, cède à la pesanteur; et tout l'édifice croule sur lui-même en moins de dix minutes."

in the late eighteenth century,[17] was ingeniously transformed into an arcade of squat and baseless Greek Doric columns that imitated such problematic new forms as those explored at Paestum.[18]

These new forms were subject to interpretations far more searching than Adam's or Petit-Radel's. If Greco-Roman architecture could be used for modish modernization that appealed to educated taste, it could also be used to explore new dimensions of Romantic feeling and imagination. On the one hand, the greatly publicized ruins of Greece and Rome could stimulate a retrospective nostalgia for a lost, irretrievable past; and, on the other, a prospective Utopianism that would heroically attempt to reconstruct these remote glories in the service of modern history.

The former kind of emotion, melancholic and passive, may be introduced here by the frontispiece[19] to the Comte de Volney's great study of 1791,[20] whose title—*Les Ruines, ou Méditations sur les révolutions des empires*—exemplifies a major late eighteenth century reading of classical architecture (Fig. 117). Here, perched on a hillside, the author contemplates the very ruins at Palmyra that had earlier provided Robert Adam with fashionable motifs for aristocratic country houses. Volney's own words epitomize the hypnotic power such ruins could exert upon another kind of eighteenth century sensibility: "L'aspect d'une grande cité déserte, la mémoire des temps passés, la comparaison de l'état présent, tout éleva mon coeur à de hautes pensées. Je m'assis sur le tronc d'une colonne; et là, le coude appuyé sur le genou, la tête soutenue sur la main, tantôt portant mes regards

[17] For a survey of eighteenth century attitudes toward the Gothic, see Paul Frankl, *The Gothic, Literary Sources and Interpretations through Eight Centuries*, Princeton, 1960, pp. 370-414. A handy anthology of anti-Gothic comments of the late eighteenth century is provided in Wolfgang Herrmann, *Laugier and Eighteenth-Century French Theory*, London, 1962, pp. 235-236.

[18] And presented in such publications as those listed above, Chapter III, note 7.

[19] This engraving is by P. Martini.

[20] For a recent discussion of *Les Ruines*, see Jean Gaulmier, *Volney; un grand témoin de la Révolution et de l'Empire*, Paris, 1959, pp. 112-128.

sur le désert, tantôt les fixant sur les ruines, je m'abandonnai à une rêverie profonde."[21] It is the same image of meditation upon a lost classical past that pervades Wilhelm Tischbein's renowned portrait of Goethe in the Roman campagna at the end of his Italian sojourn of 1786-1787 (Fig. 118).[22]

The combination of archeological curiosity and Romantic emotion suggested in these meditative portraits of Volney and Goethe is borne out most evocatively in Hubert Robert's and Giovanni Battista Piranesi's visions of the crumbling relics of Greek and Roman architecture.[23] In an etching of the ruins of Paestum (1778), Piranesi views these temple fragments very differently from Petit-Radel in his modernization of St. Médard (Fig. 119). Like Robert's painted record of temple ruins (Fig. 120),[24] Piranesi's etching interprets these forms not as the purveyors of a lucid and elementary geometric order, but rather as a stirring spectacle of transience and decay. Like their contemporary, the historian Edward Gibbon,[25] Robert and Piranesi envision these mementos of an antique past in terms of an organic metaphor, a civilization that has lived and died and is now left to be devoured by time and nature. Potentials of formal and structural clarity inherent in studies of such temples are thoroughly ob-

[21] *Les Ruines* . . . , p. 5.

[22] The fullest, most up-to-date study of this portrait is Christian Beutler, *J. H. W. Tischbein, Goethe in der Campagna (Werkmonographien zur bildenden Kunst in Reclams Universal-Bibliothek*, nr. 83), Stuttgart, 1962.

[23] For an important recent analysis of Piranesi's view of these ruins, see Karl Lehmann, "Piranesi as Interpreter of Roman Architecture," in the exhibition catalogue, *Piranesi*, Smith College Museum of Art, Northampton, Mass., 1961, pp. 88-98. For a more specific study of the interpretation of Paestum by Piranesi and others, see S. Lang, "The Early Publications of the Temples at Paestum," *Journal of the Warburg and Courtauld Institutes*, XIII, Jan.-June 1950, pp. 48-64.

[24] Robert's painting (Musée de Picardie, Amiens) may depend on G. M. Dumont's engraved frontispiece illustration of the basilica at Paestum in Soufflot's publication of these temples cited above (note 7): *Suite des plans, coupes, profils*. . . .

[25] The six volumes of Gibbon's *Decline and Fall of the Roman Empire* appeared during the highest flourishing of these images of classical ruins (1776-1788).

scured here by the oblique perspectives, the capricious luminary patterns, the scattered distribution of meandering, Lilliputian figures. What to others could be interpreted as a noble, regenerative image of geometric purity is here transformed by soggy atmosphere, porous stone, and rampant underbrush into a sadly mouldering labyrinth.

These tragic visions of the ultimate physical expiration of a dead civilization were often recreated in late eighteenth century gardens. There, wealthy patrons of Romantic sensibility could revive, in private meditation, the lost world evoked by classical ruins. So it was at the Parc Monceau in Paris, designed between 1773 and 1778 by Louis de Carmontelle[26] for Philippe d'Orléans, Duc de Chartres. In his description of this "jardin pittoresque," published in 1779,[27] Carmontelle refers to the changing sets of an opera as a parallel to the evocative possibilities of a garden design that offers "un pays d'illusions." Like the shifting milieux of the history painting of the late eighteenth century, the Parc Monceau's imaginative landscape was to recall "tous les temps et tous les lieux";[28] and its *fabriques* ranged from Tartar tents and Dutch windmills to the ruins of a Temple of Mars[29] and, still standing today, a screen of Corinthian columns traditionally identified as remnants of a rotunda designed to contain the mausoleum of Henri II but which, in imagination, were to be transformed into a "Naumachie," a basin for Roman naval com-

[26] On Carmontelle, see the exhibition catalogue, *Louis de Carmontelle, lecteur du Duc d'Orléans*, Paris, Galerie André Weil, 1933.

[27] *Jardin de Monceau, près de Paris, appartenant à son altesse sérénissime Monseigneur le Duc de Chartres*, Paris, 1779.

[28] The exact quotation follows: "Si l'on peut faire d'un Jardin pittoresque un pays d'illusions, pourquoi s'y refuser? On ne s'amuse que d'illusions, si la liberté les guide, que l'Art les dirige, et l'on ne s'éloignera jamais de la nature. . . . Transportons, dans nos Jardins, les changements de scène de l'Opéra; faisons-y voir, en réalité, ce que les plus habiles Peintres pourroient y offrir en décorations, *tous les temps et tous les lieux*." (*Ibid.*, p. 4.)

[29] The imaginary ruins of the Temple of Mars are evocatively described as follows: "Ce Temple paroît avoir été quarré, et avoir eu un péristille, dont on retrouve deux parties." (*Ibid.*, p. 8.)

bats.[30] The flavor of historical fantasy to be conjured up by the Duc's "pays d'illusions" is best seen in Gabriel de Saint-Aubin's painting of the garden (1778),[31] where the hazy atmosphere and blurred architectural fragments offer the nebulous stimuli for a late eighteenth century daydream or, in fact, an early nineteenth century one (Fig. 121). For the last painting in Thomas Cole's historical cycle, The Course of Empire (1833-1836), appropriately entitled *Desolation* (1836), still clings, though with a more inflated rhetoric, to the kind of imagery that permitted the Duc de Chartres to evoke a *naumachia* in his mind's eye (Fig. 122).[32]

Given a sufficiently Romantic patron, this subjective consideration of the classical past could reach astonishing extremes. Such a man was the elegant and wealthy François Racine de Monville, whose eccentricities included a devotion to archery rare in his time. On a solitary plain near Chambourcy, this admirer of things English designed a *jardin à l'anglaise* that came to be known as the Désert de Retz.[33] Among his garden *fabriques*, which included a Chinese pagoda,[34] the most unforgettable is

[30] For a description of the Naumachie, see *ibid.*, p. 9.

[31] For further remarks on this painting, see Émile Dacier, *Gabriel de Saint-Aubin, peintre, dessinateur et graveur (1724-1780)*, Paris, 1929, I, pp. 42-43 and II, no. 555.

[32] Cole's conception of this last painting in the cycle is found in Noble, *op.cit.*, p. 130: "The fifth must be a sunset,—the mountains riven—the city a desolate ruin—columns standing isolated amid the encroaching waters— ruined temples, broken bridges, fountains, sarcophagi, &c.—no human figure—a solitary bird perhaps: a calm and silent effect. The picture must be as the funeral knell of departed greatness, and may be called the state of desolation."

For a popular and well-informed presentation of Cole's cycle, see Marshall Davidson, "Whither the Course of Empire?" *American Heritage*, VIII, no. 5, Oct. 1957, pp. 52ff.

[33] For some studies of this garden, see: R. Lécuyer and J.-Ch. Moreux, "Le Désert de M. de Monville," *L'Amour de l'art*, XIX, no. 3, April 1938, pp. 119-126; Osvald Sirén, "Le Désert de Retz," *Architectural Review*, CVI, Nov. 1949, pp. 327-332; and Cyril Connolly and Jerome Zerbe, *Les Pavillons; French Pavilions of the Eighteenth Century*, London, 1962, pp. 150ff. The garden was called "Le Désert de Raye" at the end of the eighteenth century, but the spelling was later changed to "Retz." (Lécuyer and Moreux, *op.cit.*, p. 122.)

[34] The earliest and fullest illustrations of the entire garden (26 plates)

one designed in 1771: an enormous broken column, some fifteen meters in diameter, that resembles the overgrown stump of a ruined classical shaft in a Piranesi print (Fig. 123). Yet unlike a classical column, Racine de Monville's was not only fenestrated but actually contained four stories of highly specialized rooms that permitted aristocratic habitation of, and therefore the most intense empathy with, a fictional relic of a classical past.[35]

Almost as fractured and overgrown was the contemporaneous Temple de la philosophie moderne at Ermenonville,[36] the park of another Romantic aristocrat, the Marquis René de Girardin, most famous as a patron and disciple of Rousseau (Fig. 124). Again, this garden *fabrique*, designed about 1780, recreates in real leaf and stone the many picturesque views of actual archeological sites by late eighteenth century artists: Joseph Vernet's sketch of the *Temple of the Sibyl at Tivoli* is a typical case in point (Fig. 125).[37] In the *Temple* at Ermenonville, however, the sad spectacle of the works of man slowly being absorbed by the organic forces of nature produced a remarkable Romantic conceit. The six standing columns are each dedicated to a famous modern philosopher—Newton, Descartes, Voltaire, Penn, Montes-

are found in George-Louis Le Rouge, *Jardins Anglo-Chinois*, xiiie cahier, Paris, 1785. Pls. 4-8 are of the column house.

[35] Appropriately enough this *jardin à l'anglaise* later passed into English hands when it was taken over, in 1792, by Disney ffytche (Paul Jarry, *La Guirlande de Paris, ou Maisons de Plaisance des environs, au XVIIe et au XVIIIe siècle*, Paris, 1931, p. 7). It may be worth noting that the idea of a column-building survived into the twentieth century in Adolf Loos' design for the Chicago Tribune Competition of 1922 (illustrated in *The International Competition for a New Administration Building for The Chicago Tribune*, Chicago, 1923, p. 196).

[36] The park is described in the Marquis de Girardin, *Promenade ou itinéraire des jardins d'Ermenonville*, Paris, 1788 (engravings by Mérigot *fils*). The Marquis' name is often spelled Gérardin in eighteenth century texts.

[37] This classical ruin, so well known through Piranesi's prints, was often drawn and painted in the late eighteenth century. Other examples include those by Fragonard, illustrated in M. L. Cornillot, *Collection Pierre-Adrien Pâris, Besançon* (*Inventaire général des dessins des Musées de Province*, I), Paris, 1957, no. 34; and by Hubert Robert, illustrated in Pierre de Nolhac, *Hubert Robert, 1733-1808*, Paris, 1910, facing p. 30.

quieu, and Rousseau—whereas the three remaining columns that would complete this peripteral temple lie on the ground, presumably waiting to be revived by the great philosophers of the future.[38]

No less evocative was the tomb of Rousseau himself (Fig. 126). Isolated on an island of poplar trees, this classicizing tomb could be glimpsed from the shore as if it were a fragment of antique marble just visible within a landscape by Hubert Robert, who in fact participated in its design.[39] The tomb's power to stimulate meditations upon the greatness of the man buried on this lonely island was attested to by the many late eighteenth century visitors who came to pay contemplative homage to Rousseau, a list that included Benjamin Franklin, Gustave III of Sweden, Joseph II of Austria, and an anonymous English visitor who, overcome by emotion, swam over to the tomb and wept upon it.[40]

The power of such symbolic stones to conjure up Romantic ruminations upon irretrievable greatness was borne out as well in many paintings of the late eighteenth and early nineteenth centuries. It may be seen, for instance, in Joseph Wright of Derby's haunting pictorial record of a Roman tumulus viewed by full moonlight in the Bay of Naples (1779; Fig. 127).[41] According to legend, this was the tomb of Virgil himself, which, according to further legend, was visited by Silius Italicus, a later Roman poet who venerated the great master. In Wright of

[38] For a full description of this melancholic prospection, see the Marquis de Girardin, *op.cit.*, pp. 37-40.

[39] *Ibid.*, pp. 26-27. The tomb sculptures were by Jacques-Philippe Lesueur, and were exhibited, in the form of a plaster model, at the Salon of 1791 (no. 460). The inscriptions read: *Vitam impendere vero* and *Icy repose l'homme de la nature et de la vérité.*

[40] Anecdotes about both illustrious and anonymous visitors to Ermenonville are conveniently recounted in *Promenades à Ermenonville et à ses environs*, Paris, Touring Club de France, 1954, pp. 15, 16, 23.

[41] On Wright's painting and its variants, see the exhibition catalogues: *The Romantic Movement*, London, Arts Council of Great Britain, 1959, no. 378; and *Joseph Wright of Derby, 1734-1797*, London, Arts Council of Great Britain, 1958, no. 17.

Derby's painting a topographically precise landscape simultaneously records an archeological fact and conjures up an eerie vision of a classical past; for within the illuminated tumulus, the figure of Silius Italicus can be seen engrossed in his Virgil.

The same geographical region, so rich in classical ghosts, sets the stage for a later Romantic generation's evocation of the classical past, the generation of Mme. de Staël and Chateaubriand. In a painting at the Salon of 1822[42] inspired by Mme. de Staël's novel, *Corinne* (1807), Gérard shows us the heroine at Cape Miseno (Fig. 128). Like Chateaubriand conjuring up the pageantry of ancient Rome from the spectacle of a July sunset seen from the Coliseum in 1803,[43] or Shelley musing over "the wrecks of what a great nation once dedicated to the abstractions of the mind,"[44] Corinne resurrects haunting memories of a dead past. Dressed *all'antica*, holding a Greek lyre, and seated upon the remnants of a Doric column, this modern sibyl transfixes her audience by singing of her antique prototype, the Cumaean sibyl, as well as of the ghost of Tasso and the fabulous history of Rome.[45]

If the antique stones experienced in these ruins tended to elicit private meditations of an imaginative, retrospective nature, many other interpretations were also possible. Even in certain artificial ruins designed for late eighteenth century gardens, a different experience of the classical past can be sensed. In two

[42] No. 569. Another painting of this subject by Léopold Robert was exhibited at the same Salon (no. 1098).

[43] In a letter of Jan. 10, 1804, to M. de Fontanes, describing an experience of the previous summer. For a recent critical edition of this famous letter, see J.-M. Gautier, ed., *Chateaubriand, Lettre à M. de Fontanes sur la campagne romaine*, Geneva, 1951. For other remarks by Chateaubriand on ruins, see *Le Génie du christianisme* (1802), 3ᵉ partie, livre v, chs. III, IV.

[44] In a letter to Thomas Love Peacock (Naples, Dec. 22, 1818). See *Essays, Letters from Abroad, Translations and Fragments*, ed. Mrs. Shelley, II, Philadelphia, 1840, p. 121.

[45] For an admirably thorough discussion of Gérard's painting, see Madeleine Vincent, *La Peinture des XIXᵉ et XXᵉ siècles* (*Catalogue du Musée de Lyon*, VII), Lyons, 1956, pp. 13-17. See also the exhibition catalogue, *The Romantic Movement*, London, Arts Council of Great Britain, 1959, no. 174.

fabriques of the 1780's—the Laiterie at Rambouillet (1784) by Thévenin (Fig. 129)[46] and the Folie Sainte-James at Neuilly (1778-1785) by François-Joseph Belanger (Fig. 130)[47]—the organic power of nature is again contrasted to the geometric figurations imposed by man, yet the balance between these opposing forces is now more even than in the garden *fabriques* at Ermenonville or the Parc Monceau. The entirety of a coffered Roman barrel vault or a Greek Doric tetrastyle portico can be seen here in a more energetic contrast to the wild nature that intrudes upon them; indeed, the lucid regularity of these spherical and cylindrical shapes has a vigorous quality that firmly opposes the formal and textural irregularities of cascading stones, shadowy grottoes, and shaggy foliage. Even a strong sense of axial symmetry begins to reassert itself within this natural context. In fact, the destroyed classical past could also be used for constructive, regenerative purposes; at times, the retrospective attitudes of private, languorous melancholy could be replaced by prospective dreams of vast, public Utopias.

This vision of antiquity as the virile source of new forms and new societies was particularly prevalent in France. For many French architects working under the rapidly changing political conditions of decadent monarchy, republic, and empire, the ruins of Greece and Rome not only evoked heroic myths of a Brave New World embodying new social ideals but also a correspondingly new formal system that would eradicate, as decisively as had

[46] On the Laiterie, see J. Vacquier, *Les anciens châteaux de France*; *l'Île-de-France; Compiègne-Rambouillet*, Paris, 1925, p. 8; and Louis Hautecœur, *Histoire de l'architecture classique en France*, v, Paris, 1953, p. 30.

[47] M. Claude-Bernard de Sainte-James (whose oddly spelled name is frequently "corrected" to Saint-James) was one of Belanger's first clients for a "folie." For a discussion of his fabulously expensive "Rocher" (1,600,-000 livres), see Jean Stern, *À l'ombre de Sophie Arnould; François-Joseph Belanger*, I, Paris, 1930, pp. 140-141; and, most recently, Connolly and Zerbe, *op.cit.*, pp. 158ff.

The painting of the "Folie" is by Claude-Louis Chatelet and, as Hautecœur points out (*op.cit.*, v, p. 28 n. 1), adds imaginary mountains to the background.

the *Horatii*, the diminutive elegances and artificialities of the Rococo. The greatest of these architects was Claude-Nicolas Ledoux,[48] whose strong royalist sentiments did not prevent his revolutionary projects and executed works of the 1780's from embodying visual ideals that could be absorbed by literally Revolutionary artists and commissions. Far from seeing picturesque randomness and irrationality in classical ruins, Ledoux extracted from them potentials of a robust new geometric order. A remarkable case in point is the archway at the Hôtel de Thélusson of 1778-1781, which is inspired by the Roman arch at the Circus of Maxentius (Fig. 132).[49] In the eighteenth century, however, this Roman arch was as yet unexcavated; witness the plate in Jean Barbault's *Les plus beaux monuments de Rome ancienne* of 1761 (Fig. 133). Yet for Ledoux, this sunken classical form elicited not a passive meditation upon the transience of civilization, but a dynamic vision of a new kind of architecture. Because of its submerged base, the Roman arch belied its original proportions, offering instead a more blocky and forthright emphasis upon the purity of its spherical and cubic elements. In Ledoux's own arch, this foursquare clarity of component architectural parts is seized upon in the interests of a new proportional system. For Ledoux, as for such contemporaries as Jacques Gondoin, Jacques-Denis Antoine, and Pierre Rousseau, the prevailing architectural traditions were no longer tenable. In his architecture, the complex transitions and subtle proportional relationships of the earlier eighteenth century were replaced by an austere new formal sensibility that first sought out the most elementary geometric components and then arranged them by a system of juxtaposition rather than fusion, much as the figure groupings in the

[48] The rapidly growing bibliography on Ledoux is most conveniently compiled in Emil Kaufmann, "Three Revolutionary Architects, Boullée, Ledoux, and Lequeu," *Transactions of the American Philosophical Society, Philadelphia*, XLII, Part 3, Oct. 1952, p. 559; and, more recently, in Bates Lowry, "Ledoux," *Encyclopedia of World Art*, IX, New York, 1964, col. 197.

[49] This comparison depends on the important study by Oscar Reutersvärd, "De sjunkna bågarna hos Ledoux, Boullée, Cellerier och Fontaine," *Konsthistorisk Tidskrift*, XXIX, nos. 3-4, 1960, pp. 98-117.

Horatii asserted a new independence and isolation of parts. Pushed to its logical geometric conclusions, this eschewal of Baroque and Rococo complexity would ultimately produce an architecture of pure, undecorated cubes, cylinders, and spheres organized in equally simple relationships of wholes, halves, and quarters.[50]

This primer of architectural solid geometry was, in fact, approached by Ledoux in his projects of the 1780's for the Barrières de Paris (1785-1789)[51] and, even more, in the ideal city of Chaux at Arc-et-Senans (1775-1779). Often, the inspiration of antiquity lay clearly behind these prodigious inventions. For example, at the Barrière de Courcelles, Ledoux pushed the direction of a Greek Doric temple to an even more pristine extreme (Fig. 131). Probably inspired by the unfinished columns at the Temple of Segesta,[52] Ledoux has here eliminated even so rudimentary a decoration as fluting, so that the columns' cylindricality may be presented in an almost absolute way; and in other designs, this trend reaches such extremes that earlier architectural prototypes can no longer be discerned. Thus, at the Saline de Chaux and the Château de Maupertuis, some projects attained so fanatical a degree of absolute geometry that, in our own century, they could appeal alternately to historians seeking sources for the International Style[53] and to fantasists of a surrealist persuasion (Figs. 134-136).[54] Like a child experimenting with rudimentary

[50] The fullest analysis of the profound formal changes effected by these architects is in the classic study of Emil Kaufmann, *Architecture in the Age of Reason*, Cambridge, Mass., 1955, particularly ch. XII.

[51] A useful map, indicating which of these *barrières* are still to be seen, is found in Marcel Raval, *Claude-Nicolas Ledoux, 1736-1806* (*Les Architectes français*, 1), Paris, 1945, pp. 208-209. For a discussion of the *barrières*, see Kaufmann, "Three Revolutionary Architects . . . ," pp. 498-509.

[52] Kaufmann (*op.cit.*, p. 500) refers to Paestum as the ostensible source for the Barrière de Courcelles, but Segesta offers a closer parallel.

[53] Thus, the unornamented, volumetric clarity of Ledoux's designs could appear as a prophecy of the modern movement, as in Kaufmann's early study, *Von Ledoux bis Le Corbusier*, Vienna, 1933. For a succinct reassessment of Ledoux as an architect of his own time, and not of ours, see Lowry, *op.cit.*

[54] Ledoux's attraction for amateurs of the marvelous materialized re-

building blocks, Ledoux created designs of pure spheres, cubes, cylinders, and pyramids that take their place in a harmonious natural environment. For him, these Platonic ideals of architectural form partook of natural laws. Throughout his writings, references are made to the geometric purity of natural phenomena —"La forme est pure comme celle qui décrit le soleil dans sa course."[55]

If the obsessive geometric idealism of Ledoux's more extreme projects prevented their concrete realization or, in other cases, tended to idealize engravings after buildings actually constructed,[56] these absolute forms were nevertheless reflected, more temperately, in many actual buildings of the late eighteenth century as well as in the fictive architecture of many Neoclassic paintings of the period. Classical sources assisted most reformatory French architects of the time in their pursuit of a more austere and geometric vocabulary that could chasten the Rococo style in the interests of clarity and naturalness. In France, as in other coun-

cently in a volume included in the series, *Le Cabinet Fantastique*: Yvan Christ, *Projets et divagations de Claude-Nicolas Ledoux, architecte du roi*, Paris, 1961. Symptomatic, too, of this change was the use of the Saline de Chaux as the poetic backdrop for a lyrical French film, *La Morte saison des amours* (1960).

[55] The phrase refers to the plan of the Saline de Chaux (Ledoux, *L'Architecture considerée sous le rapport de l'art, des moeurs et de la législation*, Paris, 1804, p. 77, pls. 12, 13). Another characteristic phrase: "Toutes les formes sont dans la nature; celles qui sont entières assurent les effets décidés, les autres sont les produits déreglés de la fantaisie . . ." (*ibid.*, p. 178, in reference to the Atelier des Cercles, pl. 88).

Ledoux's belief in nature as the source of architectural law is best exemplified in the plate illustrating *L'Abri du Pauvre*, which represents a naked man sheltered by a tree and the azure dome of heaven (*ibid.*, pl. 33, pp. 104-106).

[56] Recent research has, in fact, focused upon how Ledoux, in his later publications, modernized buildings that he had executed earlier. See the two articles that appeared concurrently: W. Herrmann, "The Problem of Chronology in Ledoux's Engraved Work," *Art Bulletin*, XLII, Sept. 1960, pp. 191-210; and Johannes Langner, "Ledoux' Redaktion der eigenen Werke für die Veröffentlichung," *Zeitschrift für Kunstgeschichte*, XXIII, 2, 1960, pp. 136-166.

tries, the Pantheon appeared as a paradigm of spherical purity,[57] though its form was often pushed to even more geometric extremes. Thus, in Louis Le Masson's church of SS. Pierre et Paul at Courbevoie, near Paris (1789),[58] this venerated classical prototype is starkly interpreted in terms of the most severely simple massing: a pure dome upon an equally undecorated cylindrical base, to which is attached a primitive portico of those unfluted, baseless Doric columns that were so prevalent in French architecture of the 1780's (Fig. 137).[59]

Cubic as well as spherical purity could be gleaned from classical architectural forms. At the Hôtel de Salm, designed by Pierre Rousseau in 1782 for the German prince of Salm-Kyrburg,[60] a richer surface decoration hardly conceals the foursquare clarity of the massing (Fig. 138). The single-storied court, inspired by Roman house plans; the triumphal arch of the entry; the rectilinear wholeness of the unpedimented portico—these all contribute to a new emphasis on juxtaposed cubic masses that was to inspire almost as much admiration in Thomas Jefferson, during his French sojourn, as would the noble simplicity of the Maison Carrée at Nîmes.[61] Indeed, these reductive geometries admired

[57] The importance of the Pantheon for Neoclassic architecture, especially in Italy, is treated in Carroll L. V. Meeks, "Pantheon Paradigm," *Journal of the Society of Architectural Historians*, xix, Dec. 1960, pp. 135-144.

[58] The church is cited in Hautecœur, *Histoire* . . . , v, p. 535.

[59] As at the Hôpital Cochin (1778-1781) by Viel de St. Maux (exterior portico); and the Noviciat des Capucins (now the Lycée Condorcet) (1780-1782) by Brongniart.

The increasing variety of Doric columns, fluted and unfluted, used in the 1780's is illustrated in Pierre Antoine, *Série des colonnes*, Dijon, 1782, plate facing p. 56.

[60] For further information on the building history of the Hôtel de Salm, see J. Vacquier, *Les Vieux hôtels de Paris; Le Faubourg St.-Germain*, série xii, vol. iv, Paris, 1920, pp. 8-10.

[61] See his famous letter to Mme. de Tessé, written in Nîmes, March 20, 1787: "While at Paris, I was violently smitten with the hotel de Salm, and used to go to the Tuileries almost daily to look at it." (*The Papers of Thomas Jefferson*, ed. Julian P. Boyd, xi, Princeton, 1955, p. 226.) Jefferson also commented with interest on Ledoux's then new *barrières* (letter to Colonel Humphreys, Paris, Aug. 14, 1787, *ibid.*, p. 278).

and created in the late eighteenth century were reflected in Jefferson's belief that all architecture could be classified as cubical and spherical,[62] a concept that was to be materialized in such monuments for the new American Republic as the State Capitol at Richmond and the library at the University of Virginia.

Just as Jefferson could envision the lucid Roman forms of the Maison Carrée and the Pantheon as symbols of a virtue to be embodied in the public buildings of the newly formed United States, so, too, could French painters and architects working under the Revolution and the Empire find rich political associations in the architecture of antiquity. The architectural backgrounds of David's own paintings are revealing cases in point.[63] Stylistically, their evolution in the 1770's and 1780's parallels that of Ledoux's own architecture, as it does that of David's own composition and figure style. Thus the fictive architecture of David's history painting moves steadily in the direction of the most severe, unornamented geometries that suggest pure cylinders, cubes, and spheres as their ultimate goal. As an indication of this puristic direction, a study for the *Horatii* (Fig. 139) may be compared with the finished painting (Fig. 69). In this drawing, the Doric columns still have bases, so that the triple arcade might almost be mistaken for the courtyard of a Cinquecento palace.[64] In the painting, however, these bases have been eliminated, so that the arcade now conjures up a still simpler Tuscan order that is exactly duplicated in such contemporaneous designs of Ledoux

[62] As discussed in Karl Lehmann, *Thomas Jefferson, American Humanist*, New York, 1947, p. 167. The basic study of Jefferson's architecture is *Thomas Jefferson Architect; Original Designs in the Collection of Thomas Jefferson Coolidge, Jr.* (with an essay and notes by Fiske Kimball), Boston, 1916. For an up-to-date bibliography, see William B. O'Neal, *A Checklist of Writings on Thomas Jefferson as an Architect* [Charlottesville], 1959.

[63] For a brief study of these backgrounds, see René Crozet, "David et l'architecture néo-classique," *Gazette des Beaux-Arts*, 6e période, XLV, April 1955, pp. 211-220.

[64] Klaus Holma, in fact, suggests Cinquecento architecture (the arcade of the courtyard of the Palazzo della Valle, Rome) as the source for the background in the *Horatii* (*David, son évolution et son style*, Paris, 1940, p. 47).

as those for the Barrière de Clichy or the Barrière de la Rapée (Fig. 140).[65] In David's case, however, this severe pruning of forms is not only a question of creating an architectural background consonant with the painting's over-all geometric rigor but, in this dramatic context, a matter of imagining an architecture whose anti-Rococo, unornamented severity could create an austere visual environment appropriate to a scene of archaic Roman stoicism. Indeed, David's historicizing intention must have urged him to attempt a primitive Tuscan Doric order that would appear chronologically authentic as a setting for this early Roman drama. Its authenticity, however, was questionable to the erudite archeologist, Seroux d'Agincourt, who criticized the arches on columns as an anachronism.[66]

David was soon to correct this error in the architecture of the *Brutus,*[67] although his invented classical architecture remained anachronistic in the *Socrates,* where a barrel vault is conspicuous in an Athenian prison of 399 B.C. (Fig. 74). But apart from matters of archeological accuracy, Socrates' prison walls pursue this reductive geometry still further,[68] here eliminating entablature and even moldings in favor of a clean-edged purity of masses and

[65] A less severe Doric triple arcade may also be seen in Louis Le Masson's Palais Abbatial, Royaumont (1785), illustrated in Hautecœur, *Histoire . . . ,* IV, p. 183.

[66] As discussed in Crozet, *op.cit.*

[67] David, however, defended himself against Seroux d'Agincourt's criticism: "Le seul homme qui en fait la critique est M. d'Agincourt, parce que, dans son fond d'architecture, les arcs s'appuient sur des colonnes qui, selon cet archéologue, n'ont été en usage au temps du Bas-Empire. Or, s'il était plus savant, il saurait qu'à l'époque où la scène du tableau se passe l'Étrurie donnait le ton à l'Italie, et telle était alors l'architecture étrusque." (*Bulletin de la Société de l'Histoire de l'art français, 1921,* Paris, 1922, pp. 235-236.)

[68] It may be worth noting that even Peyron's severe *Death of Socrates,* exhibited, like David's, at the Salon of 1787 (no. 154), still maintains vestiges of molding on the Athenian prison walls. An engraving after Peyron's painting, which was in the Chambre des Députés, Paris, is illustrated in Jean Seznec, *Essais sur Diderot et l'antiquité,* Oxford, 1957, fig. 8.

voids that recalls the abstract geometries of Étienne-Louis Boul-
lée's most extreme architectural projects.[69]

In the *Brutus*, this search for fundamentals continues (Fig. 78).
Perhaps heeding Seroux d'Agincourt's criticism of the architecture
in the *Horatii*, David replaced arcuated by trabeated forms. The
baseless Tuscan Doric order is now used in an archaic post-and-
lintel system whose rectilinear formal severity contributes, both
historically and aesthetically, to the evocation of the moral
severity that David and other Revolutionaries venerated in the
early phases of the Roman Republic.

The same transformation occurs in another painting discussed
earlier, Taillasson's *Timoléon* (1796) (Fig. 94).[70] In a painted
sketch for the picture, the artist uses a rather Vignolesque archi-
tectural background with a Tuscan Doric order of the same
Renaissance origin as the finely molded entablature and the
partially visible niche (Fig. 141). In the final version, however,
the architecture regresses historically to the most elemental
classicism; here the unfluted and baseless Doric columns are
even squatter and more geometrically severe than those of the
Greek temple at Segesta and thereby conform, once more, to an
historicizing attempt to create the most archaic of settings for an
early Republic founded on classical Sicilian soil.

It should be remembered, however, that reformatory politics
and reformatory architectural style did not always go hand in
hand. If the forces of the Revolution could extract memories of
classical political virtue and heroism from these archaizing cur-
rents, many of these stylistically revolutionary forms had, in fact,
been created to perpetuate the *Ancien Régime*. Thus, the archi-
tecturally radical *barrières* of Ledoux had been erected on the eve
of the Revolution (1784-1789) as an enclosing wall of toll-houses
for the detested *Fermiers Généraux* ("le mur murant Paris rend

[69] As, for instance, in the comparably unmolded, razor-edged barrel
vaults in Boullée's modernization of a Roman circus (illustrated in Kauf-
mann, "Three Revolutionary Architects . . . ," p. 462, fig. 21).

[70] See above, pp. 92f. The change in architecture is noted too, by Boris
Lossky, "Une peinture de Jean-Joseph Taillasson au Musée de Tours,"
Revue de Louvre et des Musées de France, xi, no. 1, 1961, pp. 35-38.

Paris murmurant") to which Ledoux himself belonged; and a house designed by Jean-Jacques Lequeu in 1788 in the form of a pure Roman Doric temple that would have elicited Jeffersonian admiration was actually intended as the home for a M. S* * *, a *fermier général* (Fig. 142).[71] Similarly, the Roman simplicity of the Doric colonnades that created a noble Republican architectural background for so many dramatic events at the *États-Généraux* from 1789 on, had actually been designed by Pierre-Adrien Pâris in 1787 as a chamber for the Assemblée des Notables in the Hôtel des Menus-Plaisirs at Versailles (Fig. 143).[72]

Nevertheless, these directions toward geometric purism generally conformed to the taste of the new Republic, even if these stylistically progressive forms had often been invented by politically conservative architects and patrons. At times, these transformations offer a poignant political irony, as when that combination of rugged nature and classical *fabriques* enjoyed privately by pre-Revolutionary aristocrats suddenly blossoms into the public landscapes, ennobled by classical temples, arches and columns, designed for Revolutionary pageants. Thus, the rude simplicity of the little Doric temple enjoyed by the wealthy banker Claude Bernard de Sainte-James in the rocky picturesqueness of his Folie at Neuilly (Fig. 130) produced such politically alien heirs as the design by Claude Cochet *le jeune*[73] for a Revolutionary pageant at the Camp de fédération in Lyons, on May 30, 1790 (Fig. 144).[74] Here the type of classical *fabrique* designed for private delectation is transformed into a symbol of Republican freedom and political unity: a Temple de la Concorde is picturesquely carved into a rough natural setting and surmounted triumphantly by a Statue de la Liberté and two waving tricolors.[75]

[71] On the date and history of this domestic design by Lequeu, see Kaufmann, "Three Revolutionary Architects . . . ," p. 539; and Hautecœur, *Histoire* . . . , v, p. 87.

[72] *Ibid.*, IV, p. 313.

[73] On Claude Cochet *le jeune* (1760-1835), see E.-L.-G. Charvet, *Architectes* (*Lyon artistique*), Lyons, 1899, pp. 85-87.

[74] The engraving is by Gentot *fils*.

[75] A comparably Revolutionary transformation of a classical *fabrique* in

Apart from such engravings of the ephemeral pageantry of the 1790's and Neoclassic paintings that include architectural backgrounds, there are few extant relics of this Revolutionary preference for elementary classical forms that presumably evoked a comparable state of purity and idealism. Of these, the most telling is the Rue des Colonnes in Paris, an arcaded street erected under the Directoire (Fig. 145).[76] Here, the repetitive rhythms of baseless, unfluted Doric columns, echoing the arcade in the *Horatii*, offer the architectural equivalent of the equally rudimentary pictorial means that excited avant-garde taste of the 1790's in what were generally referred to as "Etruscan" vases. This primitive architectural statement, redolent of a remote and unspoiled classical past, is best seen in a drawing[77] by the brilliant young German architect, Friedrich Gilly, who recorded it during his Paris sojourn (1797-1798; Fig. 146).[78] Like Flaxman's outlines or the classical vase painting that inspired them, Gilly's drawing is restricted to line alone, eliminating all textural and atmospheric effects. Such an austerely abstract drawing style seems particularly appropriate to a Utopian vision of a new, unblemished architecture for a new republic; it is revealing that this style was revived in many architectural drawings of the 1920's that prophesied comparably Brave New Worlds.[79]

a Romantic garden may be seen in the famous *Fête de l'Être Suprême* at the Champ-de-Mars (June 8, 1794), designed by David. (J. L. David, *Plan de la fête de l'être suprême qui doit être célebrée le 20 prairial . . .* , Paris, 1794.) For illustrations of the *Fête* and Michelet's classic description of the event, see Philippe Sagnac, *La Révolution de 1789*, II, Paris, 1934, pp. 335-338.

[76] According to the Marquis de Rochegude (*Guide pratique à travers le vieux Paris*, Paris, 1923, p. 223), the Rue des Colonnes, originally a passage (1793), was opened in 1798 (at the time it was sketched by Gilly). Although the architect is generally identified as Poyet (Hautecœur, *Histoire . . .* , V, p. 142), Thieme-Becker mention that Nicolas Vestier was responsible for the residences on the Rue des Colonnes.

[77] The drawing is in the Bibliothek, Technische Hochschule, Berlin (B.246).

[78] On Gilly's visit to Paris, see Alste Oncken, *Friedrich Gilly, 1772-1800*, Berlin, 1935, pp. 57ff.

[79] Thus, in drawing style as well as architectural style, the International

In painting, this primitivizing current could be directed to such socially disoriented activities as those of the celebrated sect of David pupils who called themselves *Les Primitifs* and who in architecture admired, not unpredictably, only the Doric temples of Sicily and Paestum, one of which was actually to be seen, in a replica, on the Champs-Elysées.[80] However, the effeteness and aestheticism of this pictorial trend in Davidian circles around 1800[81] were less evident in the more realistic civic requirements of actual architectural commissions.

With the advent of Napoleon, architectural activity newly explored a classical past as a means of creating an iconography appropriate for the new leader rather than for such private speculation as was occasionally permitted younger painters in the Davidian circle; but at this point, a curious transformation occurred in the reading of antiquity. If, in the 1780's and 1790's, architecture seemed to move, as it were, chronologically backwards, seeking ever purer and more primitive sources in the classical past, this evolution was soon reversed. Just as David's official pictorial style began to display a new complexity and richness that controverted the laconic severity of his Revolutionary paintings, so, too, did the major monuments of Paris begin to reject images of Greek and Roman Republican severity in favor of a style that evoked, often most literally, Roman Imperial splendor. And just as Gros and

Style of the 1920's revives many aspects of International Neoclassicism around 1800. From Sant'Elia through Asplund, Gropius, Le Corbusier, and others, architects often presented their three-dimensional purist geometries in a drawing style that minimized or eliminated modeling and texture in favor of spare and precise definitions by outline and, at times, equally schematic shadows.

[80] As recorded by Delécluze, *Louis David, son école et son temps*, Paris, 1855, pp. 429, 436.

[81] It should be mentioned that the Rue des Colonnes itself displays the inevitable sophistication of the willfully primitive that characterized primitivizing tendencies in modern art from Ingres' use of Greek vase painting to Picasso's use of African sculpture. Thus, the ostensible simplicity of this arcade is countered by such hyper-elegant details as the balustrade of tiny Doric columns in the first-story windows. For a general analysis of these inherent contradictions in primitivism, see the classic study of Robert J. Goldwater, *Primitivism in Modern Painting*, New York, 1938.

his contemporaries attempted to aggrandize the image of Napoleon through allusions to Roman Imperial charity, justice, and magnificence,[82] so, too, did Napoleonic architects contribute to this reincarnation of Imperial Rome.[83]

The unfluted, baseless Doric order and elementary geometries so pervasive in the architecture of the last decades of the eighteenth century began to give way to more elaborate forms. Thus, the two most famous peripteral temples of Napoleonic Paris—Pierre Vignon's Madeleine (Fig. 147, begun in 1806 as a "Temple de la Gloire"),[84] and Alexandre-Théodore Brongniart's Bourse (Fig. 148, begun in 1808, and referred to as a "Temple de l'Argent")[85]—continue the theme of cubic clarity explored in the 1780's and 1790's. However, they vitiate this geometric idealism by preferring the imperial extravagance of the Corinthian order[86] to the geometric severity of the Doric, as seen, for example, in Ledoux's temple-like Barrière de Courcelles (Fig. 131). And on a less conspicuous level, this reversal of stylistic direction may even be seen in one of the earliest arcaded streets of Napoleonic Paris, the Rue de Castiglione (opened in 1802), which, like the Rue des Pyramides and the Rue de Rivoli, was named, typically enough, after a Napoleonic victory (Fig. 149).[87] Comparing the Rue de

[82] This Roman Imperial Revival in painting is suggested in John McCoubrey, "Gros' Battle of Eylau and Roman Imperial Art," *Art Bulletin*, XLIII, June 1961, pp. 135-139.

[83] The imperialization of European architecture is succinctly surveyed in Henry-Russell Hitchcock, *Architecture; Nineteenth and Twentieth Centuries*, Baltimore, 1958, pp. 9ff. The closest and best documented account of the imperialization of Paris is now: Marie-Louise Biver, *Le Paris de Napoléon*, Paris, 1963.

[84] On the complex building history of the Madeleine, see Antoine Kriéger, *La Madeleine*, Paris, 1937; and Biver, *op.cit.*, pp. 232ff.

[85] On the Bourse, see Jacques Silvestre de Sacy, *Alexandre-Théodore Brongniart, 1739-1813; sa vie—son œuvre*, Paris, 1940, pp. 148ff.; and Biver, *op.cit.*, pp. 224ff.

[86] It should be mentioned, however, that Brongniart's original design used an Ionic order. In this, it must have resembled Ledoux's design for a Bourse, a cubic temple of ten by ten Ionic columns (illustrated and discussed in his *L'Architecture considérée* . . . , p. 126, pl. 50).

[87] On these urban developments, see Hautecœur, *Histoire* . . . , v, pp. 226ff.; and Biver, *op.cit.*, pp. 64ff.

Castiglione to the Rue des Colonnes[88] is tantamount to comparing the architecture in the preparatory studies for David's *Horatii* and Taillasson's *Timoléon* to that of the finished paintings, except that here the evolution moves, in historical terms, chronologically forward rather than backward. Thus, instead of rejecting a Renaissance architectural vocabulary in favor of an imaginary classical archaism, Charles Percier and Pierre-François Fontaine's Rue de Castiglione rejects the archaism of the earlier Rue des Colonnes in favor of a more conventional Italian Cinquecento mode. In place of the inventive geometric austerities of the Rue des Colonnes, with its clean, undecorated surfaces and curiously squat proportions, the Rue de Castiglione elaborates the motif of an arcaded street with familiar Renaissance decorative forms— window frames, brackets that support the cornice above the arcade, moldings that alleviate the potential geometric severity of repeated arches on piers.

The promotion of an Imperial Neoclassicism was even more explicit in the triumphal arches erected under the Napoleonic Empire, whether in Paris or Milan.[89] To be sure, monumental gateways inspired by classical precedents were as common in Europe around 1800 as they had been before, yet Napoleonic triumphal arches were exclusively Roman Imperial in their references. By contrast, Neoclassic arches elsewhere in Europe generally evoked a simpler and more austere phase of antiquity. In particular, the Propylaea of the Acropolis was a familiar stimulus; its Greek Doric columns, whose severity was rejected under Napoleonic rule, ennobled triumphal gateways that ranged from Carl Gotthard Langhans' Brandenburger Tor in Berlin (1789-1794)[90] and Vasili Stasov's Moscow Triumphal Arch in

[88] A stylistic comparison between the Rue des Colonnes and the Rue de Rivoli has already been made briefly in Pierre Lavedan, *Histoire de l'urbanisme; époque contemporaine*, Paris, 1952, pp. 25f.

[89] As in Cagnola's Arco della Pace, begun in 1807.

[90] See Walter Hinrichs, *Carl Gotthard Langhans, ein schlesischer Baumeister, 1733-1808*, Strasbourg, 1909, pp. 64ff.

Leningrad (1833-1838)[91] to Leo von Klenze's Propyläen in Munich (1846-1863).[92]

Most characteristic of the new Napoleonic luxury and pomp is Percier and Fontaine's Arc du Carrousel (1806) in Paris (Fig. 150),[93] which closely imitates the Arch of Septimius Severus,[94] while also reviving the Royalist splendors of Baroque triumphal arches.[95] Here the Spartan image of classical architecture dreamed of in the formal and political idealism of the 1780's and 1790's is entirely controverted. Undecorated surfaces, elementary geometries, lucid masses are now smothered under polychrome marble, applied orders, sculptural incrustations, a crowning bronze quadriga.[96] Like the illusionistic bronze reliefs that spiral up the Colonne Vendôme (1806-1810)[97] to culminate in Antoine-Denis Chaudet's allegorical statue of Napoleon as Caesar,[98] the

[91] See G. H. Hamilton, *The Art and Architecture of Russia*, Harmondsworth, 1954, p. 212.

[92] See Oswald Hederer, *Leo von Klenze; Persönlichkeit und Werk*, Munich, 1964, pp. 342-347.

[93] For a close description of the arch, see Maurice Fouché, *Percier et Fontaine*, Paris, 1904, pp. 91ff.; and Biver, *op.cit.*, pp. 176ff.

[94] In fact, Percier and Fontaine had a *relevé* of the Arch of Septimius Severus (Hautecœur, *Histoire* . . . , v, p. 201).

[95] Thus, the Arc du Carrousel recalls not only Blondel's Porte St.-Denis, Paris (1672), but even more closely, Richard Mique's Porte St.-Stanislas, Nancy (1761). This hybrid tradition of Roman Imperial and Royalist Bourbon grandeur continued after the fall of Napoleon, as in Huyot's design for the Arc de Triomphe (1824), which also depends on the Arch of Septimius Severus (Hautecœur, *Histoire* . . . , vi, p. 23) or Penchaud's Arc de Triomphe at Marseilles (1825-1832). For a discussion of arches under the Bourbon Restoration, see *ibid.*, pp. 20ff.

[96] The statue of Napoleon on the quadriga was replaced under the Restoration by a statue of Peace by Bosio (1828).

[97] The column was designed by Gondoin and Lepère; the reliefs, under the direction of Bergeret. On the history of the Column, see Biver, *op.cit.*, pp. 162ff. The Colonne Vendôme was not the first Napoleonic monument of its kind; it had been preceded by the Colonne de la Grande Armée near Boulogne-sur-Mer, begun in 1804 after a design by Éloi Delabarre. This earlier provincial column, characteristically, is simpler—a smooth, unornamented shaft.

[98] Predictably, the constant changes in French nineteenth century political history affected Chaudet's original statue. In 1814, the Royalists tore

sculptural program of the Arc du Carrousel venerates the new imperial triumphs of the Napoleonic armies at Ulm, Austerlitz, Vienna, Munich, Tilsit, and Presburg.

Of these Napoleonic resurrections of imperial splendor, the most unusual was one no longer to be seen in Paris[99]—a huge plaster elephant at the Place de la Bastille (Fig. 151). Originally designed in 1810 by Jacques Cellerier,[100] a Dijon architect who had earlier participated in the creation of Republican rather than Imperial pageantry,[101] this great beast revived a long iconographical tradition. For Napoleon, the elephant was a symbol of Caesar and of the Emperor,[102] and as such, it contributed as fully as the

it down and replaced it with a fleur-de-lys; in 1833, Louis-Philippe substituted a statue by Seurre of the Emperor in a frock coat and hat; in 1863, under Louis-Napoléon, Chaudet's original statue, in reproduction, was replaced; and in 1871, the entire Column was torn down by the Commune, to be re-erected in 1873-1875.

[99] It was demolished in 1846. For the documentary history of this extraordinary beast, see Biver, *op.cit.*, pp. 199ff.

[100] The project was then taken over by Alavoine (Hautecœur, *Histoire* . . . , v, p. 219).

[101] He had designed a triumphal arch for a pageant of July 14, 1790 (*ibid.*, p. 120).

[102] For comments on these imperial allusions, see *ibid.*, pp. 218f. See also William S. Heckscher's basic study of elephantine iconography, "Bernini's Elephant and Obelisk," *Art Bulletin*, XXIX, Sept. 1947, pp. 155-182. It should be added that the Elephant of the Bastille was hardly unique in the French tradition. For the Place des Victoires, there was a design by Sobre that placed an obelisk on an elephant in the Berninesque manner (illustrated in Hautecœur, *Histoire* . . . , v, p. 134). Closer to the Bastille design in both form and content was one by Ribart of 1758 for a triumphal elephant on the Champs-Elysées (mentioned *ibid.*, III, p. 506; and illustrated in Ulrich Conrads and Hans G. Sperlich, *Phantastische Architektur*, Stuttgart, 1960, p. 17). A post-Napoleonic elephant fountain may still be seen in Chambéry (after designs by Pierre-Victor Sappey de Grenoble, 1839). This one, however, breaks with imperial allusions and commemorates, rather, the charity of Général de Boigne, who had made his fortune with the India Company. It might be mentioned, too, that monuments in the form of symbolic animals were frequently designed by Lequeu (e.g., *Le Tombeau d'Isocrate*, a project of 1789 in the shape of a gigantic sheep).

Elephantine architecture is discussed more lightheartedly in Clay Lancaster, *Architectural Follies in America*, Rutland, Vermont, 1960, pp. 186-196.

Roman temples, triumphal arches, and victory columns to the imperialization of Paris.

Later in the nineteenth century, under radically changing social conditions, the imperial glory evoked by this elephant was seen, most literally, from a different viewpoint. For the elephant of the Bastille was to be commemorated by Victor Hugo in *Les Misérables* (1862) as the pitiful dwelling place of the Parisian street urchin, Gavroche.[103] Indeed, after the fall of Napoleon, the capacity of Greco-Roman antiquity to be revitalized in France for political ends was lost; and the classical world was transformed, instead, into a hermetically sealed domain, inhabited by aesthetes and archeologists who either ignored or opposed the profound new challenges of nineteenth century experience. This viewpoint may best be summarized in two paintings by David's greatest pupil, but a pupil who no longer shared his master's intense political commitments. In Jean-Auguste-Dominique Ingres' *Apotheosis of Homer* (1827),[104] the image of classical Greece is now one of immutable aesthetic authority, the repository of timeless, indestructible beauty (Fig. 152). This encyclopedic assembly of great men, ranging hierarchically from modern through ancient history, reaches its symmetrical apex in the pediment of the Greek Ionic temple that forms a backdrop to this venerable scene. Like the figure of the blind Homer, the temple evokes a distant classical past of unsurpassable beauty and greatness, but one also susceptible to archeological reconstruction as scrupulous as that by Ingres and Hittorff in the Temple of Empedocles, a

[103] The episode, with an unforgettable description of the elephant itself, is found in the 4ᵉ partie (*L'Idylle rue Plumet et l'Épopée St. Denis*); 6ᵉ livre (*Le Petit Gavroche*), II (*Où le petit Gavroche tire parti de Napoléon le Grand*). It is cited, in part, in Biver, *op.cit.*, p. 206.

[104] For full and detailed studies of this painting, see Daniel Ternois, "Les Sources iconographiques de l'Apothéose d'Homère," *Bulletin archéologique de Tarn-et-Garonne, 1954-1955*, LXXXI, Montauban, 1956, pp. 26-45; and Norman Schlenoff, *Ingres; ses sources littéraires*, Paris, 1956, ch. VI. See also *idem*, "Ingres and the Classical World," *Archaeology*, XII, no. 1, Spring 1959, pp. 16-25.

temple *joujou* commissioned in 1855 by the Prince Napoléon as a gift for the great classical actress, Rachel.[105]

A far less academic image of antiquity is suggested in a more personal painting by Ingres, the *Antiochus and Stratonice* (1840; Fig. 153).[106] Here again, new archeological erudition contributes to the photographic recreation, in this case, of a Pompeian interior. Assisted by the architect archeologist Victor Baltard,[107] Ingres painstakingly reconstructs the polished, polychrome refinement of a Roman house[108] as an appropriately intimate setting for the *dénouement* of the erotic drama enacted on the pictorial stage.[109] Exquisitely wrought detail of columns, furniture, costume, mural decoration creates a diminutive image of classical preciosity that offers an elegant counterpart to such official classical statements as the *Apotheosis of Homer*. It was a vision of antiquity shared by the Parnassian poets; indeed, the very title of Théophile Gautier's collection of poems, *Emaux et camées* (1852), accords perfectly with the flavor of Ingres's painting.[110] At times, too, this aristocratic

[105] This polychrome bibelot was exhibited at the Salon of 1859, and is nicely described in the *Mémoires du Comte Horace de Viel-Caste sur le règne de Napoléon III, 1851-1864*, ed. Pierre Josserand, II, Paris, 1942, p. 6 (entry for Jan. 21, 1856): "Le Prince Napoléon passe en ce moment ses journées à élever un temple *joujou* à Rachel; quinze ouvriers y travaillent sous sa direction. Ce temple aura trois pieds de haut; le prince aurait voulu que M. Ingres en fît les peintures." The temple is also discussed in Hautecœur, *Histoire* . . . , VII, p. 124; and, in relation to Homeric iconography, in Schlenoff, *Ingres; ses sources littéraires*, pp. 299-300.

[106] Georges Wildenstein, *Ingres*, London, 1954, no. 232. The painting exists in both earlier and later versions (nos. 164, 224, 295, 322). For a study of this painting, see Schlenoff, *op.cit.*, pp. 235ff.; and, more briefly, *idem*, "Ingres and the Classical World."

[107] The setting was designed by Victor Baltard and painted by Paul and Raymond Balze.

[108] As Hitchcock noted (*Architecture: Nineteenth and Twentieth Centuries*, Baltimore, 1958, p. 45 n. 3), the *Stratonice* reflects the new interest in polychromy in ancient architecture so prominent in the 1830's. On the problem of polychromy, see Hautecœur's basic discussion (*Histoire* . . . , VI, pp. 359ff.).

[109] For a discussion of the iconographical tradition of this pseudo-incestuous love story, see Wolfgang Stechow, "Love of Antiochus with Faire Stratonica," *Art Bulletin*, XXVII, Dec. 1945, pp. 221-237.

[110] For a recent study of Gautier, see Joanna Richardson, *Théophile*

sensibility could realize in actual materials these effete and per-
fumed antique dreams. Such was the case in the Pompeian house
designed by Alfred Normand for the Prince Jérôme Napoléon on
the Avenue Montaigne (1854-1859), a palace of private luxury
frequented, most appropriately, by Gautier himself.[111] Destroyed
in 1891, the Maison Pompéienne is best recorded in a painting
by Gustave Boulanger exhibited at the Salon of 1861 (Fig. 154).
Here, in the polychrome, richly ornamented atrium, so like the
setting of Ingres's *Antiochus and Stratonice*, a group of the Prince's
favorite guests, including Gautier, lounge about in antique cos-
tumes while rehearsing two ancient Greek plays, *Le Joueur de
flûte* and *La Femme de Diomède*.[112] The thin preciosity of this
classicism recalls the aristocratic elegance of many late eight-
eenth century interpretations of the antique, whether the Rococo
Classicism of Robert Adam's and Angelica Kauffmann's interior
decoration or the fashionable parties, *à la grecque*, given by Mme.
Vigée-Lebrun. Isolated in a purified realm of aesthetic delecta-
tion and archeological learning, this mid nineteenth century
vision of Greece and Rome has totally lost contact with the con-
temporary social and political realities that had invigorated the
image of antiquity under the Revolution and the Empire.

In general, this view of the classical past—a Romantic dream
of an aesthetic idyl that might be reconstructed with the tools of
modern archeology—was even more pervasive in Germany, where,
from the time of such expatriates as Winckelmann and Mengs,

Gautier, His Life and Times, London, 1958. Gautier's admiration for In-
gres is discussed here (pp. 139-140).

[111] For a contemporary publication of the house, with very Parnassian
descriptions, see Théophile Gautier, Arsène Houssaye, and Charles Coligny,
Le Palais Pompéien de l'Avenue Montaigne, Paris, n.d. For further com-
ments, see Hautecœur, *Histoire . . .* , VII, pp. 124-125; and the Marquis
de Rochegude, *Promenades dans toutes les rues de Paris* (*VIII^e arrondisse-
ment*), Paris, 1910, p. 104, where the date of the house is given incorrectly
as 1860 and where another Pompeian house of the Second Empire is men-
tioned (by Cailleux, ca. 1860, Rue Franciade, St. Denis).

[112] This painting, which commemorates an antique *fête* held on Jan. 15,
1860, is discussed further in the exhibition catalogue, *Théophile Gautier*,
Paris, Bibliothèque Nationale, 1961, p. 57, no. 206.

Greco-Roman antiquity had been seen with the same reverence and awe of a Northerner for the Mediterranean world which had earlier characterized Dürer's experience of the Italian Renaissance. In fact, the Prince Napoléon's idea of an aristocratic residence that transplanted, with archeological exactitude, a Pompeian house to Northern soil had been preceded in Germany by the Pompeianum of Ludwig I at Aschaffenburg (1841-1846), designed by Friedrich von Gärtner in imitation of the House of Castor and Pollux at Pompeii (Fig. 155).[113]

Still more symptomatic of this transalpine viewpoint were German Neoclassic designs for museums that, appropriately enough, were to house aesthetic treasures preserved from a dead classical past. A case in point is a museum design by Karl Friedrich Schinkel of 1800 (Fig. 156).[114] Unlike Sir Robert Smirke's projects for the British Museum (1824-1847),[115] Schinkel's study is utterly remote from the realities of his own time. Located in a sylvan, Arcadian setting, his Greek Temple of beauty is surrounded by figures in antique costume rather than by the Berlin bourgeoisie who would actually frequent such a public building. This reverie upon an idyllic classical past, comparable to the private aesthetic and archeological speculations of artists like Asmus Jakob Carstens or the group of Weimar painters who clustered about Goethe, was literally realized in the Munich Glyptothek—whose very name is Greek—where Schinkel's design was reworked by Leo von Klenze (1816-1830) as an ideal building in which to house the ideal beauties of classical sculpture in the

[113] Gaertner had visited Pompeii on Sept. 3, 1844, presumably in connection with the Pompeianum. See Klaus Eggert, *Die Hauptwerke Friedrich von Gaertners* (*Neue Schriftenreihe des Stadtarchivs München*, 15), Munich, 1963, p. 173.

[114] This early design by Schinkel (Coll. von Quast, Radensleben bei Neuruppin) is also discussed and illustrated in Alste Oncken, *Friedrich Gilly, 1772-1800*, Berlin, 1935, p. 107 and pl. 90c.

[115] For a discussion of Smirke's plans in the context of early nineteenth century museum designs, see Nikolaus Pevsner, "British Museum: Some Unsolved Problems of Its Architectural History," *Architectural Review*, cxiii, March 1953, pp. 179-182.

collection of Ludwig I (Fig. 157).[116] Its palpable recreation of a classical domain of pure beauty has more democratic heirs in such twentieth century museums as John Russell Pope's National Gallery in Washington (1937),[117] where the design still follows Schinkel's (Fig. 158), or the panoramic Philadelphia Museum of Art (Horace Trumbauer & Associates, begun in 1919), where a polychrome Hellenistic acropolis, complete with the optical refinements of Greek architecture,[118] is virtually recreated above the Schuylkill River (Fig. 159).[119]

But the Romantic rejection of contemporary experience implied in Schinkel's prophetic museum design of 1800 was surely best realized in Klenze's Walhalla (1816-1842), created as a Pantheon not for classical, but for German, greatness (Fig. 160).[120] Here nineteenth century urban realities are permitted no contact at all with this meticulous reconstruction of the Parthenon's unsurpassed perfection. Situated in the wilds of an Altdorferesque forest on the Danube near Regensburg, the Walhalla obliges the visitor to make a pilgrim's journey, by boat or by foot, that thoroughly alienates him from the realities of modern experience.

[116] On the Glyptothek and a related museum design by Haller von Hallerstein, see Oswald Hederer, *Leo von Klenze; Persönlichkeit und Werk*, Munich, 1964, pp. 184-209.

[117] As one of the ultimate monuments of the Classic Revival in the United States, Pope's National Gallery design was attacked for its conservatism by defenders of modern architecture. See, for example, Joseph Hudnut, "The Last of the Romans; Comment on the Building of the National Gallery of Art," *Magazine of Art*, xxxiv, April 1941, pp. 169-173.

[118] These refinements, although noticed early in the nineteenth century, were particularly topical in the United States at the time of the planning of the museum, thanks to the appearance of W. H. Goodyear, *Greek Refinements: Studies in Temperamental Architecture*, New Haven, 1912.

[119] On the complex and uncertain genesis of the scheme for this acropolitan museum in the context of Philadelphia urban renewal, see George B. Tatum, *Penn's Great Town*, Philadelphia, 1961, pp. 125-126, where it is suggested that Jacques Gréber is responsible for the ideas of the museum which were later carried out by Trumbauer, *et al.*

[120] On the Walhalla, see Hederer, *op.cit.*, pp. 300-314; and, most recently, L. D. Ettlinger, "Denkmal und Romantik; Bemerkungen zu Leo von Klenzes Walhalla," in *Festschrift für Herbert von Einem*, eds. G. von der Osten and G. Kauffmann, Berlin, 1965, pp. 60-70.

This lofty spectacle of a classical temple in a timeless natural setting was most evocatively seized by Turner, who, after visiting it under construction,[121] then imagined the *Opening of the Wallhalla in 1842* as if he were a nineteenth century Watteau seeing a dreamlike vision of antiquity too beautiful to be attainable in the modern world (Fig. 161).[122] Turner described this ideal monument in his own awkward poetic words:

> Who rode on thy relentless car, fallacious Hope?
> He, though scathed at Ratisbon, poured on
> The tide of war o'er all thy plain, Bavare,
> Like the swollen Danube to the gates of Wien;
> But peace returns—the morning ray
> Beams on the Wallhalla, reared to science and the arts,
> And men renowned, of German fatherland.[123]

If ultimately, Klenze's Walhalla may be considered the grandiose descendant of those classical temples found in early Romantic gardens, its recreation of the mature glories of fifth century Athens is very unlike the recurrent eighteenth century image of classical architecture as something fascinating or even terrifying in its rude simplicity. Already, the reformatory directions of architects like Ledoux and Jefferson may have suggested that in the late eighteenth century, classical architecture could often be interpreted as a source of geometrically pure and hence therapeutic forms. Indeed, this attraction to primary, elemental types dominated much of the late eighteenth century's experience of the classical and the proto-classical, an experience that is most con-

[121] In Sept. 1840. See A. J. Finberg, *The Life of J. M. W. Turner, R.A.*, 2nd ed., Oxford, 1961, p. 381.

[122] "Wallhalla" is Turner's spelling. This painting has already been illustrated in connection with such a nineteenth century vision of an idealized past (Werner Hofmann, *The Earthly Paradise; Art in the Nineteenth Century*, New York, 1961, pl. 29).

[123] This poetic fragment accompanied the entry in the Royal Academy exhibition catalogue, 1843, no. 14. It is partially quoted in A. J. Finberg, *op.cit.*, p. 507. Turner's painting was later sent to Munich for the Congress of European Art exhibition (1845), but it was ridiculed there for its lack of topographical exactitude and was returned (*ibid.*, pp. 414-415).

veniently blanketed under the term Primitivism.[124] From the mid eighteenth century on, the most restless, challenging inquiries of Western arts and letters looked back to the origins of the long evolutionary sequence that had led, ultimately, to what was so frequently considered the corruption—whether political, moral, or aesthetic—of the contemporary world.[125] Rousseau's and Herder's considerations of the natural state of man,[126] Lord Monboddo's investigations of the origins of language,[127] Bishop Thomas Percy's collection of ancient ballads[128]—such endeavors, among many, were characteristic of this new concern with art and civilization in virgin, uncorrupted states. And in architectural terms as well, this reversion to unspoiled origins was a continual motif in late eighteenth century practice and theory.

What is today recognized as a major innovation in the history of these primitivist attitudes toward classical architecture appeared most unobtrusively in 1758 as a modest adornment to Lord Lyttleton's gardens at Hagley Park near Birmingham (Fig. 162).[129] This little temple, erected on grounds that already included a false Gothic ruin,[130] was designed by one of the new

[124] In art historical writing, this term is most familiar in discussions of the twentieth century, as in Robert J. Goldwater's basic study, *Primitivism in Modern Painting*, New York, 1938. In studies of cultural history, however, this term is commonly used in discussions of various eighteenth century phenomena, as in, e.g., L. Whitney, *Primitivism and the Idea of Progress in English Popular Literature of the Eighteenth Century*, Baltimore, 1934, with an introduction by the American scholar most often associated with studies in primitivism, Arthur O. Lovejoy.

[125] The classic collection of essays dealing with such matters is that of Lovejoy, *Essays in the History of Ideas*, Baltimore, 1948.

[126] On these ideas, see *ibid.*, especially Essays II, IX.

[127] *Of the Origin and Progress of Language*, London, 1773-1792. Characteristically, Lord Monboddo, like Rousseau, was fascinated by the question of primitive man, and described one such example in his *Account of a Savage Girl* (1768). For a lucid account of simple, primitive man in the ideology of Romantic literature, see Hoxie Neale Fairchild, *The Noble Savage; A Study in Romantic Naturalism*, New York, 1928.

[128] *Reliques of Ancient English Poetry*, London, 1765.

[129] For the relevant correspondence, see Mrs. Maud Mary Wyndham, ed., *Chronicles of the Eighteenth Century, founded on the Correspondence of Sir Thomas Lyttleton and His Family*, II, London, 1924, p. 296.

[130] By Sanderson Miller (1747).

breed of archeologists, James Stuart, who had studied Greek architecture *in situ* and who had used the severity of the baseless Greek Doric order at the Theseum in Athens as the model for this garden pavilion.[131] As the first example in post-classical architecture of the Greek Doric order, Stuart's little temple introduced a problematic form that could both offend conservative and delight progressive sensibilities; indeed, the subsequent history of the use of this order is connected with the most radical rejections of the Late Baroque and Rococo styles.[132] The appeal of such a primitive building could be twofold: intellectual and emotional. On the one hand, its simple trabeated forms provided a lucid demonstration of architectural principles, a primer of classical post-and-lintel construction that corresponded to the reformatory, anti-Rococo reactions of the mid century. On the other hand, these rugged, almost natural forms could inspire Romantic reveries upon the Rousseauan felicities of a remote, uncorrupted civilization or, more dramatically, upon the sublime power associated with such remote, legendary worlds as those of the newly exalted, archetypal bards of Nordic and Mediterranean civilizations, Ossian and Homer.[133]

Thus, Stuart's restatement of the Theseum's Doric order is related to mid eighteenth century theoretical inquiries into the origins of architecture. For instance, Sir William Chambers' *Treatise on Civil Architecture* of 1759 illustrates, with homage to the Vitruvian hut, the rudest beginnings of the Doric order in a building whose coarse wooden structural members seem part man-made and part natural (Fig. 163);[134] and in the same

[131] See Lesley Lawrence, "Stuart and Revett: Their Literary and Architectural Careers," *Journal of the Warburg Institute*, II, 1938, p. 138; and F. Saxl and R. Wittkower, *British Art and the Mediterranean*, London, 1948, no. 78, 1.

[132] The fundamental discussion of the introduction of the Greek Doric order into Western architectural practice is N. Pevsner and S. Lang, "Apollo or Baboon," *Architectural Review*, CIV, Dec. 1948, pp. 271-279.

[133] See above, p. 46.

[134] Illustration facing p. 1, with Vitruvian references to building origins in primitive cones and cubes.

way, progressive theoreticians like Friedrich August Krubsacius[135] or the Abbé Marc-Antoine Laugier[136] constantly cited the simple post-and-lintel system as a vehicle for the architectural reform they deemed so necessary for the 1750's and 1760's. Actual designs for buildings, whether classical or Gothic,[137] often reflected this willful retrogression to a natural, unspoiled state, particularly when associated with rustic settings. Sir John Soane's project for a dairy confounds man-made geometries with the vertical supports of real tree trunks (Fig. 164),[138] just as the Temple rustique at Ermenonville (Fig. 165) seems to take the spectator back to a temple whose thatched roof and tree-columns stand in an even more primitive relation to the evolution of Greek architecture than does Stuart's garden pavilion at Hagley.[139] Here, too, reflections of theories about the origins of the temple form are combined with a late eighteenth century daydream that conjures up a pastoral vision of Arcadian shepherds, complete with goat and thyrsis. And elsewhere, this primitivism could find inspiration

[135] Krubsacius, whose 1747 article, "Betrachtungen über den wahren Geschmack der Alten in der Baukunst," is remarkably precocious, needs study. His theoretical writing is discussed briefly in Eberhard Hempel, *Geschichte der deutschen Baukunst*, Munich, 1949, pp. 502-503.

[136] Laugier is now the subject of a lengthy study: Wolfgang Herrmann, *Laugier and Eighteenth-Century French Theory*, London, 1962.

[137] Thus, the Gothic could as easily be associated with natural building origins in its resemblance to trees and branches as could the post-and-lintel simplicity of the classical temple. On this association of Gothic and nature, see Lovejoy's classic essay, "The First Gothic Revival and the Return to Nature," in *Essays in the History of Ideas*, Baltimore, 1948, pp. 136-165. For a telling architectural example of this association, see Dauthe's forest-like remodeling of the Gothic choir of the Nicolaikirche, Leipzig (1784), illustrated in Herrmann, *op.cit.*, pl. 40. The general question of this return to nature in the Revival styles has been discussed recently in Dora Wiebenson, "Greek, Gothic and Nature: 1750-1820," *Essays in Honor of Walter Friedlaender* (ed. Marsyas), New York, 1965, pp. 187-194.

[138] In Soane's *Plans, Elevations, and Sections of Buildings*, London, 1788, pl. 44. Soane's primitivism and its connection with Chambers' references to the Vitruvian hut, cited above (n. 134), are mentioned in John Summerson, *Sir John Soane*, London, 1952, pp. 33-34.

[139] The Temple rustique is described in *Promenade ou itinéraire des jardins d'Ermenonville* (with engravings by Mérigot *fils*), Paris, 1788, pp. 32-33.

in Arcadian fantasies culled from non-Western sources. Thus, a series of German designs for garden pavilions published between 1779 and 1805 even included suggestions for a "Nordamerikanische Pflanzerhütte" of reeds and twigs and an "Otahitische Hütte" with battered walls (Fig. 166).[140]

Not all images of classical, proto-classical, or exotically primitive architecture offered such sylvan tranquillity as found in these garden follies, English, French, or German. At times, Greek Doric temples could elicit sensations of high Romantic drama of the kind associated with the terrifying rawness of the newly appreciated Aeschylus. Thus, in John Cozens' watercolor *Paestum* (1782), the squat and stumpy temple is viewed as an object of sublime terror, set out on a bleak plain under a stormy sky of uncommon menace (Fig. 167).[141] It was an image that belonged not only to the artist's imagination, but also to the architectural realities of the Greek revival. One need only consider William Playfair's Royal Institution (1822-1836) at Edinburgh, the "Athens of the North," a Greek Doric building whose low, cubic forms of graying Craigleith stone, paired in a valley with Playfair's Ionic National Gallery (1850-1854) and seen against the dramatic silhouette of Edinburgh Castle, recreate in palpable form the Romantic artist's visions of early Greek temples in savagely desolate landscapes (Fig. 168).[142]

[140] These exotic and primitive garden follies come from one of the most extravagant collections of the period: Johann Gottfried Grohmann, *Ideenmagazine für Liebhaber von Gärten . . .* , Leipzig, 1779-1805. (The North American reed hut is in vol. XLIII, pl. 10; the Tahitian hut in vol. XXV, pl. 9.) Grohmann's publication is discussed and illustrated in Alfred Hoffmann, *Der Landschaftsgarten* (*Geschichte der deutschen Gartenkunst*, III), Hamburg, 1963, pp. 151ff. For a comparably exotic and primitive French example, see Lequeu's design for a "Cabane des sauvages," illustrated in Helen Rosenau, "Architecture and the French Revolution: Jean Jacque [*sic*] Lequeu," *Architectural Review*, CVI, Aug. 1949, p. 114, fig. 10.

[141] Cozens visited Paestum on Nov. 7, 1782. For comments on his drawings of the Greek temples there, see the Burlington Fine Arts Club, *Catalogue of a Collection of Drawings by John Robert Cozens*, London, 1923, pp. 26-27.

[142] The original cubic simplicity of the Royal Institution was altered by the addition of extra porticos and columns. See Ian Lindsay, *Georgian*

Once set into motion, this pursuit of the wonders and the terrors of the primary phases of classical architecture could be pushed, in evolutionary terms, further and further backwards, to points that ventured into real and imaginary realms of pre-history. Thus, John Constable's famous watercolor of *Stonehenge* (1836) falls into the tradition of sublime topography explored in Cozens' view of Paestum, though the object of awe here moves into the most remote, preclassical reaches (Fig. 169). The penned inscription on the mount makes these Romantic sensations explicit: "The mysterious monument of Stonehenge, standing remote on a bare and boundless heath, as much unconnected with the events of past ages as it is with the uses of the present, carries you back beyond all historical records into the obscurity of a totally unknown period."[143] Two years later, this fascination with origins could lead into such remarkable realms of speculation as Joseph Gandy's *Origins of Architecture* of 1838 (Fig. 170),[144] a pre-Darwinian fantasy in which the inhabitants are subhuman and their rude shelter is created by organic processes of geological and botanical growth that again recall, as in Mme. Harvey's Ossianic painting of 1806 (Fig. 43), such Romantic wonders as Fingal's Cave.[145]

If Gandy's anthropological imagination takes us to realms undreamed of by Chambers in his reconstruction of the Vitruvian

Edinburgh, Edinburgh, 1948, p. 42; and John Summerson, *Architecture in Britain, 1530 to 1830*, 4th ed., Baltimore, 1963, pp. 309-310.

[143] The quotation accompanied the Royal Academy catalogue entry (1836, no. 581). On this watercolor, see also Graham Reynolds, *Catalogue of the Constable Collection, Victoria and Albert Museum*, London, 1960, no. 395. In addition to forming a background of would-be historical correctness in such late eighteenth century pictures as James Barry's *Death of Cordelia* (see above, Chapter III, n. 6), Stonehenge was even the basis of a garden folly designed by John Nash for Blaise Castle, the estate of J. S. Harford. (See Terence Davis, *The Architecture of John Nash*, London, 1960, no. 126.)

[144] For further remarks on this extraordinary picture and on Gandy in general, see John Summerson's admirable essay, "The Vision of J. M. Gandy," in his *Heavenly Mansions*, London, 1949, especially pp. 132-133.

[145] For further comments on Fingal's Cave and Romantic art, see above, Chapter I, n. 152.

hut or by Stuart in his Doric temple at Hagley Park, it should nevertheless be remembered that it was this late eighteenth century fascination with the primitive in classical architecture that ultimately led to these very un-Greek musings upon the dark beginnings of civilization. Indeed, like so many attitudes toward classical architecture that had their origins in the eighteenth century, the primitivist one survived into our own time. Thus, the famous hypostyle hall at Antonio Gaudí's Park Güell in Barcelona (1900-1914) perpetuates that eighteenth century scrutiny of classical architecture in terms of both problems of structural logic and evocation of a strange, primitive past (Fig. 171).[146] For, if these sloping Doric columns would investigate questions of architectural statics in the support of the shell-vaulted concrete roof, they also create a mysterious, proto-classic environment that becomes still more remote in the outer reaches of the park. There, in curving galleries of stone, branch, and leaf that follow the geological contours of the land, these sloping columns no longer bear the marks of a classical vocabulary but are confounded with the kind of natural architecture conjured up by Gandy's vision of primitive shelter (Fig. 172). Confronted with Gaudí's imaginative excursions into the distant realms of the classical and the pre-classical, the modern spectator finds himself an heir to the sensations first elicited by the rustic temples in Romantic gardens. Here, as elsewhere, the legacy of new attitudes explored in the late eighteenth century survives into our own time.[147]

[146] As Hitchcock points out (*Gaudí*, New York, Museum of Modern Art, 1957, p. 10), the very fact that the English spelling of park is used in the name underlines the ultimate source of inspiration. For further comments on the Park Güell, see George Collins, *Antonio Gaudí*, New York, 1960, pp. 17ff.

[147] Thus, following the analyses offered in Goldwater's study (*Primitivism in Modern Painting*, New York, 1938), an exploration of the comparable phenomenon in modern architecture would be worth making. It might include not only the intellectually oriented formal primitivism of the International style, but also such points of primitive contact as those between Frank Lloyd Wright and Pre-Columbian architecture; Hans Poelzig and natural caverns and grottoes (as in his theater designs at Berlin and Salzburg); Le Corbusier and prehistoric dwellings and cult sites.

IV

TOWARD THE *TABULA RASA*

OF THE many complementary and even contradictory currents that are bracketed loosely under the heading of "Neoclassic" architecture, the most vital seem motivated by that late eighteenth century spirit of drastic reform which found its most radical culmination in the political revolutions of America and France. In an effort to establish a thorough cleavage with the presumably decadent conditions into which they were born, architects of this alternately destructive and constructive period often sought out the most rudimentary building forms, as if these might create a *tabula rasa* with which to begin a new historical epoch. At times, even the noble and simple precedents offered by ancient Greece and Rome appeared inadequate to express this relentless pursuit of an architectural statement of primeval purity; and, as has been suggested already, late eighteenth century architecture frequently regressed to preclassical or even nonclassical forms of extraordinary imaginative power.

The treatment of the Greek Doric order is a case in point. Among the garden pavilions constructed under the aegis of Goethe and the Duke Karl August in the park at Weimar stands the so-called Römische Haus of the 1790's,[1] whose podium and Ionic tetrastyle portico allude respectfully to Roman precedent (Fig. 173). When we descend to the basement level, however, we also descend to a remarkably archaic moment in the history of classical architecture (Fig. 174). Like the blocky forms of Ledoux's archway for the Hôtel de Thélusson (Fig. 132), these stout Doric shafts, with their strong entasis, seem half-submerged in the earth, an effect no doubt inspired in part by the actual ap-

[1] The house was based on plans by the Hamburg architect, Johann August Arens, and was constructed between 1791 and 1797. For a more detailed history, see Wolfgang Huschke, *Die Geschichte des Parkes vom Weimar*, Weimar, 1951, pp. 86ff. For an attractive photographic presentation of the park, see *idem, Park um Weimar; ein Buch von Dichtung und Gartenkunst*, Weimar, 1956.

pearance of unexcavated temple sites.[2] The resulting proportions are so crude and elephantine by traditional architectural standards that they conjure up a remote Greek world in which even the temples that Goethe had admired at Segesta, Agrigento, and Paestum[3] would seem late and decadent intruders.

In other German examples of the 1790's, this search for the most elemental forms can move to a still earlier phase of architectural evolution. In Friedrich Weinbrenner's design for an arsenal (1795) (Fig. 175)[4] or Friedrich Gilly's design for a gatehouse (Fig. 176)[5]—building types which, like prisons and tombs,[6] seemed particularly stimulating to the primitivist imagination of the late eighteenth century—the bloated Doric columns are divested even of their broad flutings; and in the Gilly project, the use of battered walls and a baldly exposed network of the rudest post-and-lintel structure manages to evoke a dramatic vision of a gateway to some ancient Troy or Mycenae. Small wonder, then, that this kind of vision of remote classical architecture was used

[2] As discussed above, Chapter III, n. 49. The most articulate statements about the new aesthetic properties of these half-submerged forms are found in Boullée's considerations of "architecture ensevelie" in his manuscript, *Considérations sur l'importance et l'utilité d'architecture* (Bibliothèque Nationale, Paris).

[3] As recorded in his *Italienische Reise*, Goethe visited Segesta on April 20, 1787; Agrigento, April 23-27, 1787; and Paestum, mid-March 1787 and again on May 16, 1787. For Goethe's drawings of these and other sites visited during his Italian journey, see Gerhard Femmel, ed., *Corpus der Goethezeichnungen* (*Goethes Sammlungen zur Kunst, Literatur und Naturwissenschaft*), II, Leipzig, 1960.

[4] On Weinbrenner's design and related projects, see Arthur Valdenaire, *Friedrich Weinbrenner; sein Leben und seine Bauten*, Karlsruhe, 1919, p. 42.

[5] On this and other primitivizing projects by Gilly, see Alste Oncken, *Friedrich Gilly, 1772-1800*, Berlin, 1935, pp. 51ff.; and Hermann Beenken, *Schöpferische Bauideen der deutschen Romantik*, Mainz, 1952, p. 61.

[6] As discussed above, Chapter II, n. 80. A remarkably late survival of this lugubrious mode of primitivizing Neoclassicism can be seen in the Tomb of Giuseppe Mazzini (d. 1872) in the Cimitero di Staglieno, Genoa. Its pair of stumpy Doric columns framing a battered doorway in the side of a rock realizes in actual stone some of the more imaginative fantasies of Weinbrenner and Gilly.

to represent the Scaean gate in *Hector's Farewell*, a painting submitted by Gilly's contemporary, Ferdinand Hartmann, to Goethe's Weimar Preisaufgaben of 1800 (Fig. 20).[7]

Other architects could push architectural evolution even further back. Characteristic of the avant-garde precocity of Scandinavian late eighteenth century art[8]—a precocity that could produce a full-fledged Neoclassic sculptor in the 1760's (Johannes Wiedewelt)[9] and a full-fledged Romantic painter in the 1770's (Nicolai Abildgaard),[10]—it was a Swede, Carl August Ehrensvärd,[11] who, in the 1780's, imagined perhaps the most spectacularly archaic of all Neoclassic Doric orders. In his sublimely moody studies of ancient classical buildings for Nordic landscapes, he invented Doric colonnades so squat and earthbound in their proportions that they seemed more appropriate to a pre-Greek architecture and were hence considered Egyptian (Fig. 177).[12]

In their search for an Aeschylean drama of vigorous and austere simplicity and power, such projects still pay some respects, however slight, to the archeological fact of the true Greek Doric order. Yet many other late eighteenth century designs that also

[7] See above, p. 25.

[8] For a survey that includes these advanced directions, see Alfred Kamphausen, *Deutsche und skandinavische Kunst; Begegnung und Wandlung*, Schleswig, 1956, pp. 44-54.

[9] Wiedewelt's precocity in the history of Neoclassic sculpture parallels that of Gavin Hamilton in the history of Neoclassic painting. Both artists, characteristically, stem from the Northern periphery of European art, a periphery that produced most of the radical innovations in the late eighteenth century. On Wiedewelt, see K. W. Tesdorpf, *Johannes Wiedewelt, Dänemarks erster klassizischer Bildhauer, ein Anhänger von Winckelmann*, Hamburg, 1933.

[10] On Abildgaard, see above, pp. 12f.

[11] For a succinct and informed discussion of Ehrensvärd, see Sven Åke Nilsson, "Pyramid på Gustav Adolfs torg," *Konsthistorisk Tidskrift*, XXXIII, nos. 1-2, May 1964, pp. 1-20.

[12] On this and related "Egyptian" projects, see *ibid.*, pp. 13-14. Typically, Ehrensvärd admired Paestum (*ibid.*, p. 2) and pursued these primitive tastes to the remarkable point of a design composed of a pure pyramid with a Doric temple on the interior. This design for a monument on the Gustav Adolf Square, Stockholm, is in its form and date (1782) as radical as contemporaneous projects by Boullée and Ledoux.

use ostensibly primitive means for historically advanced ends reject even these oblique contacts with Greek or Roman precedent, and stretch the archeological boundaries of the term Neoclassicism to the breaking point. For instance, the most extreme of Ledoux's Utopian projects for Chaux or Maupertuis (Figs. 134-136) pursue their volumetric goals of the pyramidal, the cubical, and the spherical so far that, as we have seen,[13] they often approach Platonic ideals of architecture rather than buildings that can be explained by reference to classical or Renaissance prototypes. And in other designs of the period, this same willingness to bypass the heritage of the classical tradition in favor of still starker, more primary forms can be seen in no less drastic terms. The megalomaniac designs of Ledoux's contemporary, Étienne-Louis Boullée,[14] provide numerous examples of this zealous disclosure of an irreducible geometry. In his plan for a cemetery entrance, the severity of the triangular mass is so uncompromising that it recalls, if anything, the sublime simplicity and grandeur of the Egyptian pyramids so admired by Boullée himself (Fig. 178).[15] Greco-Roman and Renaissance principles of

[13] See above, pp. 120ff.

[14] The basic studies of Boullée remain Emil Kaufmann, "Three Revolutionary Architects, Boullée, Ledoux, and Lequeu," *Transactions of the American Philosophical Society, Philadelphia*, LXII, Part 3, Oct. 1952, pp. 436-473; and Helen Rosenau, *Boullée's Treatise on Architecture*, London, 1953. It should be added that in the winter of 1964, the Bibliothèque Nationale, Paris, held a superb exhibition of Boullée and his contemporaries, "Les Architectes visionnaires de la fin du XVIIIᵉ siècle," for which a catalogue has been promised.

[15] Boullée's comments on Egyptian architecture were typical of the late eighteenth century's attraction to the sublime effects produced by grandiose scale: "Les Egyptiens avaient des idées très grandes: on admire avec raison leurs Pyramides; l'ordonnance d'architecture qui règne dans leur Temples offre l'image du grand." (Rosenau, *op.cit.*, p. 98.) Like Boullée, Gilly was also fascinated with the possibility of pyramidal designs, some even ziggurat-like. See Alste Oncken, *Friedrich Gilly, 1772-1800*, Berlin, 1935, pp. 38-39. For a discussion of the Egyptian revival in architecture, see Hans Vogel, "Agyptisierende Baukunst des Klassizismus," *Zeitschrift für bildende Kunst*, XLII, 1928/1929, pp. 160-165; N. Pevsner and S. Lang, "The Egyptian Revival," *Architectural Review*, CXIX, May, 1956, pp. 242-254; and the unpublished doctoral dissertation, Richard Carrott, *The Egyptian*

design are equally flouted in a project for a city gate, which, like the cemetery entrance, eliminates that sense of human scale traditionally conveyed through the use of classical orders (Fig. 179). To find historical precedent for such a gigantesque project, in which the clean planar surfaces and cubic volumes of the side pavilions are brusquely contrasted with the rough textures and circular void of the battered walls, one must again look outside the classical tradition to gateways like those from the Ancient Near East (the Palace of Sargon, Khorsabad) or even the late Middle Ages (the representation of the Golden Gate in Giotto's Arena Chapel frescoes) (Fig. 180).[16]

The implicit goal of such projects—a goal that would lead to an architecture of absolutely pure cubes, spheres, pyramids, and cylinders—was, in fact, never quite attained in even the most fantastic projects of the late eighteenth century, although it was once realized less ambitiously in a remarkable garden monument, the Altar of Good Fortune, designed by Goethe in 1777 for the park at Weimar (Fig. 181).[17] If at first glance these timeless geometries—a perfect sphere resting on a cube—might be mistaken for the work of an ancient mathematician or a modern abstractionist, a Euclid or a Brancusi, they are, in fact, the late eighteenth century distillation of a Renaissance and Baroque iconographic tradition in which restless desires, represented by the instability of the sphere, are finally put to rest by virtue, represented by the stability of the solid block. It was characteristic

Revival in America; Its Sources, Its Monuments, and Its Meanings, 1808-1858, Yale University, 1961.

[16] Many of Boullée's projects for city gates have this curious combination of a medieval and ancient Near Eastern character. (See, for example, Rosenau, *op.cit.*, figs. 51-55.) Ancient Near Eastern architecture, if unknown until the 1840's, was nevertheless imagined before that, especially in the wilder fantasies of John Martin.

[17] The first idea for the altar was recorded by Goethe in his journal entry of Christmas Day, 1776. For a study of this monument, its references to Goethe's personal biography, and its iconographical sources in emblem books and Renaissance and Baroque art, see William S. Heckscher, "Goethe im Banne der Sinnbilder; ein Beitrag zur Emblematik," *Jahrbuch der Hamburger Kunstsammlungen*, VII, 1962, pp. 35-54.

of the late eighteenth century that these symbolic forms could be pushed to so absolute a reduction that they almost appear unrelated to a particular historical epoch.

Such a complete purification, however, was more of an exercise in symbolic geometry[18] than a creative work of sculpture or architecture, and Goethe's contemporaries, if approaching comparably puristic goals, could never realize them so absolutely. With the irony that accompanies the entire primitivist tradition in modern art, from the mid eighteenth century to the present, the more willfully pure and simple are the artist's intentions, the more sophisticated and complex are the results likely to be.[19] Even Ledoux's and Boullée's most radical statements of solid geometry surprise us with such eccentric details as stripped Palladian windows, contrived textural contrasts between smooth and scored surfaces, small refinements in the treatment of windows and doorways; and in those buildings actually constructed around 1800 in which these primitivist currents are dominant, the contrast between the ostensibly rude and severe vocabulary and the almost mannered refinement of the results is particularly conspicuous. In the unforgettably dramatic and eccentric façade of Peter Speeth's[20] casern in Würzburg (1809),[21] the first impression is of an unrelieved severity and massiveness that might stem from the world of Aegean archeology; yet on closer consideration, this

[18] A comparable symbolic conceit in the Weimar park is the stone altar, around which a snake winds itself to eat the votive bread above (1787; by Martin Gottlieb Klauer).

[19] The classic analysis of this tension between primitivist means and sophisticated ends is found in Robert J. Goldwater, *Primitivism in Modern Painting*, New York, 1938. Although the points made by Goldwater refer to twentieth century painting, they are generally applicable to comparable primitivist phenomena around 1800.

[20] Speeth needs study. The most useful clues for further research are given in the biographical article by Fritz Schulz in Thieme-Becker.

[21] The building is generally identified as a *Frauenzuchthaus*, but its original function was to house the Bishop of Würzburg's bodyguard. Its extraordinary façade has prompted its inclusion in many surveys of German nineteenth century art. For other analyses of its design, see Franz Landsberger, *Die Kunst der Goethezeit*, Leipzig, 1931, pp. 196-197; and Hans Vogel, *Deutsche Baukunst des Klassizismus*, Berlin, 1937, pp. 39-40.

monolithic impact breaks down into a series of architectural conceits whose perverse infractions of traditional rules rival and often surpass those of sixteenth century Mannerist architecture (Fig. 182).[22] Thus, the stringcourses, instead of clearly dividing the façade into distinct horizontal zones, intercept architectural members in a manner that confounds each story with the one above or below it. The uppermost stringcourse cuts right across the window arches, thereby establishing a curious analogy with the arched windows and doorways of the ground floor, which seem, moreover, to be half submerged in the earth; and the lowest stringcourse interrupts the battered sides of the heavily rusticated entrance, creating above it a separate Doric temple façade whose weightlessness is as baffling as its diminutive proportions. Even the seemingly Cyclopean textures of the lowest zone are contradicted by such refined details as the thin recession of concentric semicircles around the windows set into the shallowest of planes, or the extraordinary reversed batter of the doorway. Above all, these contradictions are felt in the building's unsettling scale, which alternates abruptly between the brutally gigantic and the elegantly miniature.

This paradoxical discrepancy between the would-be virility of primitive architectural elements and the actual effeteness and ambiguity of the results can be seen in even more fragile terms in many of the works of Sir John Soane. In his gatehouse at Tyringham (1794),[23] for example, the starkly cylindrical, un-

[22] Art historical analysis in modern times has tended to point out many points of contact between painting around 1800 and the styles and emotions familiar to sixteenth century Mannerism (as in, for example, Barry, Fuseli, Blake, and in later transformations of Davidian Neoclassicism by masters like Girodet and Ingres). The same phenomenon is to be observed in architecture. Sources for Ledoux have been sought out in some of the Mannerist devices of Giulio Romano and Palladio, but these affinities need exploration in broader terms. The most inventive architecture around 1800 (Dance and Soane; Gilly and Schinkel; Hansen and Bindesbøll; Boullée and Ledoux) is generally susceptible to that analysis of ambiguities and solecisms so prevalent in studies of Mannerist architecture.

[23] On Tyringham, which was constructed for William Praed between 1792 and 1797, see Dorothy Stroud, *The Architecture of Sir John Soane,*

fluted, and baseless Doric columns take us to a remote classical
world whose archaism is borne out by the blocky proportions of
the archway and the over-all elimination of any traditional archi-
tectural ornament (Fig. 183). Yet the ultimate effect is not one
of rude strength, but rather of a strange, thin-blooded perversity
and refinement. Narrow decorative incisions run parallel to the
square and circular forms of the archway so that its ostensibly
solid geometry becomes rather a series of paper-thin planes;[24]
and in the same way, the wings provide a series of shallow pro-
jections and recessions—some niched, some colonnaded—that
again produce a lean and weightless effect. Even the abaci are
so thin that they create, instead of solid, weight-bearing members,
only elegant linear motifs that continue the decorative horizon-
tal scoring of the adjacent walls. Throughout the design, in fact,
a vocabulary of the most rudimentary architectural forms is or-
ganized by a grammar of highly complex sensibility. In this,
Soane, like his finest contemporaries, often prophesies the com-
parable discrepancy between means and ends experienced in the
work of Le Corbusier and Mies van der Rohe of the 1920's and
1930's, in which the simplest architectural elements—unorna-
mented rectangular planes, lucidly exposed structure—are manip-
ulated with results of high visual ambiguity in the tensions be-
tween solid and void, plane and volume, load and support.[25]

Like architecture, the figural arts of the late eighteenth century
witnessed the same fervent search for an elemental purity and,
no less frequently, the same mannered and even exquisite re-

London, 1961, p. 80. I have taken the date of 1794 for the gatehouse from
John Summerson, *Sir John Soane*, London, 1952, pl. 30.

[24] These scored linear decorations reach a height of mannered com-
plexity in the façade of Soane's own house at Lincoln's Inn Fields, London.
For other remarkable examples of Soane's primitivism, leading to Man-
nerist effects, see, in particular, the Royal Chelsea Hospital Stables (illus-
trated in Stroud, *op.cit.*, fig. 151); and the Doric barn at 936 Warwick
Road, Solihull (*ibid.*, fig. 107).

[25] For an unusually stimulating analysis of the curious planarity of
Soane's buildings and his general position in the history of modern archi-
tecture, see Henry-Russell Hitchcock's introduction to Stroud, *op.cit.*, pp.
10-18.

sults. This retrogressive evolution may, in fact, be conveniently traced through the same deathbed motif that was used above to demonstrate the mobility of the new Historicism.[26] Again, Gavin Hamilton's *Andromache Bewailing the Death of Hector* in the Cunego engraving of 1764 may serve as a point of departure (Fig. 23). Within the formal context of the 1760's, such a painting offered an antidote to the diminutive scale and circuitous structure of Rococo art by reviving the full-scale figures and frieze-like composition that could be found in Poussin, Lebrun, and Roman relief sculpture. Gradually, however, even these stylistic clarifications were found inadequate by many artists of the later eighteenth century. Just as the Doric order could be pushed to ever greater extremes of primitivism, so, too, could such a rudimentary pictorial type as the deathbed motif be rigorously simplified.

Thus, William Blake's *Breach in a City the Morning after the Battle*, a watercolor exhibited at the Royal Academy in 1784,[27] takes Hamilton's compositional type and further abstracts it in terms of both subject and form (Fig. 184). If the theme is the aftermath of a battle, no particular battle or hero is commemorated.[28] Apart from the understated vestiges of medieval armor in the supine warriors,[29] the generalized costume of the figures

[26] See above, pp. 28ff.

[27] R.A., no. 400. The problem of which of Blake's three versions of this watercolor is the one exhibited in 1784 has been raised recently. According to Frederick Cummings (*Romantic Art in Britain; Paintings and Drawings, 1760-1860*, Detroit and Philadelphia, 1968, no. 93), the version in the Charles Rosenbloom collection (now reproduced here, Fig. 184) rather than that in the Ackland Memorial Art Center, Chapel Hill, N.C. (reproduced in earlier printings of this book) is probably the one shown at the R.A. His opinion is also shared by David Bindman.

[28] However, Alexander Gilchrist (*Life of William Blake*, ed. Ruthven Todd, London, 1945, pp. 46-47) suggests that the subject may offer a timely reflection of the official cessation of hostilities between England and the United States in 1784.

[29] Like many of the corpses in Blake's work, these figures undoubtedly reflect the engravings Blake made for James Basire of medieval sculpture, especially tomb sculpture, in Westminster Abbey and other British churches (1773ff.). For an account of this apprenticeship to Basire, see Gilchrist, *op.cit.*, pp. 14-17; and also the only full study of Blake from the point of view of the modern art historian, Anthony Blunt, *The Art of William Blake*, New York, 1959, p. 3. Bibliographically speaking, it might

could belong to any time or place; indeed, their identity is so remote from historical time that, together with the monstrous, quasi-prehistoric bird of prey in the upper lefthand corner, they might be located in that strange archaistic environment conjured up by the most extravagant of Boullée's or Gilly's projects.[30] In the same way, Blake's style regresses by millenniums from the developed techniques of illusionism still so evident in Hamilton's scene of Homeric grief and heroism. If the basic compositional

be mentioned that few of the countless studies of Blake are very revealing for the art historian. Blunt's study finally locates him in the context of late eighteenth century British art, instead of the usual location of Blake as a unique genius unrelated to a particular time and place. An implicit effort to create such a relevant British ambiance for him (ending in a debunking) was made by Geoffrey Grigson in "Painters of the Abyss," *Architectural Review*, cviii, Oct. 1950, pp. 215-220, which emphasized the importance of Fuseli, Mortimer, and Barry and thereby minimized Blake's stature. Not too unexpectedly, the most stimulating accounts of Blake's art for the art historian have been written not by Blake scholars but by art historians who happen to have written about Blake. Among these may be cited: Hans Tietze, "William Blake," *Die Kunst*, xliv, 1929, pp. 356-360; Walter Friedlaender, "Notes on the Art of William Blake; a Romantic Mystic completely exhibited," *Art News*, xxxvii, Feb. 18, 1939, pp. 9-10; Charles Seymour, Jr., "Blake's Esthetic and His Century," *Parnassus*, xi, Feb. 1939, pp. 10-13. The most important, and neglected, attempt to locate Blake within international currents of the nineteenth century is in Ulrich Christoffel, *Malerei und Poesie; die symbolistische Kunst des 19. Jahrhunderts*, Vienna, 1948, pp. 5-17, where analogies with Runge and later nineteenth century currents are made. Expanding this in my own unpublished doctoral dissertation ("The International Style of 1800: A Study in Linear Abstraction," New York University, Institute of Fine Arts, 1956, ch. iv), I have attempted to place Blake in the context of abstract linear currents of the late eighteenth century, with particular reference to parallel developments in the art of Asmus Jakob Carstens. I hope soon to publish an article dealing with analogies between these two contemporaries.

For further aids to the enormous Blake bibliography, see G. E. Bentley, Jr., and M. K. Nurmi, *A Blake Bibliography; Annotated Lists of Works, Studies, and Blakeana*, Minneapolis, 1964. This compendium, however, tends to itemize rather than to categorize, and the art historian will be at pains to single out the studies relevant to his particular Blake interests.

[30] In this light, it should be mentioned that the architecture invented by Blake for his own art conforms closely to these primitivist directions, including even representations of Stonehenge and dolmens (as in plates from *Jerusalem* and *Milton*).

format of friezelike figures standing and kneeling around the horizontal corpses is preserved, the corporeality of Hamilton's sculpturally modeled forms has all but vanished. In keeping with the symbolic environment of an abstract landscape and architecture, Blake's figures seem deprived of nearly all bodily substance; their fluent, wraithlike contours enclose spirit rather than flesh and no longer need exist in the rational spatial ambiance measured out by Renaissance perspective devices.

This primitivist direction, in which highly developed illusionistic traditions of modeling, perspective, atmosphere, and luminosity are threatened, is pursued even further in George Romney's drawing, the *Death of Cordelia*,[31] probably to be dated shortly after Blake's watercolor (Fig. 185).[32] Here even Blake's style has been drastically simplified. The deathbed itself, together with the abbreviated suggestions of an architectural background, has been reduced to a rectilinear grid that creates an even shallower space than Blake's primeval environment and dematerialized figures; and the mourners themselves—who again, as in Blake, belong to no historical time or place but represent, as it were, an abstract conception of grief—are tightly compressed into simple profile postures and rhymed groupings that conform to the rudimentary structural geometries of stark parallels and perpendiculars. In elemental contrast to the rectangular shapes of the bare architecture and the static horizontal of Cordelia's corpse, these doleful women display a lean and elegant fluency that transforms the seeming austerity of this drawing into something almost precious and mannered. Romney's son, John, spoke of his father's love of the *simplex munditiis*—"He knew how to unite Grecian grace with Etruscan simplicity."[33] Indeed, the attenuated, Blakelike rhythms of the contours that describe limbs, necklines, and

[31] For references to the drawing, see the exhibition catalogue, *George Romney: Paintings and Drawings*, Iveagh Bequest, Kenwood, 1961, no. 80.

[32] The date is probably ca. 1789, at which time Romney was involved with illustrations for Boydell's Shakespeare Gallery.

[33] John Romney, *Memoirs of the Life and Works of George Romney*, London, 1830, pp. 162-163.

shoulders recall the stylizations in Greek vase paintings, as do the strong, silhouetted contrasts of light and dark.[34]

A still greater grace and simplicity inform the even more abstract deathbed composition that Blake, in turn, used as the title page for his poetic cycle, *Songs of Experience* (1794),[35] a scene of timeless sorrow that may well reflect a knowledge of Romney's drawing (Fig. 186).[36] Here the number of mourners is reduced to two, rhythmically paired like Romney's, and the composition is based on a rudimentary pattern of bilateral symmetry, so common around 1800,[37] that is further underlined by the incorporation of lettering as an integral part of this compositionally and emotively simple structure. As in so much architecture of the late eighteenth century, the complexities of the Renaissance and Baroque traditions seem to be willfully eschewed in favor of a primitive clarity of form and feeling, here compounded from such diverse sources as Greek vase painting, medieval tomb effigies, and illuminated manuscripts.[38] Indeed, Blake's new ability to

[34] It was exactly this quality of *simplex munditiis* which John Romney found in his father's work (*loc.cit.*) that late eighteenth century writers constantly attributed to Greek vase painting.

[35] On this title page, which Blake probably worked on for several years before its completion in 1794, see Geoffrey Keynes, *A Study of the Illustrated Books of William Blake—Poet, Painter, Prophet*, New York, 1964, pp. 29ff. For an evocative analysis of the differences between this plate and the comparable title page in the *Songs of Innocence*, see Blunt, *op.cit.*, pp. 52-53.

[36] The probability of a connection is increased by the abundant analogies between Blake's and Romney's Shakespeare illustrations of ca. 1790, as indicated by Blunt (*ibid.*, p. 20).

[37] The re-emergence of bilateral symmetry as a compositional principle in the late eighteenth and early nineteenth centuries is a phenomenon worth considering. It is found not only in Blake, but in Flaxman, Runge, Friedrich, Ingres, the Nazarenes, etc., and suggests the total breakdown of the illusionistic goals of the Baroque tradition, which are replaced by images that emphasize ideal and symbolic permanence in terms of cosmological schemes (Blake, Runge), divinity in landscape (Friedrich), primitive simplicity (Flaxman), historical authority and immutability (Ingres, Overbeck and many academic followers).

[38] Characteristic of the late eighteenth century, Blake's pictorial sources are extraordinarily wide in range, both historically and geographically;

combine his images with words—the weightless spirits that float amid the sprouting tendrils create flat arabesques exactly analogous to those of the lettering in the title—speaks for his success in replacing those illusionistic techniques painstakingly developed from the fifteenth through the eighteenth centuries with a heraldic style that evokes the symbolic language of the Middle Ages. Even the colors of this frontispiece ignore illusionistic goals and are used, instead, as pure decorative zones that stand halfway between the medieval manuscript page and twentieth century chromatic abstraction.

However, the most consistent formulations of these late eighteenth century attempts to reduce pictorial art to a minimal vocabulary were the internationally renowned literary illustrations of a close friend of William Blake's, the sculptor John Flaxman.[39]

and characteristic of Blake, these sources are often so well assimilated that precise borrowings are difficult to pin down. Apart from the great impact engravings after Michelangelo and later Mannerists had upon him, Blake generally detested post-High Renaissance art, preferring anti-illusionistic styles—antique, medieval, exotic—of linear purity and symbolic intention. The fullest account of these diverse sources is in the basic article by Anthony Blunt, "Blake's Pictorial Imagination," *Journal of the Warburg and Courtauld Institutes*, VI, 1943, pp. 190-212. This material is largely absorbed in Blunt's fuller study referred to above, n. 29.

[39] Considering the historical importance and wide influence of Flaxman's outline engravings, it is surprising that they have not yet been the subject of a comprehensive study. The one monograph on Flaxman (W. G. Constable, *John Flaxman, 1755-1826*, London, 1927) is a general survey of his work, devoted largely to his sculpture. It contains a selective bibliography (pp. 119-120). His sculpture is again given prominence in Margaret Whinney, *Sculpture in Britain, 1530-1830* (*Pelican History of Art*), Harmondsworth, 1964, where it merits an entire chapter; and he is treated as an over-all artistic phenomenon in *idem*, "Flaxman and the Eighteenth Century," *Journal of the Warburg and Courtauld Institutes*, XIX, July-Dec. 1956, pp. 269-282. Actually, the most penetrating analyses of Flaxman's outlines have been made not by Englishmen but by foreigners. Of these, one should cite Max Sauerlandt, "John Flaxman," *Zeitschrift für bildende Kunst*, XIX, 1908, pp. 189-197; and Jeanne Doin, "John Flaxman," *Gazette des Beaux-Arts*, 4ᵉ période, XIII, March 1911, pp. 233-246 and April 1911, pp. 330-348. More recently, Dora and Erwin Panofsky have provided, if only *en passant*, the most cogent characterization of Flaxman's classical outlines and their general position in the history of the outline style that

In a characteristic engraving from Flaxman's first major publication, the *Iliad* and *Odyssey* illustrations of 1793,[40] we find a restatement of the deathbed format (Fig. 187). The simplicity of Homeric grief—Achilles mourning over the corpse of Patroclus—is conveyed through the equally simple means of what Henry James was to call Flaxman's "attenuated outlines."[41] Even more than Blake or Romney, Flaxman has willfully eliminated the irregularities of luminary and textural effects, paring his vocabulary down to the rudimentary language of pure outline on monochrome paper.[42] Compositional axes are correspondingly reduced

proliferated in the late eighteenth century (*Pandora's Box; the Changing Aspects of a Mythical Symbol*, London, 1956, pp. 92ff.).

The confusion surrounding the precise dates and variants of the numerous Flaxman editions published in England and all over the Continent has been considerably clarified by the recent appearance of G. E. Bentley, Jr., *The Early Engravings of Flaxman's Classical Designs; a Bibliographical Study*, New York, The New York Public Library, 1964, which attempts to list all editions of Flaxman's outlines published between ca. 1793 and 1826. In this, Bentley depends in part on the unpublished typescript by Lt.-Col. Wm. E. Moss, *The Classical Outlines of John Flaxman, R.A. . .* (Bodleian Library). Bentley's study also indicates, most usefully, the whereabouts of preparatory drawings for the various outlines. There remain, however, some unsolved problems about the mysterious first Dante edition of 1793, about which see below, n. 76. It should be mentioned, too, that further confusion is added to the study of Flaxman by the fact that his plates are numbered differently in different editions, a fact which many references ignore.

[40] John Flaxman, *The Iliad of Homer; the Odyssey of Homer* (engraved by Thomas Piroli), Rome, 1793. The title page is in English, the description of plates in Italian. These illustrations were commissioned by Mrs. Hare-Naylor. They were not, however, Flaxman's first ventures at illustrating classical literature. At the age of eleven, he apparently drew scenes from the writings of the ancient poets, which were read aloud to him by the wife of the Reverend Mr. Mathew (Allan Cunningham, *The Lives of the Most Eminent British Painters and Sculptors*, 2nd ed., III, London, 1830, p. 281). He had also been commissioned by Jeremiah Crutchely to do six drawings after classical subjects (*ibid.*).

[41] In his description of a New England parlor in the winter: ". . . a group of sensitive and serious people, modest votaries of opportunity, fixing their eyes upon a bookful of Flaxman's attenuated outlines." (Henry James, *Hawthorne*, New York, 1879, ch. III, p. 69.)

[42] Although most editions of Flaxman's outlines are printed on white paper, the first Rome edition of 1793 was printed on a light blue paper.

to the most elementary perpendicular and parallel relationships, so that all forms, animate and inanimate, are rigorously aligned against the picture surface as if invoking the planarity of an imaginary dawn of ancient figural art appropriate to the Homeric scene illustrated.

But once again, as in the archaizing architecture of Soane, this pursuit of the primitive produces strangely subtle effects. Like the thin decorative scoring of the Tyringham gatehouse or the nervous, sawtooth contours of Flaxman's own design for a commemorative arch[43] that seems only at first glance to be of a stark, semicircular simplicity (Fig. 188), the tremulous linear patterns of these engravings betray a complex and delicate sensibility. Thus, beneath the bed and behind the footstool, these parallel decorative striations vary in width to create curious linear stylizations that suggest, in schematic terms, an intricate variation of shadow and plane upon a flat and pristine surface; and similarly, the mourner on the far side of the bed is rendered in a thinner, fainter outline which offers another vestige of that postmedieval illusionism presumably expunged by these purified linear means.

Consonant with the primitivist intentions of his style, Flaxman chose to illustrate only the most ancient masterpieces of classical literature, and as Alfred de Vigny was to put it, may have been the first to express the bounding step of the Olympian gods.[44] In 1795, two years after the successful appearance of his Homeric illustrations, he published his *Compositions from the Tragedies*

[43] The arch design was for a competition of 1799 to commemorate British naval victories. On Flaxman's project and the competition, see Malcolm Campbell, "An Alternative Design for a Commemorative Monument by John Flaxman," *Record of the Art Museum, Princeton University*, xvii, 1958, pp. 65-73.

[44] The full phrase is: "Flaxmann [*sic*] le premier, je crois, a senti et exprimé la marche bondissante des dieux de l'Olympe qui, sans ailes, s'élançaient et redescendaient comme l'aigle et parcouraient la terre en trois pas." Cited in Ernest Dupuy, *Alfred de Vigny; ses amitiés, son rôle littéraire*, i (*Les Amitiés*), Paris, 1910, p. 15. For further comments on Vigny's admiration for Flaxman, see Marc Citoleux, *Alfred de Vigny, persistances classiques et affinités étrangères* (*Bibliothèque de la revue de littérature comparée*, xvii), Paris, 1924, pp. 621-622.

of Aeschylus,[45] honoring a dramatist whose severe style was as aesthetically inaccessible as the Greek Doric order until the late eighteenth century discovered the power and the fascination of the archaic and the primitive.[46] Thus, in a preparatory drawing for a scene from the *Suppliants*,[47] in which the daughters of Danaüs are shown praying to Hera, Zeus, and Athena, Flaxman takes us to the thrilling dawn of Greek civilization in both pictorial and emotional terms (Fig. 189). As in Romney's *Death of Cordelia*, the composition has been distilled to a heraldic grid of rectilinear rhythms, in which the archaic triad of cult statues presides with rigid and absolute authority. Tightly compressed within the geometric confines of the lowest horizontal band, a frieze of supplicating women, seen in profile, expresses a common prayer through the repetitive rhythms of rounded, almost Giottesque contours that offer a rudimentary emotional contrast to the stern immobility of the frontally viewed gods.

The same awesome combination of primitive ritual and primitive style is found in the even more severe scene from the *Choëphoroe* that shows Elektra leading a doleful procession to Agamemnon's tomb (Fig. 190), an image of starkly simple grief that was soon to be adapted to a scene of equally elemental Christian lamentation in Blake's tempera painting of ca. 1800, the *Procession from Calvary* (Fig. 191).[48] With bowed heads, this quartet of Greek

[45] London, 1795. These were again engraved by Thomas Piroli and printed on light blue paper. The Aeschylus illustrations had been commissioned by the Dowager Countess Spencer, and were prepared, together with the Homer illustrations, in Rome, 1792-1793.

[46] On this late eighteenth century taste for Aeschylus, see above, Chapter I, n. 50.

[47] The drawing is listed in Laurence Binyon, ed., *Catalogue of Drawings by British Artists . . . in the British Museum*, II, London, 1900, p. 140, no. 16, although it has never before been reproduced. The engraving based on this drawing is omitted in some of the Aeschylus editions.

[48] It would appear that here, as in many other cases, Blake depended on the pure and skeletal format of Flaxman's outlines for inspiration in his own work. For some other examples of Blake's borrowings from Flaxman, see C. H. Collins Baker, "The Sources of Blake's Pictorial Expression," *The Huntington Library Quarterly*, IV, April 1941, pp. 365-366.

On this painting and related tempera paintings executed for Thomas

women evokes a world of primeval ceremonial sorrow, accentu-
ated by the lucid and regularized alternations of raised and low-
ered arms, straight and curved back lines. Indeed, their grave and
geometricized body rhythms prophesy not only the comparably
elemental body movements in such symbolist masters as Hodler
and Munch, but also the related vein of emotional primitivism
investigated through the techniques of such modern dancers as
Isadora Duncan, Mary Wigman, and Martha Graham.[49]

This fascination with the rudimentary power of communal
gestures and emotions may again be seen in another illustration
from Aeschylus, the oath-taking scene from the *Seven Against
Thebes* (Fig. 192). In the context of other late eighteenth cen-
tury scenes of oath-taking—Hamilton's *Oath of Brutus* (Fig. 70),
Fuseli's *Oath on the Rütli* (Fig. 72), and David's *Oath of the
Horatii*[50] (Fig. 69)—Flaxman's image takes us to the most re-
mote and primitive world of all, in which the composition is
reduced to the simple opposition of two like groups, and an
utterly abstract, spaceless ground replaces the spatial ambiance
traditionally created through postmedieval perspective techniques.
Yet once more, this vision of archaic purity is complicated by
remarkable subtleties of space and pattern. Thanks to the deli-
cate variations of width and intensity in these outlines—whether
in the schematic shadows that fall on shields and legs or in the

Butts, one of Blake's most important patrons, see Martin Butlin, *William
Blake (1757-1827); a Catalogue of the Works of William Blake in the Tate
Gallery*, London, 1957, no. 24. The painting is also discussed briefly in
Blunt, *The Art of William Blake*, New York, 1959, pp. 66-67. For a
useful compendium of Blake's works in tempera, see the exhibition
catalogue, *The Tempera Paintings of William Blake*, London, Arts Coun-
cil of Great Britain, 1951.

[49] Some provocative suggestions about formal affinities between Art
Nouveau and the style of Blake, Flaxman, and Runge have already been
made by Robert Schmutzler (*Art Nouveau*, New York, 1962, pp. 35-55),
and other analogies between Blake and Symbolist currents of the nine-
teenth century can be implied in Christoffel, *Malerei und Poesie*. . . . How-
ever, the question of the roots of late nineteenth century primitivism in
the years around 1800 is open to further exploration.

[50] See above, pp. 69f.

pale contour that describes the hindmost figure on the right—these flattened forms generate intricate overlappings of parallel planes in the shallowest of spaces, a new kind of spatial illusionism that looks both forward to the ambiguities of Synthetic Cubism and backward to the primitive techniques Flaxman and his contemporaries enjoyed in Greek vase painting and the earliest Italian masters.[51]

For, belying the simplistic view that would locate a taste for Greek art with Neoclassicism and a taste for medieval art with Romanticism, artists and connoisseurs of the late eighteenth and early nineteenth centuries could look at Exekias and Cimabue with equal enthusiasm. From the 1760's on, in fact, there appeared in historical tandem elaborate and adulatory publications that reproduced and, at times, even compared the primitive beginnings of both ancient and modern figural art,[52] beginnings that seemed to offer the common denominator of a simple anti-illusionistic style that created forms through almost exclusively flat and linear techniques.

A landmark in these publications was the four magnificent folios of 1766-1767[53] reproducing in luxurious, if chaste, color Sir

[51] For a survey of late eighteenth century publications of and enthusiasm for the primitives of both ancient and modern painting, see Rosenblum, *The International Style of 1800* . . . , ch. III.

[52] Thus, already in 1766, P. F. H. d'Hancarville discussed Greek vase painting as conforming to Pliny's historical account of how "painting in its beginning had only a simple outline which being afterwards filled up with one colour, gave the name of monochromate to that sort of painting," and as paralleling the first steps of such Italian primitives as "Cimabué, André Taffi, Gaddo Gaddi, le Margaritone et le Giotto." (P. F. H. d'Hancarville, ed., *Collection of Etruscan, Greek, and Roman Antiquities from the Cabinet of the Honorable William Hamilton*, I, Naples, 1766, pp. 160, 169.)

For a particularly extensive listing of this taste for an art that emphasized pure outline, whether ancient or medieval, see the contents of Girodet's library, as itemized in A.-L. Pérignon, *Catalogue des tableaux, esquisses, dessins, et croquis, de M. Girodet-Trioson, peintre d'histoire*, Paris, 1825, pp. 87ff. It included, e.g., prints after Greek vases, Ghiberti, the Campo Santo frescoes, and such contemporary outline illustrations as those by Flaxman and Ruhl.

[53] P. F. H. d'Hancarville, *ed.cit.* The text is in French and English. Sir

William Hamilton's newly formed collection of those Greek
vases that, as late as Flaubert's *Dictionnaire des idées reçues,* were
still popularly considered to be Etruscan (*Étrusque—tous les vases
anciens sont étrusques*).[54] So closely did these flat and abstract
images correspond to the late eighteenth century's rejection of
illusionistic Baroque traditions that Hamilton's first collection
of vases was twice reprinted, less extravagantly;[55] and a second,
new collection of Hamilton vases, which was first published be-
tween 1791 and 1795,[56] similarly demanded later and cheaper
editions.[57] In the same way, new publications of Italian art before

William Hamilton had been appointed British envoy at the court of Naples
in 1764, at which time he began collecting vases. Sir William himself paid
for the first edition, which cost no less than £6000! (See the article on
Hamilton in *Dictionary of National Biography,* VIII, London, 1921-1922,
p. 1109.)

[54] Flaubert's dictionary of platitudes was compiled throughout his life
and was intended as a supplement to *Bouvard et Pécuchet* (first published
posthumously in 1881).
The mid eighteenth century controversy over the Greek versus the
Etruscan origins of these vases is treated in Carl Justi, *Winckelmann und
seine Zeitgenossen,* 2nd ed., III, Leipzig, 1898, pp. 340ff.

[55] *Antiquités étrusques, grecques, et romaines* . . . , 5 vols., Paris,
1785-1788; *Antiquités* . . . , 4 vols., Florence, 1801-1808.

[56] Wilhelm Tischbein, ed., *Collection of Engravings from Ancient Vases
. . . discovered in the Kingdom of the Two Sicilies . . . now in the pos-
session of Sir William Hamilton,* 3 vols., Naples, 1791-1795.

[57] *Peintures des vases antiques de la collection de son excellence M. le
Chevalier Hamilton,* 4 vols., Florence, 1800-1803; *Recueil de gravures
d'après des vases antiques, la plupart d'un travail grec . . . tirés du
cabinet de M. le Chevalier Hamilton* . . . , 4 vols., Paris, 1803-1809. A
cheap English edition of vases from Hamilton's collection, engraved by
Henry Kirk, appeared in 1804: *Outlines from the Figures and Composi-
tions upon the Greek, Roman, and Etruscan Vases of the late Sir William
Hamilton* . . . , London, 1804. This was reprinted, in somewhat smaller
format, in 1814. Another collection of ancient vases appeared at the same
time in France: Aubin Louis Millin de Grandmaison, ed., *Peintures de
vases antiques, vulgairement appelés étrusques* . . . , 2 vols., Paris, 1808-
1810.
For a brilliant survey and characterization of the style of pure line
engraving developed in the late eighteenth century, see Dora and Erwin
Panofsky, *Pandora's Box* . . . , pp. 90ff. It includes such telling analyses
as: "Reduced to pure contours, the visible world in general, and the

Raphael investigated the strong and severe roots of another great artistic tradition.[58] Already in the 1770's, Thomas Patch, an Englishman in Florence, began to publish engravings after Masaccio, Giotto, Ghiberti;[59] and by the 1790's, Italy played host to such transalpine visitors as the Netherlander, Humbert de Superville; the Englishman, William Young Ottley;[60] and the Frenchmen,

precious relics of antiquity in particular, seemed to assume an unearthly, ethereal character, detached from the 'material' qualities of color, weight, and surface texture . . ." (p. 91).

[58] An excellent survey of the history of the appreciation of Italian primitives as well as a discussion of the general revival of interest in the Middle Ages are found in Camillo von Klenze, "The Growth of Interest in the Early Italian Masters, from Tischbein to Ruskin," *Modern Philology*, IV, October 1906, pp. 207-268. See also Tancred Borenius, "The Rediscovery of the Primitives," *Quarterly Review*, CCXXXIX, April 1923, pp. 258-270; and the somewhat less informative study by Lionello Venturi, *Il gusto dei primitivi*, Bologna, 1926. A useful summary and bibliography of this subject is given in Millard Meiss, "Italian Primitives at Konopiště," *Art Bulletin*, XXVIII, March 1946, pp. 2ff. For a recent discussion of this topic, which I have not yet been able to consult, see Giovanni Previtali, *La fortuna dei primitivi del Vasari ai Neoclassici*, Turin, 1964; and also *idem*, "Les Primitifs italiens et les collectionneurs au 18e siècle," *L'Œil*, no. 121, Jan. 1965, pp. 2-15.

[59] For an account of Patch's life and works, see F. J. B. Watson, "Thomas Patch (1725-1782); Notes on his Life, together with a catalogue of his known works," *Walpole Society*, XXVIII, 1939-1940, Oxford, 1940, pp. 15-50. His publications of the 1770's are presented as biographies: *The Life of Masaccio*, Florence, 1770 (engravings after the Brancacci Chapel); *The Life of Fra Bartolommeo della Porta* . . . ; *The Life of Giotto*, Florence, 1772 (engravings and aquatints after these two masters). The edition of eleven plates after Ghiberti's *Gates of Paradise* (Florence, 1774) has no title. It should be mentioned that Patch's engraving style hardly distinguishes between the styles of Giotto and Fra Bartolommeo (the former conforming to the High Renaissance character of the latter), but in this case, it is the precocity of the idea that counts. As Patch himself claimed in his text to the Giotto plates, "After all, I believe I am the first that has ever given any Prints to the publick after this Author. . . ."

[60] William Young Ottley worked together with Humbert de Superville. In the 1790's, they prepared a publication of engravings after the early Italian masters, which, in fact, did not appear until 1826: W. Y. Ottley, *A Series of plates, engraved after the paintings and sculptures of the most eminent masters of the early Florentine school . . . and dedicated to John Flaxman* (engraved by T. Piroli), London, 1826. On Ottley and

Seroux d'Agincourt and Paillot de Montabert[61]—all of whom were involved in the study and reproduction of works by the early Italian masters.[62]

Greek or Italian, these hitherto neglected or maligned works of art provided the late eighteenth century with the stimulus of a primitive, uncorrupted style that evoked a *tabula rasa* upon which to create a new and vital pictorial tradition. Most often, writers saw correspondences between the presumably linear origins of Greek and Italian art;[63] and quite as consistently, artists admired both styles and could even combine them in a single work. A remarkable case in point is a drawing by a close friend of Blake, the amateur artist and poet, George Cumberland.[64] At-

Humbert de Superville's activities, see Giovanni Previtali, "Alle origini del primitivismo romantico," *Paragone*, XIII, May 1962, pp. 32-51; and the exhibition catalogue, *Mostra di disegni di D. P. Humbert de Superville*, Florence, Uffizi, 1964.

For a general study of Humbert de Superville, who was also an artist, playwright, and art theorist, see Cornelia Magdalena de Haas, *David Pierre Giottino Humbert de Superville, 1770-1849*, Leyden, 1941; and the essay in J. Knoef, *Tusschen rococo en romantik; een bundel kunsthistorische opstellen*, The Hague, 1943, pp. 171-196.

[61] For an excellent discussion of these two Frenchmen as well as of Artaud de Montor, another French admirer of the Italian primitives, see M. Lamy, "Seroux d'Agincourt (1730-1814) et son influence sur les collectioneurs, critiques et artistes français," *La Revue de l'art ancien et moderne*, XXXIX, March 1921, pp. 169-181; and XL, Sept.-Oct. 1921, pp. 182-190. Characteristic of the correspondence between the revival of ancient and modern primitives, Seroux d'Agincourt referred to himself as the "Winckelmann des temps de barbarie." (*Ibid.*, p. 175.)

[62] In addition to activities by these foreigners, Italy herself provided publications about the primitives, usually in conjunction with the new historicizing studies of the period. See, for example, *Serie degli uomini i più illustri nella pittura, scultura, e architettura . . .* , 12 vols., Florence, 1769-1775, which, though unillustrated, discusses masters like Cimabue, Cavallini, Buffalmaco, and Giotto; and *L'Etruria pittrice . . .* , eds. Niccolò Pagni and Giuseppe Bardi, 2 vols., Florence, 1791, 1795.

[63] See, for instance, d'Hancarville's comments, cited in Chapter IV, n. 52.

[64] There are no studies of Cumberland's activities as an artist, but references to his activities and friendships are frequent in Joseph Farington, *The Farington Diary*, ed. J. Greig, 8 vols., London, 1922-1928. For an account of Cumberland's relationship to Blake, see Mona Wilson, *The Life of William Blake*, London, 1932, pp. 35, 84ff.

tracted to all art that offered a "pure, flowing, and fine" outline,[65] and capable of referring to "the Hesiod-like simplicity of Mantegna,"[66] Cumberland merged both Greek vase painting and the late Gothic International Style in a drawing after Ghiberti's *Gates of Paradise* (Fig. 193).[67] Two figures from the Jacob and Esau scene and one from the Story of Noah (Fig. 195)[68] are copied in a flat, linear style that combines, on the one hand, the mellifluous drapery folds of Ghiberti's figures and, on the other, the simplified silhouettes of monochrome red figures on a black ground that echo Cumberland's admiration for the lucid elegance of early Greek pictorial art.[69] It is worth noting that Ghiberti's use of a checkerboard ground plane for illusionistic purposes is apparently too advanced for Cumberland's primitivist taste; for this recessive plane is transformed, in the drawing, into two flattened steps upon which the maiden at the right floats, rather than stands, in conformity with a new style of willful two-dimensionality.

Cumberland's ability to fuse two ostensibly disparate historical styles was shared by Flaxman, who, in 1806, was already described by Joseph Farington as "a mixture of the Antique and the Gothic"[70] and who, in 1956, was incisively characterized by

[65] The phrase comes from Cumberland's zealous propagation of outline as the pure and hence therapeutic rudiment of art: *Thoughts on Outline, Sculpture and the System that guided the Ancient Artists in Composing their Figures and Groups*, London, 1796, p. 1. Blake, whose fervent worship of outline probably influenced Cumberland's theory, provided most of the engravings for this work.

[66] This primitivist simile comes from another reformatory essay by Cumberland: *An Essay on the Utility of Collecting the Best Works of the Ancient Italian School*, London, 1826, p. 16.

[67] The drawing comes from a sketchbook described in L. Binyon, ed., *Catalogue of Drawings by British Artists . . . in the Department of Prints of Drawings in the British Museum*, i, London, 1898, pp. 351ff.

[68] That Cumberland was able to make such a juxtaposition speaks for his sensibility to the perception of figures as isolated, sculptural units.

[69] His sketchbook includes examples of linear purity culled from all historic and geographic sources, Greek, Italian, and even Javanese. Elsewhere, Cumberland comments on Persian and Indian painting as models of grace and simplicity (*An Essay on the Utility . . .*, p. 18).

[70] Farington, *op.cit.*, iii, p. 182 (April 11, 1806).

167

Dora and Erwin Panofsky as "both a pupil of the antiquarians and a teacher of the Pre-Raphaelites."[71] Indeed, Flaxman too could admire the art of the Middle Ages as fully as that of ancient Greece, and he even demonstrated, during his seven-year sojourn in Italy (1787-1794),[72] a precocious enthusiasm not only for Greek vases but also for such works of art, then little esteemed, as the Rucellai Madonna, the bas-reliefs on the Orvieto Cathedral façade, and paintings by Taddeo Gaddi.[73] And in the same way, his attraction to the most archaic, anti-realist phases of evolutionary cycles, extending even to Egyptian sculpture,[74] was

[71] *Pandora's Box* . . . , p. 93. The Panofskys also refer to Goethe's early awareness of Flaxman's affinities to the Italian primitives. Goethe's phrase is: ". . . eine Gabe in den unschuldigen Sinn der ältern italienischen Schule zu versetzen, ein Gefühl von Einfalt und Natürlichkeit," and may be found in his brief essay of April 1, 1799, "Über die Flaxmanischen Werke," *Goethe; Schriften zur Kunst* (*Gedenkausgabe der Werke, Briefe und Gespräche,* ed. Ernst Beutler, XIII), Zurich, 1954, pp. 183-185. For some later comments by Goethe on Flaxman's popularity in Germany, see "Polygnots Gemählde in der Lesche zu Delphi," *Jenaische Allgemeine Literatur-Zeitung,* I, Jan.-March 1804, p. 23.

[72] On Flaxman's Italian sojourn, see Cunningham, *Lives* . . . , III, pp. 294ff.; and most recently, David Irwin, "Flaxman: Italian Journals and Correspondence," *Burlington Magazine,* CI, June 1959, pp. 212-217. For some financial details of this sojourn, see E. Croft-Murray, "An Account-Book of John Flaxman, R.A.," *Walpole Society,* XXVIII, 1939-1940, Oxford, 1940, pp. 56-70.

[73] Flaxman's sketchbooks of these years are discussed in Irwin, *op.cit.*; and in Margaret Whinney, "Flaxman and the Eighteenth Century," *Journal of the Warburg and Courtauld Institutes,* XIX, July-Dec. 1956, pp. 277, 280-282. His attraction to medieval art can be seen as early as his set of Gothic chessmen, ca. 1783 (illustrated in W. G. Constable, *John Flaxman, 1755-1826,* London, 1927, pl. VIII). As for Flaxman's specific knowledge of and borrowings from Greek vases, further study is in order. Apparently he made copies after Greek vases while in Rome (see his letter to Romney of May 25, 1788, in John Romney, *Memoirs of the Life and Works of George Romney,* London, 1830, pp. 204-210). J. Doin ("John Flaxman," *Gazette des Beaux-Arts,* 4e période, XIII, March, 1911, p. 241) suggests that Flaxman knew the plates for the Tischbein-Hamilton publication of Greek vases (1791-1795) before they were printed. In any case, Flaxman must be considered a creative artist who radically transformed his sources, a point already stressed by Cunningham (*Lives* . . . , III, pp. 296-297).

[74] See his *Lectures on Sculpture,* London, 1829, ch. III.

matched by his ability to illustrate not only Homer, Aeschylus, and Hesiod,[75] but also Dante. His outlines for *La Divina Commedia*, prepared in Rome in 1793 and first published in 1793 or 1802,[76] offer no essential change in style or attitude from the classical outlines of the 1790's. In both cases a style of linear purity, evoking a remote and uncorrupted era, is used as a vehicle for the presentation of a mythical world of fantasy, heroism, and divinity that could not be properly recorded through the earth-bound empiricism of most Renaissance and Baroque styles. Flaxman's Dante illustrations are even more airborne than the scenes from Homer and Aeschylus. Like Botticelli's own late Gothic outline drawings for Dante, they locate the spectator most often in ethereal and infernal realms exempt from the gravitational and perspectival laws that generally dominated post-medieval art. In the Homeric illustrations certain scenes exploited that dissolution of normative human scale already evident in the late eighteenth century.[77] Thus, the scene of Thetis calling Briareus to the aid of

[75] The Hesiod illustrations were the latest of the classical outlines: *Compositions from the Works and Days, and Theogony of Hesiod* (engraved by William Blake), London, 1817.

[76] The Dante outlines were commissioned by Thomas Hope and were apparently completed by Flaxman in 1793. According to Bentley (*The Early Engravings of Flaxman's Classical Designs . . .* , p. 47), Hope, for selfish reasons, prevented their being published, preferring to enjoy them privately. The first published Dante seems to have been that of 1802: *La Divina Commedia di Dante Alighieri* (engraved by T. Piroli), Rome. Indeed, neither the British Museum nor the Bibliothèque Nationale possesses an earlier edition. Nevertheless, there is contrary evidence that some pre-1802 edition must have been available, at least in Germany, for it is referred to by both Goethe ("Über die Flaxmanischen Werke," written at Jena, April 1, 1799) and by A. W. von Schlegel ("Über Zeichnungen zu Gedichten und John Flaxman's Umrisse," *Athenaeum*, II, Berlin, 1799, p. 204, note).

For studies of Dante illustrations that consider Flaxman, see Ludwig Volkmann, *Iconografia dantesca*, Leipzig, 1897; and Paget Toynbee, "Dante in English Art," in *Thirty-Eighth Annual Report of the Dante Society* (*Cambridge, Mass.*), *1919*, Boston, 1921. Both of these studies, incidentally, refer to a 1793 Dante edition, as does Albert S. Roe (*Blake's Illustrations to the Divine Comedy*, Princeton, 1953, p. 31).

[77] This breakdown of rational scale is particularly apparent in early

Jupiter juxtaposes on one flat plane and in an immeasurable space all manner of figure sizes, ranging from the bizarre tininess of the Olympian Zeus at the top of the page to the no less disquieting gigantism of the hundred-armed Briareus at the bottom (Fig. 194). Such odd collisions, from the Lilliputian to the Brobdingnagian, are the exact pictorial counterparts of the abrupt and dislocating shifts of scale found in, say, the diverse architectural members thinly imbedded in the tight, planar façade of Speeth's Würzburg casern (Fig. 182).[78]

In the Dante illustrations, this habitation of a completely airborne realm of uncharted spaces is even more thoroughgoing in its rejection of the realist traditions into which Flaxman was born. In the *Fall of Lucifer*,[79] a vertiginous cosmic descent is rendered through pictorial means that almost prophesy Futurism (Fig. 196).[80] In an effort to visualize the fantastic energies of this satanic cataclysm, Flaxman rends his symbolic spaces with abstract torrents of crisscrossing lines, whose acute angularity even transforms the anatomies of the figures at the right into lightning-like bolts of rushing movement. In the words of the Dante translation inscribed on Flaxman's plate, "There I beheld the heavenly rebel hurl'd like flaming thunderbolt." Again, the

Romantic art of the late eighteenth century, especially in Great Britain. The fantastic and visionary vein, exemplified in Fuseli, Barry, Mortimer, and Blake, was conducive to the exploration of bizarre and dreamlike subject matter that eluded rational spatial treatment. The preference for sudden collisions of scale, for figures of different sizes hovering upon the picture surface suggests many analogies with sixteenth century Mannerism, whose masters—whether Giulio Romano, Parmigianino, Bandinelli, or Tibaldi—were constantly consulted by late eighteenth century artists of this irrational persuasion.

[78] As discussed above, pp. 151f.

[79] *Purgatorio*, Canto XII.

[80] In particular, they recall the Futurists' "linee-forze," which similarly attempted to render motion and force through abstract linear means. Flaxman's symbolic equivalents of motion may be, in fact, the first rejection of the perceptual illusions of motion employed in the Renaissance and Baroque pictorial tradition. It may be worth mentioning that, perhaps thanks to its defiance of gravity, this plate was accidentally printed upside down in the 1807 London edition.

scale is utterly irrational, for three different figure sizes are compressed into a space whose shallowness is affirmed by the continuity of the flat white background. No less horrific and fantastic is the ghostly vision of Limbo where unbaptized infants' souls are snatched by the mouth of a colossal death's-head seen in absolute profile (Fig. 197).[81] Once more, near and far, large and small, up and down are confounded by the insistent primitivism of Flaxman's style, which flattens and schematizes all forms, whether clouds or children, in the interest of geometric and linear purism.

In the *Paradiso*, Flaxman moves to equally visionary realms of celestial fantasy. When Dante and Virgil behold a celestial ladder in the heaven of Saturn,[82] the ladder is magically transformed from a series of recessive steps below to a pattern of abstract striations above that evoke a lofty symbolic environment whose structure no longer can be explained by earthly mensuration (Fig. 198). As in Cumberland's primitivist paraphrase of Ghiberti, the figures here slowly lose their gravity-bound stances on the steps to become sinuous, indeed Ghibertesque, spirits who float in aureoles of the most elementary geometric design. In the *Circle of Angels*,[83] these late Gothic spirits take their undulant places around a solar emanation of even greater purity, a circle as abstract and absolute as the most extravagant geometric fantasies of Ledoux or Boullée (Fig. 199). This purity reaches its apotheosis in the last plate of the *Paradiso* (Fig. 200).[84] Here, Flaxman's pursuit of the most primary forms in the most primary pictorial vocabulary attains an astonishing simplicity that leaps across the nineteenth century into the language of modern abstraction, much as Goethe's Altar of Good Fortune at Weimar appears as a Brancusi *avant la lettre*. In Dante's ultimate vision of divinity in the form of three circles of three colors that fuse into one glowing whole, Flaxman arrives at the most extreme statement of his primitivism—a series of concentric haloes that radiate, with ab-

[81] *Purgatorio*, Canto VII.
[82] Canto XXI.
[83] Canto X.
[84] Canto XXXIII.

solute symmetry, from an infinitely remote, disembodied symbol of humanity.

Such puristic images lay at the core of those late eighteenth century reforms that sought out the simple, the abstract, and the chaste as panaceas for Rococo art, which was considered overly intricate, materialistic, and sensual. If today these outlines are often criticized as inert and bloodless,[85] to Flaxman's contemporaries they appeared "to announce the morning redness of a beautiful artistic epoch"[86] and to create an art "reduced to its simple, quintessential expression."[87] For the classicizing George Romney, the *Odyssey* illustrations were "simple, grand, and pure," and looked "as if they had been made in the age when Homer wrote."[88] For the German Romantic, Philipp Otto Runge, the *Iliad* and Aeschylus illustrations far surpassed even the outlines of "Etruscan" vases and produced genuine tears of wonder and admiration.[89] Indeed, throughout the civilized world, from London and

[85] Alfred Barr, for instance, has referred to "Flaxman's inflexible academic contours." (*Picasso, Fifty Years of His Art*, New York, 1946, p. 193.)

[86] The remark is found in J. D. Fiorillo, *Geschichte der zeichnenden Künste von ihrer Wiederauflebung bis auf die neuesten Zeiten*, v, Göttingen, 1808, p. 851. He comments that in Flaxman "ist ein glänzender Stern an dem artistischen Himmel Englands aufgestiegen. Möge sein Aufgang die Morgenröthe einer schönen Kunstepoche verkündigen."

[87] In an anonymous discussion of the *Œuvre complet de John Flaxman gravé au trait par Réveil*, in *L'Artiste*, v, 1833, p. 260: "C'est l'art réduit à sa plus simple expression, mais cette simple expression en est la quintessence. . . ."

[88] In a letter from Romney to William Hayley, dated August 2, 1793 (W. Hayley, *The Life of George Romney, Esq.*, Chichester, 1809, p. 203): "I have seen the book of prints from the *Odyssey* by our dear and admirable artist Flaxman. They are outlines without shadow, but in the style of antient art. They are simple, grand, and pure; I may say with truth, very fine. They look as if they had been made in the age when Homer wrote. . . ."

[89] In a letter to Runge's brother Daniel, dated August 23, 1800 (P. O. Runge, *Hinterlassene Schriften*, ii, Hamburg, 1840, p. 54): "Die Flaxman'schen Umrisse [Iliad und Aeschylus]—dafür danke ich Dir mit Thränen; mein Gott, so etwas habe ich doch in meinem Leben nicht gesehen; die Umrisse nach Etrurischen Vasen, die ich von der Br[un] habe, fallen doch dagegen ganz weg." In a subsequent letter (Oct. 11,

Paris to Leipzig and Madrid, Flaxman's outlines to the ancient Greek writers and to Dante not only were constantly reprinted,[90] but were also constantly imitated in variations that ranged from the servile to the extraordinarily inventive.

Typical examples of the direct impact of Flaxman's outlines may be found in the work of two Frenchwomen, whose common family name, Giacomelli, has led to considerable biographical confusion.[91] One of them, a certain Mme. Giacomelli, illustrated the dramas of Sophocles[92] in a series of etchings (1808) whose oblong format and rigorous outline style paid obvious respects to Flaxmanian precedent.[93] In the scene of the *Death of Jocasta* from *Oedipus Rex* (Fig. 201), we have virtually a reprise of such plates as Flaxman's scene of *Achilles Mourning Patroclus* (Fig. 187), although the more sculptural complexity of drapery folds and the vestiges of a stage space in the horizontal line that marks the

1800), Runge requests that the Flaxman *Odyssey* and Dante be sent to him (*ibid.*, p. 57); and in the following letter (Oct. 14, 1800) he gives detailed comments on each plate of the *Odyssey* (*ibid.*, pp. 58-60).

[90] For some idea of this international popularity, see Bentley, *op.cit.*, and still more extensive, the listing in the British Museum Catalogue, which even includes a Russian edition of the Dante illustrations. I have enumerated elsewhere some of these many editions (*The International Style of 1800 . . .* , p. 125).

[91] Mme. Giacomelli was born in 1786; Sofia Giacomelli was born ca. 1775-1780. Thieme-Becker distinguishes between them, as does H. Béraldi (*Les Graveurs du XIX^e siècle*, Paris, 1885-1892, VII, pp. 104-105). However, two other French encyclopedias of art (Bellier de la Chavignerie-Auvray and Bénézit) mistakenly consider them the same person.

[92] *Compositions d'après les tragédies de Sophocle* (dessinées et gravées à l'eau-forte, par Madame Giacomelli, née Billet), Paris, 1808. The drawings for these plates were exhibited at the Salon of 1808 (no. 255) and elicited the following praise: "Avant de représenter les principales situations du plus grand maître de la scène grecque, l'on sent combien Mme. Giacomelli s'est pénétrée de l'esprit des artistes grecs. Leur noble simplicité, leur grâce, leur naturel se retrouvent jusqu'à certain point dans la plupart de ces dessins." (*Mercure de France*, XXXIV, Dec. 17, 1808, pp. 562-563.)

[93] The Sophocles illustrations, in fact, were occasionally even bound together with Flaxman's work, as is the case in editions owned by both the New York Public Library and the Bibliothèque Doucet, Paris.

rear extremity of the ground plane also suggest the more Roman style of Davidian deathbed dramas.[94]

More abstract and incorporeal and hence more closely allied to Flaxman are the Dante illustrations by Sofia Giacomelli,[95] which appeared in 1813[96] and followed Flaxman's choice of scene plate by plate.[97] In the illustration of Lucifer, "lo'mperador del doloroso regno," who insatiably devours the arch-sinners Judas, Brutus, and Cassius (Fig. 203),[98] her indebtedness to the corresponding plate in Flaxman's *Inferno* is clear (Fig. 202). Terrifyingly frontal and, by comparison to his victims, sublimely huge, Sofia Giacomelli's bat-winged Lucifer evokes, like Flaxman's, a world where the primitive power of elemental evil is matched by the equally primitive stylistic traits of stark symmetry and heraldic flatness.

Mme. and Sofia Giacomelli's use of Flaxmanian prototype set a precedent for the illustrations of works of imaginative literature which extended far into the nineteenth century. Blake's own Dante illustrations demonstrate general and particular dependencies upon Flaxman;[99] and on less exalted levels, one might also cite,

[94] In particular, the style recalls such a deathbed scene as Guérin's *Return of Marcus Sextus* (Salon of 1799) (Fig. 90).

[95] To add to the confusion between these two ladies, Sofia also illustrated Sophocles: *Sujets tirés des tragédies de Sophocle*, Paris, 1814. Her Anglophile penchant toward Flaxman is further borne out by her choice of Milton for other outline illustrations: *Le Paradis Perdu par Milton en douze figures* . . . , Paris, 1813.

[96] *Collection de cent figures, dessinées et gravées par Mme. Giacomelli pour orner la Divine Comedie du Dante* . . . , Paris, 1813. There is also an undated Italian edition of these outlines in the Bibliothèque Nationale, Paris.

[97] Nevertheless, she rarely copies his scenes literally; rather they are original compositions in a thoroughly Flaxmanian vein. There is, incidentally, a slight iconographical distinction between the two works: in Flaxman, both Dante and Virgil wear laurel wreaths; in Sofia Giacomelli, only Dante wears one.

[98] Canto xxxiv.

[99] As pointed out, for instance, in Blunt, *The Art of William Blake*, New York, 1959, p. 40. Albert S. Roe, however, tends to minimize this influence and maximize the uniqueness of Blake's genius (*Blake's Illustrations to the Divine Comedy*, Princeton, 1953, p. 11 n. 12).

in France, Girodet's outlines to the *Aeneid*[100] or Claude Jules Ziegler's to Vigny's *Éloa*;[101] in England, William Hawkes Smith's outlines to Southey's *Thalaba the Destroyer*.[102] Germany's particular abundance included Vincenz Raimund Grüner's outlines to Goethe's *Pandora*;[103] Ludwig Sigismund Ruhl's to Shakespeare and Ossian;[104] Moritz Retzsch's to Shakespeare, Schiller, and Goethe;[105] Bonaventura Genelli's to Homer and Dante.[106]

Moreover, Flaxman's illustrations could stimulate hermetic fantasies that explored private worlds of magic and mystery. Such is the case in a bizarre untitled etching of 1801 (Fig. 204) by that admirer of the Italian primitives, Humbert de Superville,[107] who was apparently inspired by Flaxman's more literal-minded *Purgatorio* illustration of unbaptized infants in Limbo (Fig. 197).[108] In the Netherlander's print,[109] a naked youth, whose

[100] *Énéide; Géorgiques*, Paris [1825-1827]. The *Aeneid* illustrations and their preparatory drawings are discussed in Henri Boucher, "Girodet illustrateur à propos des dessins inédits sur l'Énéide," *Gazette des Beaux-Arts*, 6e période, LXXII, Nov. 1930, pp. 304-319. Boucher claims that Girodet thought of illustrating the *Aeneid* even earlier than 1811.

[101] Mr. [C. J.] Ziegler, *Éloa, la sœur des anges; compositions au trait sur le poème de Mr. A. de Vigny*, Paris, 1833.

[102] *Essays in Design; from Southey's Poem of Thalaba the Destroyer*, Birmingham, 1818.

[103] *Pandora von Goethe; ein Taschenbuch für das Jahr 1810*, Vienna and Trieste. It is discussed in Dora and Erwin Panofsky, *Pandora's Box* . . . , p. 93.

[104] For example, *Ruhl's Outlines to Shakespeare* . . . , Frankfurt and London, 1832; *Skizzen zu Shakespeare's dramatischen Werken* . . . , Cassel, Leipzig, and Paris [1838?]; *Ossian's Gedichte in Umrissen*, St. Petersburg, Penig, and Leipzig, 1805.

[105] A complete bibliography of Retzsch's prints may be found in Leopold Hirschberg, *Moritz Retzsch; chronologisches Verzeichniss seiner Werke*, Berlin, 1925.

[106] *Umrisse zum Homer, mit Erläuterungen von Dr. Ernst Förster*, Stuttgart, 1866; *Umrisse zu Dante's Göttlicher Komödie*, ed. Dr. M. Jordan, Leipzig, 1867. For an excellent discussion of Genelli, an avowed follower of Carstens, see U. Christoffel, *Die romantische Zeichnung von Runge bis Schwind*, Munich, 1920, *passim*.

[107] See above, Chapter IV, n. 60.

[108] If Humbert de Superville was, in fact, depending on Flaxman's print,

stylized, rounded contours parallel those of Flaxman's airborne infants, lies upon an antique bed. Before the apparition of a huge shrouded skull, whose profile and outstretched hand of bones depend closely on Flaxman's death's-head, the youth cringes with an elemental fear that lies halfway between Fuseli's *Nightmare* and Gauguin's *Spirit of the Dead Watching*. Fully rejecting the empiricism of postmedieval art, this weird little etching exploits such primitive geometric patterns as the decorative strips on the bed, the stars on the shroud, and the striations that symbolize the open window's shadows, in order to create a precious mood of occult mystery that almost announces the perverse silhouettes of Aubrey Beardsley.

However, the generative power of Flaxman's outlines extended far beyond such eccentric experiments.[110] Corresponding to a high-point of late eighteenth century artistic reform, they offered, as it were, a basic alphabet of a new artistic language that was also to inspire artists of major stature throughout the world. Their precise impact on such diverse masters as David,[111] Ingres,[112] Runge,[113]

this is further evidence for the presence of a 1793 first edition of Flaxman's *Dante*. See above, Chapter IV, n. 76.

[109] The etching is inscribed "D. P. G. Humbert de Superville inv. del. et sculpt. Romae 1801." It is described by Christian Kramm as "Een op een rustbed liggende jongeling door den dood bedreigd." (*De levens en werken der hollandsche en vlaamsche Kunstschilders . . .* , II, Amsterdam, 1859, pp. 770-771.) For a discussion of this print and a comment on its curious mingling of ancient and Christian symbolism, see C. M. de Haas, *David Pierre Giottino Humbert de Superville, 1770-1849*, Leyden, 1941, pp. 139-140.

[110] For another example of the use of pure outline style for the expression of private fantasies, see *Danneckers Traum*, illustrated in A. Spemann, *Dannecker*, Berlin and Leipzig, 1909, figs. 71-74.

[111] For David's enthusiastic reception of an edition of Flaxman's outlines, see below, p. 178. The *Sabines*, in particular, bears evidence of a knowledge of Flaxman's *Iliad* (e.g., *Diomedes casting his spear against Mars*). French authors have commented on the relevance of Flaxman's outlines for David's style of the late 1790's (Raymond Escholier, *La peinture française, XIXᵉ siècle; de David à Géricault*, Paris, 1941, p. 24; Louis Hautecœur, *Louis David*, Paris, 1954, p. 179).

[112] Ingres' admiration for Flaxman lasted from his youth, when the English master's outlines served as inspiration for such Homeric subjects

and Blake[114] has often been scrutinized, but it is perhaps worth adding that their influence was so pervasive that it can be discerned even in a drawing by that great late eighteenth century artist whose direct grasp of reality presumably represents the very antithesis of a conceptual, linear style. Thus, in Francisco Goya's ink and wash drawing of what seems to record a quickly perceived procession of hooded Spanish monks (Fig. 206),[115] we have, in fact, a close transcription of a plate in Flaxman's *Inferno*[116]—the procession of the leaden-stepped Hypocrites trampling upon the crucified Caiaphas (Fig. 207). If Goya transforms Flaxman's vacuum spaces and immaterial forms into a world of

as the *Venus Wounded by Diomedes* (ca. 1803) and the *Jupiter and Thetis* (1811), down to his old age, when he included him among the great in his 1865 version of the *Apotheosis of Homer*. Flaxman's Dante illustration of Paolo and Francesca also lies behind Ingres' interpretations of this subject. The Ingres literature is replete with references to Flaxman. See particularly Jules Momméja, *Ingres*, Paris, n.d.; *idem*, "La jeunesse d'Ingres," *Gazette des Beaux-Arts*, 3ᵉ période, xx, 1898, pp. 89-106, 188-208; Agnes Mongan, "Ingres and the Antique," *Journal of the Warburg and Courtauld Institutes*, x, 1947, pp. 1-13; Norman Schlenoff, *Ingres; ses sources littéraires*, Paris, 1956.

[113] For Runge's own comments on Flaxman, see his *Hinterlassene Schriften*, II, Hamburg, 1840, pp. 54-57, 58-60. More precise points of Flaxman's influence on Runge's early work are studied in Gunnar Berefelt, *Philipp Otto Runge zwischen Aufbruch und Opposition, 1777-1802*, Uppsala, 1961, *passim*.

[114] Some borrowings are pointed out in C. H. Collins Baker, "The Sources of Blake's Pictorial Expression," *The Huntington Library Quarterly*, IV, April 1941, pp. 365-366; and A. Blunt, *The Art of William Blake*, New York, 1959, p. 40. Blake was, of course, a close friend of Flaxman, who in 1781 became a neighbor of his in London (see Alexander Gilchrist, *The Life of William Blake*, ed. Ruthven Todd, London, 1945, p. 28). Moreover, Blake executed many engravings for Flaxman (listed *ibid.*, pp. 400-401).

[115] On Goya's drawing, see Ángel M. de Barcía, *Catálogo de la colección de dibujos originales de la Biblioteca Nacional*, Madrid, 1906, no. 1275, where the Flaxman source is recognized. The drawing is also discussed in the exhibition catalogue, *Francisco Goya y Lucientes*, Paris, Musée Jacquemart-André, Dec. 1961–Feb. 1962, no. 149.

[116] Canto XXIII. Goya must have known a foreign edition of Flaxman since, to my knowledge, the first Spanish edition appeared in 1860-1861: *Obras completas . . .* (engraved by J. Pi y Margall), Madrid.

shimmering light and substance, he nevertheless responds to the paired, elemental rhythms of the Dante illustration and the compression of these movements within a series of shallow, frieze-like planes. His drawing, in fact, offers a counterpart to the still more severe planarity of structure and solemnity of movement in Blake's equally Flaxmanian *Procession from Calvary* (Fig. 191).[117]

It was, in large part, the widespread accessibility of Flaxman's outlines that made them serve so often as the particular catalytic agent of the pictorial reform fervently sought after by those late eighteenth century artists who wished to destroy, once and for all, the decadence of the Baroque tradition. When, in 1803, David said of a new Flaxman edition, "Cet ouvrage fera faire des tableaux,"[118] he was speaking for the many artists of his epoch who recognized in the Englishman's pristine outlines the primer of abstract forms with which a new pictorial world could be constructed; and similarly, when, in 1799, August Wilhelm von Schlegel expressed the hope that Flaxman would quickly find many followers,[119] he was only echoing the incessant late eighteenth century demand for a thoroughgoing revolution in art that would, almost literally, start from scratch. Indeed, Flaxman's puristic outlines were only symptoms that registered the tenor of

[117] See above, pp. 161f.

[118] Cited in Doin, "John Flaxman," p. 233, in connection with an announcement for a French Flaxman edition found in the *Petites affiches* (mercredi 7 floréal, an XI [April 27, 1803]), which I have not seen.

[119] Schlegel found that Flaxman executed his outlines to Dante, Homer, and Aeschylus "mit so viel Verstand, Geist, und klassischem Schönheitssinne . . . dass man ihn in seiner Gattung Erfinder nennen, und wünschen muss, er möge bald glückliche und selbständige Nachfolger darin finden." ("Über Zeichnungen zu Gedichte und John Flaxman's Umrisse," *Athenaeum*, II, Berlin, 1799, p. 203.) Goethe was not so thoroughly approving as Schlegel, finding that "im Heroischen ist [Flaxman] meistentheils schwach" ("Über die Flaxmanischen Werke," *ed.cit.*, p. 183); and the Swiss-Roman artist, Joseph Anton Koch, was also somewhat dissenting toward Flaxman, though in his case it may have been a question of artistic rivalry, for he wished to emphasize the originality of his own Dante illustrations. (See Koch's letter to J. F. Frauenholz of Jan. 30, 1802, in O. R. von Lutterotti, *Joseph Anton Koch, 1768-1839*, Berlin, 1940, pp. 141-142.)

his times. Already in the 1790's, other artists of his generation had arrived at a style that similarly distilled the transient visual complexities of the Baroque tradition to immutable linear essences;[120] and by 1801, Friedrich Schiller, discussing the paintings in the Dresden Museum with Ludwig Tieck, spoke for many artists as well as for Immanuel Kant[121] when he complained that these pictures' variable color and light obscured their true image, which, he felt, could be better expressed through simple outlines.[122]

Thus, already one year before Flaxman's Homeric illustrations of 1793, a Frenchman, Bénigne Gagneraux,[123] published a series

[120] The emergence of a purely linear style at the end of a century is discussed, in international terms, in Louis Hautecœur, *Rome et la renaissance de l'antiquité à la fin du XVIII^e siècle* (*Bibliothèque des écoles françaises d'Athènes et de Rome*, no. 105), Paris, 1912, pp. 242ff.; and considerably expanded in my unpublished doctoral thesis, "The International Style of 1800. . . ."

[121] Kant's statement of the preëminence of drawing over color in art is worth citing in full: "In der Mahlerei, Bildhauerkunst, ja allen bildenden Künsten, der Baukunst, Gartenkunst, sofern sie schöne Künste sind, ist die *Zeichnung* das Wesentliche, in welcher nicht, was in der Empfindung vergnügt, sonder blos durch seine Form gefällt, den Grund aller Anlage für den Geschmack ausmacht. Die Farben, welche den Abris illuminiren, gehören zum Reiz, den Gegenstand an sich können sie zwar für die Empfindung beliebt, aber nicht anschauungswürdig und schön machen, vielmehr werden sie durch das, was die schöne Form erfordert, mehrenteils gar sehr eingeschränkt und selbst da, wo der Reiz zugelassen wird, durch die schöne Form allein veredelt." (*Critik der Urtheilskraft*, Berlin und Libau, 1790, §14, pp. 41-42.) The statement is partially quoted in Franz Landsberger, *Die Kunst der Goethezeit*, Leipzig, 1931, p. 156.

[122] "Ich kann den Gedanken nicht loswerden, dass diese Farben mir etwas Unwahres geben, da sie, je nachdem das Licht so oder anders fällt, oder der Standpunkt, aus dem ich sie sehe, so oder anders ist, sie doch verschieden gefärbt erscheinen; der blosse Umriss würde mir ein weit treures Bild geben." (L. Förster, ed., *Biographische und literarische Skizzen aus dem Leben und der Zeit Karl Försters*, Dresden, 1846, pp. 155-156.) I have discussed this as well as some poetic remarks by Schiller on the priority of outline in "The Origin of Painting: a Problem in the Iconography of Romantic Classicism," *Art Bulletin*, xxxix, Dec. 1957, p. 285.

[123] The basic study of Gagneraux (whose name is often spelled Gagnereaux) is Henri Baudot, *Éloge historique de Bénigne Gagnereaux*, Dijon, 1847 (2nd ed., 1889). His extraordinary variety, which even includes Neobaroque battle scenes that parallel West's and prophesy Gros's, was made

of eighteen original compositions in pure outline[124] that might have assuaged Schiller's discomfort before the illusionistic surfaces of Renaissance and Baroque oil painting. In a characteristic plate, *Venus Wounded by Diomedes* (Fig. 205), Gagneraux seems, at first glance, to perpetuate the Neoclassic Erotic mode[125] in his choice of a sensual, feminine theme from the *Iliad* that was soon to inspire the young Ingres (Fig. 210).[126] However, this eighteenth century composition, still preserving a Rococo sinuosity of oblique, cloudborne movement, is presented through the starkly reduced means of black outlines on a white ground, with a willful elimination of such secondary qualities as color and texture.

Such primitivist reductions reach no less austere terms in the work of the Danish-German master, Asmus Jakob Carstens.[127]

apparent in the exhibition, *L'Académie de peinture et sculpture de Dijon*, Musée des Beaux-Arts de Dijon, 1961, whose catalogue provides informative entries for the twenty Gagneraux's displayed (nos. 87-106).

[124] *Dix-huit estampes au trait composées et gravées à Rome par Gagneraux* [1792]. Louis Hautecœur (*Rome et la Renaissance de l'antiquité* . . . , p. 245) was apparently the first to recognize the priority of Gagneraux's outlines, though it should be stated that they are outlines after pre-existing paintings, whereas Flaxman's outlines are the pictorial ends themselves.

[125] The subjects of the other prints bear out this taste. They include *Vénus et l'Amour, L'Amour vainqueur de la Force, Le nid d'Amours, L'Amour tourmentant un satyr.*

[126] See below, pp. 187f.

[127] Carstens was born in Sanct Gürgen, a small village near Schleswig, which was then part of Denmark. As a result he is generally included in the history of both Danish and German art and is often claimed by both countries. The standard source for Carstens is Carl Ludwig Fernow, *Leben des Künstlers Asmus Jakob Carstens*, Leipzig, 1806, reprinted as K. L. Fernow, *Carstens, Leben und Werke*, ed. Herman Riegel, Hanover, 1867. The most comprehensive modern study is Alfred Kamphausen, *Asmus Jakob Carstens* (*Studien zur Schleswig-Holsteinischen Kunstgeschichte, Band 5*), Neumünster in Holstein, 1941, which supersedes Albrecht Friedrich Heine, *Asmus Jakob Carstens und die Entwicklung des Figurenbildes*, Strasbourg, 1928. For two particularly stimulating recent discussions of his art, see Ulrich Christoffel, *Malerei und Poesie*, Vienna, 1948, pp. 18ff.; and Rudolf Zeitler, *Klassizismus und Utopia*, Stockholm, 1954, pp. 129-143.

Typically, his drawings and prints of the 1790's emphasize precise and firm contours that are conceived not as preliminary means to the coloristic and atmospheric ends of oil painting, but rather as the quintessential ends themselves. In a drawing of 1794 that illustrates a group of heroes in the tent of Achilles, this reductive process is evident (Fig. 208).[128] Although the figures (who range from the stubborn Achilles and the indignant Ajax to the dejected Odysseus[129]) are modeled in terms of traditional chiaroscuro techniques, the inanimate objects are seen in a dematerialized state, as it were, their images conveyed through the ideal means of pure outline. Thus, the lyre and shield on the walls, the furniture, and the table setting are still bodiless abstractions, as remote from palpable reality as the symbolic objects on a medieval manuscript page. Similarly, the space has been conceptualized in terms of a centralized box construction that represents a timeless ideal rather than a fugitive perception.[130] And in a scene of Jason arriving at Iolcos, a preparatory drawing for the series of twenty-four engravings, *Die Argonauten*, issued in 1796,[131] this regression to a state of rudimentary artistic purity is pursued still further (Fig. 209). Here, interior modeling and textures have been all but eliminated, and the arrival of the one-shoed hero is frozen for all time in an abstract realm of visual symbols that have attempted to controvert the illusionistic premises of postmedieval art. Even the architecture is strangely insubstantial, stripped as it is to those linear geometries so apparent in Gilly's contemporaneous drawing of the Rue des Colonnes, Paris

[128] This drawing and a more finished watercolor version of it are discussed in Kamphausen, *op.cit.*, pp. 169ff.

[129] The subject is closely described in Fernow, *op.cit.*, p. 125.

[130] Carstens, like David, re-introduced a centralized Renaissance box space in many of his works, a characteristically late eighteenth century effort to clarify the oblique complexities of Baroque spatial organization. For other examples in Carstens' work, see *Plato's Banquet, Priam before Achilles, The Battle of the Philosophers* (illustrated in Kamphausen, *op.cit.*, pls. 12, 16, 23).

[131] For a discussion of the series of *Argonauts* illustrations, see *ibid.*, pp. 228ff.

(Fig. 146).[132] It is no surprise to learn that Carstens' Rome exhibition of 1795 was described, like Flaxman's outlines, as announcing "a new artistic epoch."[133]

However, this new artistic epoch was announced not once but again and again in the late eighteenth and early nineteenth centuries, for the illusive goal of a *tabula rasa*, of a total artistic regeneration, continued to obsess major and minor artists of those restless, changing years that marked the destruction of one historical epoch and the desperate attempts to reconstruct a new and vital world upon the most decadent of ruins. At times, this regeneration was carried on within the hermetic realm of Romantic seclusion, as in the case of Runge's desire to create a new art inspired by the unspoiled innocence of childhood;[134] in other cases, especially in France, these urgent reforms occurred within a more public and official context. For example, David's own work of the late eighteenth century offers a sequence of reformatory manifestoes that attempt consecutive purifications of his earlier styles. Thus, if the great *Horatii* of 1784 (Fig. 69) climaxes a series of pictorial purges of the 1770's and early 1780's that were meant to exorcise the remnants of a corrupt Rococo style, by the 1790's, even the *Horatii* appeared impure to its master and, even more so, to his students. The next reform, the so-called "Greek style" that culminated in the *Sabines* of 1799 (Fig. 92),[135] was

[132] Kamphausen (*ibid.*) comments, too, on the analogies with Gilly's architecture as well as with that of his friend, Weinbrenner.

[133] For Carstens' biographer, Karl Ludwig Fernow, the exhibition "eine neue Epoche der Kunst zu verkündigen scheint." (Über einige neue Kunstwerke des Hrn. Prof. Carstens," *Der neue Teutsche Merkur*, II, Weimar, May 1795, p. 159.) And later, Fernow comments on how this new artistic epoch would bring art back to "ihrer frühern Simplicität, Wahrheit und Würde" (p. 188). Carstens' Rome exhibition is succinctly discussed in F. Noack, *Das Deutsche Rom*, Rome, 1912, pp. 106ff. See also Kamphausen, *op.cit.*, pp. 185ff.

[134] For Runge's longings to achieve a childlike naïveté that could regenerate art, see his *Hinterlassene Schriften*, I, Hamburg, 1840, p. 7, as well as his comments on *Die Quelle*, a painting that was to become a "source" for a new art (*ibid.*, p. 19).

[135] On the reformatory character of the *Sabines*, see Delécluze, *Louis David, son école et son temps*, Paris, 1855, especially pp. 180-216; and the excellent discussion by Louis Hautecœur (*Louis David*, Paris, 1954, ch. VII).

intended to correct the overdisplay of anatomical realism and sculptural illusion in the *Horatii* and was stimulated by a new enthusiasm for more archaic forms from both pre- and post-Christian artistic cycles.[136] Like the architecture of Ledoux or Boullée, David's art advanced, so to speak, by regressing. Thus, in the domain of classical art, the master's objects of admiration shifted from Roman statuary to fifth century Greek bas-reliefs, "Etruscan" vases, and their modern re-creations in Flaxman's outlines;[137] and in the same way, his taste in Renaissance and Baroque art moved from his familiar points of reference in post-Raphaelite art to masters like Perugino and other pre-Raphaelites in whom David, like Goethe,[138] saw analogies with the planar compositions and lucid figures of Polygnotan painting as conjured up by Pausanias' literary descriptions.[139]

Inevitably, this sequence of puristic regressions did not stop here. The younger generation, as represented most extravagantly by that rebellious group of David pupils who called themselves the "Primitifs,"[140] found the *Sabines* grossly inadequate as a

[136] For David's criticisms of the *Horatii* ("peut-être j'ai trop montré l'art anatomique . . ."), see Delécluze, *op.cit.*, pp. 71-72.

[137] Presumably, David took for models only "les ouvrages grecs que l'on supposait faits à l'époque de Phidias" and sought out bas-reliefs whose style "était le plus ancien." He also admired "le naturel et l'élégance du trait des figures peintes sur les vases dits étrusques" (*ibid.*). David had already been quoted in 1790 as saying that "un habile homme trouve à profiter en copiant des cruches étrusques." (*Correspondance de François Gérard*, Paris, 1867, p. 52.) For the influence of Flaxman on David, see above, pp. 176, 178.

[138] Goethe compared Polygnotan painting to early Florentine art in that both, despite their deficiencies in sophisticated illusionistic techniques, represented art in a purer, nobler, more chaste, and more essential form. ("Polygnots Gemählde in der Lesche zu Delphi," *Jenaische Allgemeine Literatur-Zeitung*, I, Jan.-March 1804, pp. 17-18.)

[139] For David's admiration of the analogous beauties in Polygnotus and the Italian primitives (especially Perugino), see Delécluze, *op.cit.*, pp. 219-220. I would suggest, in fact, that the *Sabines* is in part inspired by the stiff and planar composition of Perugino's *Battle of Love and Chastity*, which entered the Louvre in 1801 from the Richelieu collection, but was most likely known to David before its official acquisition.

[140] There are references to the "Primitifs" (or, as they were also called,

manifesto of artistic reform, and assaulted its painter with such abusive terms as "Vanloo, Pompadour, Rococo,"[141] words that evoked images of a hated society as well as a hated art. Even more than David, the "Primitifs" and their leader, Maurice Quaï, rejected all but the most primary sources of art. In literature, they accepted only Homer, Ossian and, above all, the Bible;[142] in architecture, only the Greek Doric temples of Sicily and Paestum;[143] in ancient painting and sculpture, only Greek vases and those statues and bas-reliefs of the most ancient style.[144] And if no relevant works by Quaï have as yet been discovered,[145] at least literary descriptions of his pictorial practice conform to expectations, for we are told that he advocated a monumental scale, with

the "Barbus" or the "Penseurs") throughout Delécluze, *op.cit.*, which remains the basic source. This work also includes an appendix (pp. 420-447) which reprints two articles relative to the "Primitifs"—one by Delécluze himself ("Les Barbus d'à présent et les Barbus de 1800," reprinted from *Cent-Un*, vii) and another by Charles Nodier ("Les Barbus," reprinted from *Le Temps*, Oct. 5, 1832). Another work by Nodier, *Essais d'un jeune barde*, 1804, is quoted in Delécluze, pp. 74ff. There are also some contemporary remarks on the "Primitifs" to be found in the Duchesse d'Abrantès, *Mémoires*, ii, Paris, 1831, p. 141.

The best modern discussion of the "Primitifs" remains that of Walter Friedlaender ("Eine Sekte der 'Primitiven' um 1800 in Frankreich und die Wandlung des Klassizismus bei Ingres," *Kunst und Künstler*, xxviii, April 1930, pp. 281-286), who also treats them in *David to Delacroix*, Cambridge, Mass., 1952, pp. 46-50. In addition, there are useful remarks in Louis Bertrand, *La Fin du classicisme et le retour à l'antique*, Paris, 1897, pp. 315ff.; François Benoit, *L'Art français sous la Révolution et l'Empire*, Paris, 1897, pp. 314-318; and Robert Rey, *La Peinture française à la fin du XIXᵉ siècle; la renaissance du sentiment classique*, Paris, 1931, p. 20.

[141] Delécluze, *op.cit.*, p. 421. [142] *Ibid.*, p. 90.

[143] *Ibid.*, p. 436. See also above, p. 129.

[144] *Ibid.*, p. 425.

[145] The only painting attributed to Quaï is a small head of a youth in the Musée Granet, Aix-en-Provence. Its style, however, hardly corresponds to the radical expectations provided by literary accounts of Quaï. Another painting associated with the "Primitifs," a scene from Ossian by Duqueylar, also found in the Musée Granet, Aix-en-Provence, is discussed in George Levitine, "The Primitifs and Their Critics in the Year 1800," *Studies in Romanticism*, i, no. 4, Summer 1962, pp. 209-219.

figures "six pieds de proportion," and a severe reduction of chiaroscuro effects.[146] Moreover, he was to be seen working on an immense canvas, thirty feet in length, whose Homeric subject— Patroclus sending Briseis back to Agamemnon—seemed only to have been drawn in clear outlines on the canvas,[147] in the manner of a Greek vase or, for that matter, of Flaxman's own illustration to this scene from the *Iliad*.[148] And we would probably be correct in assuming that, like many of his zealous contemporaries, Quaï despised the luminous, atmospheric effects achieved through the hard-won gains of oil painting from the fifteenth to the eighteenth centuries, and preferred instead the sharply outlined and flatly colored figures that resulted from the ceramic techniques of Greek vases or the tempera techniques of the Italian primitives.[149]

In fact, from the 1750's on, beginning with the new investigations of the encaustics of ancient painting,[150] progressive artists

[146] Delécluze, *op.cit.*, p. 72. [147] *Ibid.*, p. 424.

[148] Although there is no record of Quaï's knowing Flaxman's work, it is quite probable that, like David and Ingres, he did.

[149] A clue to this preference for archaic media is given by Delécluze (*op.cit.*, p. 97), who speaks of the influence the "Primitifs" had on that admirer of medieval painting, Paillot de Montabert, who entered David's studio in 1796, upon his return from Italy. Doubtless, Paillot's enthusiasm for medieval and ancient pictorial techniques was formed before this date, when he worked in Italy with Seroux d'Agincourt. Paillot's ideas are best resumed in his "Dissertation sur les peintures du moyen âge, et sur celles qu'on a appelées Gothiques," *Magasin encyclopédique*, March 1812, pp. 53-90 and April 1812, pp. 339-358. For further comments on Paillot and Seroux d'Agincourt, see above, p. 166.

[150] Already in the 1750's, a considerable interest, both theoretical and practical, was shown in ancient encaustic techniques. This included such publications as: Comte de Caylus, *Mémoires sur la peinture à l'encaustique et sur la peinture à la cire*, Geneva, 1755; Jean-Jacques Bachelier, *L'Histoire et secret de la peinture à la cire contre le sentiment du Comte de Caylus*, Paris, 1755; Denis Diderot, *L'Histoire et le secret de la peinture en cire*, Paris [1756?]; J. H. Müntz, *Encaustic; or Count Caylus' Method of Painting in the Manner of the Ancients*, London, 1760, another emendation of Caylus' original essay. The Salons of 1754 and 1755 also included paintings executed in ancient wax techniques by Vien and Le Lorrain (see Locquin, *La Peinture d'histoire* . . . , pp. 193, 198). Le Lorrain, as noted above (Chapter I, ns. 81, 82), was also involved in a reconstruction of

often regressed to archaic pictorial techniques that reflected a common repugnance for the illusionistic propensities of the oil medium. Thus, for masters like Flaxman, Blake, or Carstens, a finished work of pictorial art no longer had anything to do with the recording of those commonplace, transient perceptions captured through the fluidity of oil paint, but represented rather a distilled, immutable ideal, shed of sensuous qualities and fixed for eternity through the precision of drawn or engraved outlines. And should it be desirable to embellish these bounding outlines with such secondary attributes as schematic modeling or local color, this was to be done in a manner that in no way obscured the basic linear definition of the forms. Thus, in their vitriolic scorn of the oil medium,[151] both Carstens and Blake turned to flat watercolor, restricted to outlined zones, and even more archaistically, to tempera techniques inspired by the Italian primitives.[152] Their private exhibitions, held respectively in Rome

the lost Polygnotan paintings. The practice of encaustic painting continued in Paillot de Montabert's own work. He exhibited a *Léda* at the Salon of 1810, "peinte sans huile," and a series of portraits "à la cire" at the Salon of 1812. A group of his encaustic paintings is still to be found at the Musée des Beaux-Arts, Troyes.

[151] For Carstens' negative attitudes toward oil painting, see Karl Ludwig Fernow, *Carstens, Leben und Werke*, ed. Herman Riegel, Hanover, 1867, p. 80. Blake was even more vituperative: "Let the work of modern Artists since Rubens' time witness the villainy of some one at that time, who first brought oil Painting into general opinion and practice: since which we have never had a Picture painted, that could shew itself by the side of an earlier production." (*A Descriptive Catalogue of Pictures, Poetical and Historical Inventions* . . . , London, 1809, pp. 2-3.) For further statements of this viewpoint, see his "To Venetian Artists," in G. Keynes, ed., *Poetry and Prose of William Blake*, London, 1927, p. 1018.

[152] Predictably, Carstens admired Florentine Quattrocento art—Ghiberti, Masaccio, Ghirlandaio—during his visit of 1792. They appealed to him because of "ihre kunstlose, gemüthvolle Einfalt und Wahrheit." (Fernow, *op.cit.*, p. 98.) For other comments by Carstens on the Florentine masters, see *ibid.*, p. 274. Blake's knowledge of pre-Raphaelite art needs further clarification. Gilchrist (*Life of William Blake*, London, 1945, pp. 302-303) mentions how Blake "dwelt with particular affection of the memory of Fra Angelico," and how "his ideal home was with Fra Angelico." In any case, his attraction to the tempera medium surely indicates knowledge

$(1795)^{153}$ and in London (1809),[154] provided spectators with a display of new pictorial media whose effects of sharp, linear clarity were to cure the disease of blurred and sensuous forms associated with the vulgar, empirical goals of the Baroque painter's use of oils.

Little wonder, then, that this technical regression to the linear and planar origins of art could even permit the occasional application of gold leaf, an anti-illusionistic archaism that was actually practiced by Blake in his *Spiritual Form of Pitt, Guiding Behemoth* of 1805[155] and by Ingres, when he gilded the chariot and horses' manes in his Flaxmanian *Venus Wounded by Diomedes* of ca. 1803,[156] a picture probably inspired by the goals of the

of the Italian primitives. For further references to Blake's use of tempera, see above, Chapter IV, n. 48.

[153] On Carstens' Rome exhibition of 1795, see above, p. 182. It included only drawings, watercolors, and tempera paintings.

[154] On Blake's London exhibition of 1809, see his own *Descriptive Catalogue* . . . , which included such explanations to the spectator as: "Cleanliness and precision have been the chief objects in painting these Pictures. Clear colors unmuddled by oil and determinate lineaments unbroken by shadows, which ought to display and not hide form, as is the practice of the later schools of Italy and Flanders." (p. 1)

[155] See Martin Butlin, *William Blake (1757-1827); A Catalogue of the Works of William Blake in the Tate Gallery*, London, 1957, no. 41. Later, Blake was to explain that one of the proofs of the inferiority of the oil medium was that real gold and silver cannot be used with it. (*A Descriptive Catalogue* . . . , pp. 6-7.)

[156] The classic discussion of this painting and its connection with the "Primitifs" is that by Walter Friedlaender, "Eine Sekte der 'Primitiven'. . . ." For other, earlier discussions, see Jules Momméja, *Ingres*, Paris, n.d., pp. 32ff.; Mme. Roblot-Delondre, "Vénus blessée par Diomède, tableau d'Ingres," *Gazette des Beaux-Arts*, 4e période, LIV, Dec. 1912, pp. 464-468; and Jules Guiffrey, "Le premier tableau de Ingres," *Bulletin de la Société de l'Histoire de l'art français*, 1909, pp. 51-54, and 1913, pp. 30-31, where the painting is claimed to be only a copy of a larger original. It should be added that Ingres, symptomatically, was early attracted to the tempera medium and used it for his large mural, *Romulus, Conqueror of Acron* (1812). At the time, he wrote in one of his notebooks, "Il faut exécuter tous mes grands tableaux à la détrempe, et puis vernir à l'huile." (Henri Delaborde, *Ingres; sa vie, ses travaux, sa doctrine*, Paris, 1870, p. 215.)

"Primitifs" Ingres knew as a student in David's atelier (Fig. 210). Here, the reformatory directions of David's *Sabines* are pursued to an even more willful rejection of illusionism that produces, finally, a space so shallow that the forms seem almost to project, cameo-like, from a completely opaque surface.

Around 1800, these regressions to what was imagined to be the pellucid dawn of pictorial art were so pervasive that even the bloody realities of modern history could be recorded through pictorial means presumably more appropriate to the narration of Trojan rather than Napoleonic Wars. Thus, exactly contemporaneous with Baron Gros's sensuous, Neo-Baroque recreations of the vivid drama of Napoleonic military campaigns, Pierre-Nolasque Bergeret—the same artist who, on another occasion discussed above,[157] painted the very palpable deathbed of Raphael (Fig. 31)—could translate the triumphant events at Austerlitz of December 2, 1805, into the language of Greek vase painting, here designed for actual transfer to a Neo-Greek amphora to be manufactured at Sèvres for presentation to the Emperor on his homecoming (Fig. 211).[158] Just as Napoleon's conquest over the other two emperors (Alexander I of Russia and Francis II of Austria and of the Holy Roman Empire) is elevated to the ideal symbolic realm of a nude conqueror driving his victorious quadriga over personified rivers and vanquishing the imperial eagles of Austria and Russia with the airborne splendor of French Napoleonic eagles and winged victories, so, too, does the style rise from the realm of documentary realism to a timeless and spaceless icon that would locate modern history in the domain of some mythic, Homeric past. Here, a congested profusion of tumbled bodies

[157] See above, pp. 36f.

[158] The vase was to be housed at the Château de St.-Cloud. For a discussion and illustration of the Austerlitz vase (Coll. E. Meyer) and of related Neo-Greek vases manufactured by Sèvres, see Marcel Gastineau, "Denon et la manufacture de Sèvres sous le premier Empire (1805-1814)," *Revue de l'art ancien et moderne*, LXIII, Jan. 1933, pp. 21-42, and Feb. 1933, pp. 64-76; and Mogens Gjodsen, "Etruskische vaser; traek af nyklassicismens historie," *Kunstmuseets Aarsskrift*, XXIX, Copenhagen, 1942, pp. 19-30.

and flying forms—remnants of a Baroque pictorial tradition—is rigorously compressed into a vocabulary of pure profiles and sharp silhouettes. Like Ingres' *Wounded Venus*, Bergeret's drawing would evoke the airless, spaceless environment of heraldic symbols that ostensibly pertained to the very beginnings of the art of painting.

Indeed, despite the familiar historical claims that Renaissance and Baroque illusionism first began to expire in the 1850's and 1860's with Courbet's and Manet's gradual destruction of traditional perspective systems, the years around 1800, in their fervor for an artistic *tabula rasa*, witnessed a dissolution of postmedieval perspective traditions as radical as anything instigated by Impressionist color patches or by that later nineteenth century equivalent of Greek vase painting, the Japanese print.[159] Already in the 1780's and 1790's, the elementary spatial clarity of the Quattrocento perspective box had been restituted in pictures like David's *Horatii* (Fig. 69) and Carstens' *Heroes in the Tent of Achilles* (Fig. 208); and once set into motion, this pursuit of an utter purity was to lead to the abstract white spaces of Flaxman's outlines as well as to even more extraordinary negations of Renaissance and Baroque illusionism.

Two drawings of interiors by Blake and by Ingres may suggest the astonishing extremes to which these searches might lead. In Blake's undated sepia drawing, *A Vision*,[160] we see a strange

[159] This analogy was, in fact, made in the reports of Commodore Perry's visit to Japan, where it was claimed that Japanese pictorial art was "a living example of the archaic period of a national art, when the barbaric character of the past seems to be fast losing its rude features in the early and naïve beginnings of a sober and cultivated future. We are reminded, in a degree truly surprising, of the monochromatic designs upon the Etruscan vases . . . we have a beginning of that unextravagant expression of nature which, in the early Greek efforts, though crude, is so interesting to the antiquarian and the artist." (Francis L. Hawks, compiler, *Narrative of the Expedition of an American Squadron to the China Seas and Japan . . . under the Command of Commodore M. C. Perry*, Washington, 1856, p. 459.)

[160] On this mysterious drawing, see Kerrison Preston, ed., *The Blake Collection of W. Graham Robertson*, London [1952], no. 72.

apparition of a Poet and his divine Muse working in some shrine of the imagination (Fig. 212). At first glance, the convergent perspective lines of the outer and the inner sanctum seem to create two Renaissance box spaces of rudimentary clarity; yet, as in the architecture of Blake's contemporary, Soane, this simplicity is more apparent than real. Thus, the shading of the web-like component planes obeys no natural laws, but is manipulated in such a way that the would-be effects of recession are constantly contradicted, producing instead a series of simultaneously convex and concave planes whose shifting locations are matched in the history of art only by the comparable spatial and luminary ambiguities of early Analytic Cubism (Fig. 213).

In the same way, a drawing of 1807 by the young Ingres uses ostensibly the simplest pictorial language of pure line and a perspective box to create the most visually paradoxical results. Recording not a vision, like Blake's, but the material facts of his room at San Gaëtano in Rome,[161] Ingres translates the planes of the walls, ceiling, and floor into the same Flaxmanian outlines that describe the few items of furniture (Fig. 214). Yet again, the pseudo-simplicity of style that first produces the naïve effect of a childlike tracing is deceptive.[162] The orthogonals of the enclosing wall planes at the sides deviate radically from a one-point perspective system in order ultimately to accommodate the absolute flatness of the white paper; and with the same goal of a continuous, pristine flatness, even the far convex corner of the

[161] Iconographically speaking, Ingres' drawing belongs to that series of "portraits" of the artist's room so common in the nineteenth century. This motif, and its symbolic implications, are analyzed in Donat de Chapeaurouge, "Das Milieu als Porträt," *Wallraf-Richartz-Jahrbuch*, xxii, Cologne, 1960, pp. 137-158.

[162] It might be added that the same willful innocence of linear purity, faithfully outlining on white paper the data of perception, is found abundantly in the drawings of Ingres' contemporaries, the Nazarenes, who similarly distorted one-point perspective to preserve the flatness of the design. A case in point, among many, is Peter von Cornelius' drawing of the *Night Apparition* from the *Taunusreise* series of 1811, discussed and illustrated in Ulrich Christoffel, *Die romantische Zeichnung von Runge bis Schwind*, Munich, 1920, p. 21.

chest of drawers at the right is made to elide with the door frame in the concave corner of the room. Finally, the objects float like linear ghosts without threatening, in illusionistic terms, the un-interrupted extension of the drawing's surface. Again, as with Blake's interior, such a capacity to create an intensely personal spatial system that juggles traditional techniques with new goals of pictorial flatness appears to prophesy the conditions of twen-tieth century art. In fact, to find a parallel to Ingres' subtle bal-ancing of outlined but bodiless objects that retain suggestions of perspective diminution against an unbroken continuity of wall and floor planes, one would have to turn to Matisse's great studio interiors of 1911 (Fig. 215). But such analogies between the art of 1800 and that of our own time should hardly be surprising. In art, as in all domains of history, the profound transformations of the late eighteenth century left a legacy of disturbing, unrealizable dreams, including the dream of a *tabula rasa* that has never ceased to haunt and to nourish the imagination of artists working in the modern world.

INDEX

NB: Architecture is indexed under location; other works of art are indexed under the name of the artist, not under the title. If a topic indexed in the text is continued in a note that falls on the same page, then that note is not indexed separately. (Thus, 38 and 38n would both be included under 38.) Birth- and death-dates are given here only for the more important figures mentioned in the text and notes.

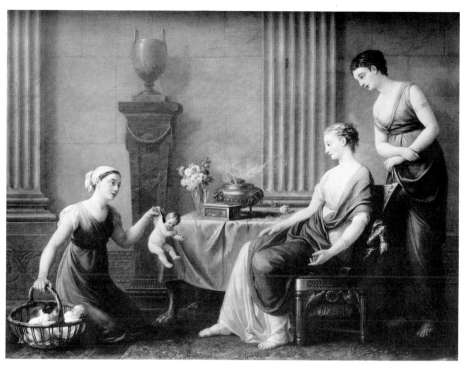

1. Joseph-Marie Vien, *Selling of Cupids*, Salon of 1763.
Fontainebleau, Château

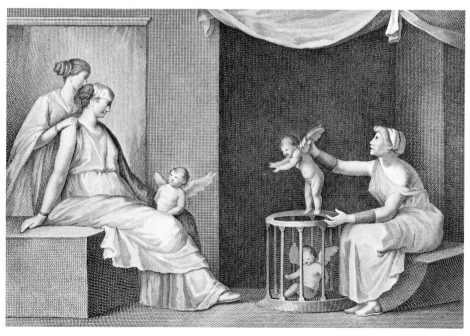

2. *Selling of Cupids*, engraving by C. Nolli, 1762

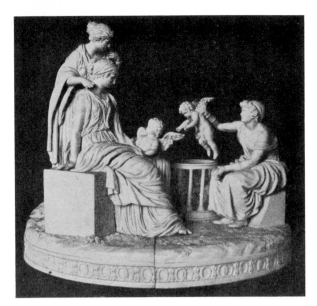

3. Christian Gottfried Jüchtzer,
Who'll Buy Cupids? 1785

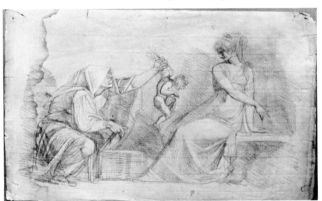

4. Henry Fuseli, *Selling of Cupids*, ca. 1775.
New York, Coll. Robert Halsband

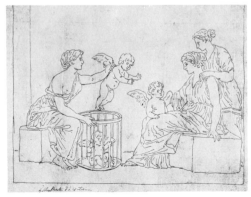

5. Jacques-Louis David, *Drawing after
Selling of Cupids*, ca. 1776

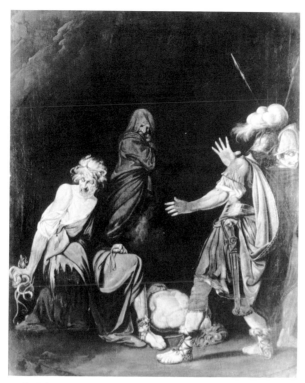

6. John Hamilton Mortimer, *Sextus the Son of Pompey Applying to Erictho to Know the Fate of the Battle of Pharsalia*, 1771. Formerly Coll. Appleby

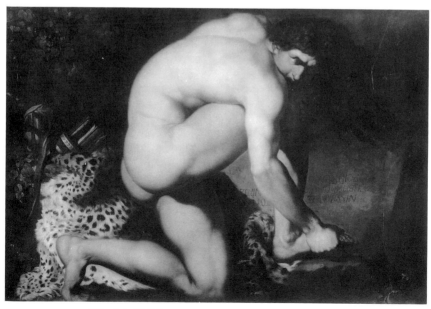

7. Nicolai Abildgaard, *Philoctetes*, 1775. Copenhagen, Statens Museum for Kunst

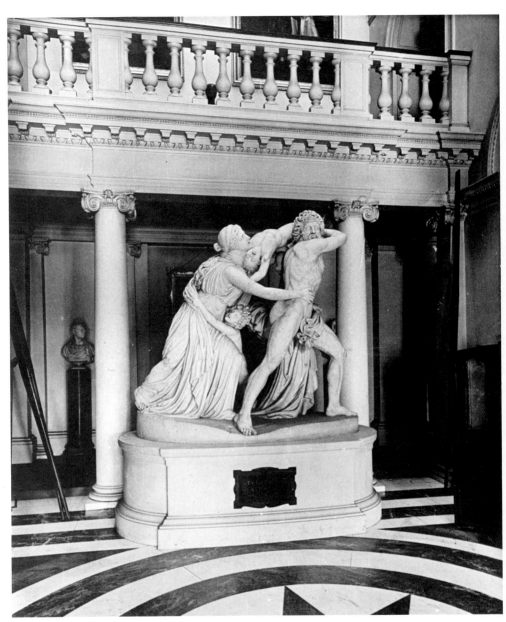

8. John Flaxman, *Fury of Athamas*, 1790-1793.
Suffolk, Ickworth House

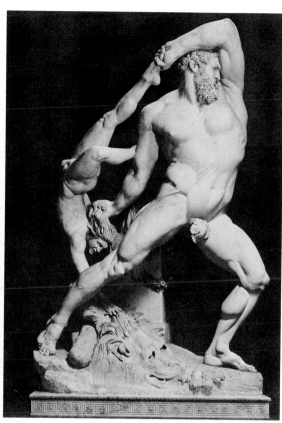

9. Antonio Canova, *Hercules and Lichas*, 1795-1815.
Rome, Galleria Nazionale d'Arte Moderna

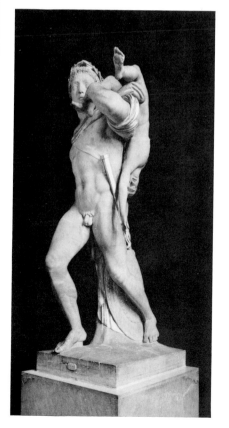

10. *Warrior and Youth* (*Hector and Troilus?*).
Naples, Museo Nazionale

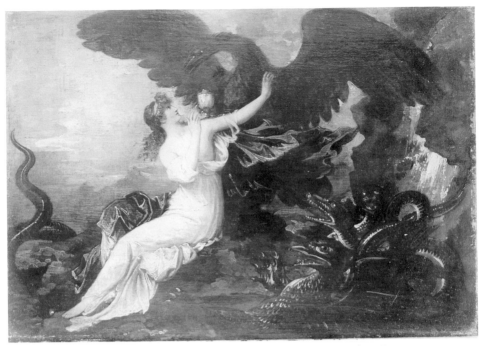

11. Benjamin West, *Eagle Bringing the Cup to Psyche*, 1805.
Princeton University, The Art Museum

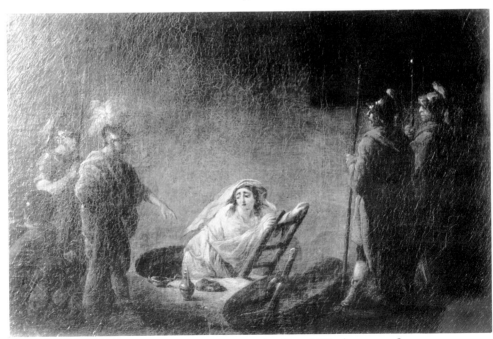

12. Jacques Gamelin, *Torture of a Vestal Virgin*, ca. 1798.
Orléans, Musée des Beaux-Arts

13. Jean-François-Pierre Peyron, *Athenian Youths Drawing Lots*,
engraving, ca. 1798

14. Pierre-Narcisse Guérin, *Clytemnestra*, Salon of 1817. Paris, Louvre

15. Joseph-Marie Vien, *Love Fleeing Slavery*, Salon of 1789.
Toulouse, Musée des Augustins

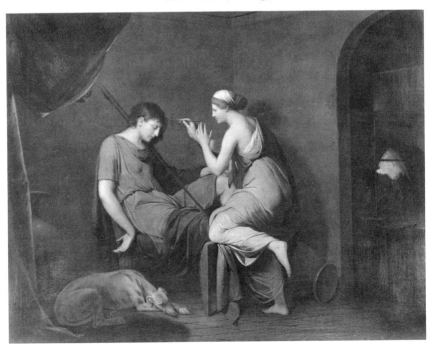

16. Joseph Wright of Derby, *Corinthian Maiden*, 1782-1784.
Upperville, Va., Coll. P. Mellon

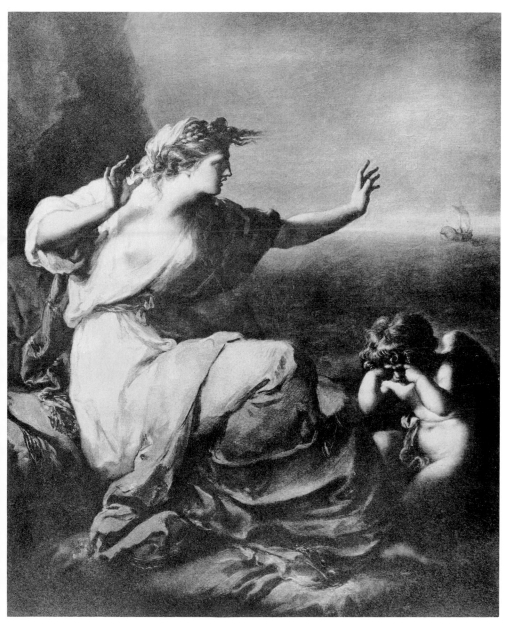

17. Angelica Kauffmann, *Ariadne*. Dresden, Gemäldegalerie

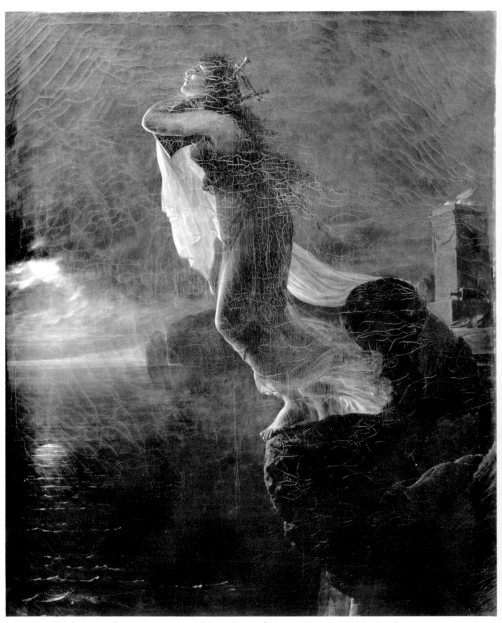

18. Antoine-Jean Gros, *Sappho*, Salon of 1801. Bayeux, Musée de Peinture

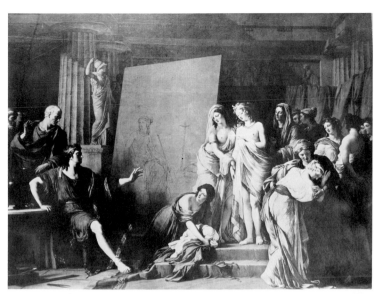

19. François-André Vincent, *Zeuxis Choosing as Models the Most Beautiful Girls of Crotona*, Salon of 1789. Paris, Louvre

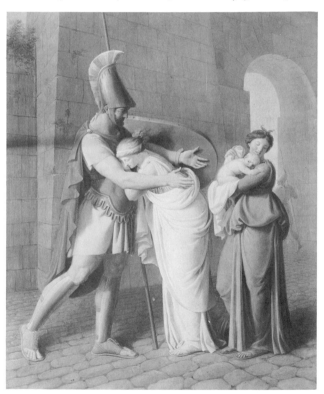

20. Ferdinand Hartmann, *Hector's Farewell*, 1800.
Dessau, Gemäldegalerie

21. Franz and Johannes Riepenhausen, *Reconstruction of Polygnotos'*
Sack of Troy [1805]

22. Louis Joseph Le Lorrain, *Reconstruction of Polygnotos' Sack of Troy*, 1761

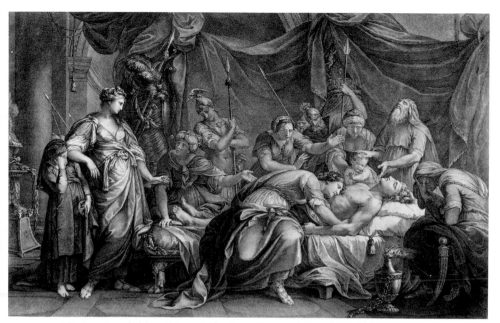

23. Gavin Hamilton, *Andromache Bewailing the Death of Hector*, engraving
by D. Cunego, 1764 (after painting of ca. 1761)

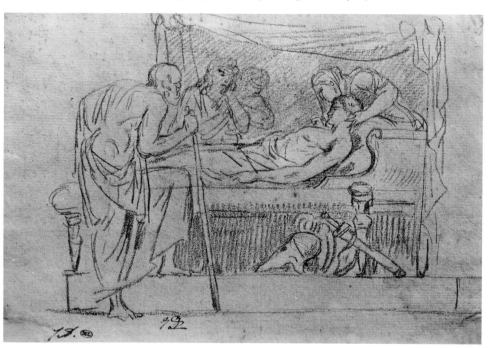

24. Jacques-Louis David, *Drawing after a Roman Conclamatio*,
ca. 1777. Paris, Louvre

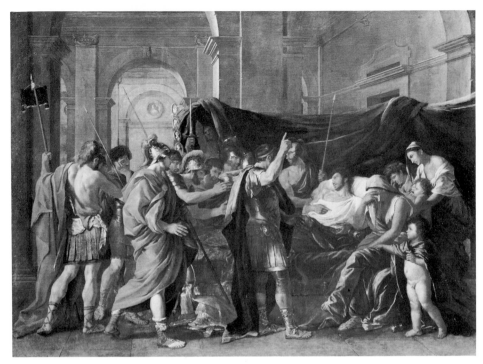

25. Nicolas Poussin, *Death of Germanicus*, ca. 1627.
Minneapolis Institute of Arts

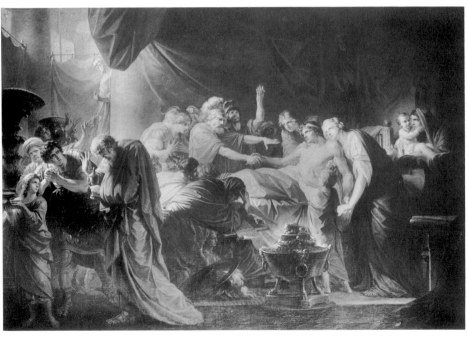

26. Heinrich Füger, *Death of Germanicus*, 1789.
Vienna, Österreichische Galerie

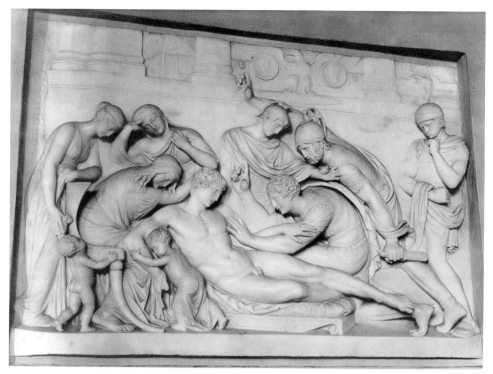

27. Thomas Banks, *Death of Germanicus*, 1774. Norfolk, Holkham Hall

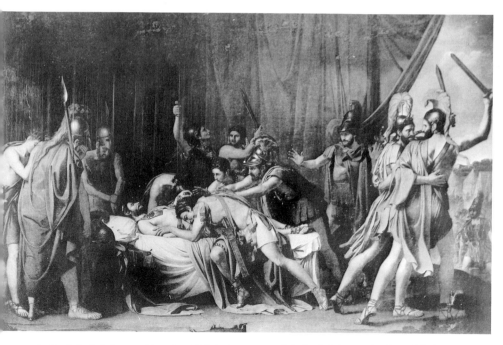

28. José de Madrazo, *Death of Viriathus*, 1818. Madrid, Museo de Arte Moderno

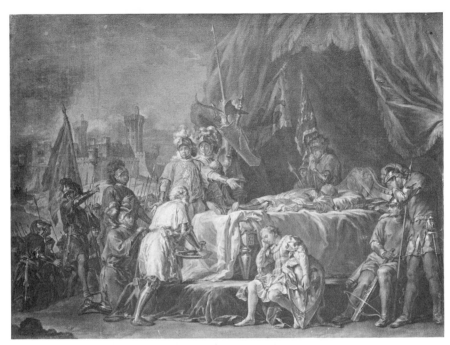

29. Nicolas-Guy Brenet, *Death of Du Guesclin*, 1778.
Dunkirk, Musée des Beaux-Arts

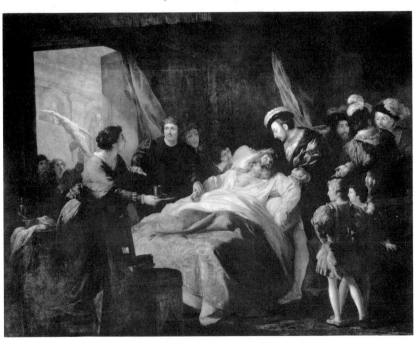

30. François Ménageot, *Death of Leonardo da Vinci*, Salon of 1781.
Amboise, Musée de l'Hôtel de Ville

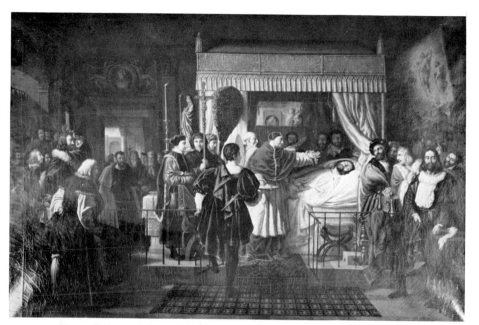

31. Pierre-Nolasque Bergeret, *Homage Offered to Raphael after His Death*,
Salon of 1806. Malmaison, Château

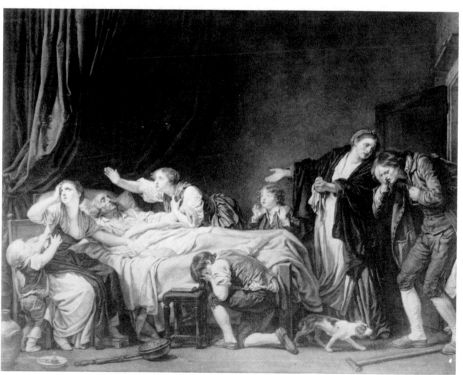

32. Jean-Baptiste Greuze, *Punished Son*, 1778. Paris, Louvre

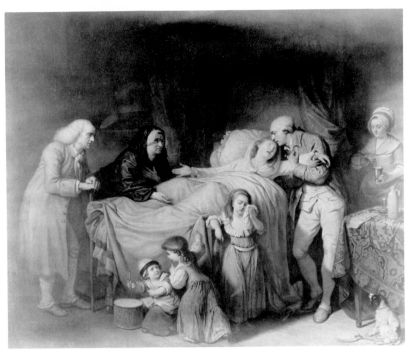

33. Pierre-Alexandre Wille *fils*, *Last Moments of a Beloved Wife*,
Salon of 1785. Cambrai, Musée Municipal

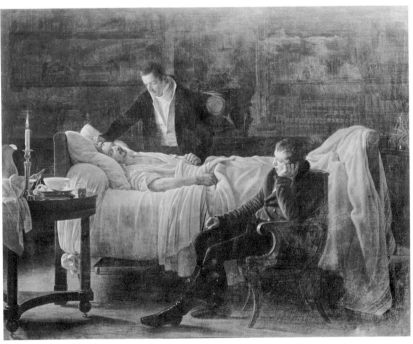

34. Louis Hersent, *Death of Xavier Bichat*, Salon of 1817.
Paris, Faculté de Médecine

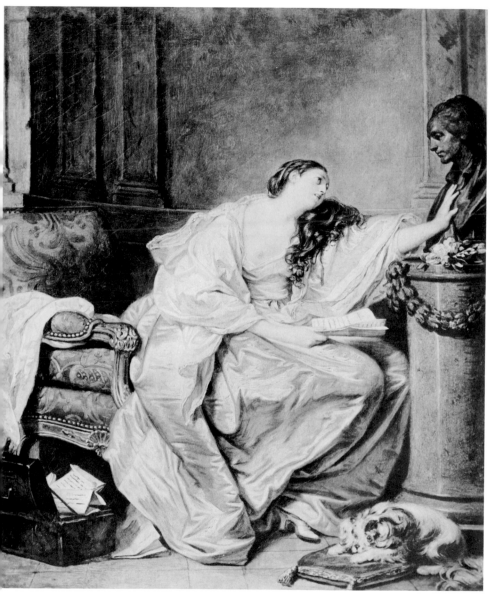

35. Jean-Baptiste Greuze, *Inconsolable Widow*, ca. 1763.
London, Wallace Collection

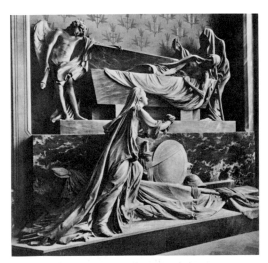

36. Jean-Baptiste Pigalle, *Tomb of
Comte Henri-Claude d'Harcourt*,
1771-1776. Paris, Notre-Dame

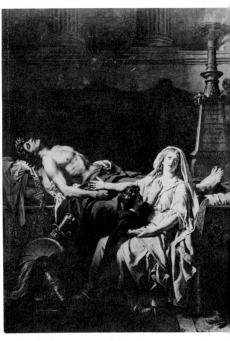

37. Jacques-Louis David, *Andromache
Mourning Hector*, 1783. Paris,
École des Beaux-Arts

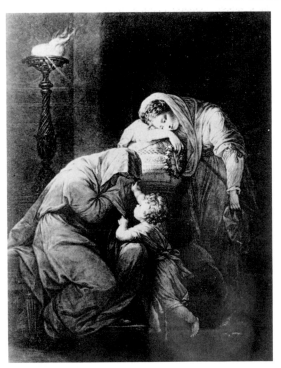

38. Angelica Kauffmann, *Andromache and
Hecuba Weeping over the Ashes of Hector*,
engraving by Thos. Burke, 1772

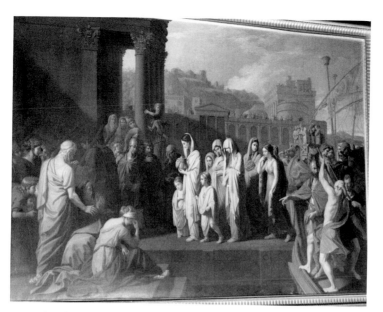

39. Benjamin West, *Agrippina with the Ashes of Germanicus*,
1768. Burghley House (Northants)

40. Fleury François Richard, *Valentine de Milan*,
engraving by C. Normand after painting
at Salon of 1802

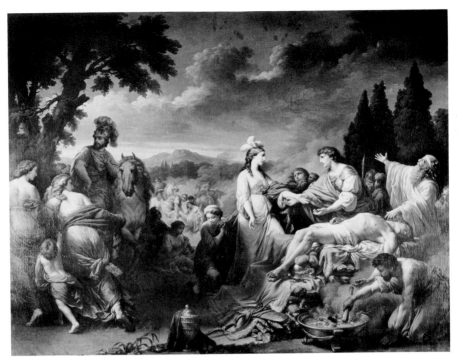

41. Jean-Jacques Lagrenée *l'aîné, Two Widows of a Hindu Officer*,
Salon of 1783. Dijon, Musée des Beaux-Arts

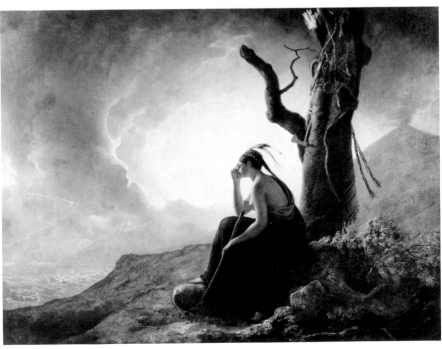

42. Joseph Wright of Derby, *Indian Widow*, 1785.
Derby, Museum and Art Gallery

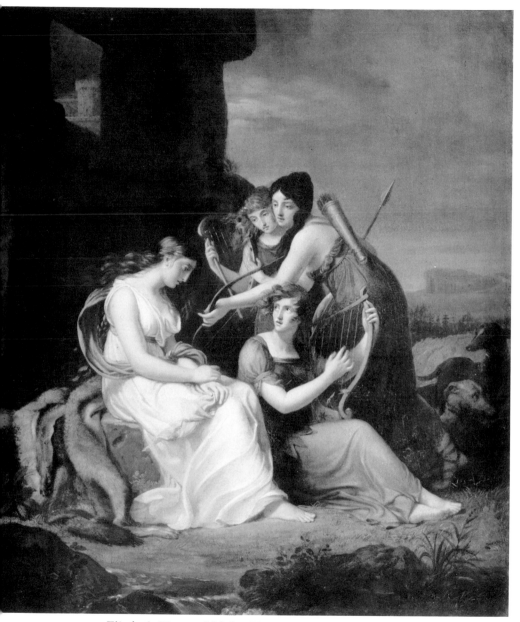

43. Elisabeth Harvey, *Malvina Mourning Oscar*, Salon of 1806.
Paris, Musée des Arts Décoratifs

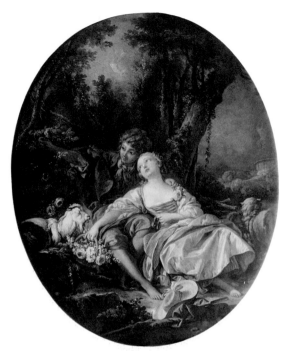

44. François Boucher, *Pastorale*, Salon of
1761. London, Wallace Collection

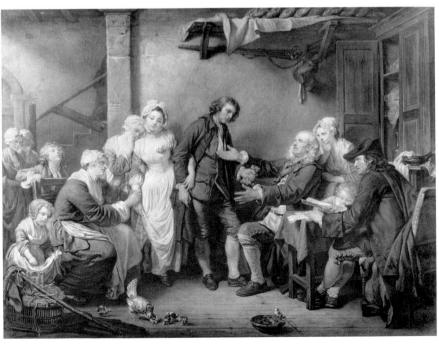

45. Jean-Baptiste Greuze, *Village Bride*, Salon of 1761. Paris, Louvre

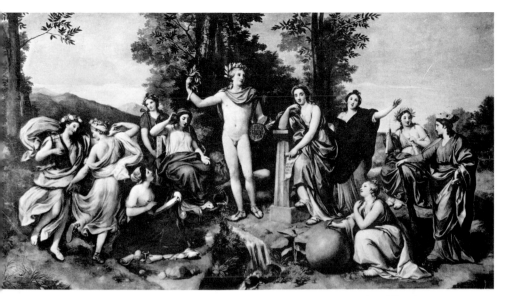

46. Anton Raphael Mengs, *Parnassus*, 1761. Rome, Villa Albani

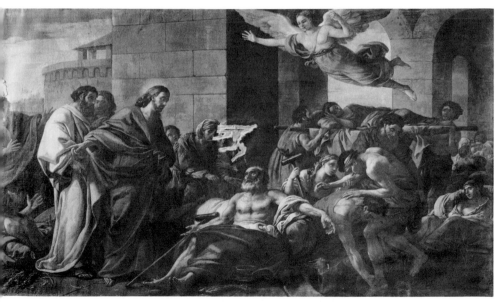

47. Joseph-Marie Vien, *Christ Healing the Paralytic*, Salon of 1759.
Marseilles, Musée des Beaux-Arts

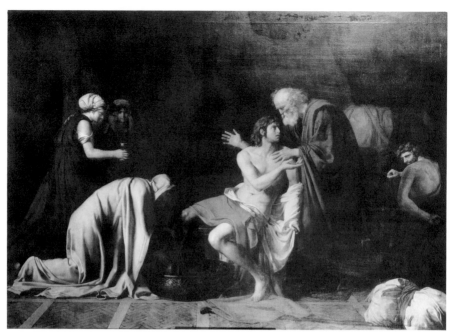

48. Jean-Germain Drouais, *Prodigal Son*, 1782. Paris, St. Roch

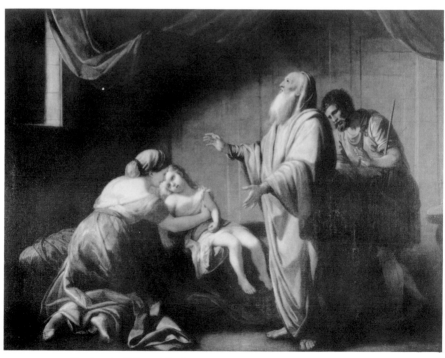

49. Benjamin West, *Elisha Raising the Shunammite's Son*, 1766.
Louisville, Ky., J. B. Speed Art Museum

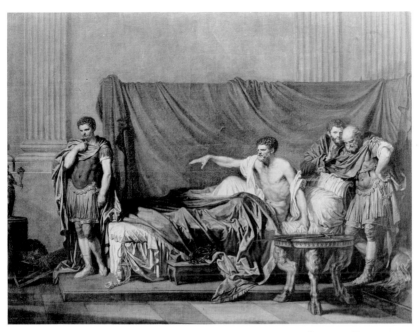

50. Jean-Baptiste Greuze, *Septimius Severus and Caracalla*,
Salon of 1769. Paris, Louvre

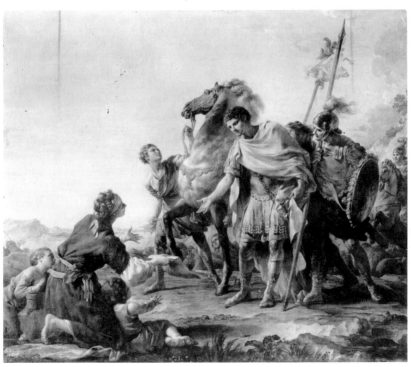

51. Noël Hallé, *Justice of Trajan*, Salon of 1765. Marseilles,
Musée des Beaux-Arts

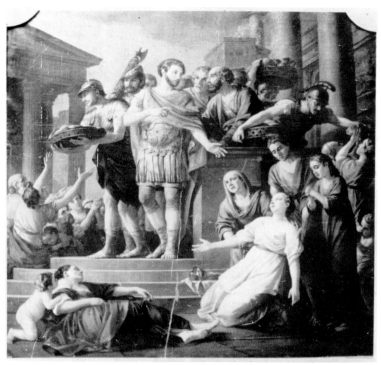

52. Joseph-Marie Vien, *Marcus Aurelius Distributing Food and Medicine*, Salon of 1765. Amiens, Musée de Picardie

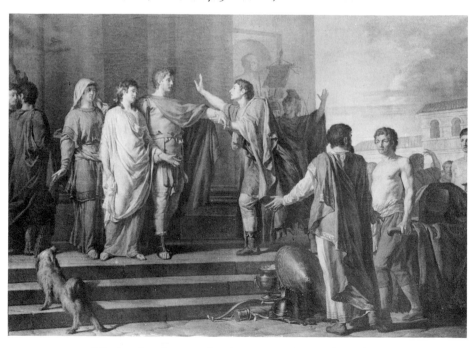

53. Nicolas-Guy Brenet, *Continence of Scipio*, Salon of 1789. Strasbourg, Musée des Beaux-Arts

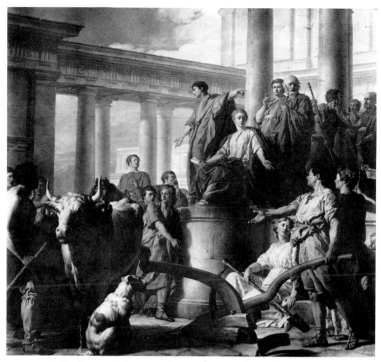

54. Nicolas-Guy Brenet, *Caius Furius Cressinus Accused of Sorcery*, Salon of 1777. Toulouse, Musée des Augustins

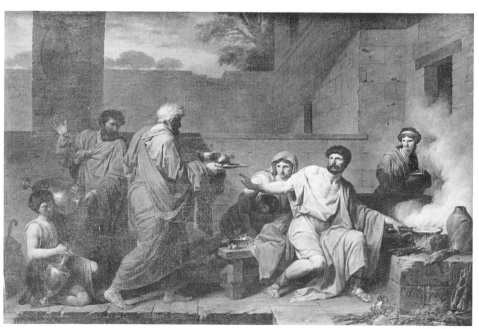

55. Jean-François-Pierre Peyron, *Curius Dentatus Refusing the Gifts of the Samnites*, Salon of 1787. Marseilles, Musée des Beaux Arts

56. Louis Durameau, *Continence of Bayard*, Salon of 1777.
Grenoble, Musée de Peinture et de Sculpture

57. Edward Penny, *Generosity of Johnny Pearmain*, R.A., 1782.
Upperville, Va., Coll. P. Mellon

58. Louis Lagrenée *l'aîné*, *Fabricius Luscinus Refusing the Gifts of Pyrrhus*, Salon of 1777. Libourne, Musée René-Princeteau

59. Noël Hallé, *Cornelia, Mother of the Gracchi*, Salon of 1779. Montpellier, Musée Fabre

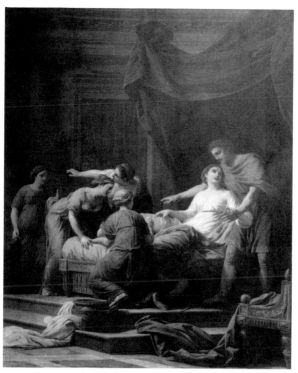

60. Nicolas-Bernard Lépicié, *Courage of Portia*,
Salon of 1777. Lille, Palais des Beaux-Arts

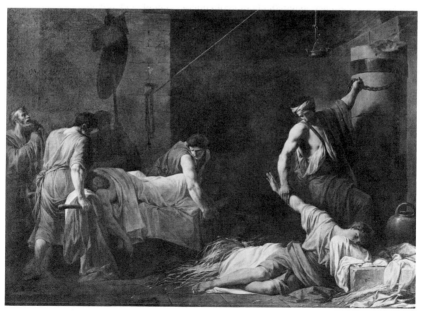

61. Jean-François-Pierre Peyron, *Cimon and Miltiades*, 1782.
Paris, Louvre

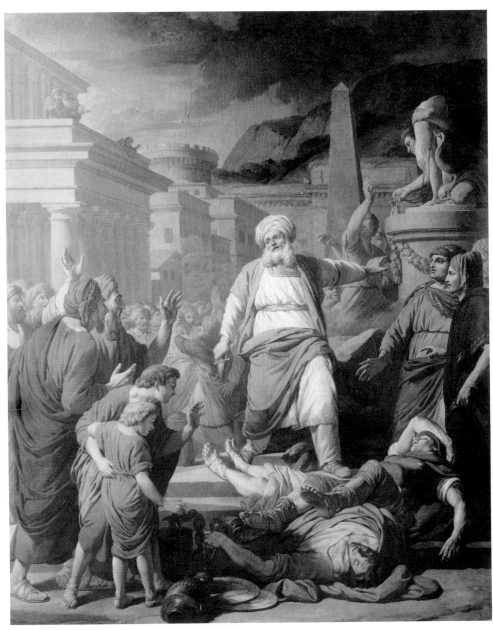

62. Nicolas-Bernard Lépicié, *Zeal of Mattathias*, Salon of 1783.
Tours, Musée des Beaux-Arts

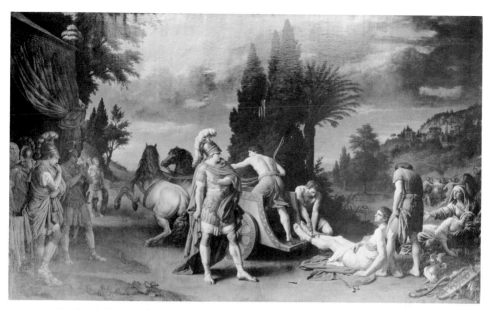

63. Louis Lagrenée *l'aîné*, *Fidelity of a Satrap of Darius*, Salon of 1787.
Aurillac, Musée Hippolyte-de-Parieu

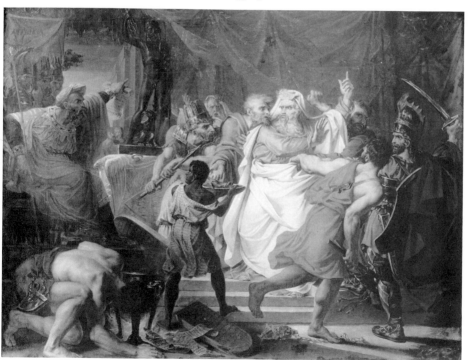

64. Antoine-Jean Gros, *Antiochus and Eleazar*, 1792. St. Lô, Musée

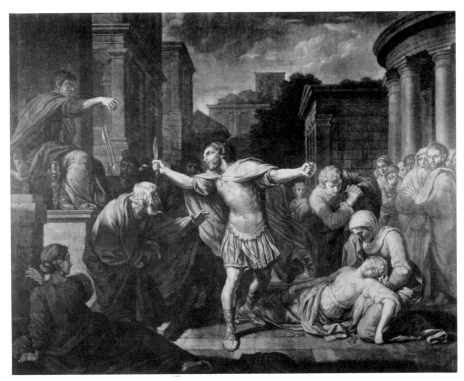

65. Nathaniel Dance, *Death of Virginia*, engraving by John Gottfried Haid, 1767, after painting exhibited in 1761

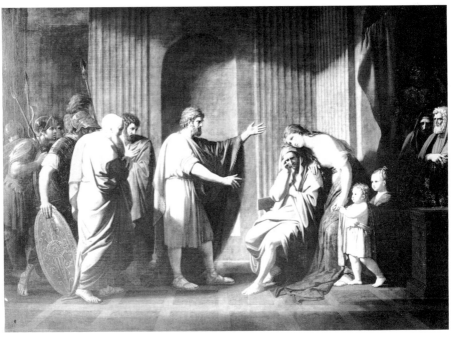

66. Benjamin West, *Leonidas and Cleombrotus*, R.A., 1770. London, Tate Gallery

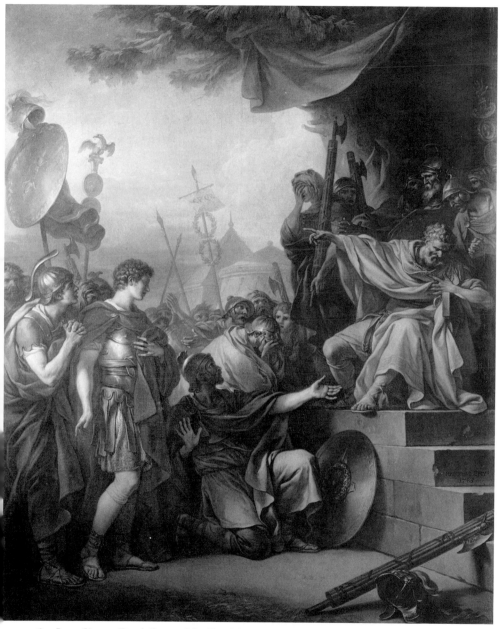

67. Jean-Simon Berthélemy, *Manlius Torquatus Condemning His Son to Death*,
Salon of 1785. Tours, Musée des Beaux-Arts

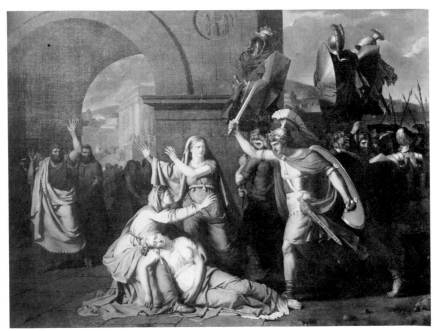

68. Anne-Louis Girodet, *Death of Camilla*, 1785. Montargis, Musée

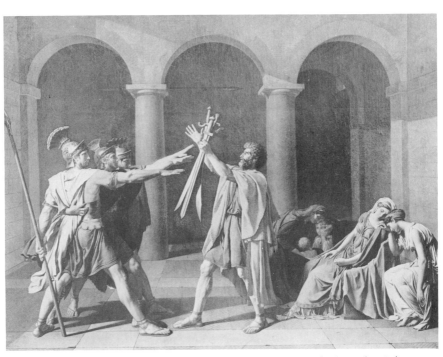

69. Jacques-Louis David, *Oath of the Horatii*, 1784 (Salon of 1785).
Paris, Louvre

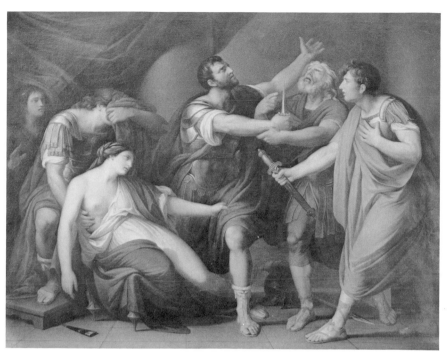

70. Gavin Hamilton, *Oath of Brutus (Death of Lucretia)*, 1763-1764.
London, Drury Lane Theatre

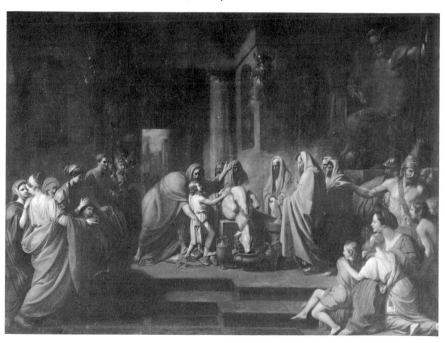

71. Benjamin West, *Hannibal Taking the Oath*, R.A., 1771.
London, Kensington Palace

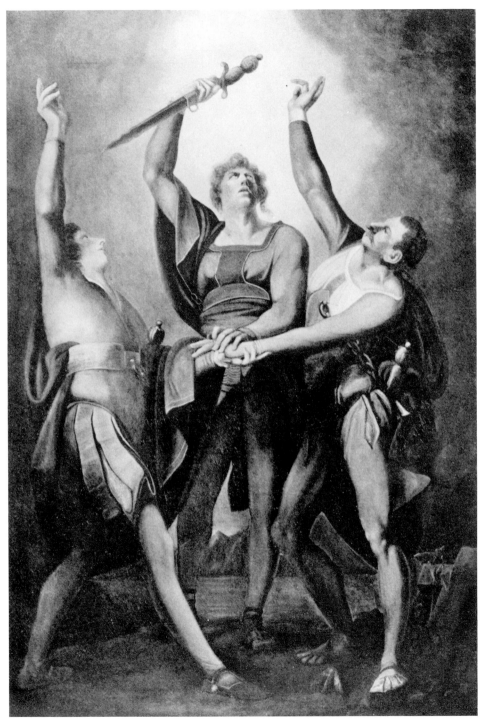

72. Henry Fuseli, *Oath on the Rütli*, 1778-1781. Zurich, Rathaus

73. Jacques-Louis David, *Death of Seneca*, 1773. Paris, Petit Palais

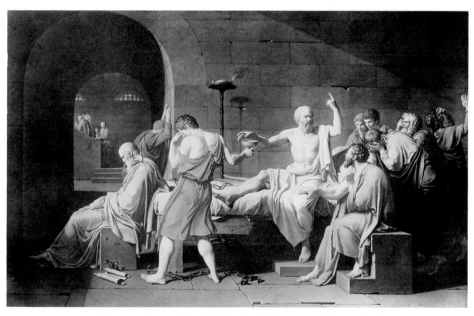

74. Jacques-Louis David, *Death of Socrates*, Salon of 1787.
New York, Metropolitan Museum

75. Jean-François Sané, *Death of Socrates*, engraving by
Jacques Danzel, 1786, after painting of 1762

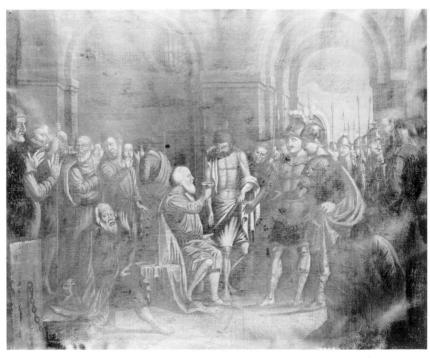

76. Benjamin West, *Death of Socrates*, 1756. Nazareth, Pennsylvania,
Coll. Mrs. Thos. H. A. Stites

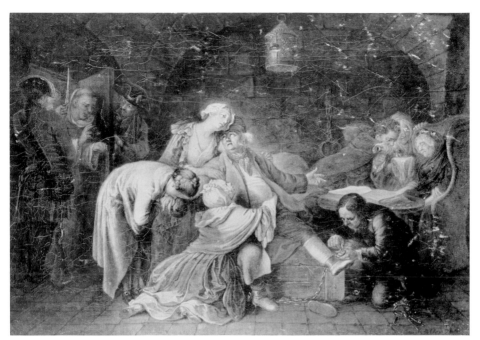

77. Daniel Chodowiecki, *Farewell of Calas*, 1767. Berlin, Deutsches Museum

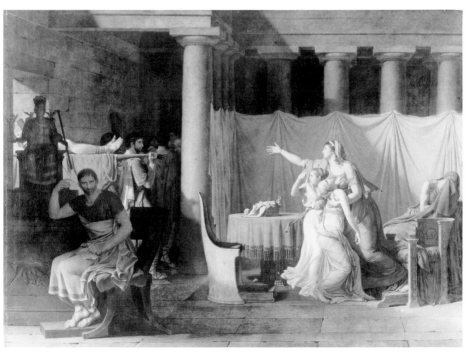

78. Jacques-Louis David, *Lictors Returning to Brutus the Bodies of His Sons*, Salon of 1789. Paris, Louvre

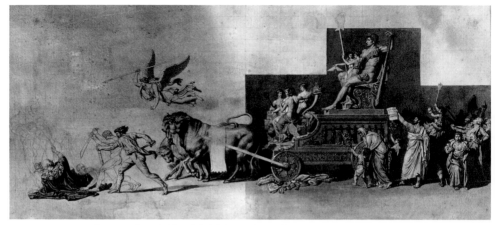

79. Jacques-Louis David, *Triumph of the French People*, 1793-1794.
Paris, Musée Carnavalet

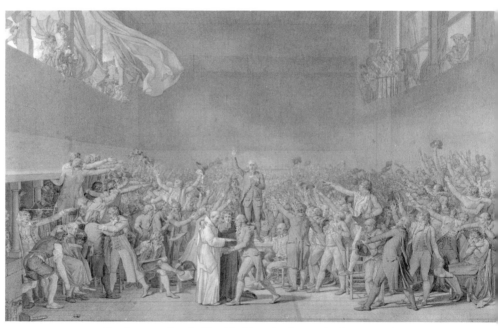

80. Jacques-Louis David, *Tennis Court Oath*. Versailles

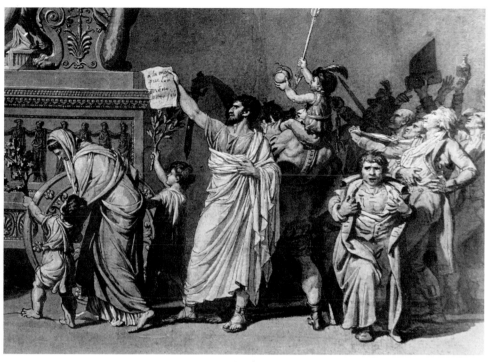

81. Detail of Fig. 79

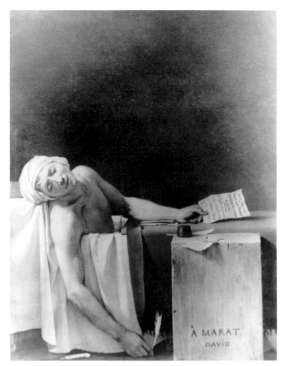

82. Jacques-Louis David, *Death of Marat*,
1793. Brussels, Musée Royal des Beaux-Arts

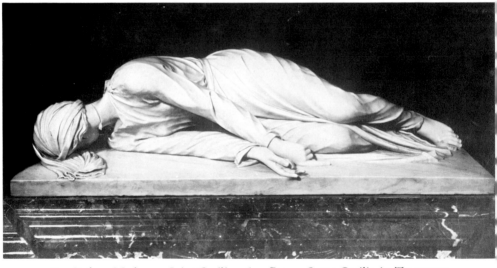

83. Stefano Maderno, *Saint Cecilia*, 1600. Rome, Santa Cecilia in Trastevere

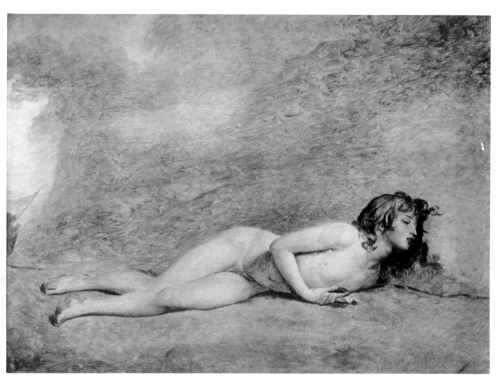

84. Jacques-Louis David, *Death of Bara (Viala?)*, 1794. Avignon, Musée Calvet

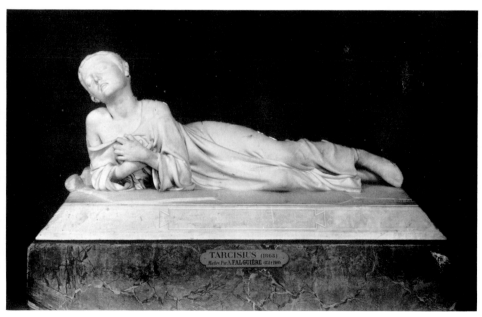

85. Jean-Alexandre-Joseph Falguière, *Tharsicus*, 1868. Paris, Louvre

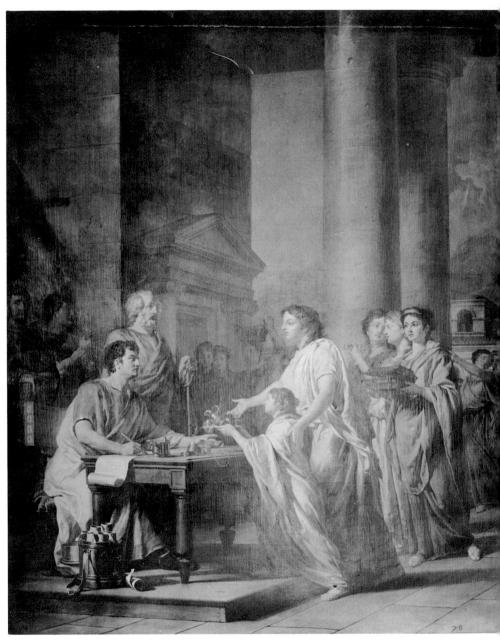

86. Nicolas-Guy Brenet, *Piety and Generosity of Roman Women*,
Salon of 1785. Fontainebleau, Château

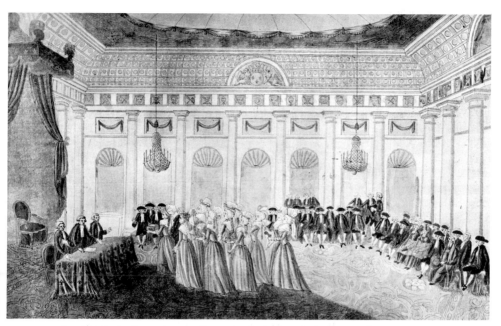

87. *Patriotic Donation by Famous Frenchwomen, September 21, 1789,*
engraving. Paris, Bibliothèque Nationale

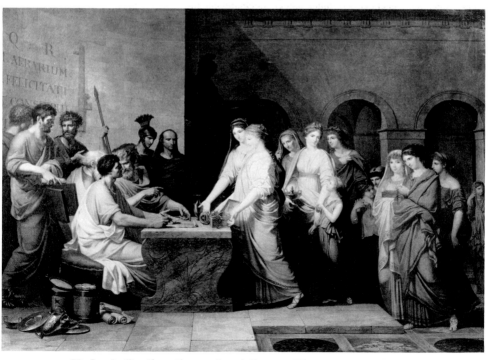

88. Louis Gauffier, *Generosity of Roman Women,* Salon of 1791.
Poitiers, Musée des Beaux-Arts

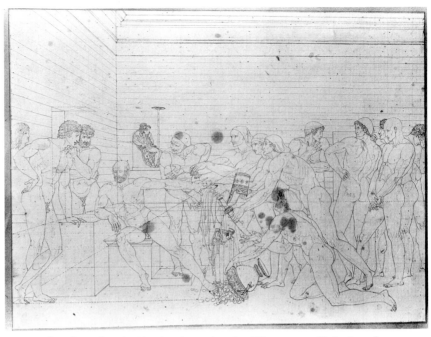

89. Anne-Louis Girodet, *Drawing for Hippocrates Refusing the Gifts of Artaxerxes*, 1791. Bayonne, Musée Bonnat

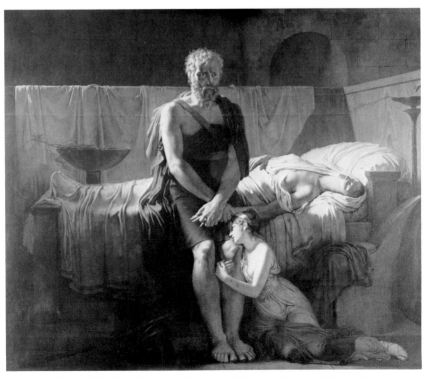

90. Pierre-Narcisse Guérin, *Return of Marcus Sextus*, Salon of 1799. Paris, Louvre

91. François Watteau de Lille, *Departure of the Volunteer*, ca. 1792.
Paris, Musée Carnavalet

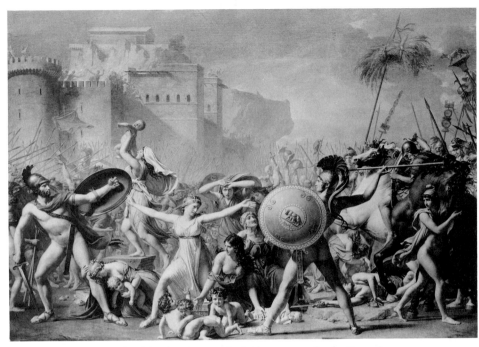

92. Jacques-Louis David, *Sabines*, 1799. Paris, Louvre

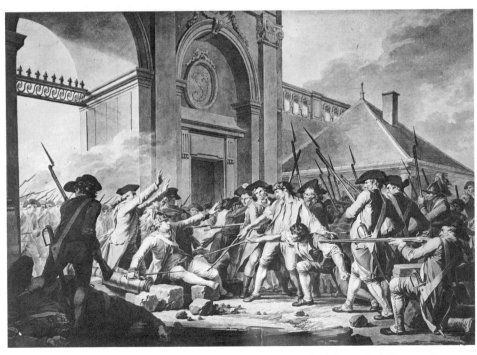

93. Jean-Jacques-François Le Barbier, *Heroism of the Young Désilles at the Affair of Nancy, August 30, 1790* (drawing for painting exhibited at Salon of 1795). Paris, Musée Carnavalet

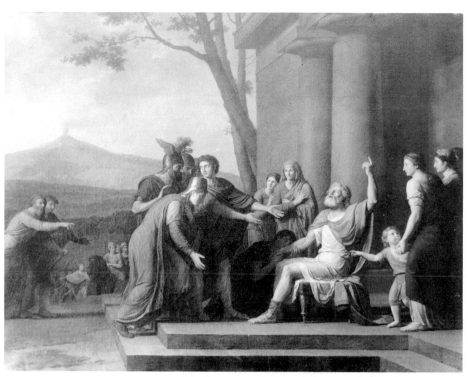

94. Jean-Joseph Taillasson, *Timoleon and the Syracusans*,
Salon of 1796. Tours, Musée des Beaux-Arts

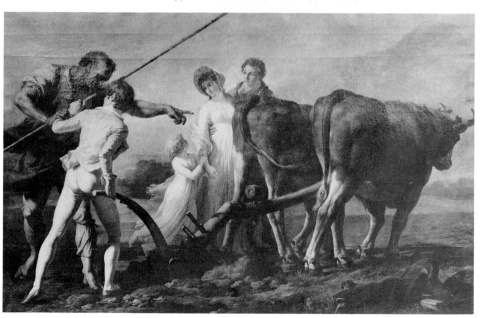

95. François-André Vincent, *Agriculture*, Salon of 1796.
Bordeaux, Musée des Beaux-Arts

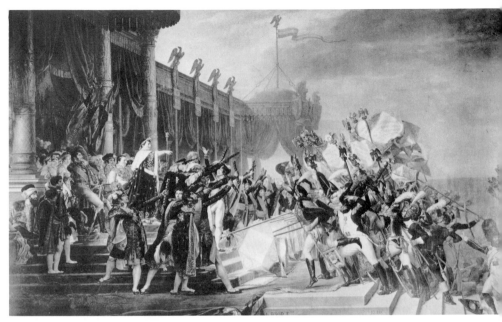

96. Jacques-Louis David, *Distribution of Eagles, December 5, 1804,*
Salon of 1810. Paris, Louvre

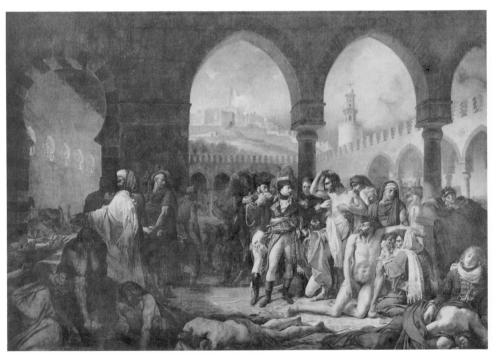

97. Antoine-Jean Gros, *Napoleon in the Pesthouse at Jaffa,*
Salon of 1804. Paris, Louvre

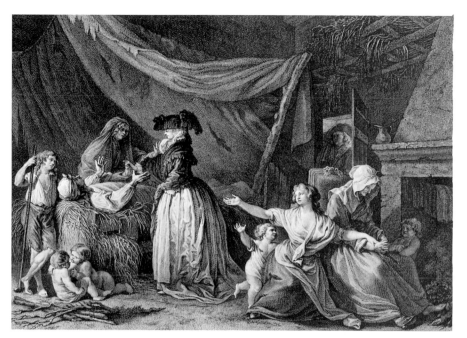

98. Jean Defraine, *Act of Humanity*, engraving of 1783 by R. De Launay
le jeune. Paris, Bibliothèque Nationale

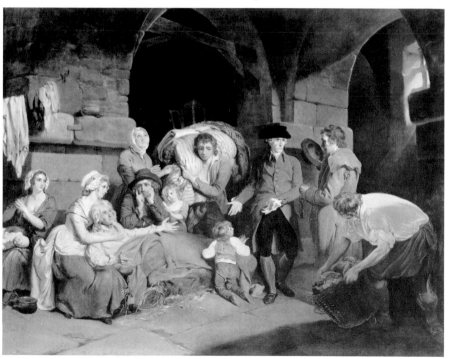

99. Francis Wheatley, *Mr. Howard Offering Relief to Prisoners*, R.A.,
1788. Coll. Earl of Harrowby

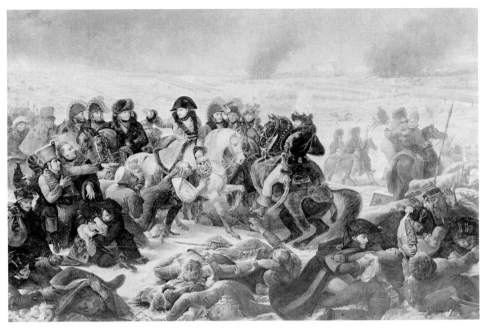

100. Antoine-Jean Gros, *Napoleon at Eylau*, Salon of 1808. Paris, Louvre

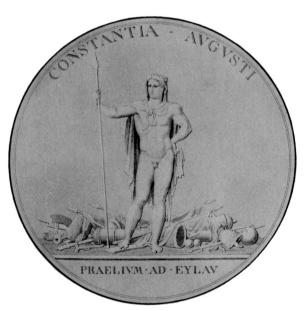

101. *Battle at Eylau*, Commemorative
Medallion, 1811

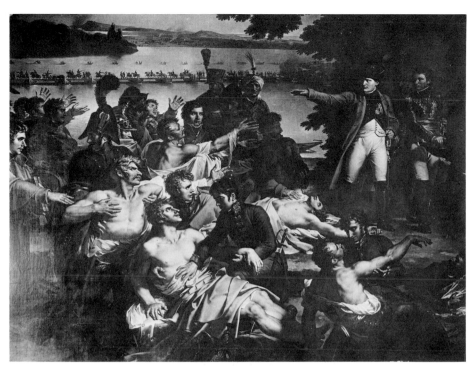

102. Charles Meynier, *Return of Napoleon to Isle of Lobau*,
Salon of 1812. Versailles

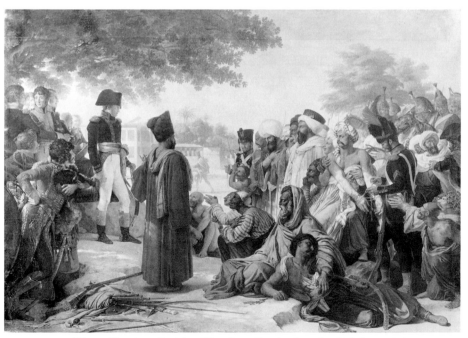

103. Pierre-Narcisse Guérin, *Napoleon Pardoning the Rebels at Cairo*,
Salon of 1808. Versailles

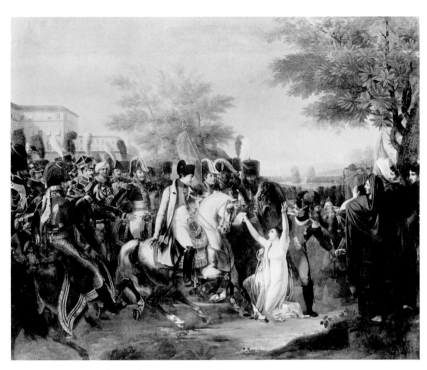

104. Charles Lafond *le jeune*, *Clemency of Napoleon toward
Mlle. de Saint-Simon, Who Asks Pardon for Her Father*,
Salon of 1810. Versailles

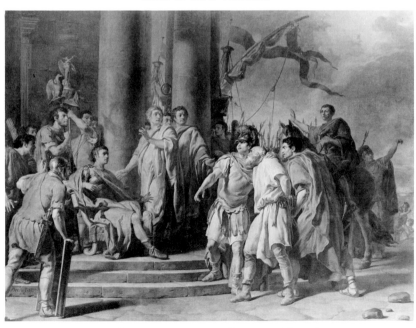

105. Nicolas-Guy Brenet, *Metellus Saved by His Son*,
Salon of 1779. Nîmes, Musée des Beaux-Arts

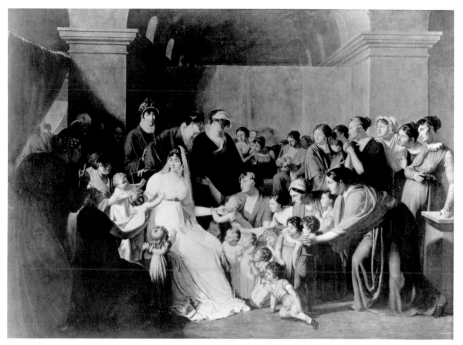

106. Charles Lafond *le jeune*, *Josephine at the Hospice de la Maternité*,
Salon of 1806. Dunkirk, Musée des Beaux-Arts

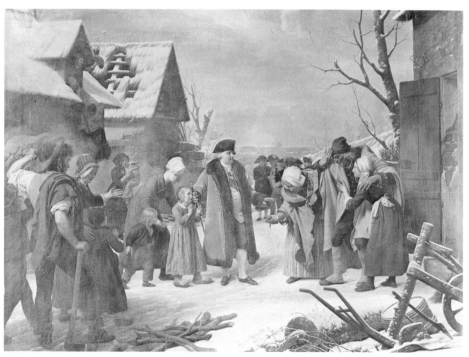

107. Louis Hersent, *Louis XVI Distributing Alms to the Poor During
the Winter of 1788*, Salon of 1817. Versailles

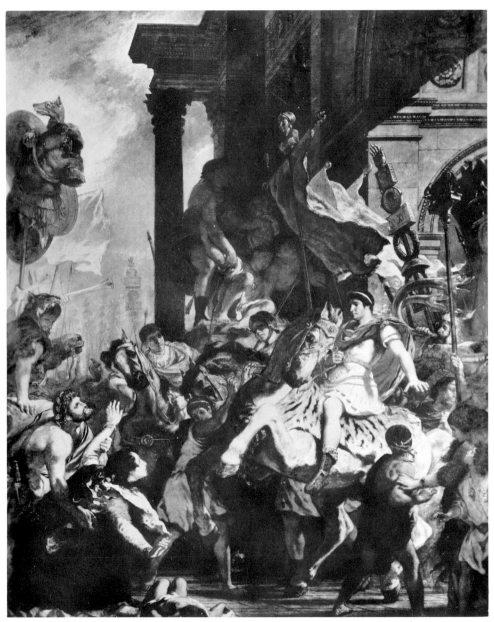

108. Eugène Delacroix, *Justice of Trajan*, Salon of 1840.
Rouen, Musée des Beaux-Arts

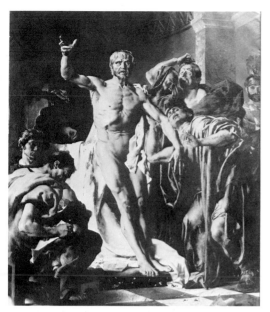

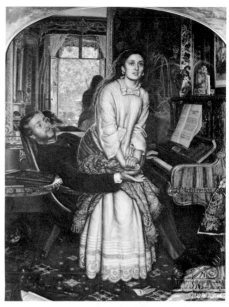

109. Joseph Sylvestre, *Death of Seneca*,
Salon of 1875. Béziers, Musée
des Beaux-Arts

110. William Holman Hunt, *Awakening
Conscience*, R.A., 1854. London,
Coll. Sir Colin Anderson

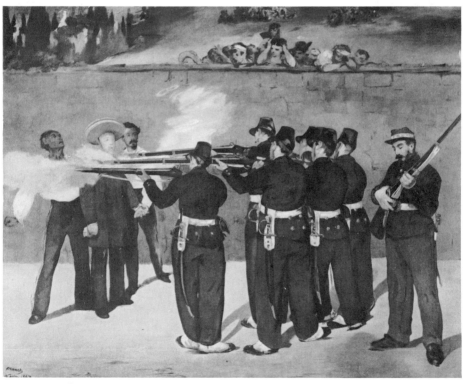

111. Edouard Manet, *Execution of Maximilian*, 1867. Mannheim, Kunsthalle

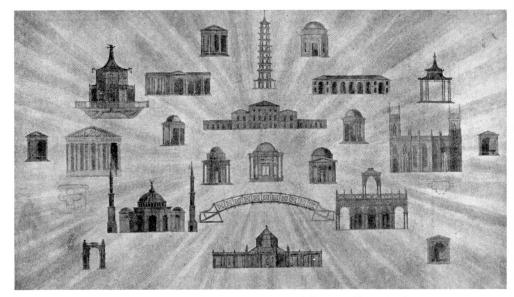

112. Sir John Soane and pupils, *Drawing of Buildings at Kew Gardens*, ca. 1815

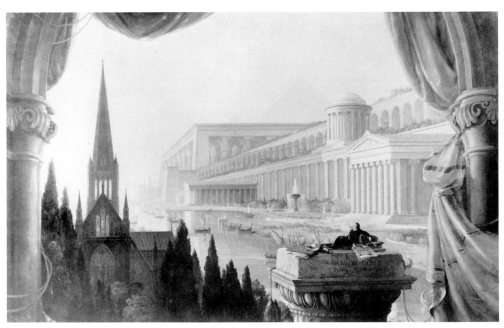

113. Thomas Cole, *Architect's Dream*, 1840. Toledo Museum of Art

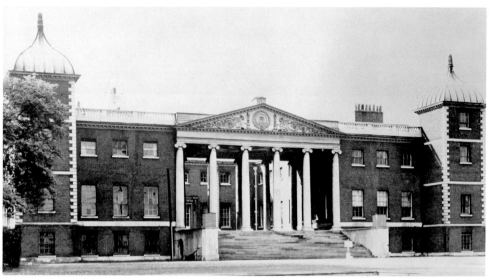

114. Robert Adam, Osterley Park, façade. Begun 1761

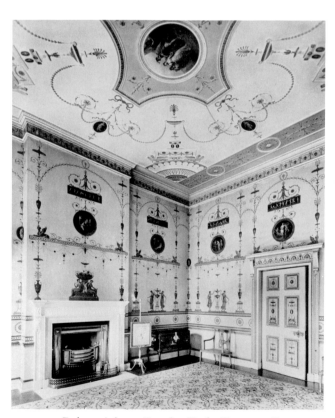

115. Robert Adam, Osterley Park, Etruscan Room.
1775-1778

116. Louis-François Petit-Radel,
Remodeling of Choir, St. Médard,
Paris. 1784

117. P. Martini, Frontispiece to the
Comte de Volney, *Les Ruines* . . . ,
1792 (2nd ed.)

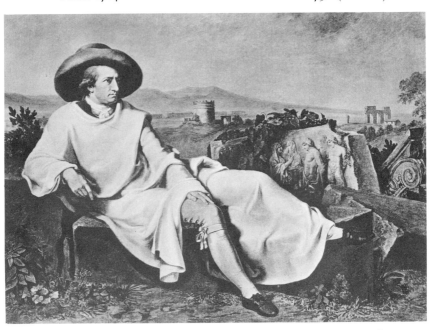

118. Wilhelm Tischbein, *Goethe in the Roman Campagna*, 1786-1787.
Frankfurt-am-Main, Städelsches Kunstinstitut

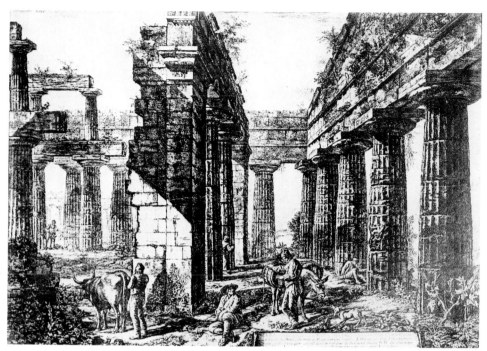

119. Giovanni Battista Piranesi, *Ruins of Paestum* (etching), 1778

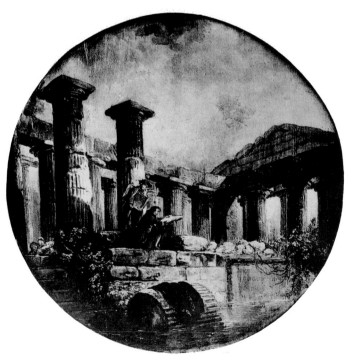

120. Hubert Robert, *Ruins of a Temple*,
Amiens, Musée de Picardie

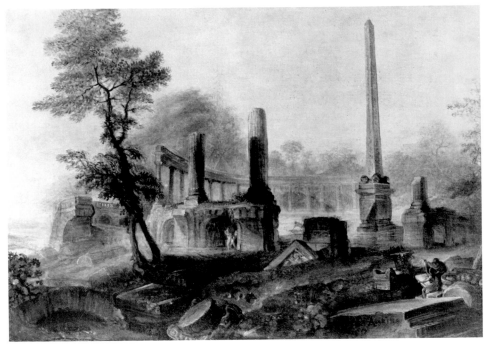

121. Gabriel de Saint-Aubin, *Parc Monceau*, 1778. Whereabouts unknown

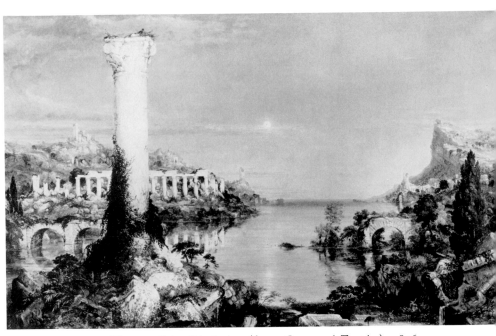

122. Thomas Cole, *Desolation* (from *Course of Empire*), 1836.
New York Historical Society

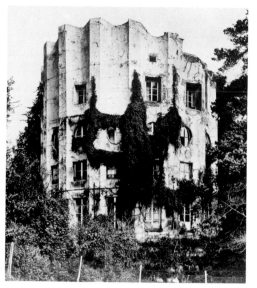

123. François Racine de Monville,
Désert de Retz (near Chambourcy),
Column House. 1771

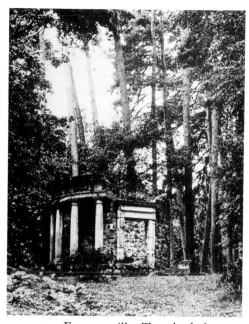

124. Ermenonville, Temple de la
Philosophie moderne, ca. 1780

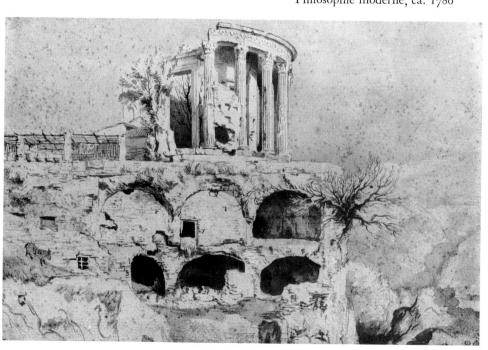

125. Joseph Vernet, *Temple of the Sibyl*, *Tivoli* (drawing).
Paris, École des Beaux-Arts

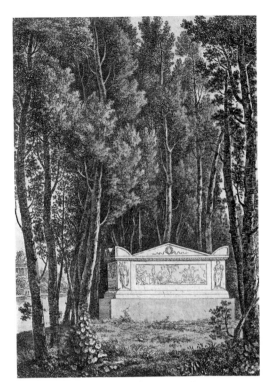

126. Ermenonville, Tomb of Rousseau,
ca. 1778, engraving by Mérigot *fils*

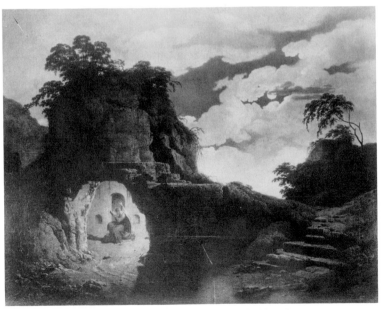

127. Joseph Wright of Derby, *Virgil's Tomb*, 1779.
Coll. John Crompton-Inglefield

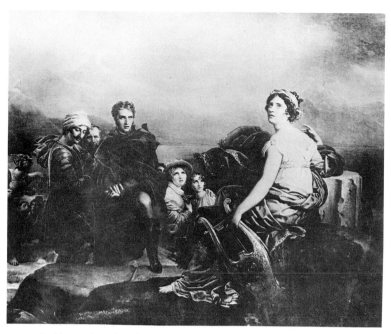

128. François Gérard, *Corinne at Cape Miseno*, 1822. Lyons,
Musée des Beaux-Arts

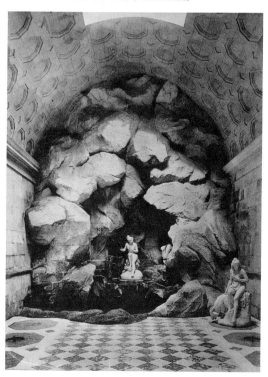

129. Thévenin, Rambouillet,
Laiterie. 1784

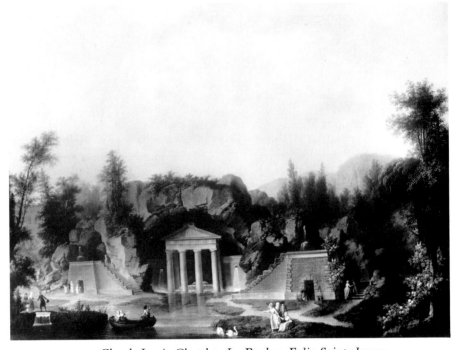

130. Claude-Louis Chatelet, *Le Rocher, Folie Sainte-James, Neuilly*. Coll. Jacques Lebel

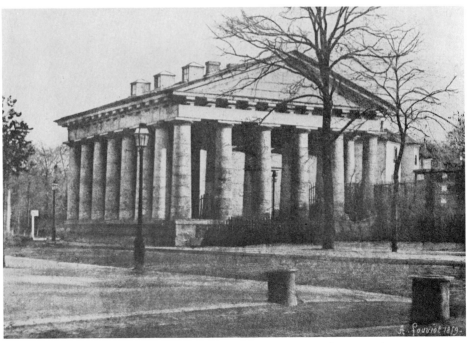

131. Claude-Nicolas Ledoux, Barrière de Courcelles (destroyed), Paris

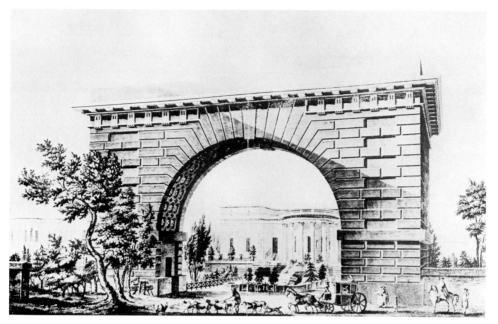

132. Claude-Nicolas Ledoux, Hôtel de Thélusson, Paris. 1778-1781

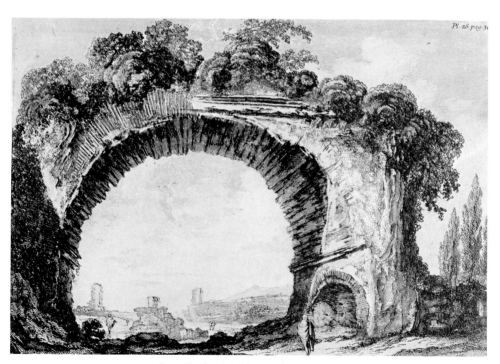

133. Jean Barbault, Circus of Maxentius, 1761

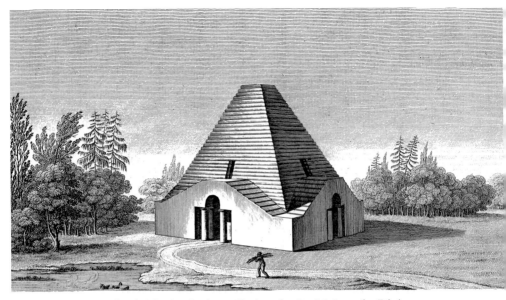

134. Claude-Nicolas Ledoux, Project for La Maison du Bûcheron,
Saline de Chaux

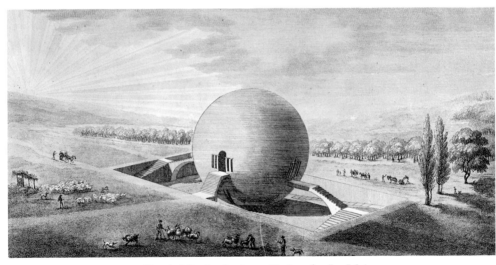

135. Claude-Nicolas Ledoux, Project for La Maison
des Gardes Agricoles at Maupertuis

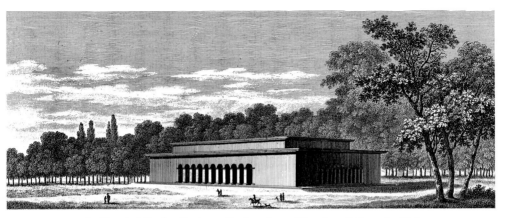

136. Claude-Nicolas Ledoux, Project for a Hospice, Saline de Chaux

137. Louis Le Masson, SS. Pierre et Paul, Courbevoie. 1789

138. Pierre Rousseau, Hôtel de Salm (now Palais de la Légion d'Honneur),
Paris. 1782

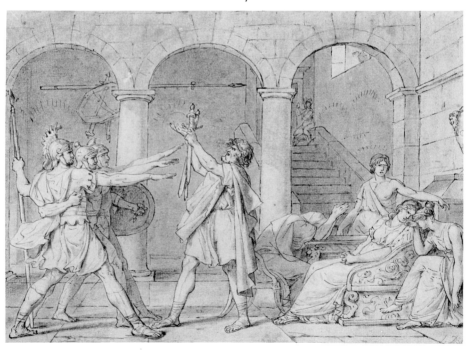

139. Jacques-Louis David, *Oath of the Horatii* (drawing).
Lille, Palais des Beaux-Arts

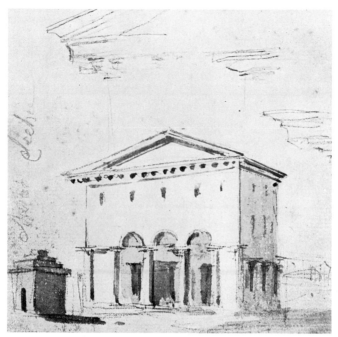

140. Claude-Nicolas Ledoux, Barrière de Clichy,
Paris (drawing)

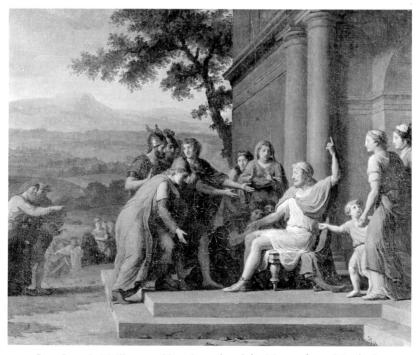

141. Jean-Joseph Taillasson, *Timoleon* (study). Montauban, Musée Ingres

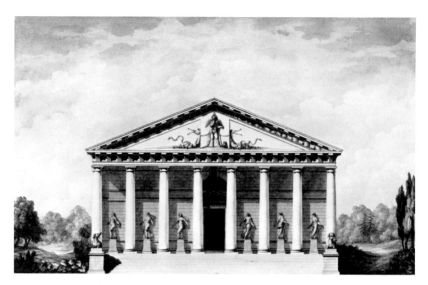

142. Jean-Jacques Lequeu, *House for M. X****, 1788.
Paris, Bibliothèque Nationale

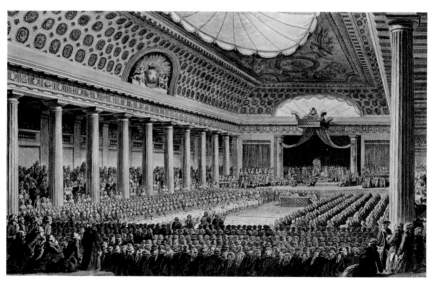

143. Pierre-Adrien Pâris, Hôtel des Menus-Plaisirs, Versailles. 1787

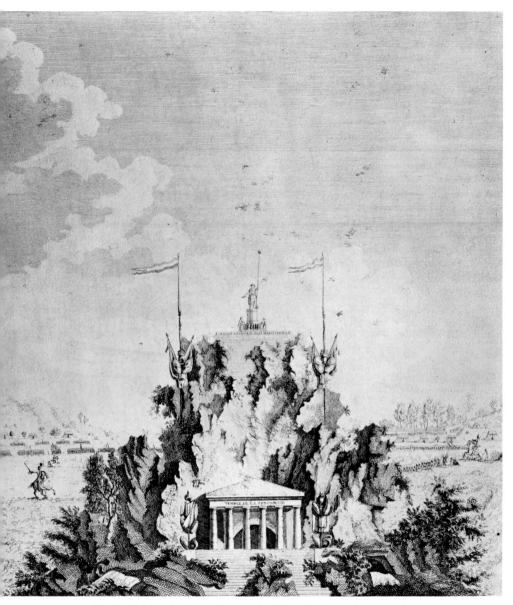

144. Claude Cochet *le jeune, Design for Revolutionary Pageant, Lyons,
May 30, 1790,* engraving by Gentot *fils*

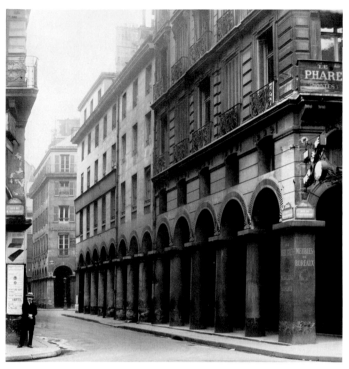

145. Bernard Poyet (?), Rue des Colonnes, Paris. ca. 1798

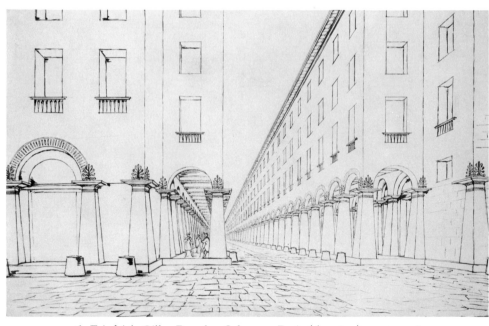

146. Friedrich Gilly, *Rue des Colonnes, Paris* (drawing). 1797-1798.
Berlin, Technische Hochschule, Bibliothek

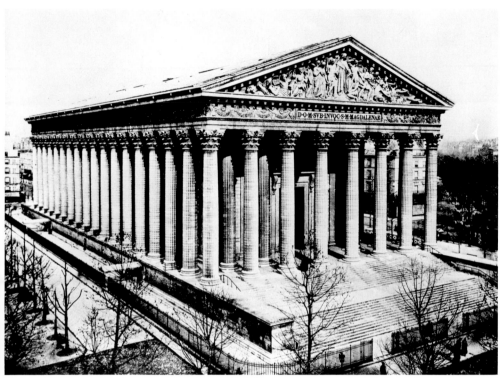

147. Pierre Vignon, La Madeleine, Paris. Begun 1808

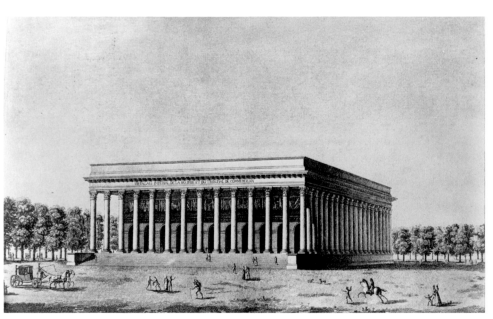

148. Alexandre-Théodore Brongniart, La Bourse, Paris. Begun 1808

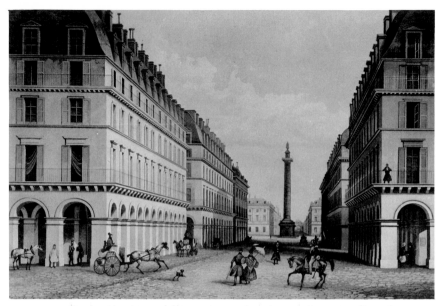

149. Charles Percier and Pierre François Léonard Fontaine, Rue de Castiglione, Paris, engraving by Himely after drawing by Gilio

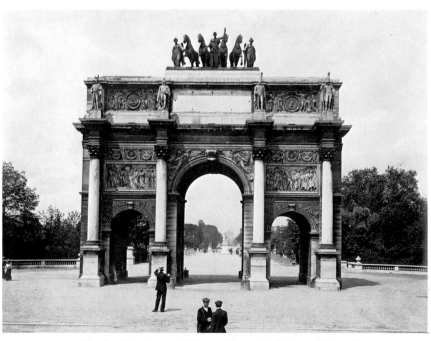

150. Charles Percier and Pierre François Léonard Fontaine, Arc de Triomphe du Carrousel, Paris. 1806

151. J.-A. Alavoine, Place de la Bastille in 1814 (watercolor).
Paris, Musée Carnavalet

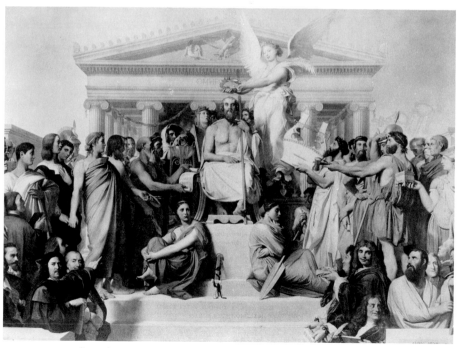

152. Jean-Auguste-Dominique Ingres, *Apotheosis of Homer*, 1827.
Paris, Louvre

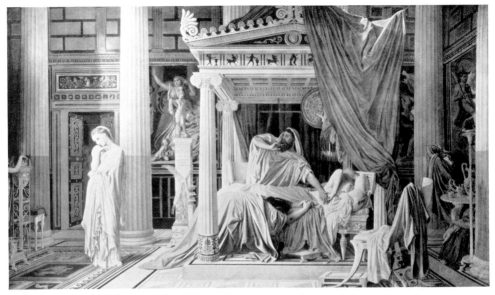

153. Jean-Auguste-Dominique Ingres, *Antiochus and Stratonice*, 1840.
Chantilly, Musée Condé

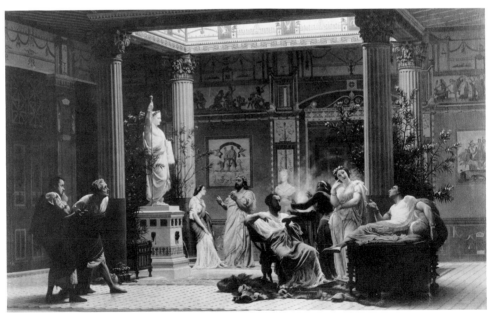

154. Gustave Boulanger, *Rehearsal of "Le Joueur de flûte" and
"La Femme de Diomède,"* Salon of 1861. Versailles

155. Friedrich von Gärtner, Pompeianum, Aschaffenburg. 1842

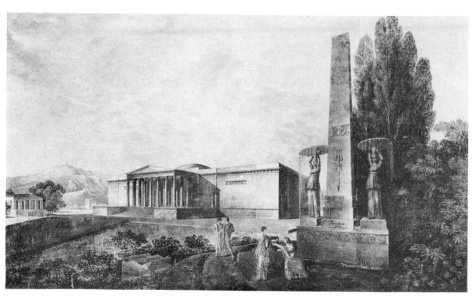

156. Karl Friedrich Schinkel, Design for a Museum, 1800.
Radensleben bei Neuruppin, Coll. von Quast

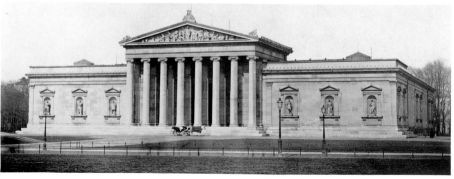

157. Leo von Klenze, Glyptothek, Munich. 1816-1830

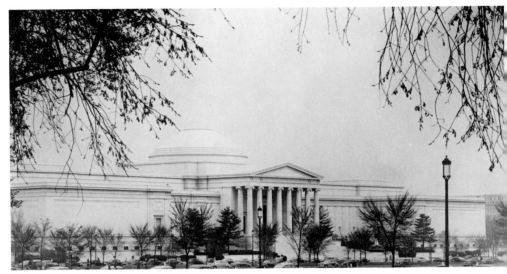

158. John Russell Pope, National Gallery of Art, Washington, D.C. 1937

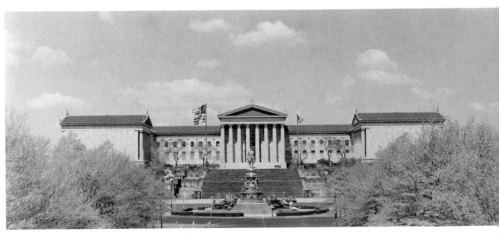

159. Horace Trumbauer and Associates, Philadelphia Museum of Art. Begun 1919

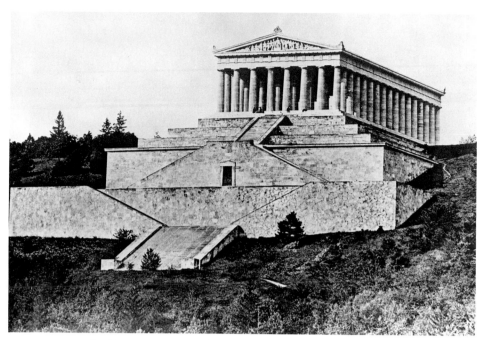

160. Leo von Klenze, Walhalla, near Regensburg. 1816-1842

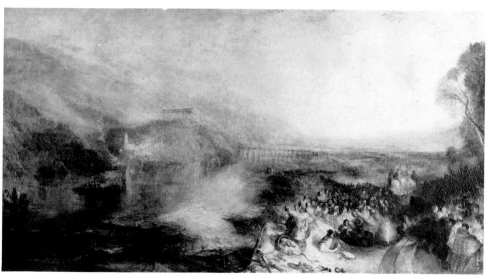

161. J. M. W. Turner, *Opening of the Walhalla in 1842*, R.A.
1843. London, The Tate Gallery

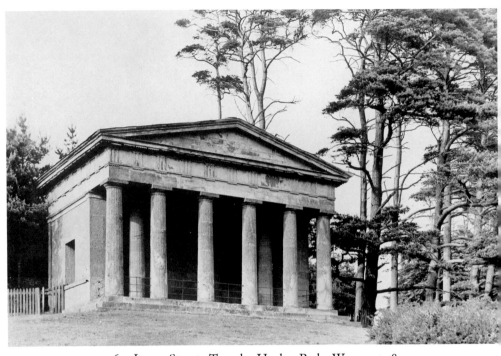

162. James Stuart, Temple, Hagley Park, Worcs. 1758

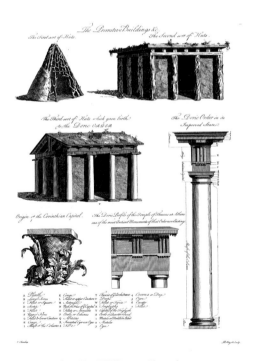

163. Sir William Chambers,
Primitive Buildings, 1759

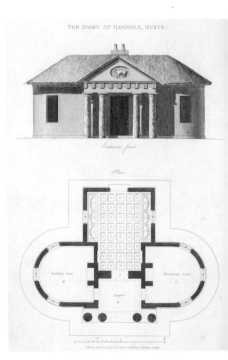

164. Sir John Soane, Project
for a Dairy at Hammels,
Herts, 1788

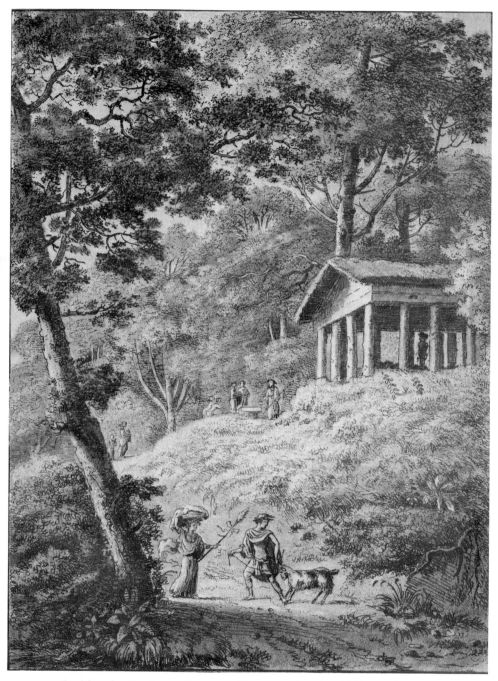

165. Temple Rustique, Ermenonville, engraving by Mérigot *fils*, 1788

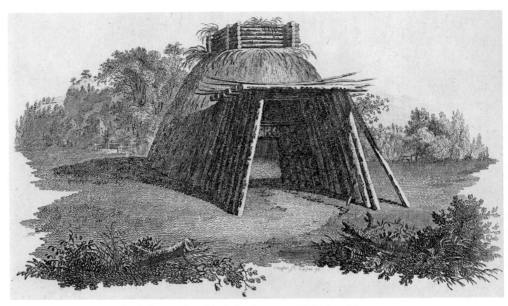

166. Johann Gottfried Grohmann, Tahitian Hut, 1799

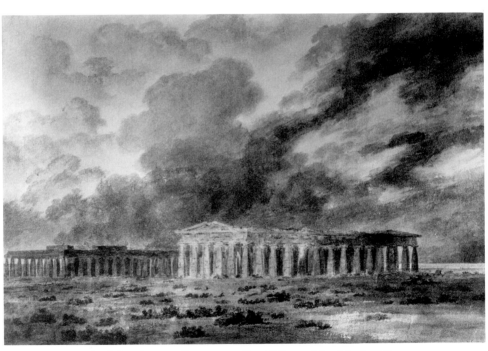

167. John Cozens, *Paestum*, 1782. Oldham, Municipal Gallery

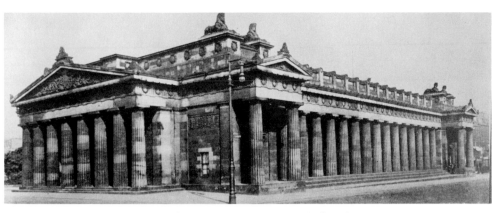

168. William Playfair, Royal Institution, Edinburgh. 1822-1836

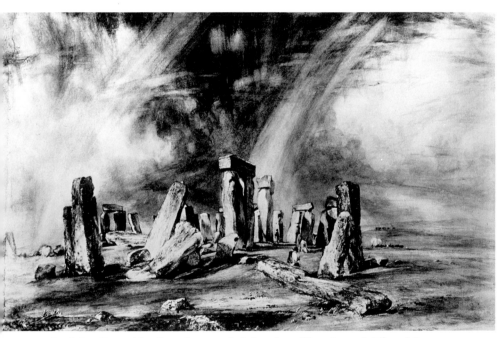

169. John Constable, *Stonehenge*, 1836. London, Victoria and Albert Museum

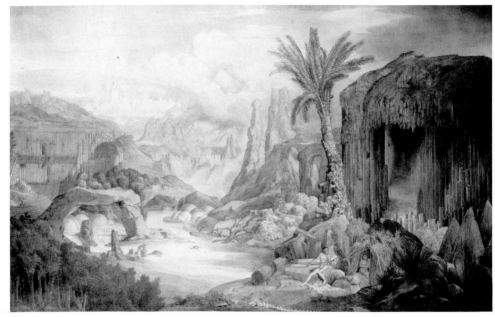

170. Joseph Gandy, *Origins of Architecture*, 1838.
London, Sir John Soane's Museum

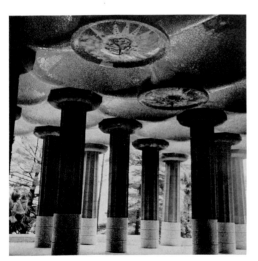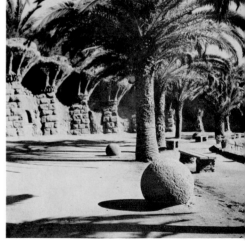

171-172. Antonio Gaudí, Park Güell, Barcelona. 1900-1914
Hypostyle Hall Galleries

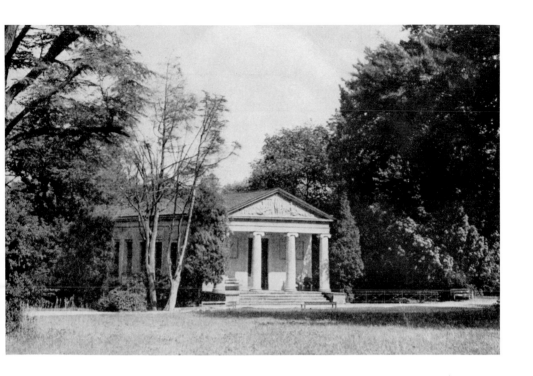

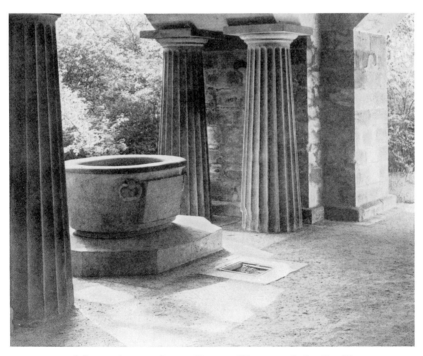

173-174. Johann August Arens, Roman House and detail of basement
level. Weimar, Park. 1791-1797

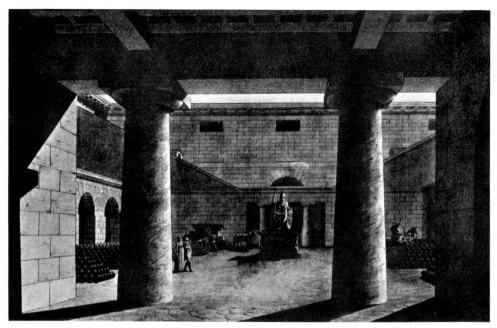

175. Friedrich Weinbrenner, Design for an Arsenal, 1795

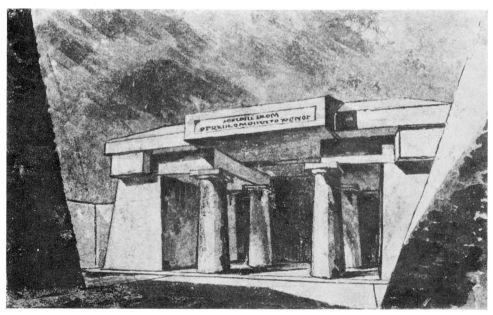

176. Friedrich Gilly, Design for a Gatehouse.
Berlin, Technische Hochschule, Bibliothek

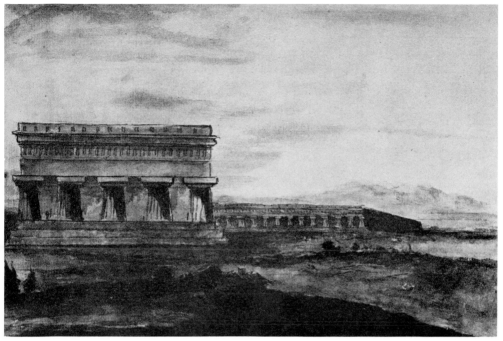

177. Carl August Ehrensvärd, "Egyptian" Architecture in a Nordic Landscape
(watercolor). Stockholm, Nationalmuseum

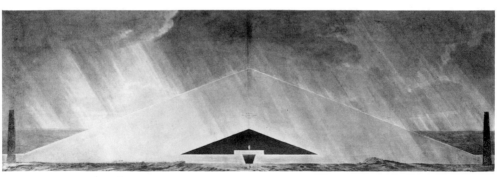

178. Étienne-Louis Boullée, Design for a Cemetery Entrance.
Paris, Bibliothèque Nationale

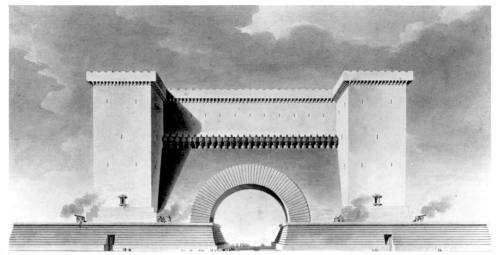

179. Étienne-Louis Boullée, Design for a City Gate.
Paris, Bibliothèque Nationale

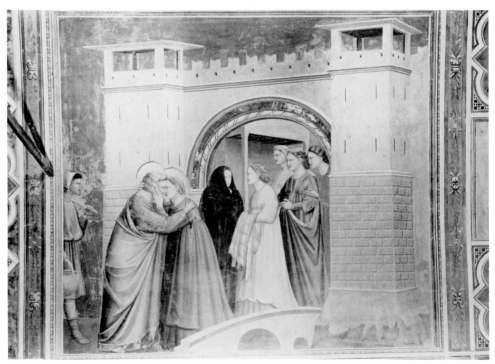

180. Giotto, *Meeting at the Golden Gate*, Padua, Arena Chapel

181. Johann Wolfgang Goethe, Altar
of Good Fortune, Weimar, Park. 1777

182. Peter Speeth, Women's Prison
(formerly Casern), Würzburg. 1809

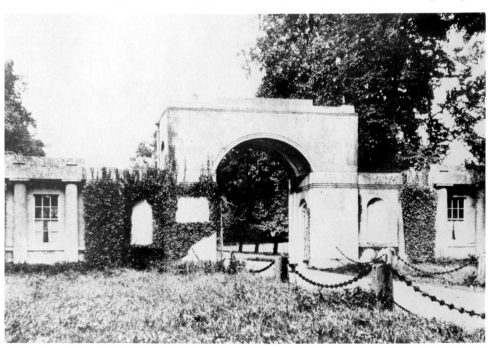

183. Sir John Soane, Gatehouse, Tyringham, Bucks. 1794

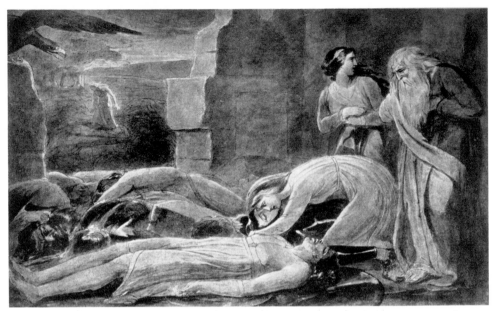

184. William Blake, *Breach in a City the Morning after the Battle* (watercolor),
1784. Pittsburgh, Coll. Charles Rosenbloom.

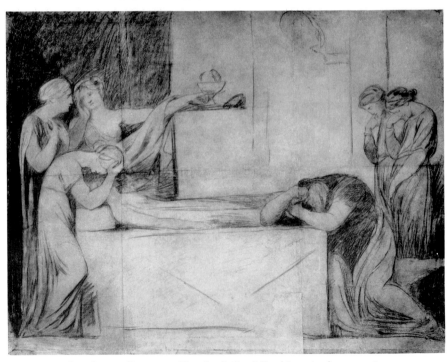

185. George Romney, *Death of Cordelia* (drawing), ca. 1789.
Liverpool, Walker Art Gallery

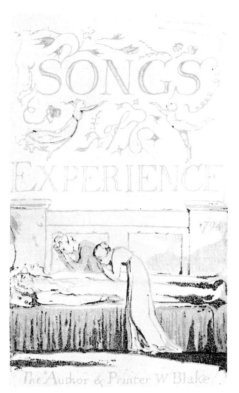

186. William Blake, *Songs of
Experience* (title page), 1794

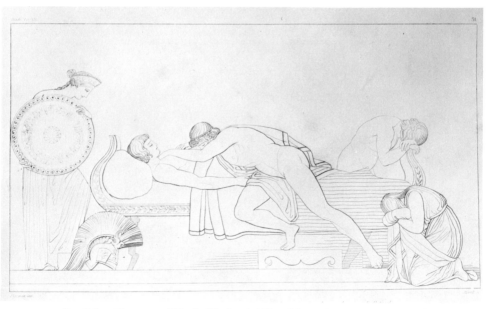

187. John Flaxman, *Thetis Finds Achilles Mourning over the Corpse
of Patroclus* (from the Iliad, 1st ed., 1793)

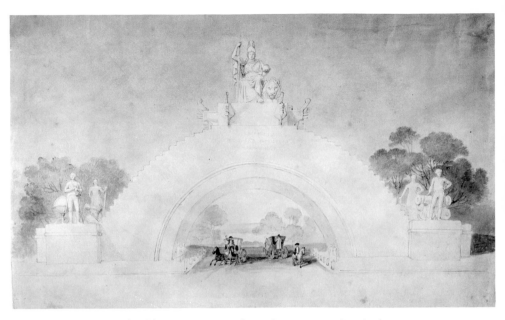

188. John Flaxman, Design for a Commemorative Arch, 1799.
Princeton University, Art Museum

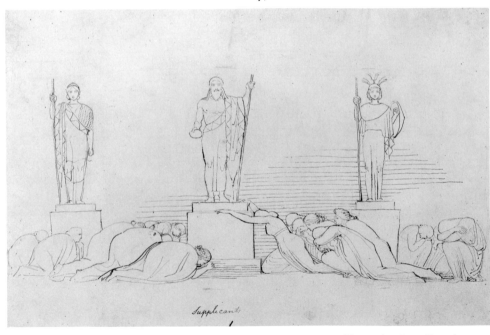

189. John Flaxman, *Prayer of the Daughters of Danaüs* (from the *Suppliants*)
(drawing), ca. 1793. British Museum

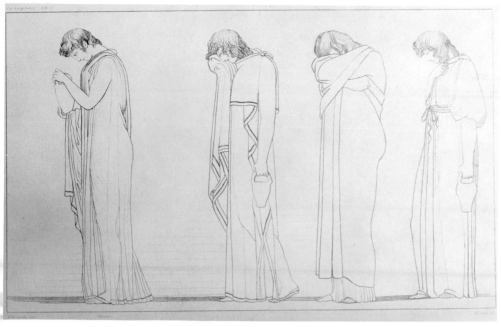

190. John Flaxman, *Elektra Leading Procession to Agamemnon's Tomb* (from the *Choëphoroe*, 1st ed., 1795)

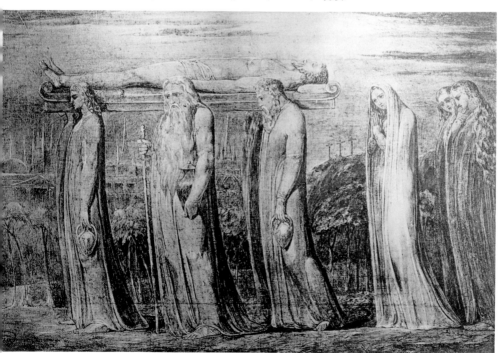

191. William Blake, *Procession from Calvary*, ca. 1800. London, Tate Gallery

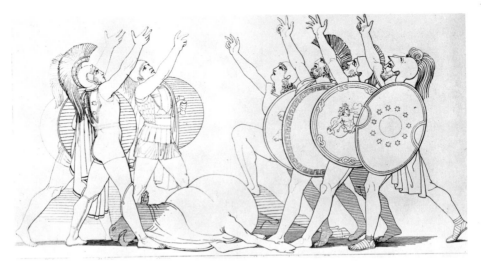

192. John Flaxman, *Oath of the Seven Against Thebes*
(from the *Seven Against Thebes*, 1st ed., 1795)

193. George Cumberland, *Figures from Ghiberti's "Gates of
Paradise"* (drawing). London, British Museum

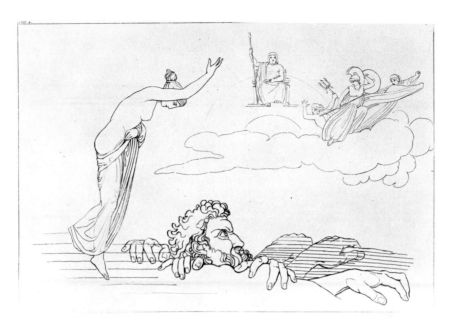

194. John Flaxman, *Thetis Calling Briareus to the Aid of Jupiter*
(from the *Iliad*, 1st ed., 1793)

195. Lorenzo Ghiberti, Jacob and Esau (detail) from
Gates of Paradise. Florence, Baptistery

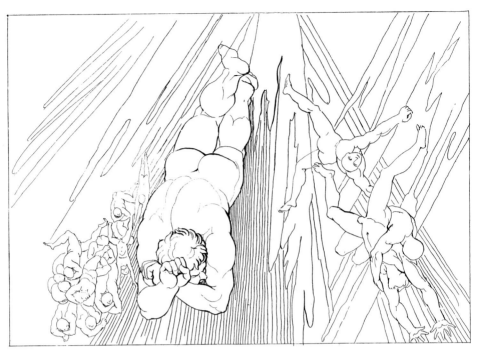

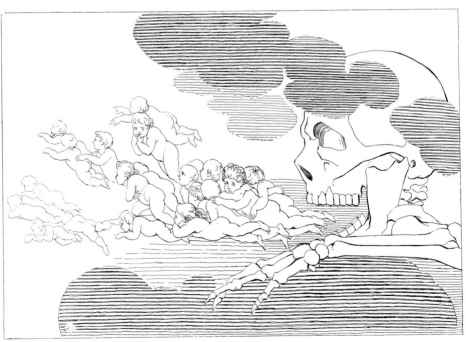

196-197. John Flaxman, Illustrations from *La Divina Commedia*, 1st ed., 1793 (?) *Fall of Lucifer* (Purgatorio, Canto XII) *Limbo, the Guiltless Throng* (Purgatorio, Canto VII)

198-199. John Flaxman, Illustrations from *La Divina Commedia*, 1st ed.,
1793 (?) *Celestial Steps* (Paradiso, Canto XXI)
Circle of Angels around the Sun (Paradiso, Canto XXXIII)

200. John Flaxman, *Beatific Vision* from *La Divina Commedia*
(Paradiso, Canto XXXIII), 1st ed., 1793(?)

201. Mme. Giacomelli, *Death of Jocasta* (from *Compositions
d'après les tragédies de Sophocle*, Paris, 1808)

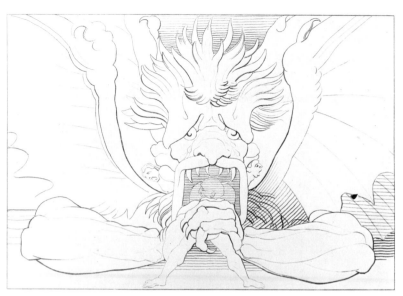

202. John Flaxman, *Lucifer* from *La Divina Commedia* (Inferno, Canto xxxiv), 1st ed., 1793(?)

203. Sofia Giacomelli, *Lucifer* (from *Collection de cent figures ... pour orner la Divine Comédie du Dante ...* , Paris, 1813)

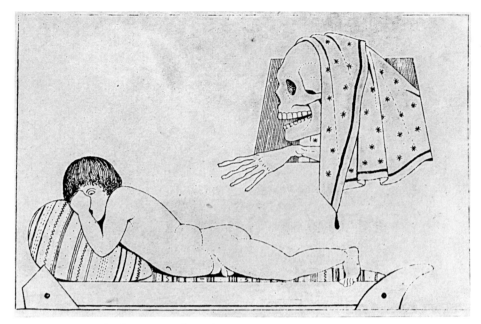

204. D. P. G. Humbert de Superville, *Allegory* (etching), 1801

205. Bénigne Gagneraux, *Venus Wounded by Diomedes* [1792]

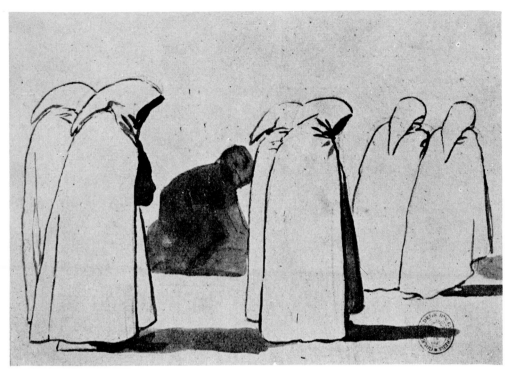

206. Francisco Goya, *Procession of Monks* (drawing), 1795. Madrid, Biblioteca Nacional

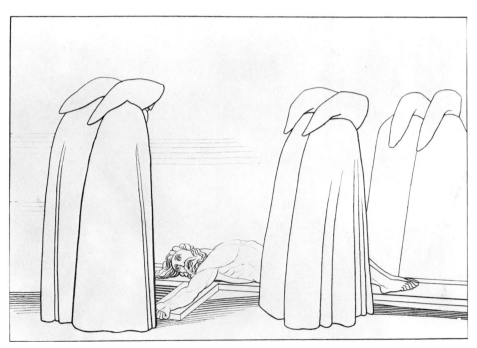

207. John Flaxman, *Hypocrites* (From *La Divina Commedia*, Inferno, Canto XXIII), first published 1793(?)

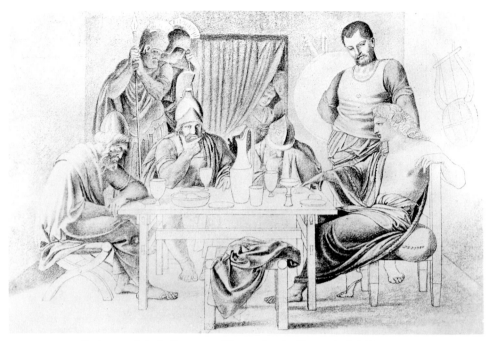

208. Asmus Jakob Carstens, *Heroes in the Tent of Achilles*, 1794.
Weimar, Schlossmuseum

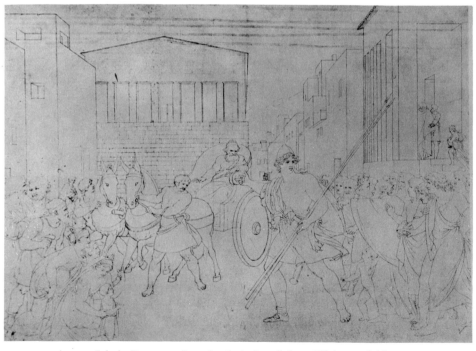

209. Asmus Jakob Carstens, *Jason's Arrival at Iolcos*. Weimar, Schlossmuseum

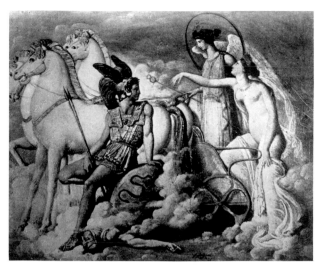

210. Jean-Auguste-Dominique Ingres, *Venus Wounded by Diomedes*, ca. 1803. Basel, Coll. Baron Robert von Hirsch

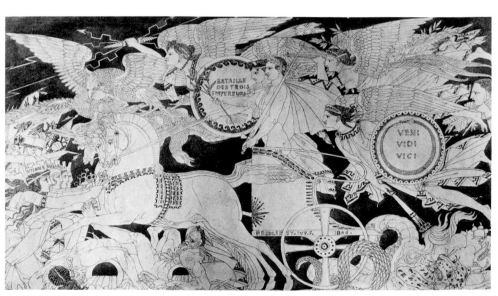

211. Pierre-Nolasque Bergeret, *Battle of Austerlitz*, 1806. Sèvres, Manufacture Nationale

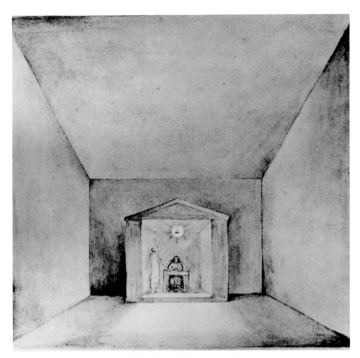

212. William Blake, *A Vision*
(drawing). Formerly Coll. W. Graham Robertson

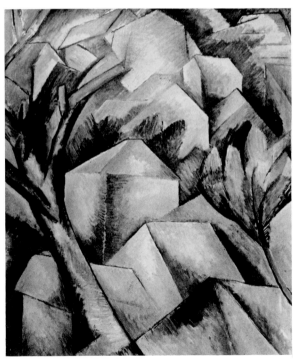

213. Georges Braque, *Houses at L'Estaque*, 1908. Bern, Coll. H. Rupf

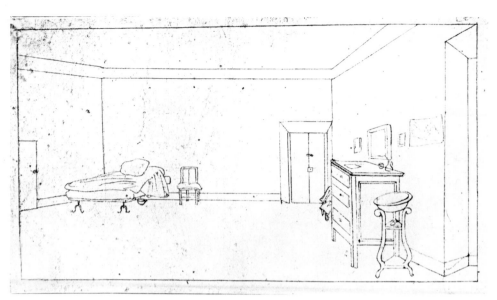

214. Jean-Auguste-Dominique Ingres, *Room at San Gaëtano* (drawing), 1807.
Montauban, Musée Ingres

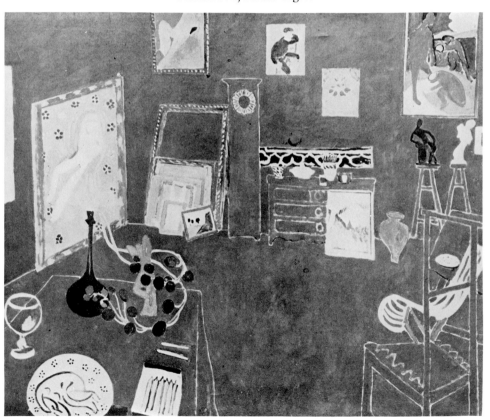

215. Henri Matisse, *Red Studio*, 1911. New York, Museum of Modern Art